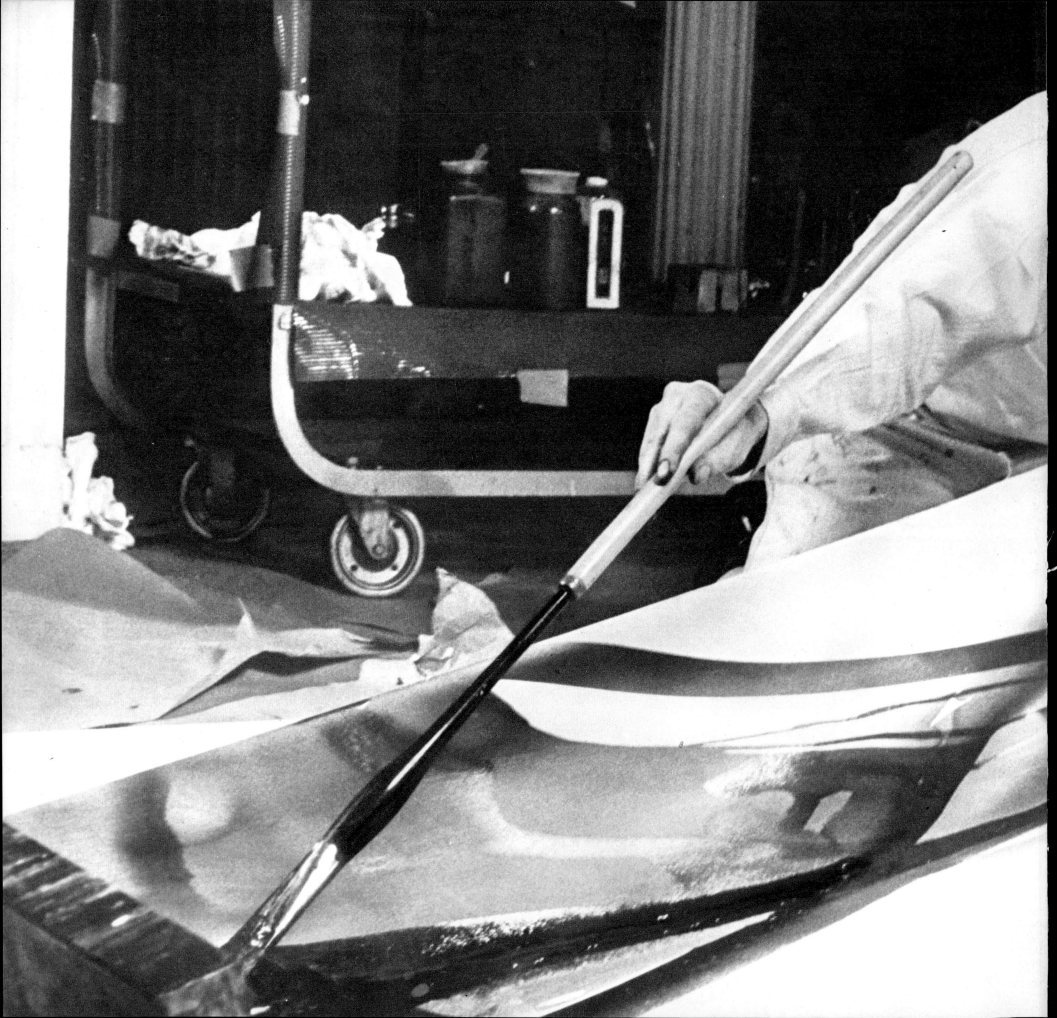

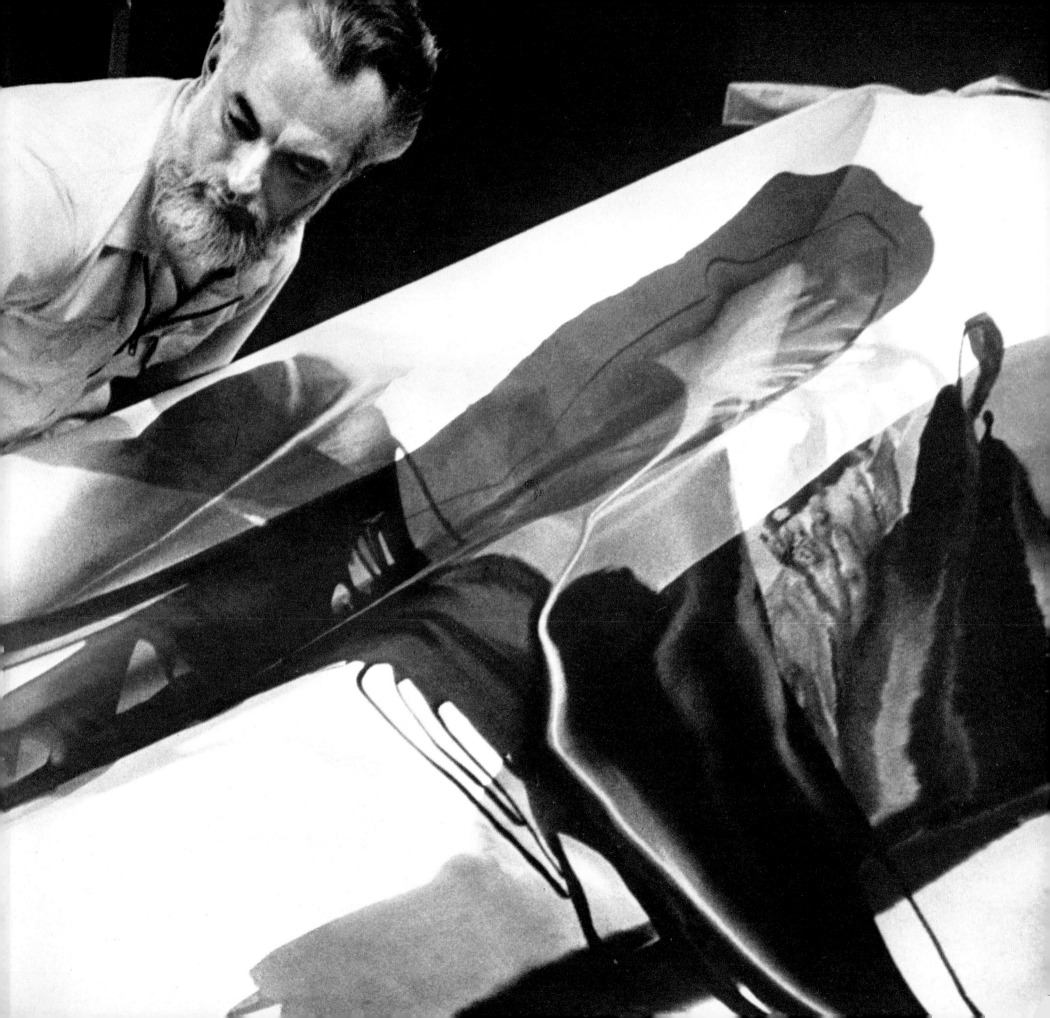

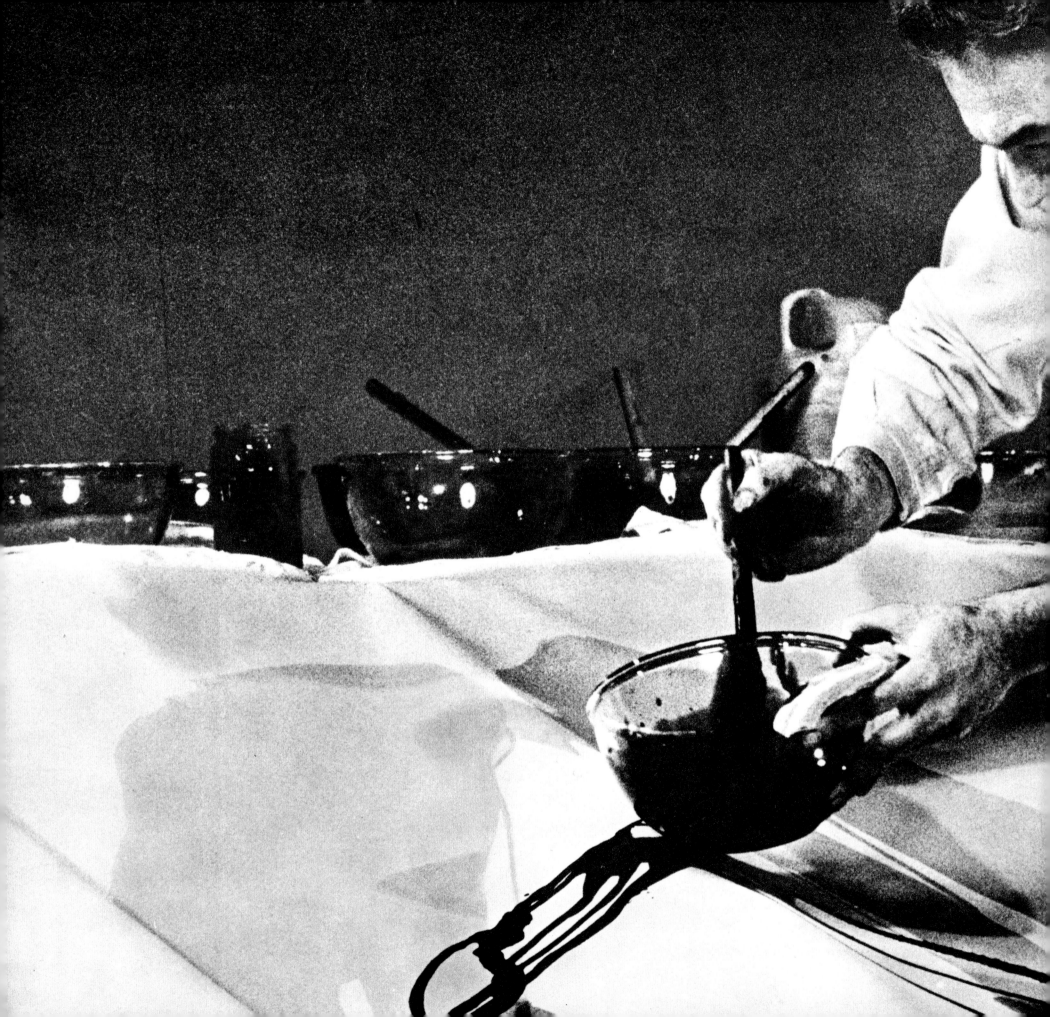

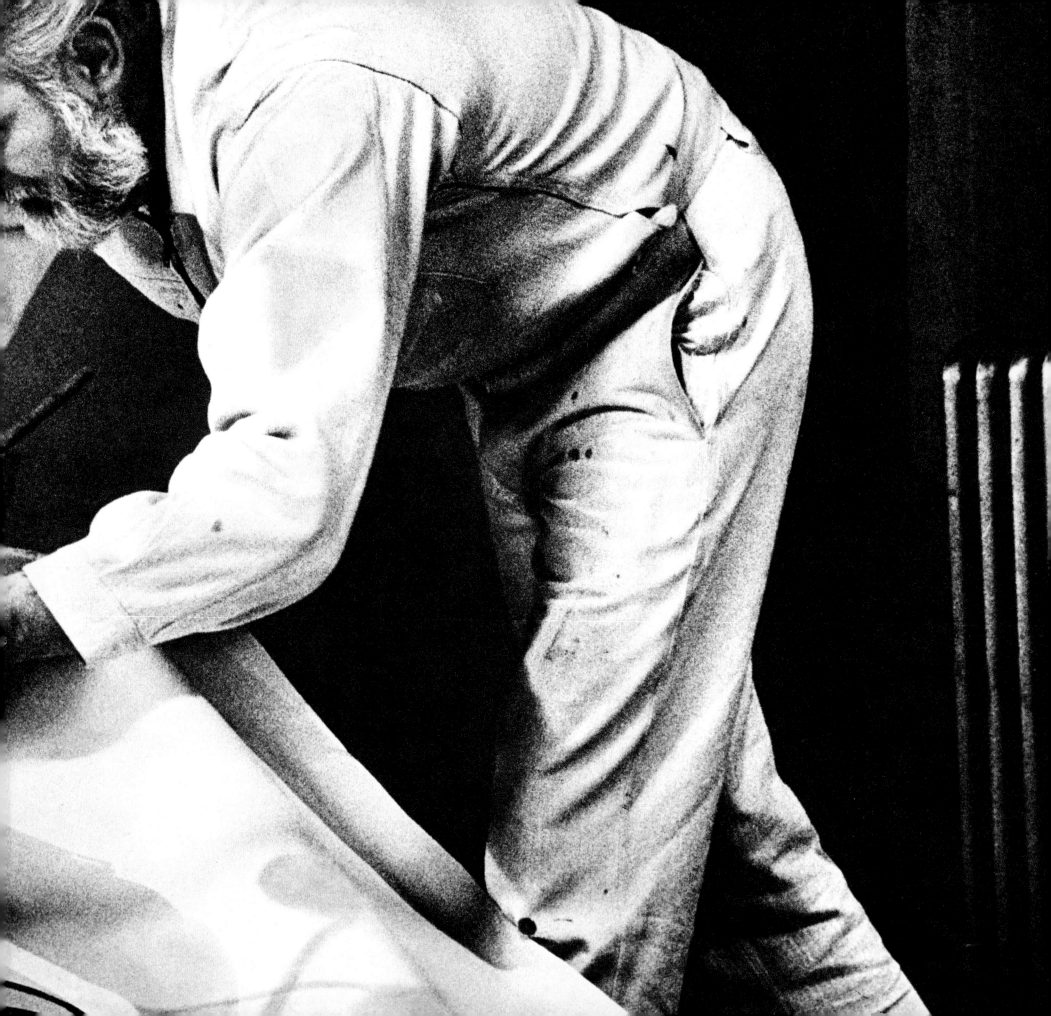

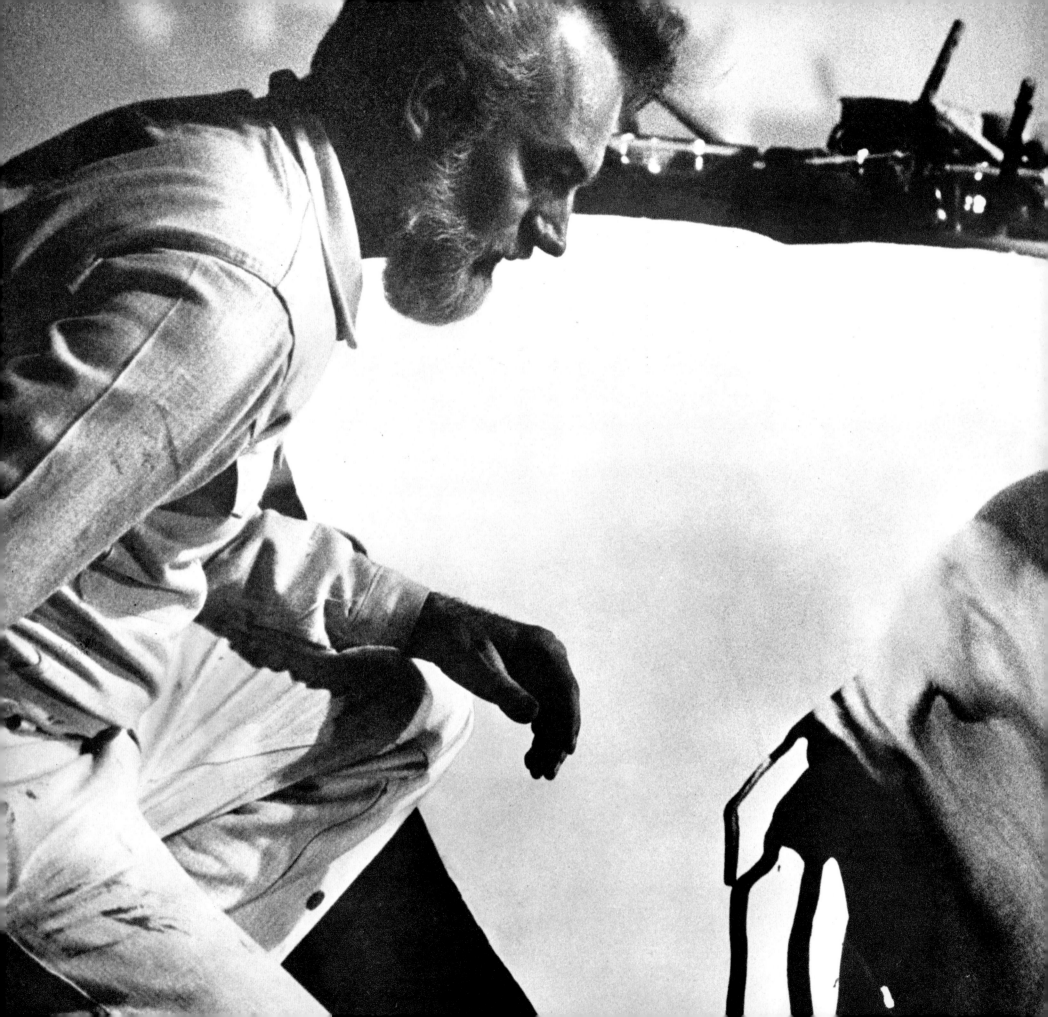

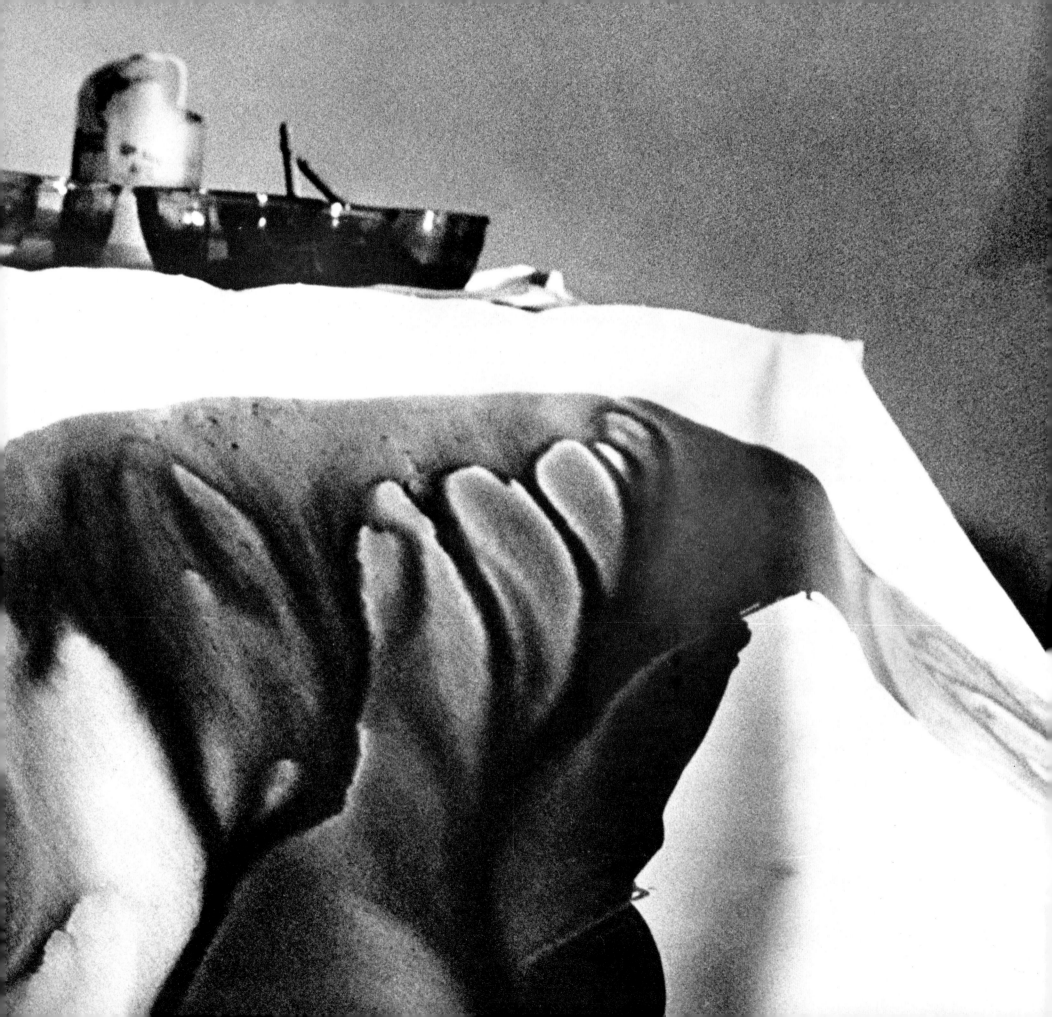

AUTHOR'S NOTE

In writing about a living artist, the historian must remind himself that he should ask questions such as those we would like to have had answered by artists of the past, before the recording of art history. I have tried this approach in my book on Seymour Lipton and in the present one on Paul Jenkins. In each case, the artist is quoted at length. Further, the selection and arrangement of the illustrations are mostly the decisions of the artist, in order that he may also have his say in the visual presentation of his work. As much as possible I have tried to let the artist speak through, as well as with, the art historian, while reserving the right to speculate and criticize.

Albert Elsen

PAUL JENKINS

TEXT BY ALBERT ELSEN

PAUL

Harry N. Abrams, Inc., Publishers, New York

JENKINS

LIST OF PLATES

Colorplates are marked with an asterisk (*)

THE ARTIST AS A MEDIUM

Many years ago Paul Jenkins was asked how his paintings might be interpreted if they were found in some cave or cellar two hundred years in the future. He thought they might be construed as religious pictures, twentieth-century altar paintings. They are, in effect, the equivalent of the great Flemish altarpieces he has admired in Bruges. Comparing his own paintings of revelation with those of the Flemings, Jenkins wrote in 1962: "I don't deal with subject matter. I paint marvels instead of scenes from miracles such as the Flemish painters did. . . . I don't paint what God did, I paint what God is to me."*

Jenkins regards himself today as "a devotional and inspirational artist," but he is not religious in an orthodox sense, in spite of his liberal Protestant family background. Paul Jenkins was born William Paul Jenkins on July 12, 1923, in Kansas City, Missouri. His mother, Nadyne, was a journalist and newspaper publisher, and his father, William Burris, was in real estate. As a very young man Paul met Frank Lloyd Wright, who had been commissioned to build a church for his great-uncle, the Reverend Burris Jenkins. And Jenkins himself had an early inclination toward the ministry. The paintings have grown out of his search for the self and God. By nature he is both mystical and pragmatic, seriously interested in the occult, astrology, alchemy, Zen Buddhism, and Jungian psychology, yet preferring the company of those he feels "have their feet on the ground."

Jenkins's views about what he could and could not paint were formed early. While still in high school he was ejected from class at the Kansas City Art Institute for eating the still life. In 1969 he said: "For me the pear is to be eaten and experienced, not painted." Today he reiterates what he said earlier: "I'm drawn to marvels . . . not Cézanne's apples. I want the receptive world I reflect to become as known and as accepted as is the absurd but compelling constancy of a Campbell's Soup can to Andy Warhol. . . . I want my marvels to become common ground, not commonplace."

Jenkins views himself as a medium responding to supernatural guidance. Rejecting nomination as a visionary who illustrates dreams or preformed fantasies, Jenkins explains his mediumist view with the example of Japanese microscopic writers: "Using a common lettering brush without the aid of a magnifying glass, they credited their accomplishments not to extraordinary vision but to superhuman guidance which enabled them to write what they could not see." Speculating on his own contribution to art, Jenkins says: "If I make a contribution, it's painting something that is there but

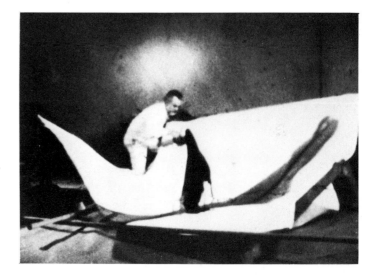

The pictures in the text section are a sequence from *The Ivory Knife*, filmed by Jan Yoors in 1964

*Unless otherwise noted, all statements by Paul Jenkins are from his diaries (1948–53) or from letters, journals, and interviews (1962–71).

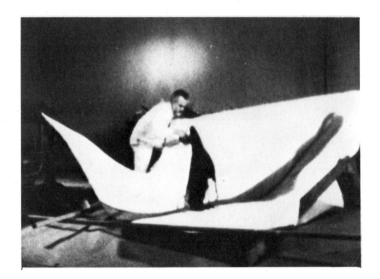

cannot be seen except through the experience of painting." The poet George P. Elliott summed up this view when he wrote: "He had to make it in order to look at it."[1]

European Surrealism, with whose literary aspects Jenkins is impatient, also provided him with a paradigm in art for the creation of "the marvel." He sees nothing to emulate in the interest of Surrealists for the absurd or their desire to startle, and believes that it was not sufficiently and consistently concerned with the underlying drama of the psyche. But he observes that with Surrealism "the unconscious depths of the individual were revealed to have dignity and a passion. The assertion of content was brought about through paint, not a literary idea—paint which went beyond symbol, which is about something, and became independent, a presence, which is a thing in itself."

Jenkins's exposure to Jung came at the critical moment of his emergence as an artist in the early fifties, and his diary notes record this influence: "Not by accident do I achieve what I wish, but by conscious destruction do I find my way. I have discovered myself to be a curious labyrinth—both ancient and young—primordial yet corrupted. Within me there exists no peace—only a light in the darkness whereby it is possible to find the way further into the darkness where the light exists more intensely." From Jung's *Psychology and Alchemy*[2] he paraphrases:

> The regions of the soul in each individual may be infinite in their variations, but like the alchemical symbols they are variants of certain types, and these occur universally. They are primordial images from which the religions each draw their absolute truth. . . . There are, I believe, vast areas of the unexplored being which are never asleep but in many of us are lying dormant, pushed downward like the white ice beneath the surface of the iceberg. . . . A level of being which is submerged beneath the water . . . in the darker regions out of sight, hidden but nevertheless there. . . . The only way to make its presence known and the existence of it rich is to feel it, understand its latent possibility in order to further explore its seemingly endless capacity for mystery. It is possibly the strongest link we have with the cosmic demand which exists in us. It is a force which remains with us always.

More recently he observed: "I think there are certain structures that are eternal and constantly manifest themselves, and it does not matter which one you choose. What matters is how you give it meaning."

The appeal of the occult to Jenkins lies in its preservation of the psychic history of man, its encoding of the primordial symbols: "According to the Kabala, all men are endowed with magical powers that they themselves may develop," the artist wrote. In 1949, even before his experiments with the *I Ching* and the oracle coins, Jenkins noted Lord Halifax's aphorism: "He that leaveth nothing to chance will do few things ill, but he will do very few things." And from his readings on magic came further observations: "Dreams, reality in its hallucinations and impalpable aspects. Painted images being a species of conjuration were often used in exorcism. A picture, a painted likeness, has by its very nature something of sorcery attached to it." But Jenkins's interest in the occult has been balanced by his recording of such writings of Paul Klee as:

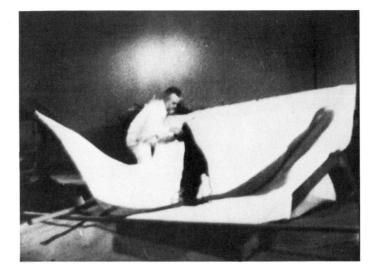

> In addition to having developed a language, man has developed means of making on clay tablets, bits of wood or stone, skins of animals, and paper, more or less permanent marks and scratches which stand for language. These marks enable him to communicate with people who are beyond the reach of his voice, both in time and space. . . . The very effort to render visible those impressions and conceptions not in themselves visible determines the character of the picture.

Reflecting on the influence of this artist, Jenkins recently noted: "Klee also helped me to feel that I wasn't altogether an occultist, but a certain kind of visual phenomenist . . . exactly what kind I am not sure." Indeed, he has referred to himself in print as an "Abstract Phenomenist." Since about 1960, all the titles of his paintings have been prefaced by the word *Phenomena,* followed by a terse *poetic* association induced in him by reflecting on the finished work. By not being causative, the titles preserve the character of the painted phenomena, which are *unaccountable occurrences.* The inspiration for referring to his paintings as phenomena came in the late fifties, after an actual experience of allowing a work to realize itself without forethought:

> The word phenomenon came to me after finishing a painting which happened with no preconceived idea. The sensation of the experience happened within me, not outside me, as though it were done by a "medium." Within the act came the discovery, not arbitrarily before. I have to approach it indirectly through the meshes and foliage of darker memory and it comes in the working, in the discovery with paint; vortexes, shafts, pillars of light, images moving unceasingly,

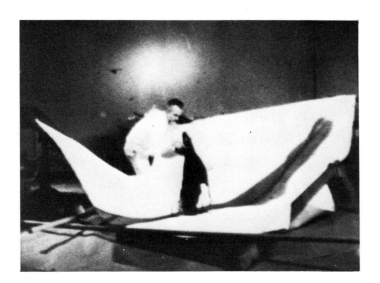

caught with purpose. Laws are made as one moves and method joins with meaning.[3]

Explaining the change to the plural form the painter says: "Because it is always an ensemble of sensations which point the sense of wholeness. Wholeness or incident, singular, is always predicated on a combination of things or events happening at the same time, and the 'instant of time' indicates all these forces coalescing in this given moment.

"We see one thing, but are never one. We are many things, but gravitate toward the single point. It is an acknowledgment of the variables which make the plural ever present."

Jenkins explains his understanding of phenomena and their appropriateness to modern imagery by referring to Goethe and Kant, whose writings came to his attention about 1959:

Goethe . . . when speaking about the unfathomable before which he too resigns himself . . . has yet revealed to him in the world of phenomena not the absolute in itself, but the mirrored reflection of its majestic remoteness. . . . Kant . . . made the important distinction which helped release us from the ancients' impasse. Phenomenon, an object of sense perception as distinguished from ultimate reality. This meaning of Kant's certifies in his own mind absolute separation of the thing in itself from the object of experience or phenomenon. It asserts the utter unknowability of the thing in itself, while the ancients conceive essences to be knowable.

"To Be a World, Not a Thing"

Jenkins does not want his paintings to be static situations—the knowable—or essences, nor does he want them to be so literal or specific that they become "just painting" or opaque aesthetic objects eliciting fixed responses. There is no *object* matter in art whose subject is movement or events. "It's got to be a world, not a thing." But

Jenkins's created world is not given to us by means of the conventions of illusionism in Western art. "It is a metaphysical illusion rather than an optical illusion, because optical illusion is what I try very hard to control, like not having a recessional depth going into infinity." The space is found by the artist while painting, and it interpenetrates with the colored forms whose passage is so quick that only the eye and not the mind can follow. He presents us with what might be called exciting metaphysical dramas, "an imagined image of something I know is there but cannot see optically."

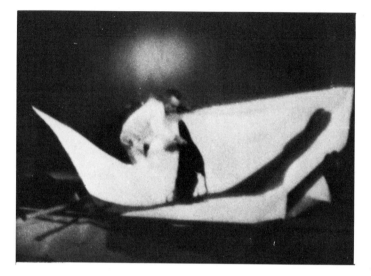

Jenkins's art presupposes for its creation and reception the manifold modern experiences of seeing the world from varying speeds and staggering velocities, through scientific instruments and personal insight.

Perception for us is quite different from what it was for Leonardo da Vinci. . . . When he walked down the street his source of light created an illusion of sculptural dimension. Candlelight, sunlight, these shaped the way the accustomed eye saw its reality. We see and perceive differently, even though we may also have the ability to see as they saw. It is difficult to see what is really there in front of our very eyes. We cannot see all there is in any outward manifestation, but rather what we can perceive. The retina is no longer the mainspring of perception. We are caught up in ambiguity—the adventure being to distinguish the real universe of ourselves from the other one we reel through; the chasms of light outside ourselves which catch our own inner light projecting from us in forms unseen, presences, radiations, invisible but felt gestures.

It is the recollection of his perceptions and insights that is "visualized" when Jenkins paints by what he calls "indirection." The triggering of memory by the process of painting permits the artist to come to terms with nature; he must approach it as if seen "out of the corner of the eye." "When I see nature directly it looks at me. I cannot begin to see it. . . . For me to approach it directly would be a self-conscious act of painting 'at' it or 'about' it." What is distilled through the filter of the "meshes and foliage of darker memory" in the painting process are the abstract elements of nature, its varying luminosities, textures, and color vibrations. "But this does not mean that I have nothing in my mind when I begin a painting. A white canvas does not frighten me, the grain and size of the canvas gives me a clue, the time of the year and light of the place get into the act, everything involving nature is there, and it is a veritable Pandora's Box from which the chosen verity at that moment derives meaning."

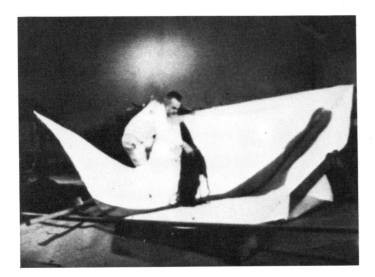

The Significance of Moisture

If we consider some of the components of his paintings, we can begin to understand what Jenkins meant when, in describing how he paints phenomena, he said that "method joins with meaning." Crucial to investing his art with the sense of being a world and not a thing is the relentless, persistent quality of fluidity. All is in flux, ebb and flow, moving into, across, and extending beyond the field of the canvas. The making and meaning of Jenkins's paintings presuppose wet on dry and wet on wet. Since 1950 he has worked with many materials, differing pigments, but always he has relied upon a liquid binder that allowed saturation and that permitted the pigments to flow or spread like a molten tide. "I paint with water and water mediums, and before I painted with water I painted with turpentine, benzine, damar varnish, and sun-thickened linseed oil. I always remember Barbara Butler saying that I drowned Odilon Redon in turpentine." When he was in his teens, Jenkins worked in James Weldon's ceramic factory in Kansas City, Missouri, and he recalls his fascination with glazes and how they fused under extreme heat. In the early fifties, when he began combining water and enamel on paper and canvas, he achieved that quality peculiar to ceramic glazes, "like a moon surface, or an encrusted and crazed river bed or a moon surface." In discussing some of his paintings he uses analogies such as "washed and worn tablets" and "an underwater Rosetta Stone" or refers to rock beds beneath a rushing stream. It is not surprising that the painting which dramatically changed his art in 1951 was a watercolor and ink titled *Sea Escape*.

When studying with Yasuo Kuniyoshi, the quality that attracted him in his teacher's art was one that came to distinguish his own. "The abstract quality I was drawn to in Kuniyoshi's work was the moisture in it." In a 1950 diary entry Jenkins noted: "Moisture is water and air. . . . The quality of moisture is life, a thing which breathes has moisture. This is a felt quality in painting." In 1951, he began working with Chinese inks and gouache, and experimented with polymer mediums and pigments. "Frustration—it stuck too fast and did not permit glazing with any true results—polymer at this time did not have yield or covering power." It was his work with watercolor in Spain during 1959 that cleared the way for his use of acrylics, since then his preferred medium for painting. Jenkins first saw the work of Wolfgang Schultze Wols in Paris in 1953; it was Wols more than Pollock who made him aware of the ambiguity which fluidity can induce and of the character of moisture. It increased

his belief that the "subjective could have dignity." But Jenkins's use of moisture as a felt quality led him to develop another characteristic: specifically, his veils.

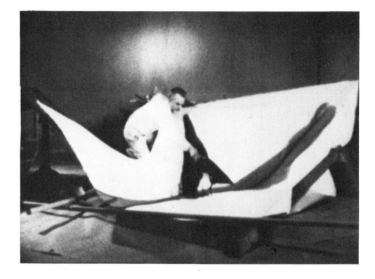

The Veils

Looked at from historical perspective and then close up, the paintings of Jenkins, Helen Frankenthaler, Sam Francis, and Morris Louis are seen to be similar but distinct languages. As Jenkins puts it, he is "part of a time but not of a group."

It is not difficult to understand how, by allowing liquid paint to pour down a tilted canvas, or by flowing it back and forth across a surface with a long-handled brush or ivory knife, translucent veil-like effects can be achieved. Even when working in oils, heavy saturation with turpentine, as in *Water Crane* of 1956, allowed Jenkins veil-like skeins. "Wols had a kind of veil in his little watercolors and in his oil paintings. The veils in my paintings came from this source in Paris, not out of Washington color painters." Although Morris Louis's veils appeared as early as 1954, they were not seen by Jenkins until 1957, after *Water Crane* and *Lotus.* Thematically, the veil can be found in Jenkins's earlier figurative work of the late forties and early fifties, notably in his drawings and lithographs, where it takes the form of a backdrop curtain for a symbolic figure or banner used by performing acrobats. *Veiled Equestrian* of 1952—both a watercolor version and an oil painting—was inspired by his remembrance of the covered statue of Juan José de San Martín before its unveiling at the 59th Street entrance to Central Park. "The motif was indelibly stamped on my mind—the form beneath the veil." In his drawings after Piero della Francesca and studies of Giotto and of Van Eyck's *Canon Van Der Paele,* Jenkins sought "the authenticity of what was underneath that gave the form mystery and beauty." In 1953 his painting *Egyptian Profile,* with its fused color absorbed by the papyrus on which it was painted, manifested the "veil" as a substance "you could see into, like the Flemings' use of cool on top of warm and warm over cool colors."

Jenkins came to know Morris Louis's work through Clement Greenberg in 1957.

Louis had a one-man show that same year at the Martha Jackson Gallery. These paintings were like what was seen in that time of Abstract Expressionism. They

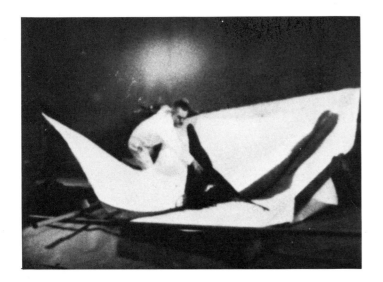

were striking in impact—viscid, torrential, unleashed. His paintings of this period were later destroyed. There was one painting, an earlier work of 1954, owned by Clement Greenberg, which had been loaned to the exhibition. It was different in its sense of oneness; it had a stillness and haunting strength that stood out in contrast to the others.

Clem invited me to see rolls of paintings of this same period in his Bank Street apartment. After seeing one after another of these canvases spread out on the floor of the small apartment, I was convinced that Louis was a dark horse with a new luminous vision. Hoping to encourage Louis to return to the "unique presence" which I saw in these earlier works, I borrowed a rolled Veil as a gesture of conviction and admiration. I never did unroll it at the St. Mark's apartment studio, though, because there had been a recent fire there, and the place was constantly plagued by plaster dust and dirt from reconstruction work.

As the years peeled off, and comparisons were made pro or con with Frankenthaler or Louis, I became more and more aware of the differences that existed in our conceptual intentions. Helen represented to me the continuation of the objective high spirit of Matisse in her own original vein. Louis became for me the twentieth-century embodiment of the Talmudic visual man, finding in the non-graven image special significances one could give no name to, except adjectives of awe, or the convincing deduction that color was the subject matter.

Jenkins does see an affinity with Louis and Frankenthaler in their veils of color. "And to this extent, as I said earlier, I feel that we are of a particular time, but different in conceptual intention. These veils relate to a certain time in painting history . . . just as the Flemish painters had an affinity with each other in terms of their luminosity and their belief that miracles happened from without." Jenkins's own work testifies to a logical evolution of the veil as one means among several by which to record his "peripheral and inward vision" of nature. Louis and Jenkins seem to come together in spirit even more than form in Louis's first fluid monochromatic oil paintings of the early fifties, which have a free or more "natural" configuration that explodes or fans over the surface. Louis is most compelling in his mystical, richly colored veils overlaid with somber tones. His subsequent more symmetrical pure colored forms have no counterpart in Jenkins. Further, Louis and Frankenthaler stained raw canvases; Jenkins has always preferred to prime his, for the protection of the canvas and the stimulating context it gives him. The white undercoat imparts a distinguishing luminosity to his art

and gives the veils a different substance, quality, and texture than those bonded with raw canvas. In spite of his employment of chance, Jenkins sees the final colors of his veils as irrevocable, what he terms "non-alternate." Louis evolved toward purely abstract formal conception, which eventually encouraged his striped compositions. Jenkins's veils enhance revelation and remain allusive. The veils of the sixties variously evoke tidal movement, wings, even veiled figural forms, recalling Jenkins's early drawing of Martha Graham's movement. His experiences with studying the undulations of the great tricolor flag hanging under the Arc de Triomphe, as well as the windblown shrine curtain at Ese in Japan, influenced his use of asymmetrical veils.

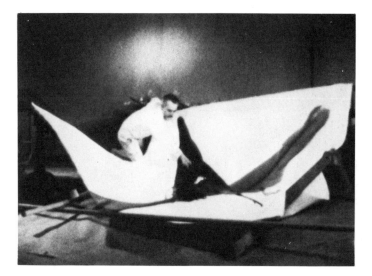

Light

In 1950 Jenkins came upon Monet's statement: "The light is the real person in the picture." Nineteen years later he reflected: "This is one of the first statements which allowed me to see, feel, and know that what is most important to me is what I can't see—and that this is what I must paint. Paint the invisible which you know is there. Paint its astral colors and light and substance."

When he was sixteen Jenkins had an unforgettable experience that must have conditioned his thinking about using light in the quest for unaccountable occurrences to confirm his awareness of a divine presence:

One time I witnessed a Fata Morgana when I was visiting my mother in Ohio. We were driving back from the lake and I looked up into the night sky and I saw a great city in the luminous clouds. But it wasn't clouds. It was curious things and structures that were transforming and changing in front of my eyes. And yet, they were right out there. I saw a man—his face was translucent—walking down a marble staircase as though he were about to speak to people. It could very easily have been a visiting personage come to impart a message. And I thought— am I mad? I'm seeing something that's a miracle, but I won't tell about it. At that time I kept it to myself, and much later I learned that what I had witnessed was a Fata Morgana, a phenomenon of nature which can occur in a lake district, sometimes for as long as twenty or thirty minutes. I had to learn, and painfully,

27

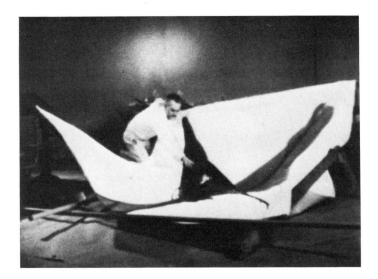

that this kind of experience can be dangerous. One has to be an honest person to take it on—otherwise it can create delusion. For one moment you're experiencing a revelatory natural phenomenon, and the next moment you're "aestheticizing" a very strange and possibly self-induced spiritual sensation.

Light has always been indispensable to Jenkins's method and meaning. In talking about his work he will allude to such diverse experiences as watching the constant burning intensity of Bessemer converters seen at night in Pittsburgh and Youngstown, or the cold, "remorseless" brilliance of the Canary Diamond in Tiffany's. His comments on older art illuminate what he seeks in his own painting: "Two kinds of light have always drawn me. The light of Georges de La Tour, which seems to radiate from the painting, and that reflected light which was most evident in Turner's imagination. From these two sources—reflection and radiation—I have tried to achieve a kind of form in its own discovered space, a kind of light which reveals itself from within, while the reflected element affirms itself from without." Jenkins first saw Mark Tobey's work in 1949, during Tobey's retrospective at the old Whitney Museum, and met him in the early fifties. While there were influences from Tobey in his drawing and use of white line, Jenkins noted the following in February of 1955: "Tobey and I came to have a basic conflict. For him the sun was a constant. All things are the reflection of it. But I hope to observe that curious light which comes from within, even if it is only the glow of a moth's wing in intensity."

Mark Rothko's painting in the early fifties impressed Jenkins by its "quite apparent mystery of luminosity. It is like the mystery you feel at twilight when something is about to happen and everything about it has a trembling quality; it will only last for an instant. But it just goes right on trembling indefinitely." But before 1953, while he was in New York, Jenkins was not prepared to act on these influences. His trip to Paris in 1953, after stays in Sicily and in Madrid, opened up his art in many ways. "The Prado and its treasures finalized for me objective representational reality. There could be no going back—only forward—to a reality which leaned toward other hidden aspects of man."

Just as his structural use of the veil was encouraged by his first Paris experience, so too were his ideas about light engendered by that of the city itself. "There was a filtered light, a luminous filtered light, that I was inspired by when I came to Paris, which I was totally unprepared for. . . . I was matter-of-fact about Paris as a city, but one thing I did see was its light."

"What Will We Do with the Human?"

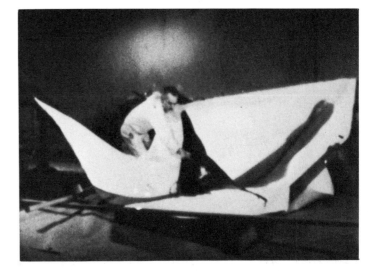

Jenkins was still studying figure painting with Kuniyoshi in 1950. But within three years he was to evolve his abstract compositions in which, though not absent, the figurative was implied, fragmentary, ambiguous, and phantom-like. Compensation for the loss of explicit figural forms came with the artist's idea that light could metaphorize the human, evoke its presence, resonance, vibration gesture—"chasms of light outside ourselves which catch our own inner light projecting from us in forms unseen, presences, radiations, invisible but felt gestures."[4]

In the winter of 1953–54 Jenkins, who was grappling with the problem of leaving the figure, noted the following observation by William C. Seitz:

> Figurative Rapport. The contemporary growth of a concept of reality based on structure, energy, movement and process has dissolved corporality, revolutionizing sculpture and posing an unprecedented problem for all artists who represent the figure. Modern sculptures have dissolved mass—transparency, interpenetration, the skeleton, the grid and spatial calligraph. If the figure is to be represented, some rapport must be established between the new reality, the new pictorial means and the tactile fact of flesh. As Mark Tobey expresses it: "Every artist's problem today is 'What will we do with the Human?'"[5]

Seitz could have substituted the word "painting" for "sculpture." Jenkins was a witness and a partial beneficiary to what painters such as Tobey, Pollock, and de Kooning had done to the figure. After 1953 he would make his own contributions to its transformation, which were predicated on such discoveries as:

> Often I get sensations of colors and temperatures from a human that I don't get from flora and fauna, trees, mountains, rivers. Something that I feel about the figure enters into a painting, because to me the figure is a universe, a mysterious universe. . . . A human form can stand in a certain way and it can hold itself in a way that is profoundly abstract, such as the *Winged Victory of Samothrace.* I see an expression of a spiritual event but through the human—I felt that way when I first saw the photographs that Barbara Morgan did of Martha Graham. And

29

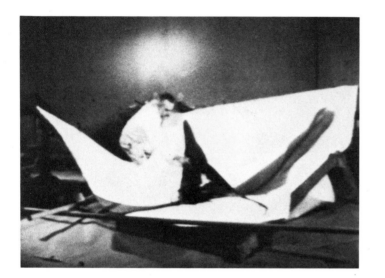

these disturbed me terribly because I thought—perhaps here is a way for movement to express the drama of the human.

It was the movement enacted in his luminous liquid phenomena that helped Jenkins solve the problem of what to do with the human *and* the divine.

THE LEAGUE YEARS, 1948–1952

One of the first and most important influences on Paul Jenkins's art and his decision to become an artist was his high-school art teacher, Marjorie Patterson, who also recognized his writing and acting ability. Between the ages of fourteen and eighteen, he attended classes at the Kansas City Art Institute and worked with the Kansas City Community Playhouse and the Youngstown, Ohio, Playhouse when he lived in Struthers. During this period he also worked weekends and summers with the ceramicist James Weldon. In 1942 he received a fellowship to the Cleveland Playhouse, where he spent most of his time in the paintshop mixing large amounts of powdered pigments with water and melted rabbit-skin glue for huge flats which became the sets. After work he would go to his rented room and paint watercolors. Between 1943 and 1945 he was a medical corpsman in the Naval Air Corps. The chaplain allowed him to use the library after hours and there he worked late at night on watercolors and curious, subjective black-and-white graphite drawings which had a Düreresque linear obsessional quality. After this, following the advice of the artist Clarence Carter, he decided not to study painting in an academic school. Seeing the natural aptitude that Jenkins had for painting, Carter advised him to go to the Art Students League in New York and "flounder."

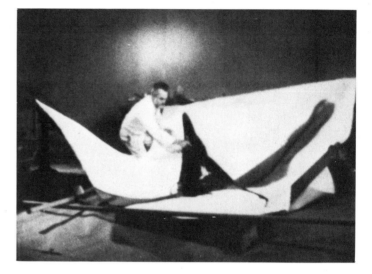

Jenkins appeased the conflict he felt between painting and the theater after leaving the Naval Service by becoming a special student in playwriting at Carnegie Tech in Pittsburgh from 1946 to 1948. Even when he went to the Art Students League in 1948, he took a course in playwriting with John Gassman. Writing became more and more secondary, however, as he grew to realize the total commitment painting demanded.

Between January of 1949 and June of 1953, Jenkins kept a diary which contains many interesting and, in retrospect, prophetic comments about himself, the criticisms of his principal teacher at the League, Yasuo Kuniyoshi, reflections on painting, and reactions to the art and films he saw in New York at that time. During these years Jenkins remained seriously interested in being a playwright, and there are many pages with notes for stories and plays and his reactions to the New York theater. The following extracts would be even more meaningful if the artist had not destroyed so many of the figure paintings he made while at the League, but in hindsight many are appropriate to his thought and work in the intervening years and still today.

1/14/49 *Kuniyoshi: "The artist has no castle—he has the world. When he ignores the world he dies—the world is his source of reality in which he must portray, interpret,*

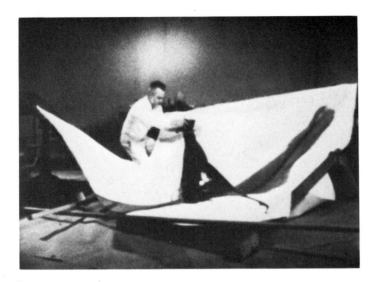

and observe through the lens of his individual temperament."

1/17/49 [Kuniyoshi tells Jenkins to give his work more "punch."] *He said, "Push and dig deeper in the color within the color."*

2/13/49 [Jenkins sees the Kandinskys at the old Guggenheim.] *Impressive.*

2/18/49 [Kuniyoshi sees Impressionist influence in a portrait Jenkins is painting.] *"Accident is one of the beauties also—the secret is in holding it in your grasp when you've caught sight of it and learning what to do with it."*

4/30/49 *Went to the Frick—decided that Nature detests symmetry . . . studied the flesh tones on the paintings—must understand.*

5/9/49 *Composition problem—the important objects in the picture are too similar in size.*

6/6/49 *Ibsen: "When I write I sit in judgment of myself."*

6/8/49 *I want to express essential emotions that men can identify.*

6/10/49 *Chinese ink sticks have a quality I've searched for.* [Jenkins was doing black-and-white drawings.]

11/2/49 [Jenkins sees the Van Gogh exhibition at the Museum of Modern Art.] *I can never forget the painting he did after Millet. A landscape done in one color which glows like phosphorous winter, a twilight hour—the beginning of something new on earth, yet old. Oh God, I trembled in front of it. Here was painting which portrayed the earth in the process of existing and not the result of its existence. A cosmic picture which will remain in my mind as the first spiritual experience I've had while looking at a painting—a complete, overwhelming one which purified me.*

1/16/50 *Read Bullfinch—interest in myth symbols that represent forces of nature— have a knowledge of what you intentionally avoid.*

1/17/50 [Jenkins had been studying Leonardo da Vinci's drawing.] *Have studied closely how he uses his line to build form. Several periods where he varies it considerably.*

2/1/50 [Jenkins decides to stop playwriting, a decision by which he will not abide.] *Painting will be paramount. In innocence I didn't realize how limited I was. I did not*

know how overwhelming the demands of painting were. I did not understand the manifold qualities it takes to paint a fine piece of art.

I must excel. I must paint pictures which are undeniably good. I must master my trade—not be its slave. Perception demands the artist to be an exception—out of the ordinary and without fear.

On January 30th I went to Wildenstein's to see the Rembrandt collection. Lucretia *impressed me. I sat and stared at it for an hour trying to probe its mystery. It had none—it was what it was, a masterpiece, well conceived and realized.*

3/28/50 [Jenkins sees a Renoir show.] *He's full of air and water. It was worthwhile seeing someone who loved life—that love couldn't help expressing itself.*

4/19/50 [Jenkins visits the Museum of Modern Art.] *Felt disquieted when I saw Brancusi's* Fish*—I was in the presence of something alive yet simplified to the nth degree.*

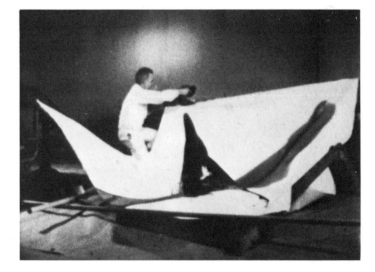

8/28/50 *I did not realize it at the time but while in high school I was strongly influenced by Poe's conception of beauty and his preoccupation with self-torture.*

9/27/50 [Jenkins starts an oil seascape.] *An underwater sea life painting.*

10/31/50 [Jenkins sees a Soutine show.] *I remember strongly a large painting of a flayed carcass of a cow. Wet, huge, dripping—magnificent. I'm so upset by Soutine. I get to feeling smug about my love for the early Italians and the strength of their fragility—then he comes along and wants to uproot me! As did Kokoschka, El Greco, Goya, and Daumier!*

11/4/50 *On the end of one of the docks were over 80 gulls. I walked toward them slowly, then they all flew away in unison—rising in slow, dreamlike movement. It was like watching irritable Baptists on their way to heaven.*

11/15/50 *Worked all day on the seascape—must say I damn near overworked it. It is as wet as a sail. Anger, confusion—must control myself, my efforts.*

11/16/50 *I'm concerned with the light an object throws off, not entirely with how the thing is affected by light.* [Jenkins here refers to his oil seascape, which he later destroyed.]

2/1/51 *The painting should be just a picture, a seemingly simple statement, but this is*

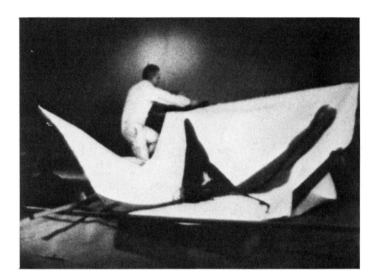

the lie, it should be more than a visual pleasure. Like a person, it should have a life of its own. Like the person with a vital core in its being it should visually imply paradox.

Under limited conditions life can be pleasant, but life to me is strangely beautiful, awesome. To me terror is the thing that comes closest to beauty, rather than serenity. Granted, terror for its own sake is histrionic and may hold the attention of a theater audience, but not the eye. The eye demands the unspoken truth. Words veil the truth and the master of words knows this, it is his most powerful instrument. To say one thing further, that which has seemingly little drama in a painting may be packed with it, but it has to be stated in visual language, not literal.

5/4/51 *Saw an incredible sight. The covered statue of San Martín on Horseback. It looked like shrouded death.* [This sculpture had just been erected but not unveiled at the entrance to Central Park on 59th Street and Sixth Avenue. Jenkins drew it and felt that this experience later helped him to become more abstract. He also wrote a poem, "Veiled Equestrian."]

5/9/51 *I have a disorderly and forgetful mind, so I make every effort to make order outside myself.*

5/22/51 [During a picnic on City Island Jenkins sees and draws a horseshoe crab.] *When I went to bed and closed my eyes I saw the monster's claws—one of them was particularly grotesque and the memory image was terribly vivid.*

1/7/52 *Can't forget* Rashomon—*makes me believe there is a place for my understanding and conception of reality.*

2/29/52 [Jenkins admires a painting by Morris Graves of a bird.] *Beautiful color.*

6/7/52 *Create deep space by making the planes rotate or move around a central point, back and forth in space, without destroying the picture plane.*

Kuniyoshi died of cancer in 1953. Jenkins had obviously been deeply attached to the man and the painter even after he left the League. Several times in his private notes Jenkins wrote variations on the following: *One day Kuniyoshi climbs the stairs of his studio building. Someone follows him, he stops, it stops, he moves, it moves. He closes the studio door behind him and waits for the knock from outside. He will not let the visitor in for he knows who it is. He locks the door and goes on painting.*

Gurdjieff and Objective Art

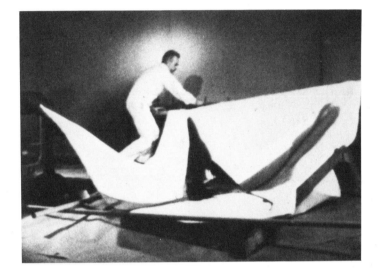

In 1952, Jenkins came into contact with the New York circle of the Russian mystical philosopher George I. Gurdjieff, who had died in 1949. Through the writings of Gurdjieff and attending Dr. John Bennett's public lectures, the artist encountered ideas that transcended his Protestant upbringing and encouraged his future study of Oriental religions. Important for Jenkins's later mediumistic view of himself as an artist were certain statements recorded by Gurdjieff's disciple P. D. Ouspensky in his book *In Search of the Miraculous*:

> Man such as we know him, the "man-machine," the man who cannot "do," and with whom and through whom everything "happens," cannot have a permanent and single I. His I changes as quickly as his thoughts, feelings and moods, and he makes a profound mistake in considering himself always one and the same person; in reality he is *always a different person,* not the one he was a moment ago.
> *Man has no permanent and unchangeable I.*[6]

It was Gurdjieff's idea that certain special persons could transcend their physical body and develop a second, "astral" identity, a spiritual trace or second self, which could be reincarnated. In describing what he sought and looked for in his later paintings, Jenkins frequently uses the term "astral presence."

Gurdjieff's views on "real or objective art" were a great shock to the young artist, for they went against his own instinctive nature and views on painting. "In real art there is nothing accidental. It is mathematics. Everything in it can be calculated, everything can be known beforehand. The artist knows and understands what he wants to convey and his work cannot produce one impression on one man and another impression on another." An objective work of art for Gurdjieff was like a chemistry book, with the artist transmitting his ideas through certain feelings which he excited in a conscious and orderly way. Only by complete control could true creation occur. Subjective art, of which the philosopher disapproved, "creates itself" and was not a deliberate act. The artist was viewed as being "in the power of ideas, thoughts and moods which he himself does not understand and over which he has no control whatever."

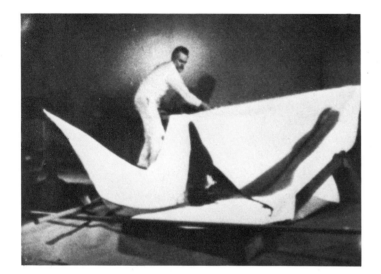

Jenkins now views Gurdjieff as having been a "dark father influence," and it became imperative for him to refute what Gurdjieff contended about objective art and to gravitate toward the world of phenomena through Jung, Kant, and Goethe.

I came to feel Gurdjieff's contention . . . had a built-in obstruction to growth. His insistence that only objective art could come from supreme consciousness sounded to me like academic rules which only he could acknowledge or enforce. But the ideal was spellbinding : Objective is the only real. It is invariable. . . . He further contended that people once knew the difference between the real and unreal in art. But when asked if he knew of any contemporary real art he avoided the question. But it was Gurdjieff who encouraged me to want to elevate the subjective in art, to make that my purpose, and to accept the notion of chance in a new but not negative way. Consciousness of not being fully conscious became my source of energy. I accepted the obligation of knowing I could not fully know myself and . . . that something within and without might work through me. And this gave meaning to what otherwise might seem meaningless existence. To acknowledge and begin with the limitation and in it find an arena of expanding boundaries and changing insights. Ever-changing reality or the world of Phenomena later became a way toward life rather than an avoidance of it.

Opening the Floodgates: Jenkins on New York Painters Before 1953

As an art student, Jenkins reacted strongly against the impact of the major abstract painters. He saw the "Twelve Americans" show at the Museum of Modern Art before leaving for Europe in 1953, and it left an indelible impression on him, adding to the many ideas he had to work out in Paris about what was happening in New York. Looking back, Jenkins noted in his Paris diary in 1953: "I had no truck with abstract painters in the States. Their visual language grew out of the kinetic response, and for me it grew out of the spiritual realm . . . the interior realm."

Jenkins was fighting for his identity. Rather than accepting pure abstraction, he committed himself to an art that drew its meaning and form from personal psychic experience. As a student he had admired such artists as Kuniyoshi, Ben Shahn, Morris Graves, Francis Bacon, and Pavel Tchelichew; it was a shock for him to see the work of venturesome men like de Kooning, Pollock, Still, Rothko, and Newman, which ran counter to all that he had come to respect and consider important in American painting.

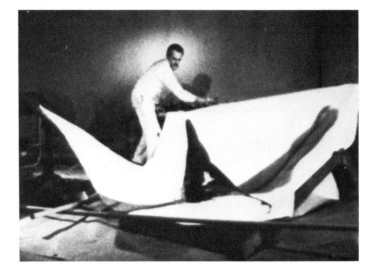

Whether Jenkins correctly read Pollock, Still, Rothko, and de Kooning in 1953 is secondary to our purpose, which is to understand the evolution of his thought and art. Later, he fully recognized the psychic element in Pollock. He first met Pollock in 1952, when the latter was working in black-and-white on raw duck canvas. "I thought the imagery was powerful, unrelenting, a total statement." Jenkins liked both Pollock's "blood struggle" and the "intuition" of such paintings as *The Key* or *Eyes in the Heat,* and he admired the times when Pollock "allowed his more *skein side* to appear, as in *Lavender Mist* and *Out of the Web.* There was another side of Pollock which I felt flawed his sustained inspiration—the structural influences of Cubism combined with totemic influences of Surrealism. His totemic images did not move me, with the exception of *She Wolf* and *Guardian of the Secret,* which I thought were profoundly valid because these related in a symbolic way to Jung's archetypes. But it was that kind of all-over thing that the greatest total image sprang from." Jenkins's lack of interest in Cubism may have reflected his League training and interest in *movement.*

Jenkins gave Pollock a copy of *Zen in the Art of Archery* in 1955.[7] "He was at that time practicing archery. He had a bow and arrow, and he had a target in the backyard; and he even shot off a few in the house, which landed in the kitchen wall."

Jenkins remembers an incident in the old Cedar Bar which reveals how he gained insight into Pollock's sources and the character of his art. It may also indicate a certain affinity between the art of the two men. Pollock was listening to another artist "putting Mondrian down. And Jackson turned to him and said with great pain in his face: 'You don't see Mondrian in my work?'"

Jenkins did not know Gorky. "He's somebody that I had to come back to America to see. I saw a monumental, sensitive drawing which had hints of color which were iridescent. It had a strong sense of the overall. The overall statement had great parallelism at that time; it sprang from Tobey, Tomlin, and de Kooning's *Attic* series."

There was nothing of a technical nature that Jenkins remembers being influenced by in the paintings of Pollock, Still, or Rothko. He later said: "With Clyfford Still it was a sense of scale and terrain, elemental forces, inchoate intimations. With Pollock it was

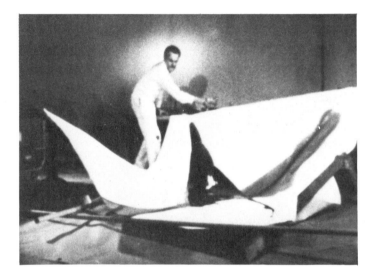

in such paintings as *The Deep* that I felt he was touching quite tactilely the unconscious, the flesh of the unconscious, the unseen aspect. With Rothko it was the still, quite apparent mystery of light . . . and envelopment of color. In 1953 I could not see how to relate to their art but was profoundly affected by it."

Remembering that at the time he first saw the work of these artists he was still a student and defensive about what he believed in, he nevertheless agrees that Pollock and Rothko helped to make him receptive to Wols. "I am sure I didn't know it then. Because there was a part of me as an art student that was probably even trying to resist it. But they opened the floodgates." By this Jenkins does not mean being venturesome or striking out on his own. "None of these things. They showed me a kind of imperial dignity that painting can have and a kind of astonishing state of mind that can be achieved and found through painting." Pollock, Still, and Rothko did influence him toward having the courage to work from the unconscious and the recognition of its power.

Jenkins also knew Mark Tobey's work while a student. He had seen a retrospective at the old Whitney on Eighth Street, but before 1953 made no attempt consciously to emulate his work. "I have to say I appreciated his 'white writing.'" But it took time to appreciate Tobey. Tobey's work was to make its influence felt around 1953, when Jenkins began drawing with enamel, and it was to this artist more than to Pollock that Jenkins owed some incentive for his personal calligraphy.

The Dark Journey, 1948–1953

The few paintings completed before 1953 and not destroyed by the artist give us an indication of what his figurative painting looked like, and how a seascape watercolor played an important role in his movement to abstraction.

The small figure painting that Jenkins today calls *The Emissary* dates from 1948 and portrays an aged priestlike figure performing some kind of incantation, making a gesture to ward off evil. This painting is executed in oils, and it is apparent that Jenkins applied a washlike scrim over most of it and that the heavily turpentine-saturated medium was allowed to cascade in rivulets across the bottom of the canvas. What caused him to keep this painting for himself was the overall veil or "mantle," which Jenkins feels gave the work "more life than the eyes, the nose, the beard, and the

headdress." He asserts that "even if you place your hand over the head, the body has its own story to tell beneath the robe. And this veil? Something is there, not just a *backdrop* in the round. It's the vibration of the human which I feel is ever apparent." There is something of Jenkins's interest in the theater and in the mystery of religion behind the motif, and there is in his analysis a premonition of how the figural would be transformed a few years later in such paintings as *Sounding, The Alchemist,* and *The Elizabethan.* In these works the human presence is evoked by vestigial and generalized silhouettes, and there is a more consistent textural integration of the figure with its environment. Work from the figure as a deliberate motif ended in 1953.

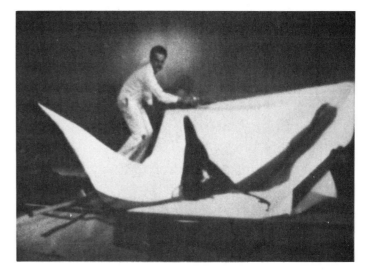

Although most of his painting done while at the Art Students League was figurative, one of the nonfigural pictures to survive the artist's destructive editing of his early history as a painter is *Thisbe's Wall,* painted during June and July of 1950 in his studio on Lexington Avenue, which overlooked the Public Library on 58th Street. In his diary of June 6 he wrote: "The garden wall—a brick roof garden wall painted blue-white faded to pale turquoise with red showing through—ivy growing but in hopeless condition, a few untended bushes and flower plants which grow in spite of not being tended or cared for. Here is an example of Will to Live." The next entry may have been connected to the foregoing description of what he saw from his window: "I love this city—I love it because I've accepted its every disadvantage. I begin to see and breathe its poetry in color and words."

In style, *Thisbe's Wall* comes from what the painter refers to as "the magic Flemish period," which is revealing both of his development as an artist and his interest in certain contemporary artists with whom he later showed in Philadelphia in 1951. The title comes from the classical legend of two Babylonian lovers, Pyramus and Thisbe, who were forbidden to see one another but talked through a crack in a garden wall. They decided to meet, and their rendezvous was fatal, for Pyramus mistook a blood-stained veil belonging to Thisbe as a sign of her death; his suicide later led to hers. As a result, the fruit of a mulberry tree that witnessed the tragedy turned from white to red.

In Jenkins's painting the ivy emerges from a coffin-like planter, and as if in paraphrase of a resurrection a small praying marble angel or putto is shown at the left, like a reverent witness to a miracle in a Flemish panel painting. The painter's penchant for seeing his environment in terms of myth and his own condition, basing his poetic art on meticulous observation of life and discipline of craft and hand, is thus early met in his career.

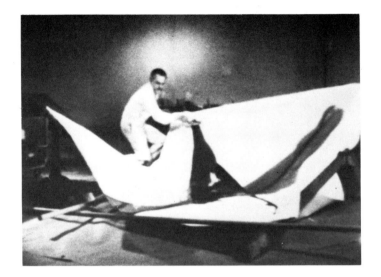

In the early paintings it is not surprising that Jenkins began to find himself by working with water as his means and meaning. The watercolor *Sea Escape,* of 1951, represented a change in motif and attitude that was deeply to influence later paintings such as *Hommage à Melville.* It was painted while the artist was on Fire Island. "I really became involved with the medium, which was the sea itself." For saturation he used actual seawater in this painting. "And although the frame of reference was a seascape, what became most important was the watercolor itself, and the using of the water and making something imaginary which wasn't out there at all." As a result of this consciousness of the imaginary, Jenkins made the background come forward and the foreground go back, "and the middleground overtook that relentless, unbending feeling about the horizon line, which was an anathema. And I felt that I was able to touch for the first time the medium—the experience of working wet on wet—and the format and the entity, the sense of *entity* rather than just doing an atmospheric backdrop with infinity for dramatic emphasis. I fought infinity and tried to find the sense of a tactile entity."

One can see that the artist at one time had a horizon line, but then, as if pulling up a curtain of moisture, he extended the sea into the upper half of the painting. The effect is to dislocate the viewer, as in the later paintings. It is as if one is looking at both the surface and the subsurface of the sea. The spray manifests reflected light while the grayed areas now veil a light which seems to come from the depths. But these discoveries were peripheral to what Jenkins was doing at the time, and they did not become central until two years later.

In January of 1953, Jenkins decided to leave New York to travel and work in Europe. In March of that year he settled in Paris, but he spent the first two months abroad in Italy, Spain, and Sicily. He continued to paint in Europe, attempting to resolve his problems with the human figure and its relation to the whole painting.

Two paintings done in Sicily show Jenkins working on the problem of the human figure: *Orpheus* and *Zeus.* The former was done in Taormina and was inspired by the Greek theater there. Although Jenkins had begun to paint "on the spot," this painting on unstretched canvas was done on the terrace of his hotel from imagination. The arch made by the amphitheater had made a strong impression—the painting confirmed this—and subsequent paintings inspired by Paris bridges saw the motif liberated from a specific content and transformed into what the artist felt was an archetype. Within

Orpheus one senses figural presences through shadows and gesticular passages. The ambiguity of the figural may be explained by a note in the painter's diary of February 3, 1953: "Painting is a shorthand now. . . . I secretly wonder if what I think of as shorthand isn't the means of final statement. Isn't it the image that is important? The image, its emphasis and essence. This is what not to fear but to find, recognize, capture."

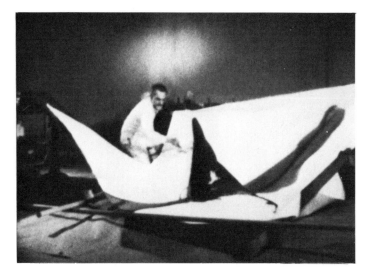

At the same time that Jenkins was becoming conscious of his "shorthand," he was still plagued by Gurdjieff's insistence that objective art was the only real art. This was at the time of his "most confused state." Gurdjieff cited the statue of Zeus at Olympia as an example of an objectively or consciously made work of art that in its own time was clearly understood by everyone. The painter found a marble head of Zeus in Taormina, and in recalling the painting he did of the head of Zeus, he remembers: "Here is the straight-on wish to express the objective while I was in Sicily." It is doubtful that Gurdjieff would have agreed that the result was as "objective" as its marble prototype. While the principal features are quickly discernible, even they, as well as the contours of the head, verge on dissolution under the broad stroking. The generous pigmentation offers an evocative material richness, but not a submission to the characteristics of stone. Unlike working on *Thisbe's Wall,* Jenkins had been caught up in the thrall of spontaneity and rich painterliness which overcame the possibilities of the earlier textural discrimination and separation of figure and ground.

Jenkins's elation with the substance and the unpremeditated act of painting was reflected in his choice of the motif for *Door in Sicily.* It was a two-foot by three-foot painting done on the spot, before "a door which a housepainter used to clean his brushes off on. I loved it. In fact, I love old doors. They invite the imagination to enter . . . into one's self." Shortly before leaving for Sicily, Jenkins had painted his *Astrologer's Door,* and other destroyed paintings included representations of doors found on his walks through New York. The arched doorway had earlier appeared in *The Emissary,* and subsequently its form recurred in more abstract compositions, where its identity became merged with tablets, windows, and cave apertures.

Jenkins was in Spain in March of 1953, and did a small oil painting of a religious procession which seems redolent of Tobey's work that he had seen at the latter's retrospective at the Whitney Museum of American Art. "I saw this procession in Spain. The strange angles of the buildings I saw in Madrid brought the sky crashing down on my optic nerve. What was above? What was below? The horizon line obliterated once again. The crosses, the peaked hats, the religious procession becomes a universal

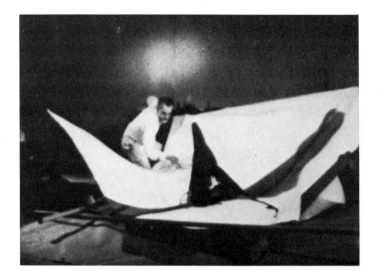

symbol—of what? Surely not the outward emblem of Christ any longer, but the insistence to live and not die." A few weeks before, while still in Sicily, Jenkins had noted: "Last night I thought that if I approached men as species instead of illustrated personalities I might possibly express an objectivity. . . . I am going to do a series of drawings which are expressive of life and not illustrative of men." Contrary to Gurdjieff, Jenkins found that his true life as an artist depended upon openness to subjectivity, letting his sensations and impulses exert themselves as he painted. Paris was to provide the appropriate environment for Jenkins to stop denying his gifts and to realize in a new way what constituted an image.

THE FERTILE SWAMPY GROUND, PARIS, 1953

Jenkins arrived in Paris in the spring of 1953. Of the artists whose work he encountered there that mattered to his own development, two were Gustave Moreau and Odilon Redon. It was the small, almost abstract oil sketches in the back room of the Moreau Museum that impressed Jenkins, because they showed "great imagination in informal or expressionistic tendency. It's amazing how many I saw that were done with a palette knife and reminded me of Clyfford Still." Jenkins's painting *Magic Circle* of 1955 shows the influence of Moreau by its "jewel-encrusted" character. It also suggests that the painter had looked hard at the big, opulent, symbolic Moreau paintings on view in the main rooms of his museum, and Moreau, like the great Flemish painters, inspired him to painterly richness.

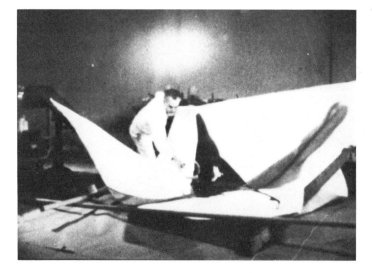

There was also a large Redon exhibition on view in Paris, and he was able to see a great number of black-and-white drawings as well as paintings. What drew him to the drawings and prints was their "infinite value going to very deep dark black, to an almost silvery gray, to a luminous white. I always felt that Redon was more of a magician than a painter. He was as magical in his allegorical works as he was in his flower still lifes—the very iridescence of his colors spoke first." After his first show at the Studio Paul Facchetti gallery in March 1954, Jenkins thought of himself as a continuer of Redon and the art of making the invisible visible. Jenkins ironically adds: "I feel that I've grown out of some rather swampy ground."

Before the 1954 exhibition, Jenkins's most important contact with the work of an artist in Paris was with that of Wols, which he saw in a gallery window while walking on the Rue de Cirque. "And with him were Michaud, Fautrier, and Dubuffet. Not to be forgotten are the early Raoul Ubac black-and-whites on paper. The man who really impressed me because of his elevation of subjectivity and use of ambiguity was Wols. It was something that approached what I always felt movement could attain, and that was a kind of classical dignity." Jenkins saw Wols as an extension of Redon, "a magic intimiste," a man who was exploring within the self, as in a cave. What in Wols was appropriate to his own style was the use of liquidity. "You could tell he'd worked wet on wet. But within that wetness was a great deal of control. It wasn't one of these mono-chromatic miasmic mists or prismatic phantasmagorias that had always made me want to shun that aspect when I'd seen it before." A diary reflection of 1953 on his painting *Shooting Gallery* shows his attempt to apply the ideas gained from seeing Wols and Michaud to the painting of the figure. It proved to be one of his last such efforts:

The form I sought was not yet emerging from space itself. But this was to make

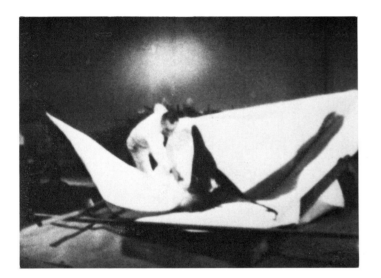

itself more apparent after painting the profile in *The Shooting Gallery*. I gathered this experience in the actual shooting gallery, where a flat metal profile stood precariously; clay pipes were stuck around the head. I kept popping at the damned thing until all the clay pipes were shattered. Was it perhaps an unconscious need to destroy form in order to arrive at another kind of form? It was an exciting painting for me and the first use of the so-called "informal." The picture *came* and I was able to stop because it grew out of a deep experience. It had a previous frame of reference which gave me a certain kind of judgment. But this, like the perfect shot of a Zen novice, was like ripe fruit which fell from a tree . . . it didn't grow out of a lotus flower. In other words, its development didn't occur sequentially, but happened.

Among painters of his own generation for whom Jenkins now developed great respect were Norman Bluhm, Jean-Paul Riopelle, and Sam Francis. "Bluhm was ever-present at the openings and cafés. He was aloof and did not show his work in galleries. He was a ubiquitous loner, who did saturated lyric and often monochromatic paintings which had density and illumination. Riopelle was showing with Pierre Loeb when I arrived. Sam Francis expressed magnitude in simple, if subtle, emblematic paintings, which were referred to as *Ecole de Pacifique*."

Art Autre

Another important influence which gave Jenkins confidence to break with his past as a painter came from his contact with the French critic Michel Tapié. "[In] his book, *Art Autre* . . . the images stepped into another universe. The impact was tremendous and I catapulted. Paradox, primordial image, interior realms latently causing my downfall became force." Tapié believed that Dada had destroyed classical art, wiped the slate clean, and afforded artists a new beginning. He could not accept Surrealism as that beginning, but saw its emergence in 1942–44 in the work of Michaud, Fautrier, Dubuffet, Wols, Pollock, Tobey, Mathieu, and Hartung. His idea of *Art Autre* involved the creation of artistic worlds homologous to, or other than, those of the pre-Dada period: worlds of metaphysical "generalized" space and matter, not subordinate to rule and compass. Form and beauty were not to be conscious artistic ends, but supports of

a mysterious artistic magic. While Tapié opposed Surrealist automatism as "trickery" and saw its previous use as an end in itself, the new audacity and free adventure of the spirit which would enrich the possibilities of creation presupposed its use by all of the artists he admired. Compositionally Tapié opposed the static and praised those artists who achieved structure not by geometry but by "continuity and proximity" of elements. Jenkins would have been sympathetic to Tapié's insistence that *Art Autre* have content but not that subject matter which contributes a kind of outward illustration of an event. The content he recognized as appropriate to the exploration of nongeometric abstraction was that which would "satisfy norms of scientific psychoanalysis." Jenkins was prepared to receive encouragement from Tapié to work not from drawings but directly and complexly, and to create paintings that were both lyrical to the point of delirium and made from a "lucidly elaborated violence," which would engender "new signs." Out of admiration, Paul and Esther Jenkins edited and published *Observations of Michel Tapié* in 1956. From the preface we gain a more specific impression of what had impressed Jenkins in Tapié's thought:

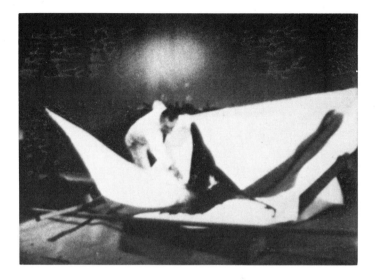

> If heretofore crystallized aesthetics are recognized, they are at the same time to be transcended by perpetually renewed awareness and cognizance, deliberate or unconscious, of the continuously moving world to which all existence is related. *Autre art* confronts the intangible, the unknown, the unseen, with fearless equanimity and acknowledgement. It accepts the paradoxical, the contradictory, the interference of chance, with grace as a blessing. The allowance for untold possibilities does not mean that the voyager is adrift on a sea abandoned to winds and currents. It means he knowingly risks, for the sake of growth, the course where capricious winds and currents must be dealt with, governed, so that evidence of non-empirical form may be presented.[8]

Artless Art

Shortly after Jenkins settled in Paris he read Eugen Herrigel's *Zen in the Art of Archery*, which proved to be a powerful weapon against Gurdjieff's views on objectivity in art, and which gave him philosophical sustenance for his own development. In the early fifties, Zen Buddhism interested many people in the New York intellectual and artistic

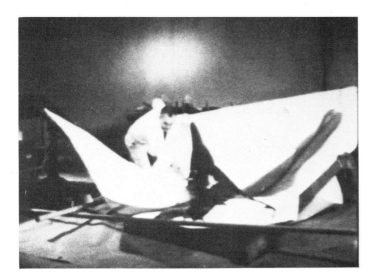

community, in part because of Dr. D. T. Suzuki's teaching and writing. In his introduction to *Zen in the Art of Archery,* Suzuki summarized the importance in Japan of archery's training of the mind:

> The mind has first to be attuned to the Unconscious.
>
> If one really wishes to be master of an art, technical knowledge of it is not enough. One has to transcend technique so that the art becomes an "artless art" growing out of the Unconscious. . . . As soon as we reflect, deliberate, and conceptualize, the original unconsciousness is lost and a thought interferes. . . .
>
> Man is a thinking reed but his great works are done when he is not calculating and thinking. "Childlikeness" has to be restored with long years of training in the art of self-forgetfulness.[9]

It was as if Suzuki were laying out Jenkins's future as well as corroborating his intuitions about where his identity as an artist lay. One can imagine how meaningful it was for an artist who had felt compelled to get out of his studio and away from New York to read that the answer to learning was, in the words of Herrigel's archery teacher, "by letting go of yourself, leaving yourself and everything yours behind you so decisively that nothing more is left of you but a purposeless tension."[10] The process of letting go of oneself is crucial to the Zen idea of true focus on the act of painting, whereby the mind is kept free and agile. To get into "the right presence of mind" means that the mind cannot be attached to any place. "Out of the fullness of this presence of mind, disturbed by no ulterior motive, the artist who is released from all attachment must practice his art."[11] Not to be in such a state would be never to experience "how intoxicatingly the vibrancy of an event is communicated to him who is himself only a vibration, and how everything that he does is done before he knows it."[12]

Jenkins's self-effacement in not drawing attention to his painting process met its Eastern counterpart in the Zen ideal that the archer must learn to efface himself in the event of shooting and that there is no need for control by a reflecting intelligence. Herrigel summarizes the Japanese teaching of a pupil and its consequences in a way which predicts Jenkins's subsequent experience with his Phenomena in painting: "He grows daily more capable of following any inspiration without technical effort, and also of letting inspiration come to him through meticulous observation. The hand that guides the brush has already caught and executed what floated before the mind at the same moment the mind began to form it, and in the end the pupil no longer knows

which of the two—mind or hand—was responsible for the work."[13] To this day Jenkins's way of working can be summarized by Herrigel's words: "For the skill to become 'spiritual' a concentration of all physical and psychic forces is needed. . . . The right frame of mind for the artist is only reached when the preparing and creating, the technical and the artistic, the material and the spiritual, the project and object flow together without a break."[14]

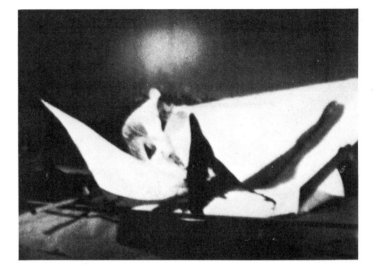

The Alchemy of Painting: Notes on Jenkins's Technique and Materials in the Mid-Fifties

Fortunately, we have some of the painter's formulas and observations about the effects of his materials and their combinations from notebooks he wrote about the time he painted *The Alchemist:*

Fragments

1. Mix white paint, white powdered pigment, Winsor Newton, mixed with water, pour in thin varnish mix of black. The white will sink to bottom and the black will fuse around it. If a blot is made the white shows strongly, if not blotted, the globules will make spots, iridescent in character.
2. Chrysochrome enamel white makes a *poured line.* This dries rapidly and after glazing over the line it can be scraped down without lifting the underpainting or scratching the surface. The line can be made to seem to appear, it emerges rather than looks like the direct calligraphic stroke.
3. The unnatural light. The luminosity achieved by powdered pigment washes either with water or varnish. In the beginning it is better with water, for if one wishes to wash the surface down it offers infinite possibilities of contrast. Winsor Newton pigments do not bleed. They can be abraded, rubbed down, finding the surface again, such as *Sounding* and *Shooting the Sun.*

Methods of distemper

Working with hot glue glazes mixed with powdered pigment. Undersurface

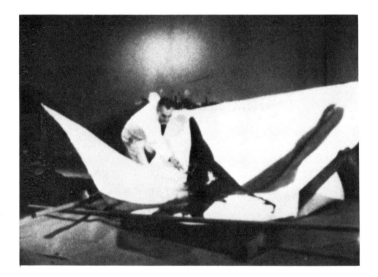

started with an unnatural determined light, high-keyed, the structure of which is definite but not obviously blocked out. The essential element is light.

After it is thoroughly dry, then comes an application of washes, imprints, marks—with various mediums, watercolor, inks, casein, powdered pigment mixed with hot glue. Washes are best with a large flat sable brush, and round bristle brushes are best for mixing the hot glue with pigment. (Hot glue washes with powdered pigment—should have definition but not too thickly laid. One's sense of consistency governs this best.) After the statement comes the destruction, the conscious effort to touch the undefinable. That which comes from underneath begins to discover its mysterious function. In the darkness one begins to find one's way. It is dangerous, for the temptations are asking to be embraced, the danger of superficial effects rises to the surface of the water; it is beneath the waters one must go or one is lost above the surface. The light which is seen from underneath must be within the form and work with the structure to be significant. The essential, like the fire in Siva's hand, which destroys and creates, comes slowly, at the same time violently. To know which of you does the dictating is hard to ascertain, one must not get in the way of the other if there is to be the meeting of heaven and earth which creates an element and terrain of its own, a meeting place which touches and encircles at the right given time. For me only this creative destruction can validate art.

Beware of art materials books lest they make you want to break your brushes.[15]

Black-fluid substance underneath, on top—spray with white. Congeal and break.
Black and white fused on top of red . . . ugly, red eye, kill and cure.
Solid yellow—freeze with varnish.
Hate red, white, and blue . . . so paint red, white, and blue.
Violet over yellow—result earth gold.
Cold red, warm red, reds within many reds—a bar of light enters—cool colors lose local or solid non-breathing quality.

Masonite panels prepared on chases

Heavy varnishes, quick drying, watch out for sicatives with yellow . . . cool blues underneath harsh orange, hot or ice, then rose madder and poison violet can bring something, but as thing in itself.
Catch the pigments, then allow to cascade.

Plaster—experiment for form on panels

Free forms, anything to break academic occurrence inherent in method of working.
White Splatter—*allow to dry partly* . . . then wash down.
Copal, mix with turpentine . . . only with dense color but not with yellow or white.
Fusion of colors with varnish combined with benzine, and after pouring on the canvas the benzine evaporates and leaves a tenuous veil and amorphic edges.
Hardware turpentine breaks up the pigment more.
Rectified turpentine modulates the pigment, as does distilled water with touche for lithographs.

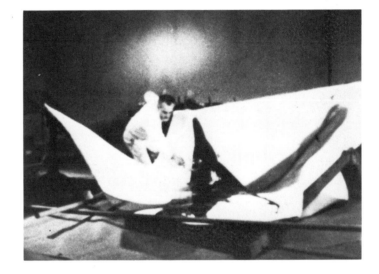

Tentative approach

Water-based paint for underpainting, then glaze on top—in a sense, building a surface. Sensing a latent form. Establishing an underneath light with pure powdered pigments and varnish.
Painting with oil white, allow to dry for a few days and then scrape down; leaving the ruin and the rim of the form. The light shows from underneath. Then of course it is fused together, this is the alchemy, the process, ambiguity, there and not there. But underneath, the structure makes itself felt, a ruin which leaves only the soul, *the lasting has a great secret, it always looks as though it just happened.* New forms take place as if by a predestined miracle. The seeming accident becomes a discovery of the underwater reaches and rapture.

Hokusai

By chance Jenkins came into possession of the epic work of a great Japanese artist. Even before he had begun to create his own artistic world, he could hold in his hands what he still thinks of as Hokusai's "affirmation of the immensity and endless possibilities within one world which was consistent unto itself." Jenkins's painting during the last twenty-one years, by the consistency of its underlying character and varied form, may be looked at as his equivalent of Hokusai's *Mangwa*. In 1971 he wrote:

I discovered Hokusai for the first time in Paris in 1953 in an antique shop on the

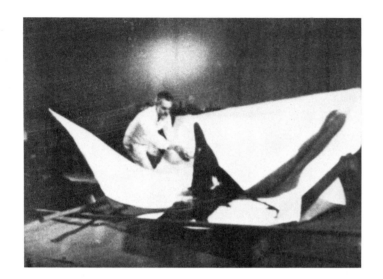

Rue de Tournon. I had the good fortune to fall on most of the volumes of his *Mangwa*. This was the outward manifestation of a world belonging to a particular man, the one they called "The old man crazy with drawing." These volumes of woodcuts were his lifetime observation of every turn and facet of Japanese life. Nothing seemed to escape his notice; flora and fauna, landscape, the pageant of humans. There were the most devoted and detailed drawings of insects and birds, fabulous animals from his imagination . . . the rejuvenation of the traditional view of what was fabled, ghosts coming back to haunt the living, priests quite alone . . . Samurai on fierce moving horses, ladies of such elegance and the common people making fun and being matter-of-fact about their craft endeavors. Then there were strange men who were not typical but suggested to me archetypes of the spirit. Violence of nature. A flood. A driving rainstorm. A quiet moon that drove men mad. . . . Hokusai gave dignity to movement, no matter how topical the subject or sublime the intention. . . . As he went along in his life, Hokusai had his drawings carefully done in wood-engraved prints. Very simply, only one or perhaps two color values added. . . . It was Hokusai who made me believe that limitation can be the key to endless possibilities within a given arena. Limitation far from being confining can be a wellspring.

In the summer of 1953, Jenkins was working in Paris with watercolor, as well as with oil and enamel. A garage served him as a studio, and under the influence of Hokusai and Wols he created his "scrolls." He used house paint on large sheets of linen-backed rag paper; his largest painting, eight feet by five feet, was to be rolled and hung like a scroll. He started some pictures with India ink and added nuances of color, and then he moved to powdered Winsor Newton pigments mixed with glue. These "scroll" paintings, which have been destroyed, included a turbulent seascape. Working on the floor Jenkins "felt more enveloped," and the nature of his liquid medium demanded different decisions and a more dynamic sense of totality as opposed to filling in one given area at a time. It was an optical embrace. This was a personal and natural discovery. The pouring method, according to the artist, was not a preconceived notion; it solved the problem of "how to sense the total scale and control movement, rather than lose it through pouring." In a now lost "savage landscape" he felt he "unconsciously recognized an archetypal form." By liquefying his medium Jenkins was also becoming more conscious of the "chemistry of colors," reviving his remembered interest in the ceramic factory where he had witnessed the "chemical fusion of glazes."

Working with copper enamel pigments that gave a pearlescent tonality, he realized the alchemic nature of his work, the "idea of transformation, taking ordinary matter and imbuing it with mystery, not familiarity." This was undoubtedly encouraged by his recent reading of Jung's *Psychology and Alchemy*.

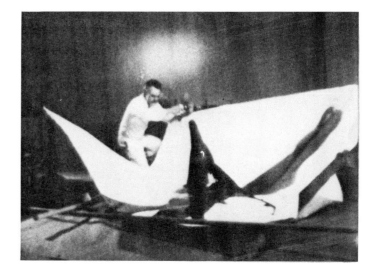

Psychology and Alchemy, 1953

In Paris, Jenkins began to feel that he was doing something "imaginary" in art. "I would say that the influence first occurred through Jung, through a kind of illuminated feeling that I was on a dark journey, and this was a way of life and not just a hazardous adventure." Jenkins read Jung's *Psychology and Alchemy* on a visit to Vence, in southern France, in December of 1953. "For me it was a cellar of treasures that I was exposed to." Jenkins may have been encouraged at the time by such statements from Jung as the need to "repudiate the arrogant claim of the conscious mind to be the whole of the psyche, and to admit that the psyche is a reality which we cannot grasp with our present means of understanding."[16] Jung criticized Western man for not experiencing God in his soul and Christianity for being too dependent on outward forms. For Jung the soul "contains the equivalents of everything that has been formulated in dogma and a good deal more."[17] In other words, the soul has lying dormant in it images equivalent to the sacred figures of Christianity. These images are put there by God. "God is an archetype, I mean by that the 'type' in the psyche. The word 'type' is, as we know, derived from . . . 'blow' or 'imprint'; thus an archetype presupposes an imprinter."[18] In his notes of 1953–54 Jenkins wrote: "I painted Notre Dame. It had to be, and the result was the use of paint directly, as in Sicily and Spain. But unknown to myself a meaningful change was taking place. Having experienced the 'glancing blow,' 'the imprint,' the form I sought for was not emerging from optical space itself." A Jungian interpretation might stress Jenkins's painting of the cathedral of Notre Dame as the painting of an "outward" symbol of Christianity, and his subsequent rejection of that motif and way of painting as resulting from his having made contact with his psyche and the desire to have an inward religious experience.

Being tied to motifs such as figures and buildings may have seemed to Jenkins to have inhibited what Jung felt was imperative to the unconscious, "free play, which is the basic condition for the production of archetypes. It is precisely the spontaneity of archetypal contents that convinces."

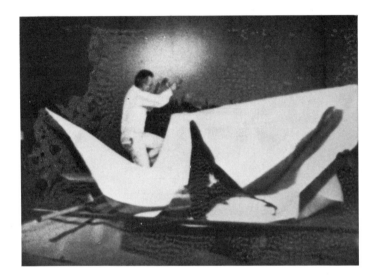

Of probable value to Jenkins's self-understanding was Jung's insistence that the individual recognize, confront, and live with the "dark side of his own psyche" in his quest for "wholeness" and salvation outside the Church. "We must not underestimate the devastating effect of getting lost in the chaos, even if we know that it is the *sine qua non* of any regeneration of the spirit and personality."[19] Jenkins's paintings, which in the second half of 1953 came to depend upon spontaneity formally as well as thematically, exposed him to the dangers of "chaos." Perhaps relevant to his psychic paintings was Jung's quotation from an old treatise ascribed to Hermes : "I the lapis beget the light, but the darkness too is of my nature."[20]

One of the most important and variable motifs discussed and illustrated by Jung is that for the self, the *mandala,* a concentric configuration that is among the oldest religious symbols of humanity. Jenkins transcribed the following : "All that can be ascertained at present about the symbolism of the mandala is that it portrays an autonomous psychic fact characterized by a phenomenology which is always repeating itself and is everywhere the same. It seems to be a sort of nucleus about whose innermost structure and ultimate meaning we know nothing."[21] The mandala is thus one of the archetypes that Jung believes has an eternal presence, either perceived consciously or not, and it is inherent in the collective unconscious and therefore beyond individual birth and death.

In his chapter on the "Basic Concepts of Alchemy," Jung goes briefly into the significance of various elements used by alchemists. Most relevant to Jenkins, who was working with water and inks and increasingly with a liquefied medium, was the alchemists' view of water. "Water is the life-giving soul (anima) and can be extracted from stone. . . . And by whatever names the philosophers have called their stone they always mean and refer to this one substance, i.e., to the water from which everything [originates] and in which everything [is contained], which rules everything, in which errors are made and in which the error is itself corrected."[22] To this day Jenkins uses water to correct "errors" made during the process of his painting with acrylics. "Philosophical water" for the alchemists was not ordinary water, a composite of some mineral and water. An old alchemical formula states : "Grind the stone to a very fine powder and put it into clearest, celestial . . . vinegar, and it will at once be dissolved into the philosophical water."[23] Jenkins was to mix increasingly various things with water, and powdered mineral and chemical pigments with different liquid mediums beginning in 1954, not long after reading this book. His fascination with recipes and the intricacies and mysteries of materials and processes goes back to his youthful days

in a ceramic factory and extends to the present. In 1971, he began studying techniques and mediums used in medieval painting with a private tutor. It is ironic that modern chemistry, which grew out of alchemy and destroyed its credibility, created the materials by which Jenkins was to perform his own alchemy as an artist. The medieval alchemist and Jenkins have in common the pursuit of the marvelous: the former the marvelous "philosopher's stone"—the stone of "invisibility" or the ethereal—and the latter the marvels of God manifested through ethereal phenomena. Both projected their own psychic backgrounds into the unknown and have respective theories or intuitions of correspondence between the spirit and physical matter. For Jung, the appeal of alchemy to the experimenter was the psychic experience, which appeared to him as the particular behavior of the chemical process, "but what he was in reality experiencing was his own unconscious. In this way he recapitulated the history of man's knowledge of nature."[24]

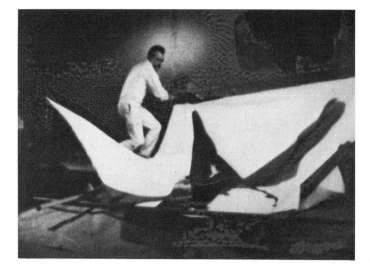

Jung points out that for the alchemist a certain psychological condition was indispensable for the discovery of the miraculous stone and he deduces that the essential secret of the art lies in the unconscious and that the alchemists *did* know that their work was somehow connected with the psyche. It was assumed "that a species of magical power capable of transforming even brute matter dwells in the human mind."[25]

Jenkins has referred to his watercolor *Sea Escape* of 1951 as one of his first imaginary works. It was after his arrival in Paris in 1953, however, that Jenkins was able consistently to create imaginary images. In Jung he read about the act of imagining for alchemists: "In this way the alchemist related himself not only to the unconscious but directly to the very substance which he hoped to transform through the power of imagination. . . . Imagination is therefore a concentrated extract of the life forces, both physical and psychic."[26]

In his letters and diaries as a young man there are references to the painter's feelings of guilt and the hope for salvation or redemption. The symbols, theology, and liturgy of orthodox Christianity did not meet his needs. In Jung he read about and saw from older art "myth pictures [that] represent a drama of the human psyche on the further side of consciousness, showing man as both the one to be redeemed and the redeemer. The first formulation is Christian, the second alchemical." For the alchemist "his attention is not directed to his own salvation through God's grace, but to the liberation of God from the darkness of matter." This was to be achieved through the opus of work produced. Jenkins has said: "I paint the face of God. Not as I would have Him but as He chooses to come to me."

OUT OF THE MESHES AND FOLIAGE
OF DARKER MEMORY, 1953–1959

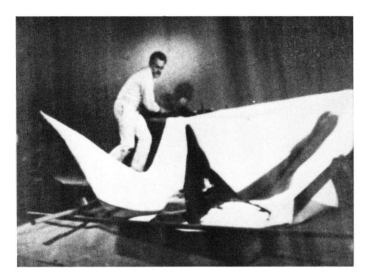

Between 1953 and 1959 Jenkins's paintings have a distinguishing density of unquiet events which do not resolve themselves in such a way as to allow the beholder to orient himself easily to the embattled genesis performed before his eyes. There are no horizon lines, focal points, or footholds, no scaling of luminosity to separate sky and earth, or top and bottom, no textural gradation to measure near and far, no crystallized forms for anchorage during our visual voyage. In Jenkins's personal type of field painting of the fifties there is an absence of neutral or passive reserve areas, static shapes, and consistent demarcation of figure and grouped relationships. This absence results from the ubiquity of his veils, and the lost-and-found character of his lines. One starts to imagine a drawn configuration, only to find that the line dissolves into a shimmering vapor. Conversely, a mist may distill into a filament. Irresolution and indeterminacy are formal and thematic. The paintings have a sustained, turbulent intensity within themselves and from one work to another that gives them a breathless urgency. Jenkins had found a creative triggering device through a personal psychic automatism, and the "informal" composition reassured him that this was an appropriate form for his questing in the caverns of the self. He exuberantly allowed the found treasures to pour forth as he painted by "indirection."

Jenkins's inexhaustible inventiveness leads to amazing textural occurrences and color within color, spanning from rock to fog on an allusive level but for the most part resisting paraphrase. Evolution is meaning and method. The effacement of evidence of facture helps engender the impression of the work's natural emergence. All evidence of touch is eliminated to intensify our absorption in the drama of events.

The luminosity of these paintings is self-generated, like that of phosphorescent caves, coral reefs, minerals, and moths. Some have lights in the darkness that lead us deeper into strange but not inhospitable depths, others scale upward to brilliance. "The image must go through a purifying fire. The light and darkness mingle. They come to know one another. They even enhance each other's substance."

There are no motifs, no repertorial shapes that thread through these paintings, for they were made by a hand being disciplined to forget the past. One may intuit a human profile, but none was previsioned by the painter. There are elusive circles, phantom mandalas, or Jungian archetypal forms.

Jenkins's images are like segments of occurrences intercepted on all sides by the frame, flooding from zone to zone, coagulating and dissolving, pulled by some invisible or self-contained force that drives the substances in and out or sets up rotary vortices or sets off explosions and implosions. The compositions carry and hold in the eye as

well as in the frame. Randomness, which the painter equated with the natural, had to be achieved by a hidden artistic calculation, but each quadrant has an overall density equivalent to its neighbor's. His colors well up through each other in the wondrous and natural profusion of a volcanic eruption. There is no self-conscious steadfast surfaceness calculated to pay homage to the picture plane. There is no flagging of pictorial thinking, of sensibility to craft, of response to suggestion and insight. Their masculine vitality lies in their unpredictable depths and textural surprises. These are paintings where drawing and color are achieved with unobtrusive but unmistakable authority; they demonstrate that the artist has at last found a meaning to his life as a painter by fusing himself with nature and with human and divine existence. He is adding to life as well as to art. It is the Zen ideal of the archer identifying with his target.

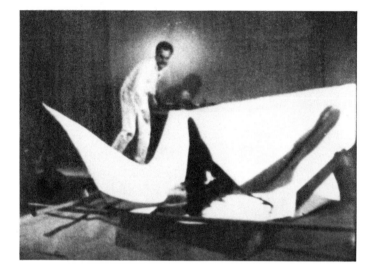

Jenkins's commitment to a mediumistic approach gave him sources that removed his paintings from emotional abstraction. In Jungian terms he was making a Herculean night voyage through the darker side of the self. But when one reads his notes, one finds descriptions of experiences of nature, his own and those evoked by others, whose selection for transcription testify to their impact on "the meshes and foliage of darker memory." Recalling his days in the Naval Air Corps and his trips while on leave to Chincoteague Island in Virginia, Jenkins has said: "I would go into areas that were like primordial swamplands and I felt something that went back before the beginning of man. And I had a very strong, awesome sense of inchoate forces, about things we do not know." The painter's fascination with the primordial and inchoate forces probably made him susceptible in 1953–54 to a passage from the conclusion of Charles Darwin's *The Origin of Species* that may give us an insight into the "evolutionary" nature of Jenkins's painterly world:

It is interesting to contemplate a tangled bank, clothed with many plants of many kinds, with birds singing on the bushes, with various insects flitting about, and with worms crawling through the damp earth, and to reflect that these elaborately constructed forms, so different from each other, and dependent upon each other in so complex a manner, have all been produced by laws acting around us. These laws, taken in the largest sense, being Growth with Reproduction; Inheritance which is almost implied by reproduction; Variability from the indirect and direct action of the conditions of life, and from use and disuse; a Ratio of Increase so high as to lead to a Struggle for Life, and as a

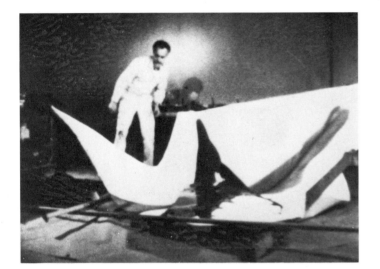

consequence to Natural Selection entailing Divergence of Character and Extinction of less improved forms. Thus, from the war of nature, from famine and death, the most exalted object which we are capable of conceiving, namely, the production of the higher animals, directly follows. There is grandeur in this view of life . . . and that, whilst this planet has gone cycling on according to the fixed law of gravity from so simple a beginning endless forms most beautiful and most wonderful have been, and are being evolved.

Letting Go, 1953–1955

In just less than a year, beginning roughly in April of 1953 and including his first one-man show at the Studio Paul Facchetti gallery in Paris in March of 1954, Jenkins radically changed his artistic handwriting; he began pouring paint, and his imagination too began to flow. The imaginary became more real to him than his previous painting of persons and places. This new beginning appropriately took place in a "watery void" out of which he "groped" for an "all-over form." Water mediums finally proved responsive to his temperament and sensibility. A discernible fluid layering initiates and supports the paintings' construction in this period and thereafter. At times there is a type of linear etching that cuts down to the pictorial support—canvas or paper—as in *Water Mirror.* Then, as in *Cosmic Vertebrae,* there are spattered and more calligraphic linear skeins superposed on veils, with which the artist sought to generate a "backbone" of substance or impart a "presence."

The interaction of materials, meaning, and life experience conjoined in *The Bridge* and the repetition of the arch form from *Orpheus* reinforced Jenkins's belief in the persistence of archetypal forms in his art and gave him a kind of span between past and present. Before undertaking this painting, Jenkins remembers: "I noticed the verticality which occurred when I looked in the water of the Seine, lights which joined water, bridge, and heaven. I saw my own plane tilt forward in my own way. I felt something in nature come up front and not by tilting a table all the way as Cézanne tipped his, to serve a monumental purpose. But surely I must have experienced a phenomenon, just as I did when I witnessed a true Fata Morgana."

Pendant to *The Bridge* in time and theme is *Underpass,* inspired by reading about

56

the French explorers of caves that go miles beneath the surface and entice to perilous journeys. An artist conscious of being on a "dark voyage" would be susceptible to themes of subterranean passage as well as hallucinations of mystical mergence of light, water, and bridge.

Mystical mergence of the self and subject—"I too am nature"—could now influence his painting to the extent that often there is a more intricate embedding of motifs within their environment. This environment extends to the shape of the field, so that in *Window* and *Rosetta Stone* the specific areas that inspired the title reiterate the painting's rectangular format. *Window* presents us with what suggests twin columns of colored luminous volume whose near surface is sporadically darkened by inchoate markings. No longer invisible, the window is a receptacle that arrogates a world to itself. As in Redon, the window is the aperture of the subconscious. Jenkins had been reading about Champollion's deciphering of the Rosetta Stone and perhaps subconsciously recalled his own youthful affinity for stream-washed stones. In his new reductiveness what might be called motifs, such as Veronica veils, bridges, tunnels, windows, mirrors, and stone tablets, are presented either frontally or parallel to the surface, recalling his student journal entry: "Will paint flat objects if their flatness pertains to the reality I know." By closing the window of illusionistic painting, Jenkins opened himself to new associations and the satisfactions of achieving unities of experience. Drawing and painting had entered a new symbiosis; liquidity was undammed to flood everywhere; light was disconnected from the sun and free to operate under new laws.

The crucial painting from the 1954 Facchetti show was *Hommage à Melville,* in which, in contrast to *Le Poisson Blanc,* similarly subtitled *Hommage à Melville,* there is a greater interpenetration of entities and continuation of substance throughout. Color and line had greater self-sufficiency than when they had served a more obvious motif and thereby invited textural comparison with an external source. Water mediums inspired in *Hommage à Melville* a "sense of silence" and "ever-present movement of those who wait beneath the surface." The painter describes the effect as "a marvel which I draw from constantly." Adding to the painting's pivotal importance was the success and, to the painter's mind, credibility of its imaginative motion and luminosity.

The first painting which I feel involved movement and at the same time had a kind of light that I was searching for was *Hommage à Melville,* and from that time on I had to embrace a certain responsibility and commitment to pursue this

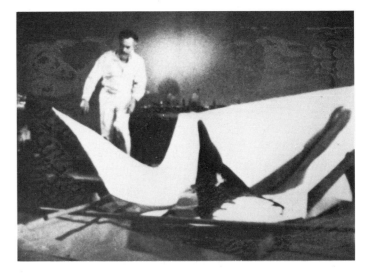

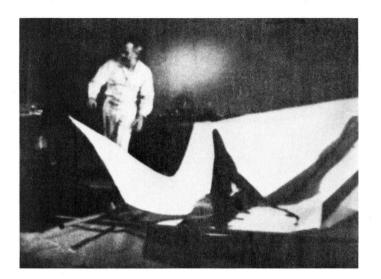

direction. The linear white became important because it involved reflected light. The luminous light also contributed to finding my form. I felt that this led to a kind of light which contributed to a form enclosed in movement. Tobey's light and line is what he himself has described as a "moving focal point"—and it was to me an optical dictation. What I tried to do was to make the form move without it becoming dangerously romantic in the same sense as Géricault or Delacroix.

Jenkins's choice of title parallels the interest of other American artists, such as Theodore Roszak and Seymour Lipton, in Melville and *Moby Dick,* which in the late forties and early fifties was part of the search for an American myth. Jenkins's title was inspired by the image and form of the finished painting. What he saw in his work was the suggestion of the form of the white whale. "It was the Moby Dick and it was the sensation of the enigma, the enigma which you can see one moment and then not see the next, the presence of something more than the actual familiarity of it. It's also Ahab and the pursuit of himself, the pursuit of his own unconscious. And the whale is the abundant unconscious in its natural habitat, which is the sea." *Hommage à Melville* was a breakthrough for the painter in his search for himself. "To me it was one of the first strong evidences of enigma. I was convinced that this had a meaning that I had been searching for and it's as though it was a moment where many things coalesced which were always in separate domains before—form, movement, reflection, luminosity, all of these things seem to enter into it—hot and cool, even with the limited colors that I used." As with his experience in *Sea Escape,* "I was using something that wasn't out there at all but was found in the process of painting."

Pulsing through Jenkins's development is his alternation between the motif and compositional gesture that is found and lost, isolable or submerged. In paintings such as *Magic Circle, Black Dahlia, Uranus,* and *Umbra,* done between 1954 and 1958, the vortex or mandala form is strong, so that the energy seems to go toward the center and sometimes "pulls up rein tight." In 1945, Jenkins had completed a graphite drawing of a flowered woman's hat in which there is a clustering of detailed botanical forms contained within the oval circumference of the brim, below which floods the hair. Looked at abstractly this drawing adumbrates the later compositions such as *Eyes of the Dove* of 1958, and shows the long-felt influence of meticulous observation of nature. Before coming to Paris, he did a black-and-white drawing showing a "conclave" of black-shrouded figures disposed like musical notes on a spiral pavement, which in retrospect the artist links with the subsequent mandalesque compositions.

Magic Circle stands out because of its circular broad-stroked shape superimposed on a dense background. The circle formed by one sweep and without correction may have been a gesture inspired by the Zen idea of the kendo stroke—made suddenly after intense concentration. The circle is at once a compositional binder and a sign made all the more suggestive by Jenkins's readings in Jung and in Zen, where the fully extended archer's bow is thought to "enclose the All" and the empty circle relates to a primordial state in which the mind is thought to be everywhere. The evolution of the mandala in a composition such as that of *Uranus* came about naturally and not as a conscious symbol. The artist also reads this painting as a yin and yang "S" broken by the circle that is drawn through it. "In other words, it doesn't stop being, it never stops being a painting first for me. . . . I go back intermittently to certain archetypal forms, but I try not to use them as a stylized motif or in a thematic way. This does not mean that there is not persistent recurrence of images in my painting. I respect the intention of significant artists like Albers, Stella, and Newman, who confine and repeat their forms to create in their painting both maximum potentials and results."

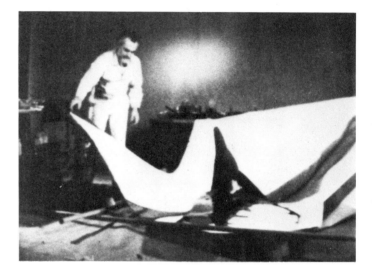

Characterizing the oscillation that takes place in the foregoing and other paintings of the fifties, Jenkins sees his other polarity as the "labyrinthine and baroque. The pendulum would swing back and forth from a Zen gesture to interpenetration of forms."

Before 1956, his paintings were no larger than eight feet by five feet and were usually smaller, as is *Uranus*. With respect to their modest size, the painter felt that thematically he "was always concerned with microcosm and macrocosm." For several years he set himself the formal problem of learning to express great scale in a small format. He would move to a larger scale only when he felt that expansion was inherent and needed, instead of being a forced format.

The resolution of the figure problem for Jenkins partly depended upon doing a number of images without discernible figuration. He was creating a suitable painterly matrix and frame of mind for its return, which did not depend upon invitation. Before leaving New York, Jenkins had seen Pollock's black-and-white paintings, drawings, and silkscreen prints, in which figural elements had worked their way back into his art in terms of fragments, heads, and occasionally an entire body. This phenomenon, coupled with interest in Jung, could have left its mark. The evolution of the figure in Jenkins's work generally proceeds from portraits, to personifications or vaguely identified personages, to presences—from literal figures to figural "forces," as in *Hypnotist*. In New York, before leaving for Europe, he had done paintings bearing this title, of two people facing each other. In this oil-and-enamel-pigment painting of 1953,

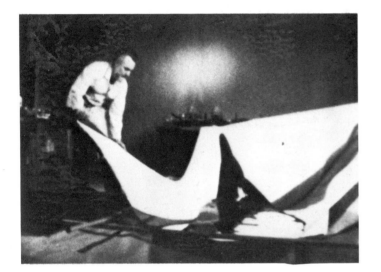

which he destroyed, the motif had become "the suggestion of two forces facing each other." This work and *La Fenêtre* were the closest Jenkins came to symmetry. *Hypnotist* was dominated by orange-encrusted paint. It was a meaningful failure. "It got me moving toward the granular veil. This painting would show a relationship to the mineral substance *Ore Lode Vein* paintings I am doing now."

An earlier painting, also destroyed, was *Funambule* of 1953, an unconscious metamorphosis of earlier themes of clowns and acrobats. Perhaps inspired by Gurdjieff's discussion of how certain humans have physical and astral bodies, Jenkins notes: "The attempt was to create the emerging astral image." Like his subject, the artist was artistically walking a tightrope with respect to what he could do with his new medium, and still unexplored methods, in order to achieve "suspension or levitation." "In this one I distressed it by rubbing away the black areas down to the white ground underneath."

The profile head occurs with a kind of Egyptian consistency in works of 1953 through 1955. *Egyptian Profile,* which was done with ink, gouache, and varnish on papyrus mounted on canvas, "was like a personal Rosetta Stone." The Rosetta Stone attracted Jenkins both as a theme and as a cherished psychic emblem. "It was like a talisman of the mind, a challenge that never failed to excite a kind of trust in the darkness, the void, and strange light." Since childhood visits to the Nelson Gallery in Kansas City, Missouri, Jenkins had been drawn to Egyptian art, and the Louvre revived this fascination. The connection of papyrus and motif was probably not fortuitous. Gurdjieff had cited Egyptian art as embodying a timeless, objective quality, and by being subjective Jenkins was contesting his former mentor and making love to art of the past. Both *Egyptian Profile* and *Amethyst Profile* have simultaneous qualities of the specific and general. The juxtaposition of the tangible and elusive signified the "astral" nature of his subjects. These are not the ambiguities of Pavel Tchelitchew, or Dali-like paranoiac images, or duck-rabbit optical illusions. The profile images have a fugitive relationship to an indefinable environment which was more developed in *Astrologer, Archer,* and *Alchemist.* The three titles fittingly relate to generic types which mystically assume an identification with their vocations, materials, or environments. "The Archer brings to mind certain haunting meanings for me when I read *Zen in the Art of Archery,* the idea of embracing the target rather than trying to conquer it with a fixed-point attitude." The silhouette of *Astrologer* is a constellation of lights and darks, moons and clouds. The spiky corona around the head recalls Jenkins's earlier silverpoint of the masked woman from whose head grew bare branches. The

metamorphic aspect of *Astrologer,* his energetic and irregular silhouette and unnatural being are earlier met in two of the artist's graphite drawings of men—not portraits, but invented beings. These drawings were done while Jenkins was in the Navy and possibly under the influence of Tchelitchew's *Hide and Seek* in the Museum of Modern Art, which at first fascinated him by its obvious use of ambiguity, but later disturbed him by its blatancy.

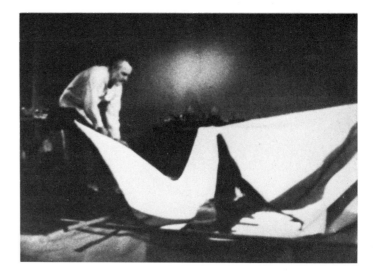

 Alchemist, done in 1955, had a distinct presence for Jenkins, that of "a magician or shaman who was holding some kind of ceremony or performing an incantation." The torn gold color of the painting contributed to these associations and the title. "It was the idea of trying to turn a base metal into gold, something common turned into something uncommon." It was not only his reading of Jung, but also a comment made by Kenneth B. Sawyer that stuck in the artist's mind and seemed a challenge and poetic reference: "After all, you painters are working with dirt, you're working with minerals, you're still working with common substances and you're endowing them with your own meanings. You're giving it a meaning that it doesn't have itself."

 Technically, the elusive spotting, corroding, and broken subsurface skin glow of *Alchemist* involved Jenkins's use of oil for the ground colors and water-based pigments. He used Chrysochrome and Winsor Newton pigments mixed with water and applied to the canvas. They were either allowed to dry, or the enamels were worked on it while the surface was still wet. "And then over the enamels I would use water in streams and create breakages and cleavages against the ground. Then I would sometimes break some of the images with a palette knife." Jenkins had not yet discovered the use of the ivory knife.

Vortex and Labyrinth, Heaven and Hell, 1956–1958

The earliest painting by Jenkins that resembles his work since 1960 is *Water Crane* of 1956. The title came from one of the Hexagrams in the *I Ching,* whose specific meaning the artist cannot recall. But it could also have been inspired by the rising white line that is crane-like in its slenderness and gesture. The work was done in Paris while Jenkins was under the influence of the *Book of Changes,* particularly the foreword by Jung

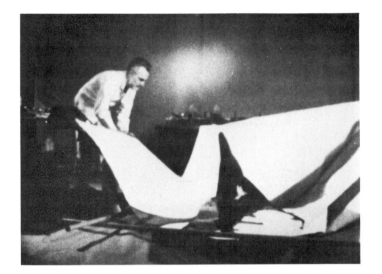

"and how he gave every respect to the importance of the notion of change. And it made me remember that passage in Tolstoy's *War and Peace* where one of his chosen wise men said the only thing which was certain was change." The painting was important for the artist in what he characterizes as a "potential" way. He poured his pigments over the canvas. A matte varnish sealed in the powdered pigment "like a fly in amber. Here was the veil. Here was the Zen kendo stroke. Here was the line which was form and image." What inspired the use of this white line was his study of Hokusai, particularly the *Mangwa,* which he owned, and specifically a woodcut of a waterfall. "This I think had an influence on *Water Crane,* which has a linear form ascending as well as descending." Jenkins admired Hokusai's line because it was more than descriptive, "it had an independent meaning, and created its own significant form."

Water Crane, Divining Rod, and *Sounding,* all of 1956, and shown in New York at the painter's first show at the Martha Jackson Gallery, helped establish the artist's use of Chrysochrome enamel drawing. Using it directly from the tube or with a brush, he was able to get very precise, "dictated" white lines, or to move from a large to a smaller image. In *Sounding* it takes the form of an homage to Pollock's skein and Tobey's white writing, but it is an event marginal to the whole composition and not the basis of its structure. *Sounding,* though visually dramatic, lacks resolution. That this work caused difficulties for the artist, but was important in his psychic development, comes through in this statement:

> *Sounding* has intimations of what is beneath the water. I would build up and then scrape down. I used water and turpentine and certain areas were fused. Then I finally found a form. I thought I would never find a form in this one. And finally the one that evolved was a monster, for me, a monster of the unconscious that cannot be ignored. . . . That's why from time to time I say that some paintings I do are to me monsters I cherish. These two aspects of life, the dark side and the light side, are important to us. And the dark side is what gives us inchoate energy and forces which we otherwise wouldn't have.

In *Divining Rod,* the white enamel drawing is less obtrusive as such and acts like a magnet to its environment or a force radiating particles on all sides. It functions more in concert with his aim of "setting up the visual possibilities for the marvels of occurrence." His associations with this painting are "magic, in relation to man not

letting Nature conquer him. In other words, warding off evil spirits or finding water. Everything relates to water." It was with this painting that Jenkins also felt he had reached the point of being able to handle larger scale. Though surrounded in New York by huge canvases of the avant-garde, scale was something which had to evolve in its own time.

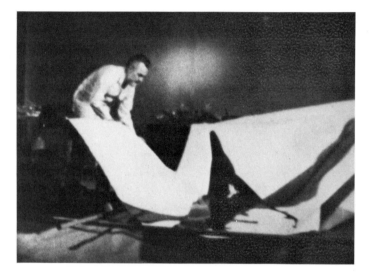

This evolution toward greater scale had to wait until he had developed his own painter's arsenal, and paintings like *Sounding, Lotus,* and *Darkling Plane* were important strides in achieving "a kind of electric white drawing, a reflected light, a light, as Alice Baber expressed it, like the underside of toadstools where you can find iridescent swamp light, a kind of light you wouldn't see by day. And I used it much the same as Van Eyck or Memling would use a bar of light going down a shoulder on a red and gold robe . . . as though it were a contributing thing that gave volume and luminosity to the darkness of the subject."

Jenkins's use of Chrysochrome enamel was a form of problem-solving, for it replaced the earlier etching of his painted surfaces and gave him a more spontaneous, fluid resource with which to find simultaneously a reflected and a luminous light, and to create form rather than simply a graphic counterpoint to his color. *Lotus,* more than *Darkling Plane*, illustrates how his white lines could have a variegated history of being lost and found, being grounded in or emanating from other colors or swinging free like a windblown kite line. At times in *Lotus* and *Dakota Ridge*, the white line suggests a rope stretched across a flooding stream in winter gathering ice, but quixotically bending against as well as with the adjacent currents. In *Lotus* the use of the line is more constructive in intention "and not random filaments in the void."

As a devotional painter, Jenkins will reread his earlier paintings in terms of heaven and hell. "*Water Crane* is an evidence of heaven. *Darkling Plane* is an obvious evidence to me of a kind of hell, but a kind of magnificent hell. . . . *Lotus,* which was done in 1957 at the very same time as *Darkling Plane*, strikes a kind of middle ground. It is neither heaven nor hell, but a season with its warm place when things are allowed to grow. It's a certain time of day, when everything is in its fullness."

What makes *Lotus* rather than *Darkling Plane* anticipate Jenkins's art of the sixties is its more veil-like substance and lightness, its easier breathing and fluidity by contrast with the compacting and turgidness of the darker image. To the artist it afforded strong proof of his ability to combine the linear with vibrant luminosity. This was a combination sought for by Rothko before he eliminated the linear in favor of construction by his color bars. Rothko's earlier calligraphic "signs" hovered always in front of a

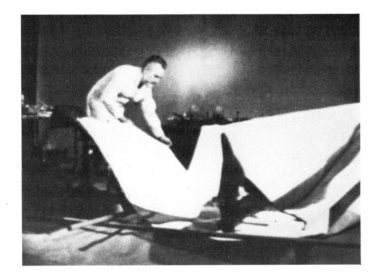

colored wash background, and his lines never took on luminosity. Jenkins also singles out *Lotus* for its prophetic manifestation of "determined color of a nonalternate nature. In *Lotus* I found cardinal meaning in the color itself, which could not be changed or thought of in a different way."

From *Lotus* the painter sees a carry-over of his kendo stroke and color conviction and even the use of cadmium and vermillion red in *Dakota Ridge* of 1958, painted in New York the year after a disastrous fire in his studio in St. Mark's Place and during one of his most painful, yet fruitful, years as an artist. "They were done at a very violent time, a time of tremendous transition—divorce, leaving Martha Jackson's Gallery, going back. It was a time of fantastic transition, personally and creatively. *Hommage à Melville* and *Water Crane* at last join into an embracing union. . . . The forces of *Hommage à Melville,* which have a headlong rush, and the diagonal cut of *Water Crane* finally join for me. . . . It is movement and containment occurring simultaneously." The forces he refers to are "elements charged with energy fused with heat and cold." The 1958 paintings here reproduced in color are all of active presences that have experienced violence but are indestructible. They are all dense conglomerates of textured color, and there is a strong tendency to the vortex and labyrinthine. *Lunar Moth* separates from the rest by its large white phosphorescent shape that gives the whole a varied scale. This large "positive image was a harbinger of the later negative white from without."

The titles of the 1958 paintings—*Natchez Trace, Cherokee Strip, Western Sphinx,* and *Pawnee*—suggest the Midwestern background of the artist. He found these titles "related to a certain kind of terrain where savage things could take place in untamed nature."

Pawnee is a unique painting for Jenkins because of its immense oval shape, and because he once hung it on the ceiling of the Martha Jackson Gallery. Aside from its format, *Pawnee* belongs to the previously discussed paintings of 1958, and it, too, was painted in the St. Mark's Place studio. "I came on this oval stretcher in a Tenth Street framing gallery. When I did the painting the canvas was free from its stretcher. It evolved completely whole in the sense of being an organic image, an arena, that moved me intensely because it had a sense of vortex, of a particular violence that I was drawn to at that time." To the suggestion that he might have been thinking of Renaissance or Baroque illusionistic ceiling paintings by Mantegna, Correggio, or Pozzo, Jenkins replied: "No, I didn't, I had a sense of looking down . . . because it's like a whirlpool, rather than a ceiling that allows you to speculate on clouds. It also helped me to break

the corners of the square format, but large scale is important for the tondo. It had a sense of being caught in . . . the spring of the unconscious."

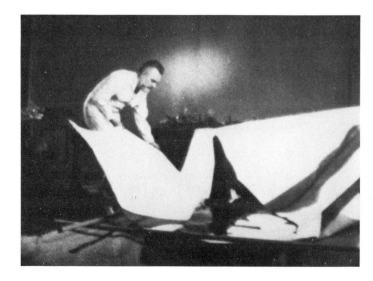

Eyes of the Dove, 1959

By 1959, Jenkins felt a need for some kind of "reversal" in his art that would move his painting away from the overall dense conglomerations and almost unrelieved intensity of the previous work. By his own assay, he is no more systematic with respect to stylistic progression than he is a thematic painter. "I've never relinquished a certain current, river, tendency, or methodology. . . . Therein lies the possibility of constant recurrence."

The *Eyes of the Dove* series consists of about forty paintings, of which the first was made in 1958. It was inadvertently started by a story from Harold Rosenberg,

> . . . who spoke to me about a Jewish rabbi who used to visit different synagogues. He would stand on the topmost step and he would then come down one step and say: "The eyes of the dove," and then go into a kind of revelatory explanation in words of religious experience. When he completed that he would step down and go into another transport. He was greatly admired and followed. I thought to myself, "Yes, the eyes of the dove, they see everything but never the same thing twice." Then I got involved with a rectangular format. The *Eyes of the Dove* are all 30 × 40 inches and I proved to myself beyond question that this "dumb size" could take on different dimensions.
>
> When people ask me if I make a drawing before a painting, or do I have an idea before starting a picture, I point out that the very size of the canvas dictates to me. A blank canvas gives me a clue. In the series *Eyes of the Dove* . . . I discovered that one painting might seem to contract and concentrate, fold into itself. But another might appear to expand beyond its boundaries. All achieved a difference of scale. My eye measured a reality which had nothing to do with the arbitrary scale of the yardstick.

The most striking change in the paintings of this series is the ground. Jenkins started to paint against more white forms within the format. He began to paint certain areas in

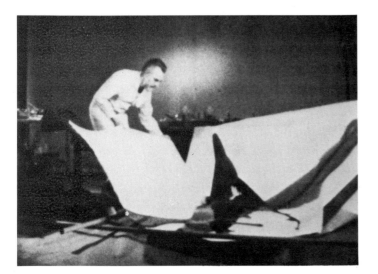

acrylic white gesso, allowing some of the areas to dry and then going over them with color veils and forms. This series "opened up the negative-positive, positive-negative, the interpenetration of white ground and evident images." It was the 1959 exhibition of these paintings in Paris that earned Jenkins the comment from Clement Greenberg: "One of the most individual painters of his time."[27]

Most of the *Eyes of the Dove* paintings were done on unstretched canvas, placed horizontally on the floor. The poured shapes "came from *drawing underneath the canvas* . . . putting actual forms, tilted pieces of wood, like a long bar, under the canvas is what caused definite flows and rivulets. The gulleys and valleys were formed with structural intention beneath. Sometimes, I would take up the corner of the canvas and staple it to a box, a table leg or wall . . . so that when I poured I would get defined veils."

Jenkins had been using unstretched canvases since 1953, when he went to Paris. He continued to use this method until 1960, when he learned to work on large-scale stretched canvases. He found, however, that when the work was over six feet by ten feet, he achieved the best results with unstretched canvases.

In 1958, Jenkins had the good fortune to receive a gift of an Eskimo ivory knife from the painter Alice Baber, whose intention was to add it to his collection of ivory. Neither of them knew that this knife would become one of his most essential tools. "It was found to control and make precise designations and fusions at the same time, and to carry the color into a vast area as well as a contracted form which could be dictated by the ivory knife. With the smooth organic surface of the ivory I could use great pressure against the sensitive tooth of the canvas. It wouldn't abrade, like a metal knife would."

PREPARING THE GROUND
FOR A POSITIVE IMAGE, 1959–1964

In 1959, the writings of Kant and Goethe came to Jenkins's attention, and their views on the knowable and unknowable, the object of sense perception as distinguished from ultimate reality, strengthened his conviction by their philosophic parallel to his imagery. "So I greeted the unknowability. I greeted having no possibility that one could touch absolutes which the Greeks contended they could do. Perhaps the solutions were not apparent, but at least my state of mind was not clouded with false hopes or nostalgia."

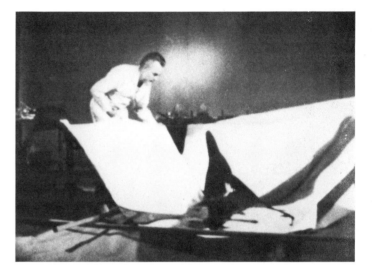

The validation of subjective experience by Kant and Goethe helped Jenkins live with another problem: "Artists take on a kind of spiritual prowess. They do want to convert you, and they do want to tell you that theirs is the only way. And this is not the case." This statement can be taken to mean that just as the artist, emulating Goethe, resigns himself to the unfathomable in nature, he must accept the fact that his art and life attitude cannot divert the public from all others. In the late fifties Jenkins was reminded in many ways of being a loner. "In Paris, I am an *Artiste Etranger*. In New York, a suspect." By 1959, Jenkins sensed that the sympathetic attitude of the public and many artists toward subjective painting and Abstract Expressionism was "fast disappearing." He recalls, "I could sense something occurring within other artists—their doubts." It was for these reasons that Jenkins feels Kant, and especially Goethe, did not give him peace of mind, but, he says, they "gave me stamina to continue . . . knowing that *meaning* would now have its chance to continue without the encouragement of mode."

During a trip to Spain in 1959, Jenkins worked extensively in Porta della Selva with watercolor in ways which did a lot to clarify some of the possibilities of *Eyes of the Dove* and his attitude toward imagery and his mediums. He recalls becoming more intensively involved with color, perhaps aided by the brilliance of the light experienced working out of doors, and painting on the *whiteness* of rag paper. "I worked on a small patio with a deep cement wash basin. The light was brilliant. I felt I was able to see and account for the color no matter how delicate, strong, or vibrant it might be in this very difficult watercolor medium. I wanted to grasp the positiveness of a nuance that had a certain emotional strength, a vibrancy. . . ." He was also increasingly drawn to sustained translucency of color, which in turn influenced his feelings about using an oil medium. "Oil tended to coagulate." He experienced a new feeling of fluency with watercolor that helped convert him to acrylics, which in turn fertilized the emergence of his paintings of phenomena. The words of Goethe, paraphrased in Jenkins's notes as "his frustration with knowing the absolutes is yet revealed to him in the *world of phenomena*," came at a time when he could artistically and consciously realize phenomena. This evolution had to be worked out in the paintings of 1960 and entailed

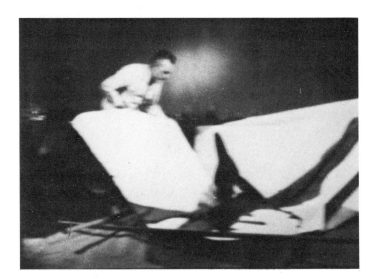

slowly surrendering textural aggregates or "coagulations" which tended to impede the flow of the image, and the search for the veil that had *substance.* "When I returned to Paris I stopped the tendency of painting with the envelopment and fusion of oils."

Phenomena After Image and *Phenomena When I Looked Away*—originally titled *When G Looked Away,* meaning Goethe—relate to Goethe's investigation of phenomena. "One of the things about which he wrote, which proved beyond doubt the optical phenomenon which can occur within the eye itself, was when he was watching a smith hammer an anvil. Goethe was looking into the smith's fire, then he turned his eyes away and looked into the coal bin. Suddenly, as a result of this optical experience of looking into a very bright light and then into darkness came all of these different colors; the colors disappeared in sequence." In the foregoing paintings and *Phenomena High Octane,* Jenkins was working predominantly with a strong image against the ground of the canvas, which had been sized. Jenkins was not staining his canvas, because of the sizing and priming.

The veils of color which were made to occur in these paintings "were perfect in terms of helping me to establish certain luminous nuances, as I did in *Water Crane,* and encouraged me to then go to acrylic. Most of the manufactured acrylic colors at that time put me off. They were either chalky or they were like tints when thinned." What the painter does remember being conscious of was "a greater need to be more assertive with the positive shape, but not to relinquish ambiguity." The conflict he experienced was between his all-over painting, such as *Phenomena Burnt Under* and *Phenomena When I Looked Away,* and the new image-ground relationship of *Phenomena High Octane* and *Phenomena After Image.* The first two phenomena are totally immersed:

> The image is enveloped, the color is fused, and the saturated, nuanced, luminous color reaches out beyond the boundaries of the format. I wanted to try to find openness through contrast. And although this was a strange world for me, the idea of a positive image and a negative space, I found that the white ground of the canvas could become interpenetrating and could actually take on different colors. The white in the upper part of a painting might become one color, whereas, because of the proportion and the shape or color that was against it in the lower left, it would become another color or have another intensity. Sometimes the white of the bottom would come forward. Sometimes the white at the top would come forward. They were not simply negative spaces, but instead became an interacting arena for excitement in which I could state myself positively.

Jenkins's traditional training as a painter and scrupulous attention to his craft caused him to be concerned that the merely sized canvas might in the future cause his ground to yellow and thus flaw the interaction with color that had been so precisely established. When he returned to Paris in 1959, he began to research acrylics with the help of a man named Adam, a *marchand du couleur.*

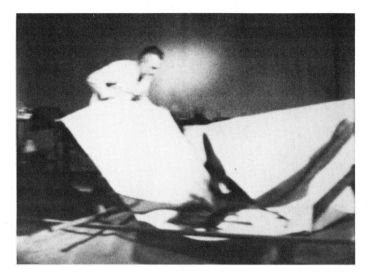

And I found a paint which was manufactured in Germany. It was highly viscous . . . like a very thick honey. From this I mixed my own colors with a Roplex AC33 medium, made by Rohm and Haas. I also made my own ground from titanium white mixed with the AC33, because at that time they had not manufactured, or I had not found, Liquitex gesso, with which I later primed my canvases. So through trial and error I was able to eventually build up a new ground and a whole new range of colors. For a while I used a traditional matte varnish containing pure beeswax. Then several years later, in 1963 in New York, I lucked out and tried acrylic Liquitex matte varnish. This varnish proved to have durability and showed less danger of yellowing than did the traditional wax varnish. I could now maintain one of the things that I was able to achieve in oil, which was great density. In these new colors I was able to go to a very, very deep and rich cadmium red, flaming orange, intense violet, or translucent blue.

One of the first totally acrylic paintings, and one which illustrates the search for density and substance in the veil, was *Phenomena Big Blue*, completed and shown in the winter of 1960–61 at Karl Flinker's gallery in Paris. It was Jenkins's first large-scale monochromatic painting. The choice of color may have been influenced by a visit to the Toulouse-Lautrec Museum in Albi, where the painter stopped on his trip from Spain to Paris in 1959. "I could not help but notice many of Lautrec's incomplete works. Lautrec employed blue, blue lines, blue masses as a beginning in many paintings. With some artists this was a very traditional way to begin. But it later struck me as being like a springboard to move into acrylics." In *Phenomena Big Blue* "there were some very subtle nuances of earth colors within the blue to give warmth, it was not just sheer unrelieved monochromatic blue. The blue had a vibrancy that held ambiguity. There was once more the recurrence of the persistent image of Moby Dick, of the White Whale." This reversal of color and form relationships is for Jenkins a means of contrasting his art with Impressionism, which he sees as "an illustration of an event in nature."
 Other paintings in the Flinker Gallery show have strong subjective references,

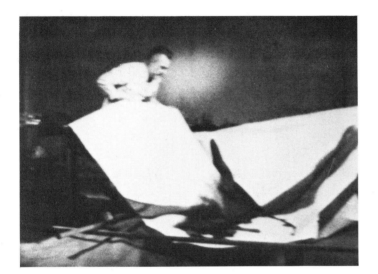

"definite images," for the painter. *"Phenomena Resuscitation* could be a kind of underwater Rosetta Stone, a washing tablet that came either on or through it. And it makes me think of *Hommage à Melville* of 1953. There's great stillness. It's like entering an underwater cave where all around are things that float and undulate. That's what I mean by the persistence of certain images. Although you never do the same thing twice, you also go back to certain archetypal images. *Phenomena Fly Sandman* has for me the implication of the persistent need for the human psyche to take on increased awareness and not be the sleepwalker. *Phenomena Big Blue* is an assertion that one has to face the enigma, knowing that one can't come up with answers."

The Self-Contained Image as an Experience, Not a Motif

Phenomena Over the Cusp was Jenkins's largest canvas prior to 1961, and it remains one of his most successful large-scale paintings. More modulated earth and marine colors fuse and produce subtle iridescent tones in place of the vibrant "emotional colors" relinquished by the artist not long before. Despite the generous range of textures, the image is unified because of the subtle repetition of substances and their natural gradation into one another. This phenomenon gives a clue to how the title was induced: "If you were born on the cusp it meant that astrologically you were born between, let's say, Cancer and Leo, around July 21st is when it starts to change from one to the other. I cite this astrological example as a way of saying that something is on the verge of changing, and is caught between two distinct signs or influences. 'Over the Cusp' can also mean entering a new domain or a different domain, and this was certainly happening to me at the time." One can find a similar sensation, though in a different painterly form, in Mark Tobey's *Edge of August* of 1953. Both men were interested in processes in nature, and their affinity is manifest in Tobey's account of his painting: "*Edge of August* is trying to express the thing that lies between two conditions of nature, summer and fall. It's trying to capture that transition and make it tangible. Make it sing. You might say that it's bringing the intangible into the tangible."

Contrary to Tobey's evolution, in 1961 Jenkins moved into the area of the more emblematic image, such as *Phenomena Tide Finder.* There was a decided limitation of color, but a greater emphasis upon the impact of the image and its interaction with the white area. "The intermittent recurrence after 1962 of the self-contained image has

resulted because, as in *Tide Finder,* the image has to be so strong and so forthright that it can stand on its own as an experienced event rather than an applied motif." Two paintings of 1961 which also meet this qualification in the artist's view are *Phenomena Near Euphrates* and *Phenomena Ring Rang Rung*: "These two could very well have been a diptych; I later had the opportunity to hang them together in my retrospective show in San Francisco. They both expressed the solid image with interpenetration from within, and penetration of the white ambiance. There is a very solid image within the format of *Phenomena Near Euphrates.* And within that image is another captured image like the form of twisted, melted salt, of the color of stalactites and stalagmites, joining to create a curious presence. However, in *Phenomena Saracen Fray,* there's a heraldic sign much the same as you might see in a shield, but organically found rather than arbitrarily made. These were the first paintings of this tendency that I exhibited in New York City. They had a special kind of impact. They were either ignored or acknowledged."

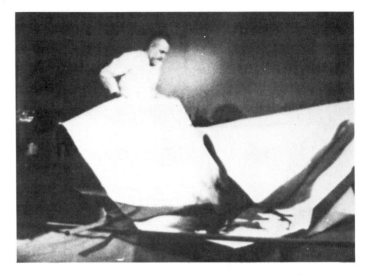

In such strong emblematic images as *Phenomena Blue Carries,* Jenkins feels that his work "might possibly have an affinity with Ellsworth Kelly, although mine is much more organic and informal. The interacting whites turn in, and the negative space pierces the positive." The process of strengthening the image meant that in certain ways Jenkins was simplifying his art, contracting or minimizing his painterly decisions: "The values from dark to light were infinitely more sustained and intentional."

Searching for a new unity in his art led to varied handling and control of the canvas and the employment of different tools. "I was using French housepainters' brushes, round ones, to mix my primary colors. Then I would pour a line from the brush and fuse and work with the ivory knife." He worked on either stretched or unstretched canvas. When working with the former, as in *Phenomena Near Euphrates,* "by tilting and flowing the fluid pigment I was able to avoid rivulets and coagulations. I wanted to achieve a single impact and eliminate all the cleavage, breakage, and fissures that were so perpetually recurrent in the oil paintings."

The Marvels of Occurrence, 1963–1964

Our first meetings had been in Paris in 1962, at the studio on Rue Decrès. In the winter of 1963–64, we met again in Jenkins's new studio at 831 Broadway in Manhattan,

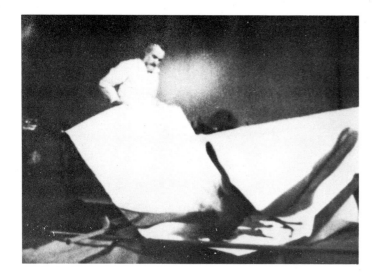

which had previously belonged to Willem de Kooning. It was here that many of his paintings of the early sixties could be viewed under ideal conditions. In the artist's own words, "because of its great space, 3,000 square feet, I was able to get off at a great distance or up very close and have a strong sense of the physicality of the painting. . . . I could turn them face out or lean them diagonally against the wall and walk past, seeing them out of the corner of my eye."

In the 1963–64 paintings Jenkins was reinvolving himself in the experience and painting "of emotional color and at the same time holding to the original commitment of doing images which have decisive impact against a white ambiance with an interacting relationship." *Phenomena High Mantle, Phenomena Yellow Strike, Phenomena Yonder Near,* and *Phenomena Astral Signal* resulted from the artist's efforts to obtain greater vibrancy and simplicity after the previous more monochromatic and emblematic series. But, as he put it, "Everything has something to relate to something in the past." It was *Lotus* of 1957 that was most indicative of this relation to the 1963–64 paintings.

Phenomena Reverse Spell was the first large canvas done at 831 Broadway and, in connection with the preparation of an article, I was able to witness its coming into being. Although it had not been titled when the article was finished, this is the painting on which Jenkins was working as I made notes on his technique. What follows is an edited version of that article, "Paul Jenkins: The Marvels of Occurrence,"[28] which contains judgments with which I still concur:

> For the understanding of many painters accounts of their working methods are irrelevant. . . . In the case of Paul Jenkins . . . it helps to distinguish him from artists who stain or drip and from others who pour and puddle. . . . Jenkins has finally been able to develop a consistently homogeneous acrylic medium. The priming coats may be laid on stretched—or in the case of large works unstretched—canvas placed on the floor. The primer is an acrylic medium mixed with gesso, applied with wide resilient brushes first moistened to prevent a feeling of stiffness as they are dipped into paint. The proper viscosity of the priming coats is judged by the feel of their mixture, for the painter is stimulated by the returns to his hand of the liquid medium's application to the canvas. The laying on of the first coats may properly begin the painting itself, for he may make dominant, or more saturated, certain white areas as opposed to others. The second coat is an acrylic, Liquitex, with titanium white. (In Paris he mixes

his own titanium white.) This is the most important color, for it becomes the ubiquitous setting for the phenomena. Whether or not he applies color to the canvas while it is still wet or dry depends, as he puts it, upon what "kicks" him that day.

Before the first pouring of color, Jenkins wraps clean white rags around his shoes, as he must often step onto part of the canvas. Similarly the wearing of white work pants is not an affectation but a necessary precaution against unwanted accidents, for he often kneels within the borders of the painting.

Jenkins' colors are industrially made in Germany and come in paste-like form which varies in thickness according to the color. They are non-drying substances by themselves, arrested pigment, until mixed with the binder, an acrylic matte medium. This binder liquifies and enhances the color and permits its slow matte drying. The final varnish, invented by a London chemist, allows light rays to penetrate from all angles, thus preventing shiny surfaces. The varnish is never brushed on but is sprayed, because this is more consistent with the total facture.

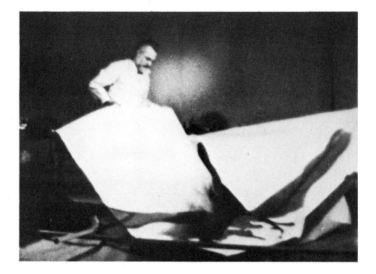

Although he uses long-handled round brushes to drag and push (but not stroke) the paint, his preferred tools are dull single-edged ivory knives. They permit the spreading of paint and shaping of forms but leave no discernible trace. He doesn't want the furry or bristly marks obtained with the brush as he feels they are inconsistent with the "occurrence effect" he seeks. So fine is their balance that the weight is hardly felt in the hand, and psychologically they become a sixth finger. Attached to long handles, they are used when the artist must work from a distance. The most precise close-up work is also done with these instruments.

Before the first color is poured, Jenkins will staple two opposite corners to a ladder, saw-horse, or log, with the angle or pitch of the slopes being carefully judged. The tilt is necessary for the flow of paint. Unlike the Futurists, he doesn't want the painting's movement to be the sum of perceivable touches and hence too mechanized or static. With a bowl of liquid color in hand he will make a preliminary pass or dry run over the canvas without releasing the paint but judging its weight and feeling how much he wants to pour. The color is then allowed to run down from one of the corners toward the center. He pours color because it is for him an ideal way to get the color down and establish immediately the natural quality of the occurrence that will be sustained throughout. "The way color is applied is important. I do it in a way to get a

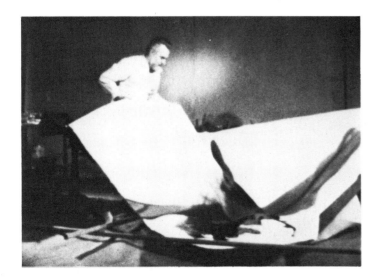

natural line that can be as precise as a black branch against a green sky. . . .
Once it is down all sense of blot, *tache*, stain is rendered into a meaning." The
pouring of color is thus not a neutral means but the occasion for a lyrical
response.

As the first color spreads, the artist may quickly move to adjust the angle of
the opposite corner. A large shape evolves that may or may not determine the
final compositional gesture. In the canvas's center a pool forms as additional
color is added. It will grow and change with each addition. Water may be poured
down one edge of the nascent configuration to mute or lighten its tone and
severity. The long-handled brushes are used to pull the paint from the central
reservoir up a slope or into folds he may have made with his hand by reaching
under the canvas. Erasures are quickly made with water and clean cloths. An
ivory knife is used to spread the color outward from the center or to draw it into
extended filaments. It may create or true a contour, but always preserves a
"natural irregularity." Whether knife or brush is used, care is taken not to allow
paint to drip on to the white area when the tool is withdrawn from the canvas.
Of necessity the painter has evolved practiced and sure gestures with which he
moves in to attack an area or break off contact with a shape. Only when he
advances toward or retreats from the canvas, but not while painting, are his
gestures stylized. Unconsciously he has developed certain habits of drawing, and
often a looping or checked shape will be disengaged from the larger mass.

From the beginning of painting the artist will circle the canvas, frame its view
with his arms, mount a ladder to look down in what he considers an optical
struggle to find views devoid of light reflections from still liquid surfaces. Usually
in the early stages he finds the one side which will establish bottom and top or
the structural source of gravity. Subsequent additions of color and shaping
depend upon this viewpoint. Although the painting remains on the floor until the
end, he has no trouble visualizing how it will look when placed upright.

The scale of the emerging image is actual and not virtual. It is not reduced or
enlarged as in illusionistic art. The phenomenon is not something seen from a
mile or foot away, as in Renaissance perspective.

As more colors and water are added, the working puddle on the canvas
becomes darker in color. It is always the sum of all colors used, and when drawn
away from itself over the white or previously colored areas it is simultaneously
a new color, but also is of the family of its predecessors. The changing character

of this color reserve is but one of the factors that the artist must keep in mind during the hours the painting develops. He must also keep in mind the speed at which each area is drying and what can still be done before it dries. Rags may be allowed to soak up excess paint in the central puddle, and these are carefully lifted into cans held out on the canvas so that the color can be used again on the outer edges of the image. With a long stick he may reach under the canvas to prod the puddle into a new location. Some areas, often few in number, may receive only the initial color application, while others will be repeatedly reworked. He must ask himself: "Does the color in the image have a specific meaning unto itself or could it be another color just as well?" If a green could just as easily be a blue or dark purple, he becomes uneasy. For Jenkins, colors are not actors on a stage but emotional commitments. "When I use a green, I must be in that green."

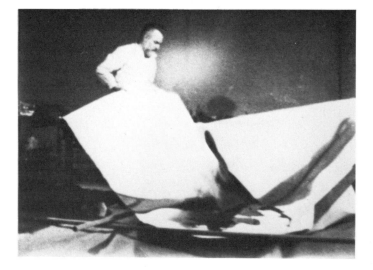

Counter-motion is invariably established to provide visual dramatic contrast, and for this reason the color is swept across the surface in such a way as to prevent concerted direction. In its purest sense the phenomenon is encountered during the act of painting. What we see is its trace in the track of paint sediment that has settled during the course of its movement. The slow drying action of the paint allows precise determination of effects. Thus he can ensure the continued luminosity of the white underpainting by diluting or wiping the moist layers with a large saturated sable brush when they become too dark, dense, or indistinct as color. Because of the slow drying and the flexibility of his medium the emergence of unintentional recognizable natural shapes can be corrected ("I didn't like the look of that owlish eye-like shape") or certain textures, such as those that are too silky, can be eradicated.

At certain critical moments the artist will work on his knees, elbow locked to his side, intensely focusing upon the point of his knife or finger as the smallest segment of an edge is corrected. The next moments may see him trailing a line or wave of color the width of the canvas. The corrections he makes are intended to prevent the "killing of an area." Once, explaining a change he was making in a shape, Jenkins commented: "I am trying to arrive between that dumb shape and that lyric shape." Drastic changes may come when the work was thought finished. The demands placed upon the painting as it evolves are "that it breathe, have its own light, and that its form takes the viewer, causing an intake of breath, or makes the viewer feel he is sharing a personal secret or encountering

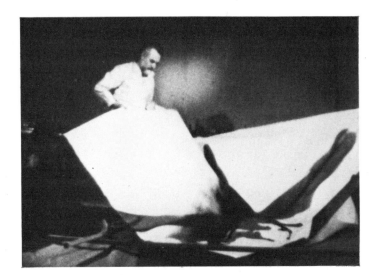

a surprise or discovery. There must be the unexpected, which when once seen, however, seems most rational and natural unto itself, and not out of keeping with its own madness."

The foregoing was written in 1964. Five years later the painter was again asked to discuss how he evaluated his own work, and in many respects his responses were the same. "It's imperative that the color be totally alive and not dead . . . the life of the color is essential." As for the image, one of the questions he asks himself is this: "Is it just hanging up there like a sheep-lined coat? Or is it a taut, drum-like thing, that if you bump on it you get a resonance? . . . The image is of utmost importance to me. . . . I do not look upon the format as something I can have a field day on and an indiscriminate kind of explosion of my emotions." Mindful that skeptics may think he no longer works from inspiration, Jenkins said in 1969: "I think that during the past six years, more than ever before, my paintings have taken on a strong consistent emphasis that I have achieved from painting to painting, possibly because I know that world whereof I speak. My responsibilities grow clearer. I don't mean that I come to know my metier better. I mean that I feel the conceptual responsibility is becoming more inherent in me."

Jenkins's way of painting inevitably raises the question of what happens when a work goes wrong for him and he sees unsatisfactory passages:

When a painting gets away from me I eliminate through addition. Using *Phenomena Graced by Three* as an example, you can see that granulated veil of white not only as an addition, but also as an elimination of what lies underneath. I can work on top of the white again where the color does not function or contribute to the whole, but this requires a knowing and not just a painting over of what doesn't work. What is most important is that what lies underneath must bring to the painting unseen enhancement of warmth, mystery, and meaning. You are not merely painting something out which doesn't work; you are bringing something more to that which is not resolved. If you ask me if I destroy paintings —yes. But not until I am satisfied that the patient is completely dead. Sometimes what I may really have on my hands is a monster waiting to be turned into light and not into mud.

The Marvels of Recurrence, 1964–1969

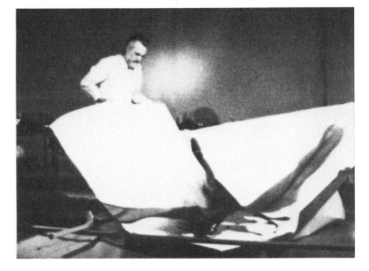

Jenkins's art is so conceived as to avoid conscious repetition of themes and formal configurations. His creative spontaneity and "informal" construction have nevertheless yielded certain readily identifiable compositional formats and gestures, which become manifest when one can see a generous sampling of his painting of the sixties. His shapes always taper and steadfastly resist association with geometry. This swell and contraction is vital to the enactment of phenomena. There are shapes having different velocities, such as the more blunted, vertically and diagonally oriented configurations that date back to *Hommage à Melville* and were prevalent in the early sixties. Their nearest associations are with whales and icebergs or dissolving stone tablets. Akin to these shapes are those which taper into more roundness or pointedness, eliciting memories in the case of the former of furling flags and billowing veils and in the latter of knives and feathers. To counter any suggestion of a static image Jenkins often resorts to a strong diagonal thrust across the canvas or a curving, pliable column or upright mantle shape, both of which seem to emanate from outside the painting's edge. Mandalas recur occasionally in the form of pointed ovals, like leaves, or, more rarely, as circular gestures. The compositional form that combines the diagonal impetus of the feathered shapes and centrality of focus of the ovals is the intersecting, criss-crossed, or winged phenomenon, the most graphic symbol of flight. "The wing span motif which appears constantly in my work is to me what the square is to Albers, but the justification is different. . . . I do not relinquish the graven image." This forked or splayed configuration may generate a drifting X, Y, or V shape. Sometimes the bifurcated motif may run laterally, as in *Phenomena Day of Zagorsk,* or be joined with the mandala as in *Phenomena Sign of Zagorsk.*

The granular veils which recur after 1960, after *Phenomena Falling Mountain* and notably after *Phenomena Reverse Spell,* were evolved not only to give a new sense of substance, but also to introduce another kind of light, a reflecting or incandescent light. Jenkins sees these drifting, sandy areas as the equivalent of his dense textural effects in such paintings of the fifties as *Darkling Plane.* These textures operate most successfully when they fuse with the veils around them or assume some of the color of what lies beneath. They give Jenkins's painting qualities similar to Whistler's paintings of fireworks over the Thames, which he has admired in the Tate.

The recurrence of strong emotional color such as the reds resulted from his

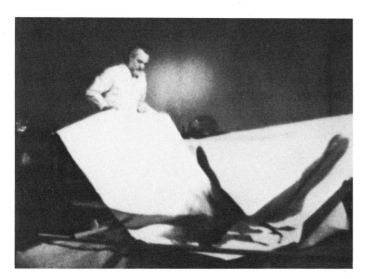

seeing the brilliant dyes worn by people in India in 1964, and the exhibition of the Rublev icons in Russia in 1967. He feels that his experience in India overcame his "fear" of bright color: "I felt the color I was able to experience in India was man-made color and not the constant variables of nature's color which Monet enjoyed investigating, in his haystacks, times of day and times of season. I am more interested in non-alternate color which I feel only man can achieve. I thought that at last I could see a validity in this irrational contribution and the impulse to distinguish Man himself from nature, but at the same time acknowledge nature's envelopment." As for his Russian experience a few years later, "it was like rediscovering red. It's a color I've always loved. But I never beat a color to death unless it has a vibrant or challenging meaning for me. *Phenomena Phenomena* was influenced by the icons because it has something rather centralized. . . . I was very impressed by the impact of the icons."

The period roughly from 1964 until 1969 might be called the greening and blueing of Jenkins's art, with reds and yellows most effectively used in admixtures or as psychic temperature changes. As with the alchemists, Jenkins has shown a relentless loyalty not only to liquidity, but also to fire. "Fire has always been one of the sources of my color. I always enjoyed watching highly combustible gas, and when the flame became very small it would become blue-green. Blue took on for me, in *Uranus Burns,* a flamelike aspect."

Between Heaven and Hell: The Coming of the Grays

Beginning with *Phenomena Eminence Gray* of 1967 and *Phenomena Nacreous Veil* of 1969, gray began to move into the paintings until with *Phenomena Grisaille* it shared the canvas only with white. There was a slow exiting of first emotional, then delicate colors, leading to what the artist feels has been a long transitional period and a series much the same as *Eyes of the Dove*. "And it's simply the treatment of using the Liquitex gesso as a color within itself against the gray ground or the soft white ground of the primed surface of the duck which I work on. After I finish, I still varnish them with Liquitex matte varnish." The coming of the grays was prompted by the artist's feeling that "I wanted to find another temperature. Maybe I wanted to find that temperature between heaven and hell. In *Phenomena Over the Cusp* I think it came in, and

intermittently I can find it in certain blues." The new mysteries sought through gray cause the artist to refer to Goya: "You know that painting in the Louvre by Goya of a woman standing straight on? There's silver gray in that painting that I always used to go and look at. And it had dignity, it had violence, it had arrogance, it had many things for me. And I think that maybe what I am trying to do is approach that Goya gray or that Goya silver. They have some kind of indeterminate clause whereby you're unable to decide why it is what it is, or why it's even there."

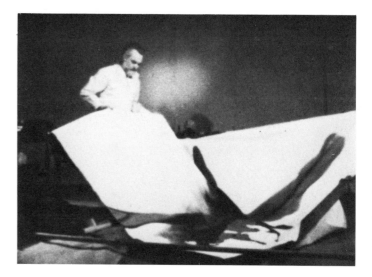

With the grays and whites, Jenkins feels that he has been able to get in touch with a new sense of "structure, or substantial substance." "Every square inch of the canvas, no matter how delicately it may be treated, or how turgidly, must have substance for me." Along with variations of substance, Jenkins believes the gray paintings have provided him with

an arena of very curious space, enormous openness. . . . I don't mean arena in the sense of a situation. I mean in terms of the challenging scale of a painting no matter how small or how big. An arena is all four sides. It's very simple, but it's the only place where you can go and try to come back out of. . . . It's a place of life and death. It's a confined area where no matter how much it may go beyond its format it can only go beyond it so far: you're still dealing with something very finite wherein you express something . . . of the infinite . . . through psychic illusion. . . . You escape into a significance, into a meaning, into a decisiveness that in ordinary life is constantly performed by hazard. And so although my methodology might seem to be hazardous, what I try to bring to it is an enormous sense of order and meaning.

Though perhaps not Jenkins's most beautiful painting, *Phenomena Grisaille* lays claim to being the most powerful and masterly. The previous multicolored paintings are presupposed in his handling of the grays and whites with respect to nuance, values, and their outflung dispersal. The painter's authority in interrelating the layers of white and gray has never been stronger, and while preserving the implication of an event intersected by the field of the canvas, this is one of his most poetic and satisfyingly composed images. At no point does texture become gratuitous; rather, it grows out of the shapes and adds a certain ruggedness to the span of lyrical substances. Here is the consummation of a lifetime's drawing in color that gives his images the richness and credibility of nature for which he has provided his unique alternative.

POSTSCRIPT AND PRELUDE

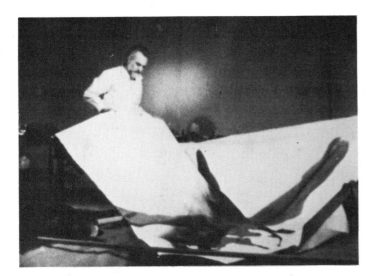

In the early 1970s Jenkins remains in a long transitional phase. The grays brought a necessary sobriety after the preceding tendency to effulgency, and slowly, as he works color back into his painting, he appears to be mining an earlier vein. *Phenomena Big Sur Lode* and *Phenomena Jonas View* have the tonalities of ore and earthy rather than ethereal color, such as he introduced in *Phenomena Over the Cusp.* When in *Phenomena Earth Above, Sky Below* the phenomena occupy the total field, there is a warm gravity, a new sonority to the blues, and the white granular veil perfectly keys the space and light. Despite occasional explosive images such as *Phenomena Katherine Wheel,* too obviously additive in its red against the blue, one senses a new quiescence, a deceleration of the phenomena as if they are now seen in slow motion. The impression grows that the artist is himself changing, and there results in his art a deeper voice, a new seriousness and focusing of forces into more frugal and potent expressions. It has been a long struggle to come to want and to be able to embrace the simplicity he admires in artists such as Hokusai, Rothko, and Newman. By the persistent mirroring of his nature, which accounts for the changing but unmistakable identity of his art, Jenkins reminds us of the phrase from Heraclitus he copied in his diaries twenty years ago: "You can never step into the same river twice."

Phenomenon Author's Inning

As a painter Paul Jenkins has taken risks all his life. His alchemic materials, his means of painting so reliant on timing, and his dependence on inspiration are such that he is uninsurable for turning out perfect paintings every time. But Jenkins is an experienced gambler who knows how to minimize his losses and has such a hefty bankroll of talent and conviction about what he is doing that he is durable and always in the game. He does not actually make big paintings today that rely just on "one throw." They may take days or be interrupted for weeks, months, or years. But some do get away from him in more ways than one. There are reproductions in this book, selected by the artist, that as a friend trying to stress only his successes I would have left out. But as a historian I welcome both his selection and the fullest possible exposure to Jenkins's work that is strong and that does not quite come off. For personal and professional reasons Jenkins now regrets having destroyed or painted over many of his works from the early fifties.

There is much the artist, critic, and historian can learn from important "failures," as Richard Diebenkorn and Jenkins himself have reminded me. I regret the loss of Jenkins's student works, through which we could see more of his development of motifs and painterly ideas. No modern artist has ever batted a thousand, and in the long run his career must reflect both hits and errors. We should see artists as they are, not screened by others, no matter how well-intentioned.

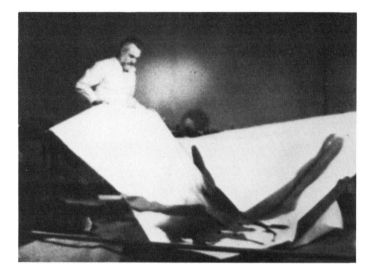

Jenkins's work is less impressive to me when one or more of the following things occur: when he has not worked over his color and allows a single hue to occupy a large area without modulation, tempering, or a mixture of some sort (*Phenomena Red Wing*, a rare example, has an Ellsworth Kelly-like shape and a cold, flat, cardinal red that are alien presences); when he is spendthrift and there are a lot of brilliant colors and compositional activities, as in *Phenomena Devil's Footstep*, which do not add up to a cohesive or memorable image (like razzle-dazzle in football, ending either at the line of scrimmage or in a loss); when one feels that one is not looking at the most interesting segment of a particular phenomenon, as in *Phenomena Night Stage* (one's impulse is to move the frame either higher or lower, to the right or left); when one feels the "presence," in the artist's terms, is weak, has just left, or never materialized, as in *Phenomena Light Column*; when Jenkins cannot sustain the spell, and a texture either obtrudes and is too insistent, as in *Phenomena Day of Zagorsk*, or there seems to be a relaxing of his authority to consummate his ideas, as in *Phenomena Eminence Gray*; or when one just cannot believe in the phenomenon because it is too turgid and has too many, in his term, "dumb" shapes, as in *Phenomena Ramashandra Ramashandra*.

As a professional gambler Jenkins never loses completely, and the viewer always comes away with something (perhaps including disagreement with the author). Every painting has some beautiful drawing or luminous passages in it even when the whole may not seem to jell. But when Jenkins connects, he makes some of the most beautiful paintings ever seen anywhere. *Phenomena Grisaille* has the mystery and power to make converts. Sometimes he scores when he withholds much of his fire and talent, as in more monochromatic pieces like *Phenomena Diagonal Points Right* or *Phenomena Play of Trance*. When he can balance his opposites, including the artistically tough with the tender, he can be dramatically stunning, as in *Phenomena Sound of Grass*. I am prejudiced toward those infrequent images that are either entirely within the field, such as *Phenomena Tide Finder*, which I have lived with for eight years, or come close to being entirely inside the frame, as *Phenomena High Mantle*. Then Jenkins is forced to come up with an image that has the punch if not the form of an emblem, and that holds

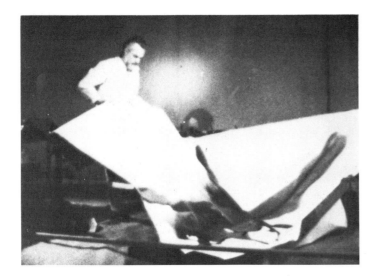

in the eye as well as on the canvas. *Phenomena Ever Near, Phenomena Earth Above, Sky Below*, and *Phenomena Astral Signal* are examples of the artist putting his considerable all together: inspiration and critical judgment, meaning and method, color and drawing, the sweet and bitter, lyricism and grit.

Phenomena Himalaya has all of the foregoing requisites and a haunting quality that endorses its bid to be the artist's finest as well as most ambitious work. By comparison, the smaller paintings are at times like waist-high projection screens and we are conscious of being this side of the phenomenon. Properly hung so that it is almost at floor level, thereby engaging the viewer from head to toe, *Phenomena Himalaya* induces the sensation of levitation, of ascension or hovering above overlapping deltas. Even in what seem to be the remotest recesses of the image, there are granular substances that seem to say "the picture surface begins here." Like a diamond, the painting seems at one moment all depth, and the next all surface. His most absorbing work, this big painting engages the whole body as well as the mind. The cruciform juncture of blue and white veils and their varying velocities are rare in Jenkins's art and serve to steady the composition within the rectangular field. Despite its complexity, the work has a compelling wholeness and dramatically reflects the pressure of the artist's sustained and intense concentration.

Jenkins's images are impressive and compelling because of their source in modern awareness of motion, pluralistic perspectives, and luminosities. He shares with Tobey, Rothko, and Newman the conviction that modern painting can fulfill the individual's spiritual needs, which had previously been served by artists working for the Church. An early and constant commitment to this view has separated him from adherents to the formalist developments, theories, and "issues" of the last twenty years. Like a long-distance runner, he sets his own goals and his own pace, while taking time to enjoy the life he is passing through. This awareness feeds his stamina.

The Artist as a Long-Distance Runner

Modern art has been characterized as fidelity to the medium in terms of experiences the artist would engender and formal adherence to the physical characteristics of surface and field. The emphasis, we are told, should be upon achieving "purity" and

82

"concreteness," the giving up of illusion and presumably allusion. This formalist view, it is argued, meets our needs for the "literal and positive" by rejecting the third dimension. While Paul Jenkins's paintings have on various occasions received praise from formalist critics, they cannot be said to meet our needs for the literal and positive. Far from it. They meet our needs not for more surfaces but for space that is immeasurable but felt; movement rather than static emblems; the irrational rather than the verifiable; the spiritual as opposed to the prosaic. Jenkins's painting belongs to a more important and pervasive characteristic of modern art than its formalist definition, which is too often honored in the breach. The modernity of Jenkins's imagery resides in his *fidelity to the self,* not to deterministic critical theories. This and not surfaceness is what separates his painting of the miraculous from that of the fifteenth-century Flemings. Where Van Eyck's imagery was grounded in theological and literary symbolism, that of Jenkins is personal and unparaphrasable. As Flemish symbolism was the link between heaven and earth, Jenkins's phenomena link the known and unknown, the material and spiritual. His canvases are revelations emanating from a kind of pantheistic elation not unlike that which inspired the Flemings at the end of the Middle Ages. Flemish symbols were plausible and effective because of their origins in the world of objects and in the natural phenomenon of light.

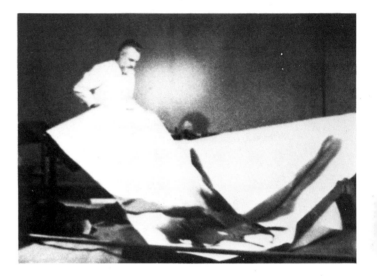

NOTES

1. "Lascaux and Jenkins," *14 Poems*. Lanham, Md.: Goosetree Press, 1964, n.p.
2. Trans. R.F.C. Hull, Bollingen Series XX, vol. 12 of *The Collected Works,* ed. Herbert Read *et al*. New York: Pantheon Books, 1953.
3. Paul Jenkins, "An Abstract Phenomenist," *The Painter and Sculptor*. Winter–Spring 1958–59, p. 5.
4. *Ibid.,* "A Cahier Leaf," *It Is*, no. 2, Autumn 1958, p. 13.
5. *Mark Tobey*. New York: The Museum of Modern Art, 1962, p. 33.
6. New York: Harcourt, Brace & World, 1949, p. 59.
7. Eugen Herrigel, *Zen in the Art of Archery,* trans. R.F.C. Hull, New York: Pantheon Books, 1953.
8. New York: George Wittenborn, p. 7.
9. Herrigel, *op. cit.,* pp. 10–11.
10. *Ibid.,* p. 52.
11. *Ibid.,* p. 59.
12. *Ibid.,* p. 60.
13. *Ibid.,* p. 63.
14. *Ibid.,* p. 66.
15. This advice on art materials books was given to Jenkins by the painter Daniel Maloney in 1951.
16. Jung, *op. cit.,* Bollingen Series XX, pp. 481–82.
17. *Ibid.,* p. 13.
18. *Ibid.,* p. 14.
19. *Ibid.,* p. 73.
20. *Ibid.,* p. 105.
21. *Ibid.,* p. 175.
22. *Ibid.,* pp. 223–24.
23. *Ibid.,* p. 225.
24. *Ibid.,* p. 234.
25. *Ibid.,* p. 248.
26. *Ibid.,* p. 266.
27. Catalogue for the one-man show at the Galerie Stadler, Paris, June 1959.
28. *Art International,* vol. 8, no. 2, March 1964, pp. 66–70.

PLATES

4. Photograph of the artist by Wallace Litwin. 1970

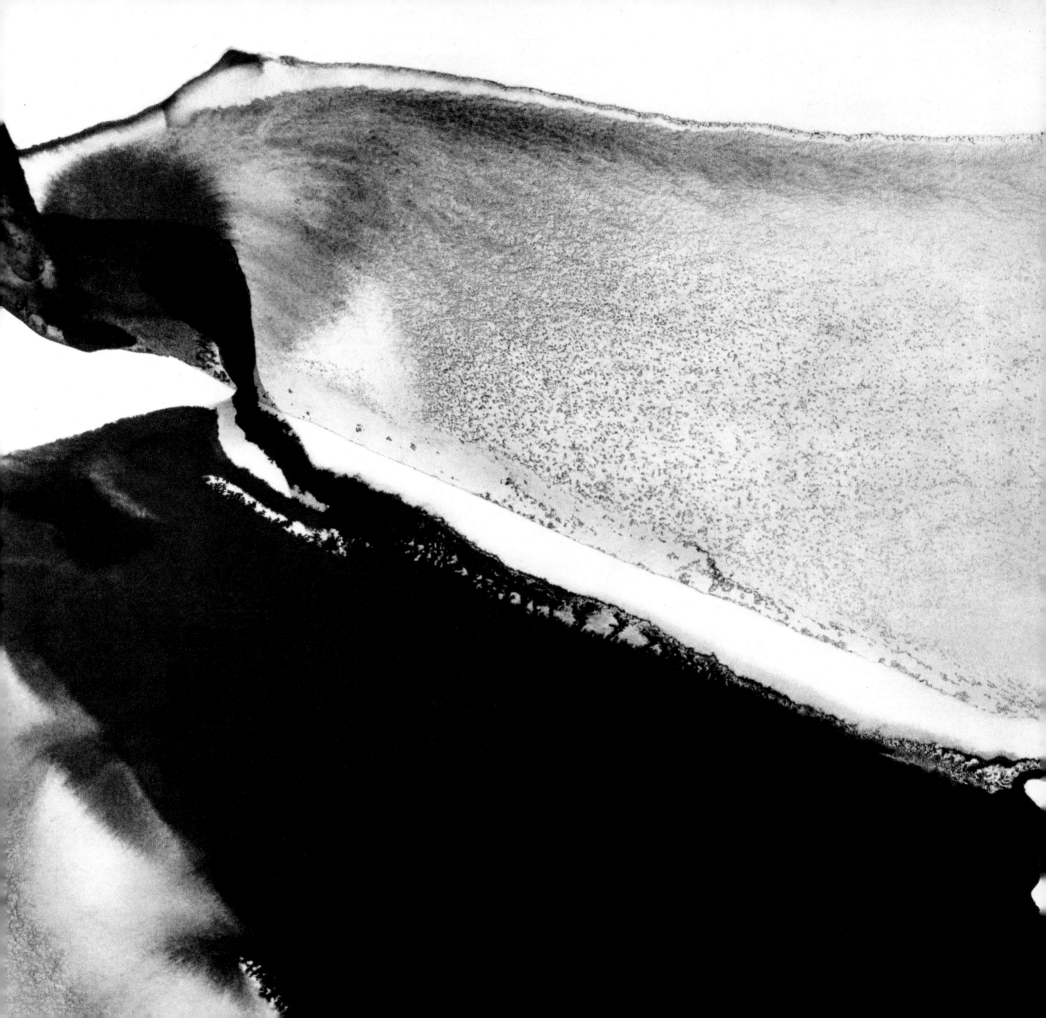

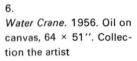5.
Drawing from *Paris Suite*.
1970. Ink, actual size.
Private collection

6.
Water Crane. 1956. Oil on
canvas, 64 × 51″. Collec-
tion the artist

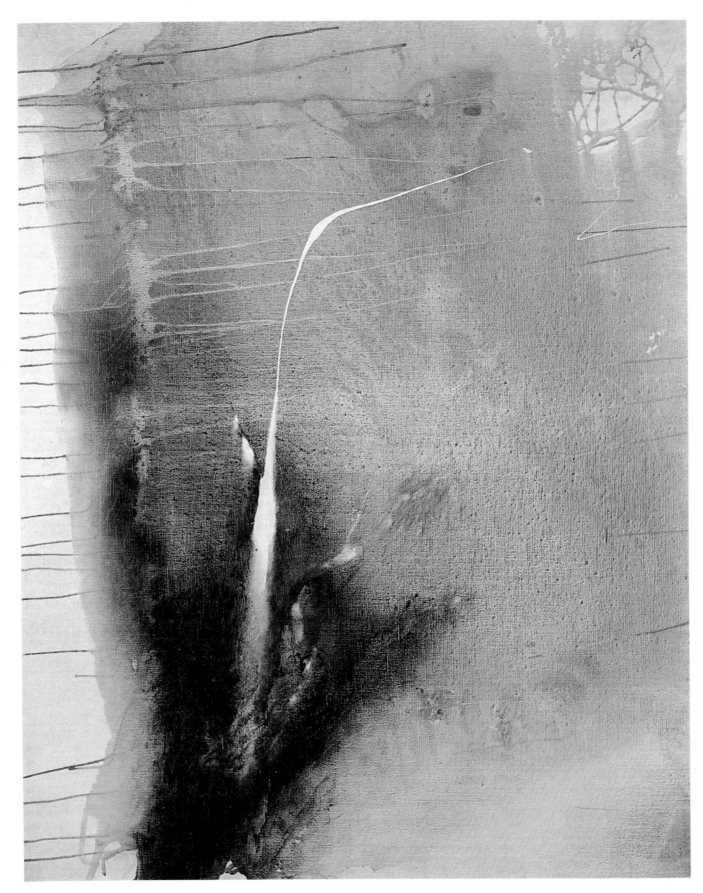

7. *Sea Escape.* 1951. Watercolor and ink, 10 × 14''. Collection Esther E. Jenkins, New York City

8. Photograph of the artist by Wallace Litwin. 1969▶

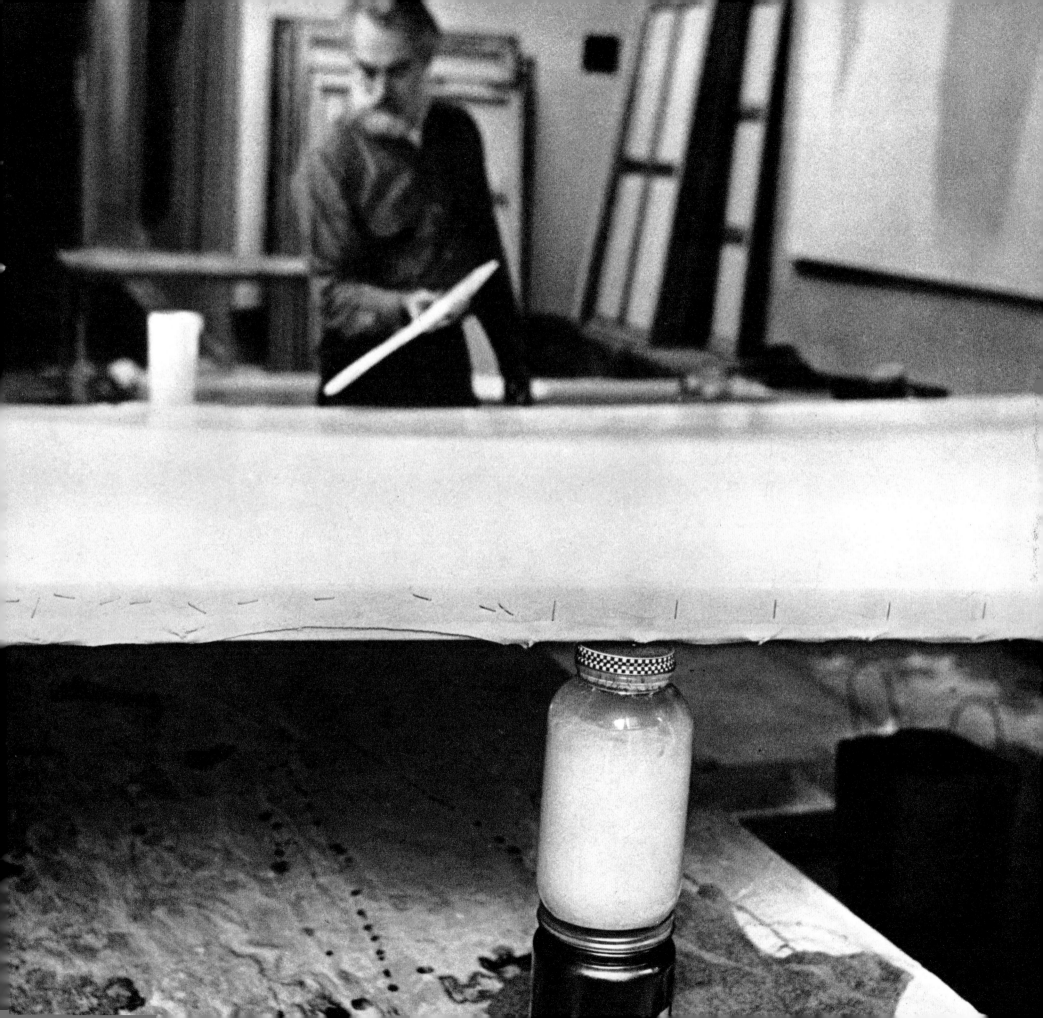

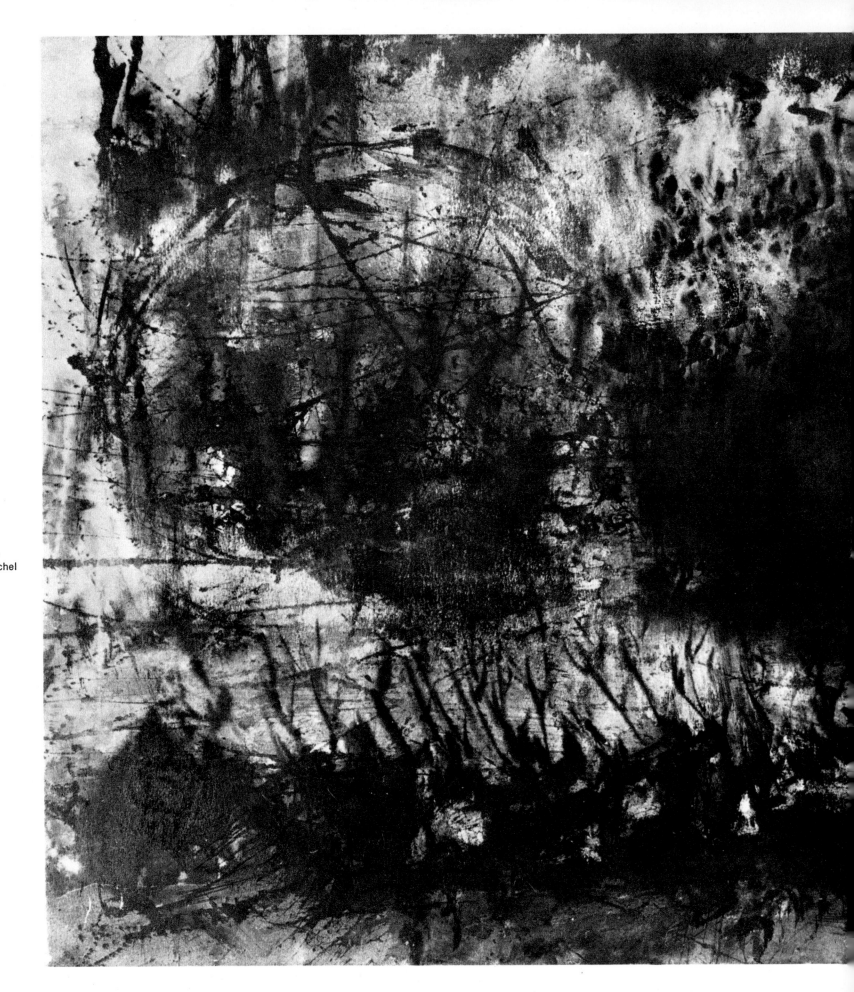

9.
Underpass. 1953. Water
media, gouache, and ink,
36 × 57''. Collection Michel
Tapié, Turin

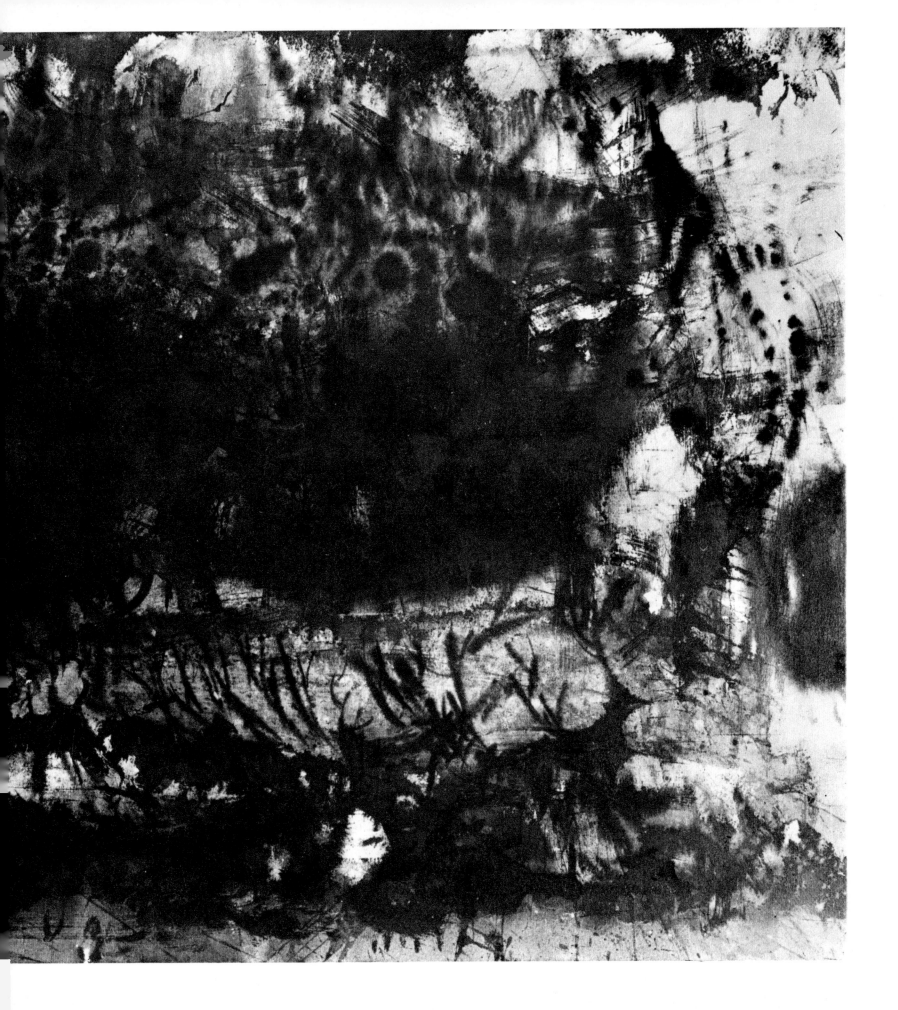

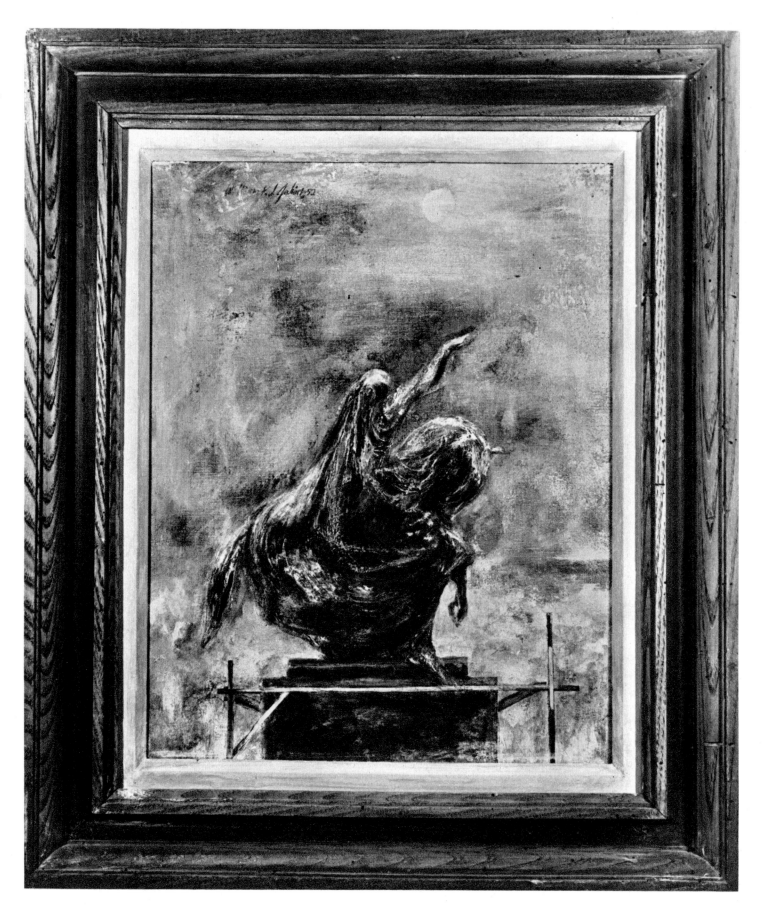

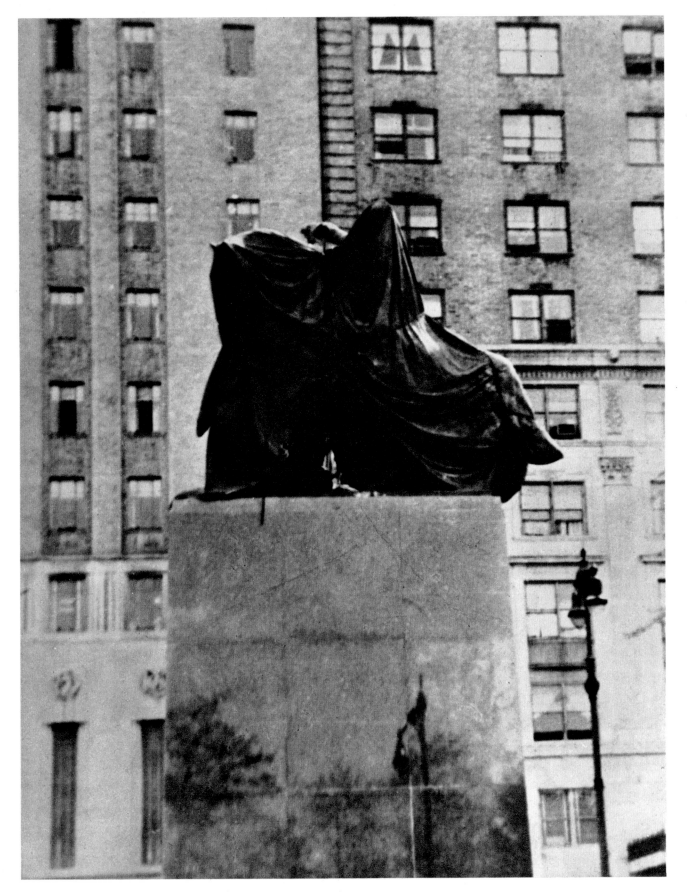

11.
Photograph of veiled
equestrian statue by un-
known street photographer.
1951

12.
The Estuary. 1956. Oil
and Chrysochrome on canvas,
32 × 51''. Collection Mr.
and Mrs. Guy Tooth, London

13.
La Fenêtre. 1953. Water
media, gouache, and ink,
53 × 20''. Private collec-
tion

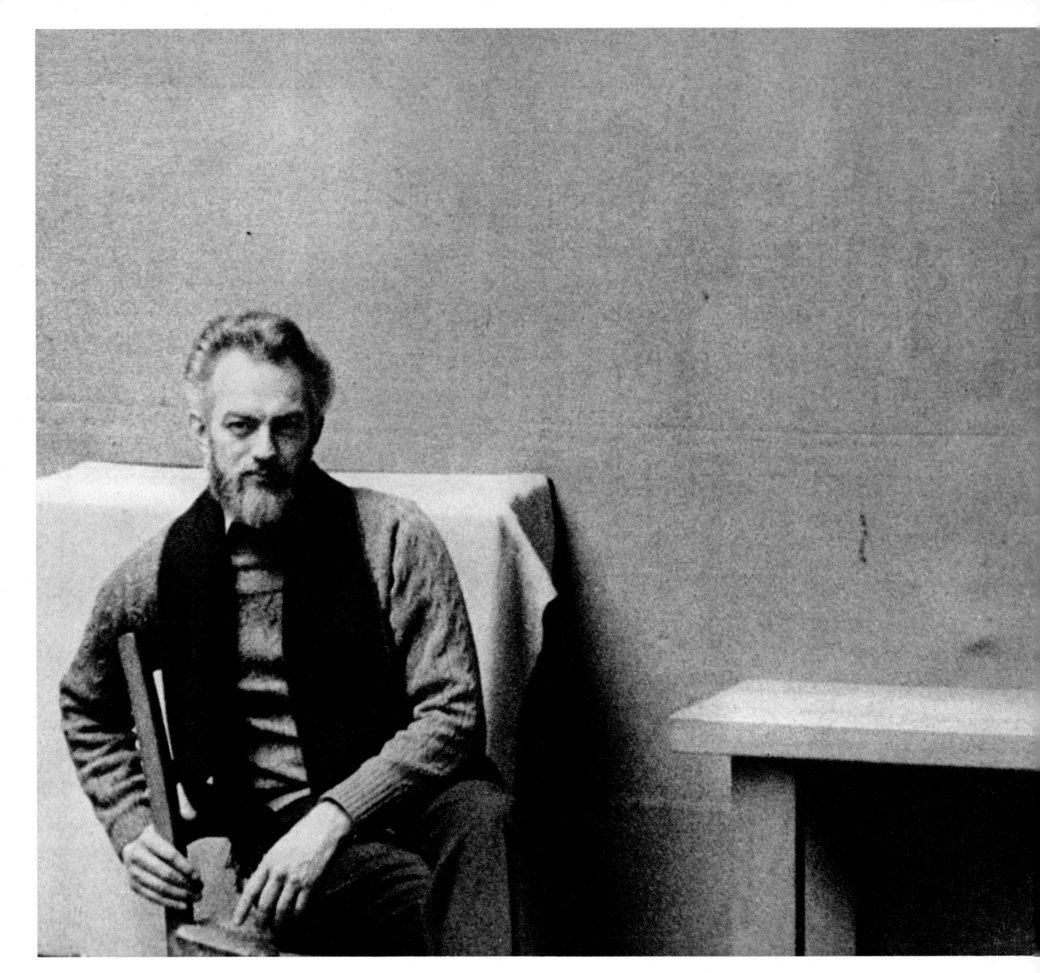

14. Photograph of the artist by Walter Silver. 1959

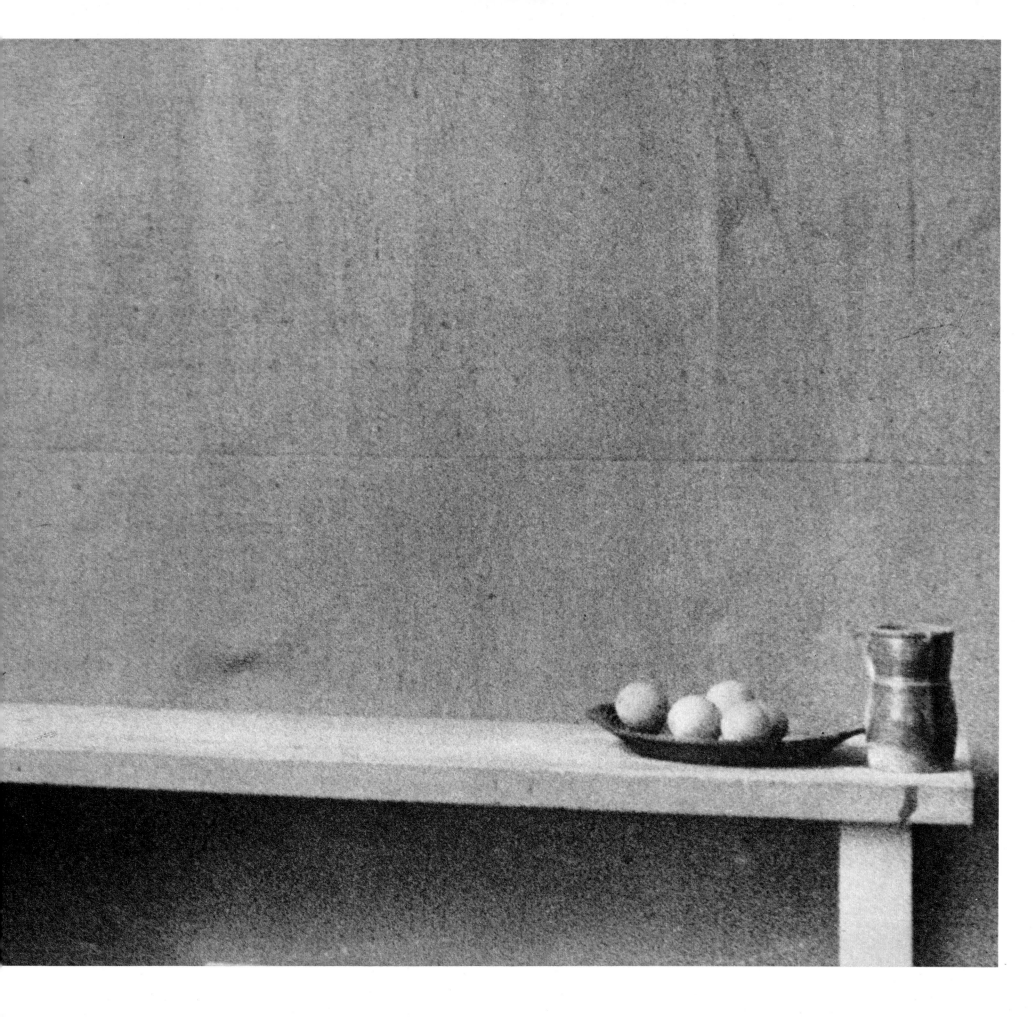

15.
Hommage à Melville. 1953.
Tempera on paper mounted
on canvas, 46 7/8 × 24 3/8''.
Private collection

16.
Phenomena Falling Mountain.
1960. Oil and acrylic on
canvas, 38 1/8 × 57 1/2''.
Collection Marion Schuster,
Lausanne

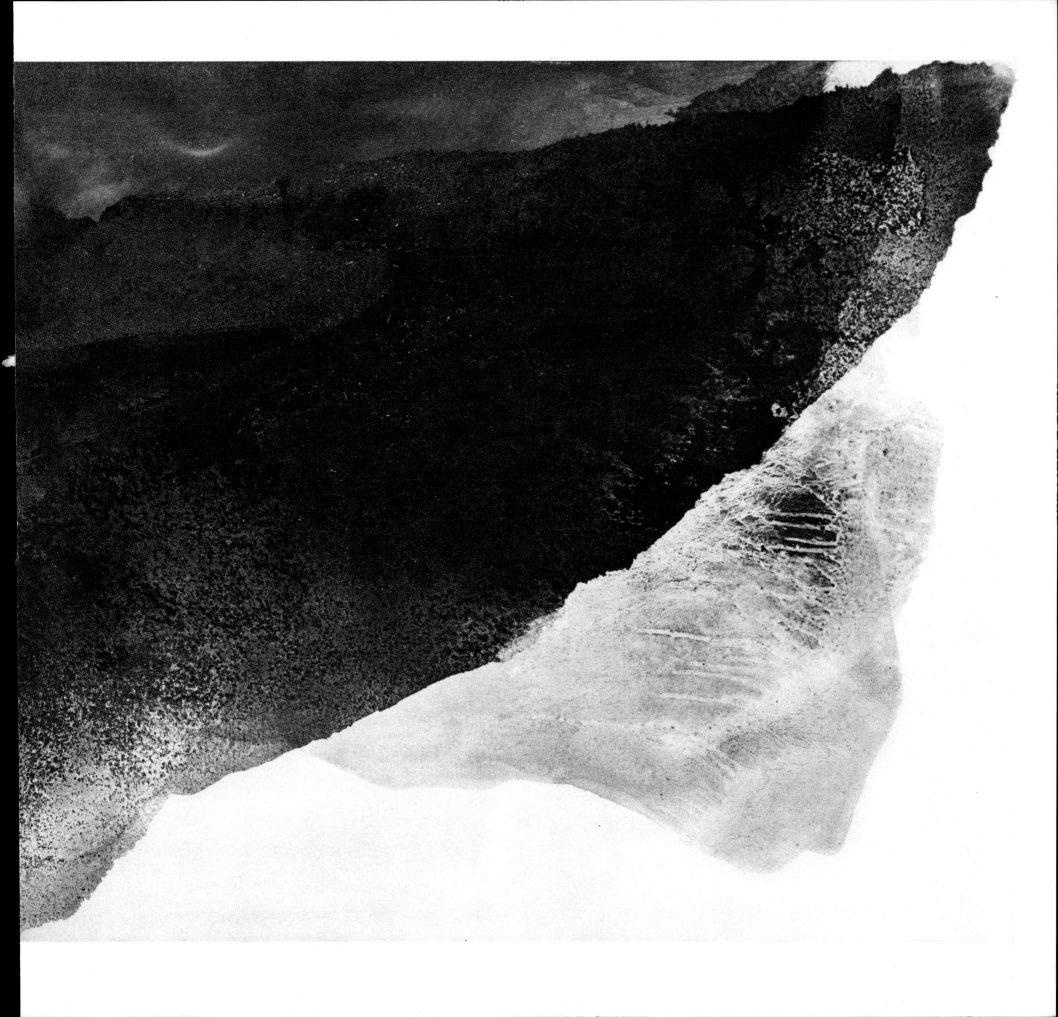

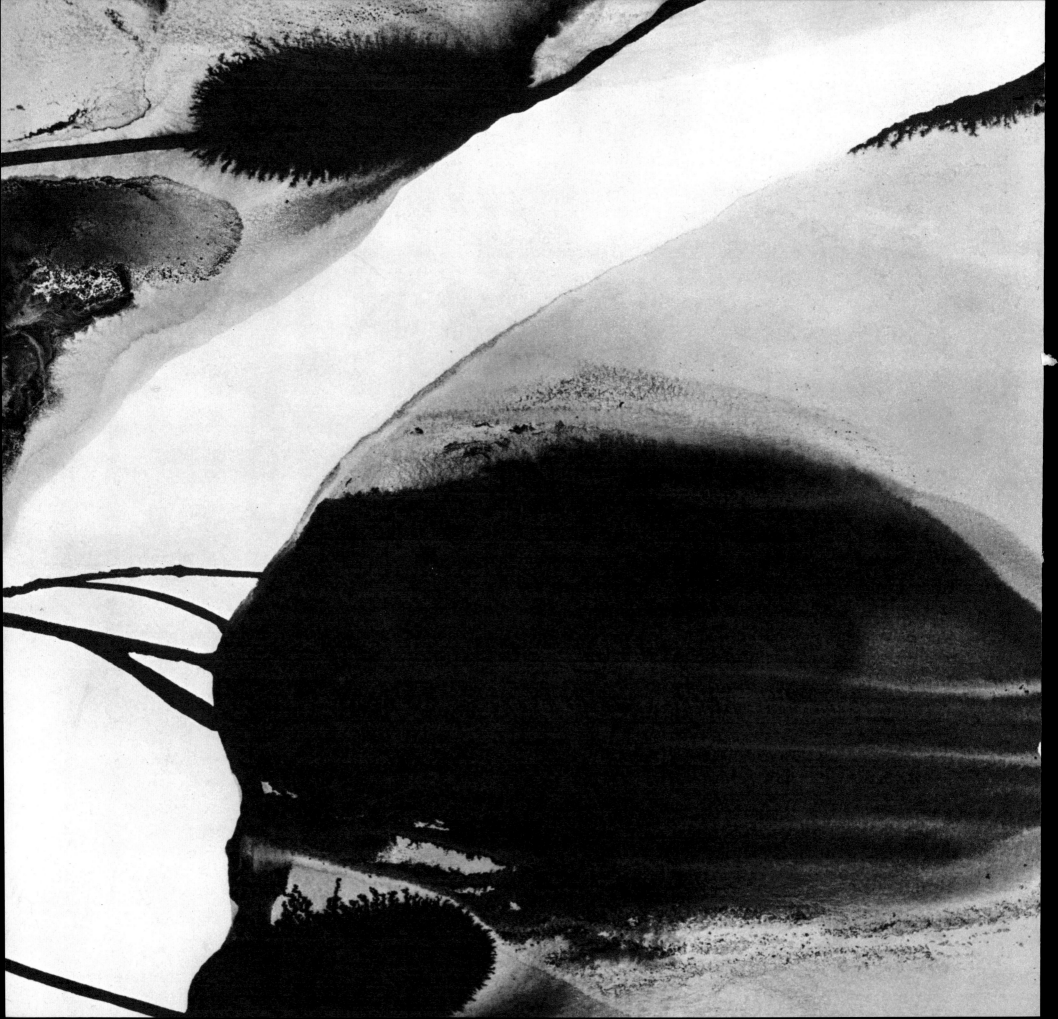

◀17. Drawing from *Paris Suite.* 1970. Ink, actual size. Private collection, New York City

18. *Le Poisson Blanc.* 1954. Oil on canvas, 26 × 39″. Collection the artist

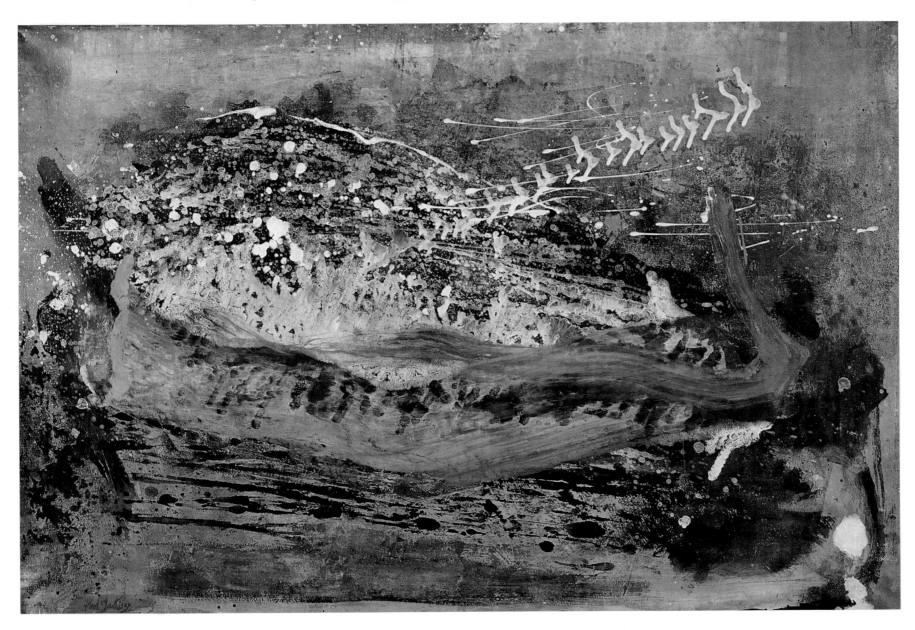

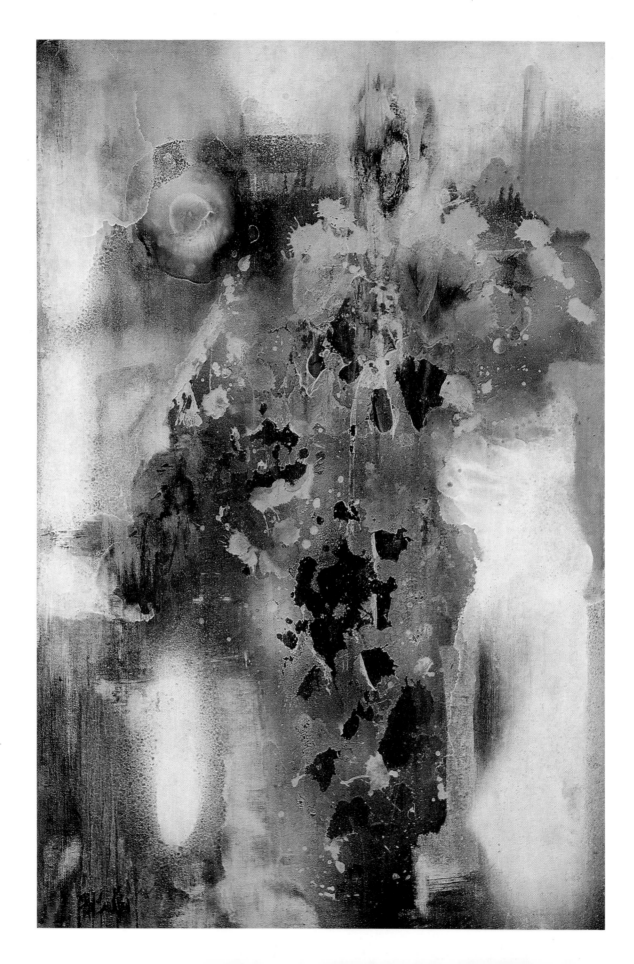

19.
The Alchemist. 1955. Oil on canvas, 74 × 38''. Martha Jackson Gallery, New York City

20.
The Astrologer. 1954.
Oil on canvas, 58 × 38″.
Collection Frua di Angeli,
Paris

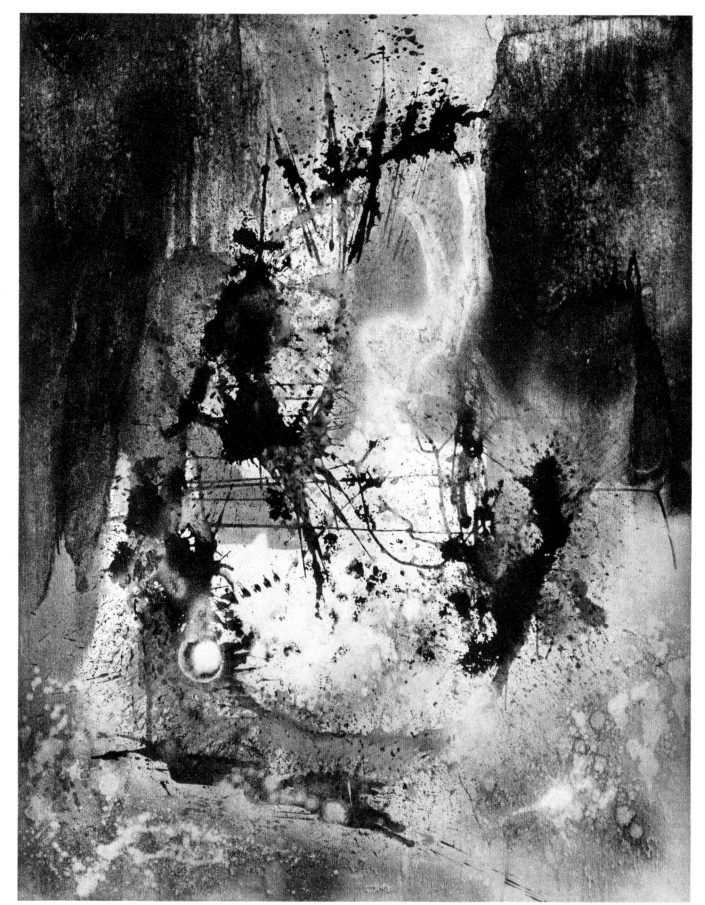

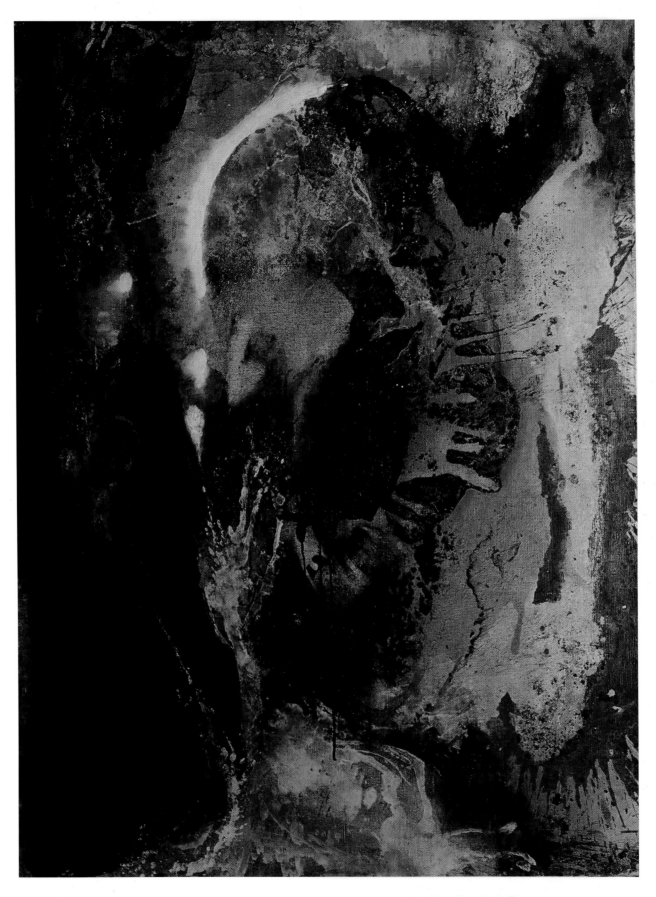

21. *Shooting the Sun.* 1956. Oil on canvas, 64 × 58''. Collection Esther E. Jenkins, New York City

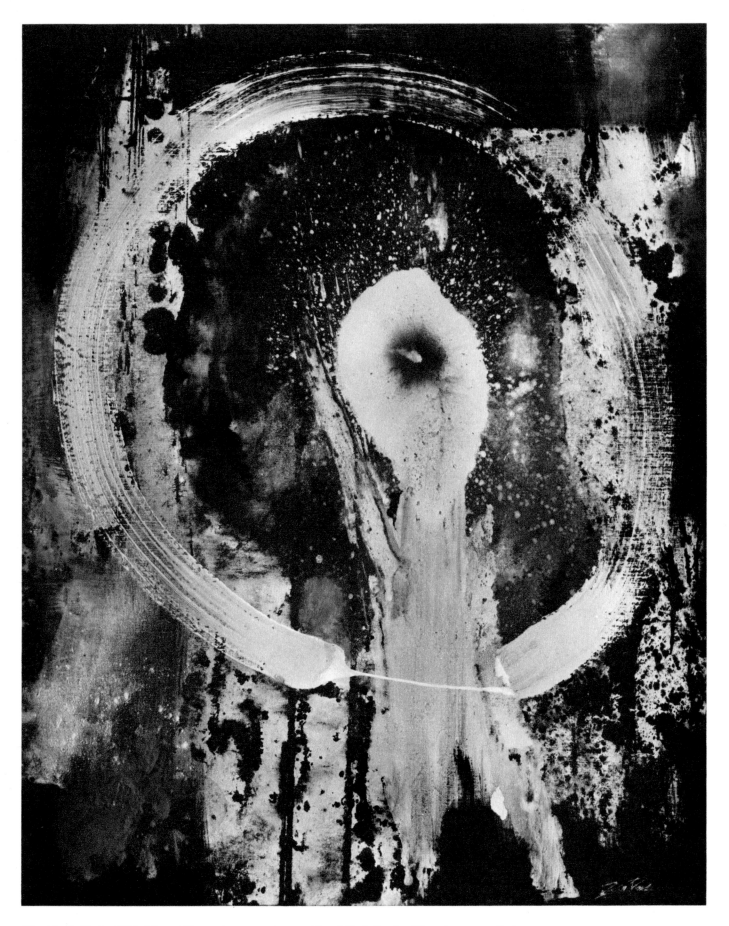

22. *Magic Circle.* 1955. Oil and Chrysochrome on canvas, 37 × 33''. Collection Pierre Lamaroux, Paris

23. Photograph by Syeus Mottel of the artist making a "light graphic." 1969.

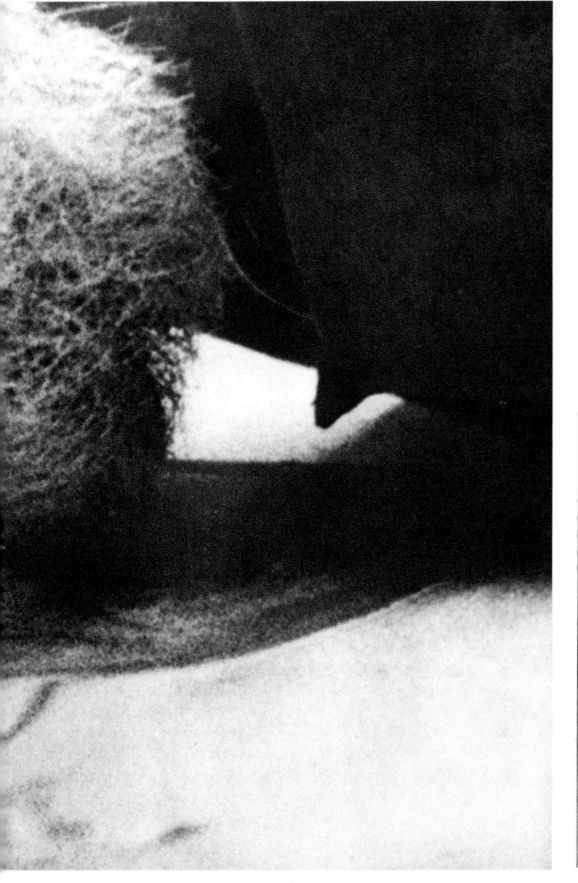

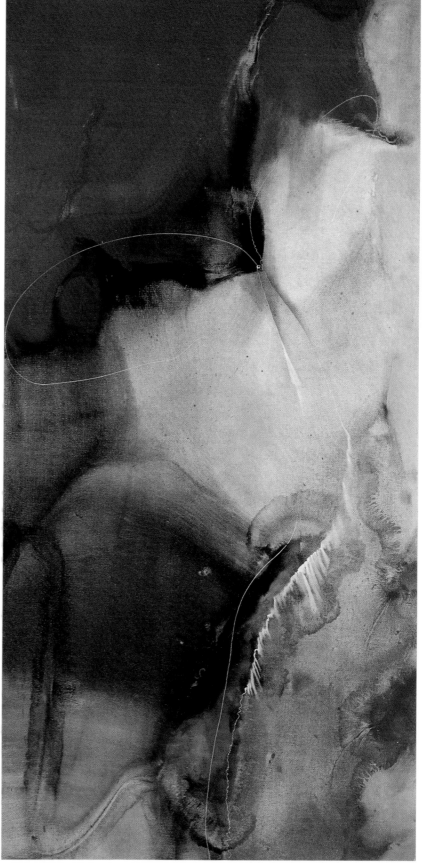

24. *Lotus.* 1957. Oil on canvas, 58 × 35''.
Collection Mr. and Mrs. Nathan Kroll, New York City

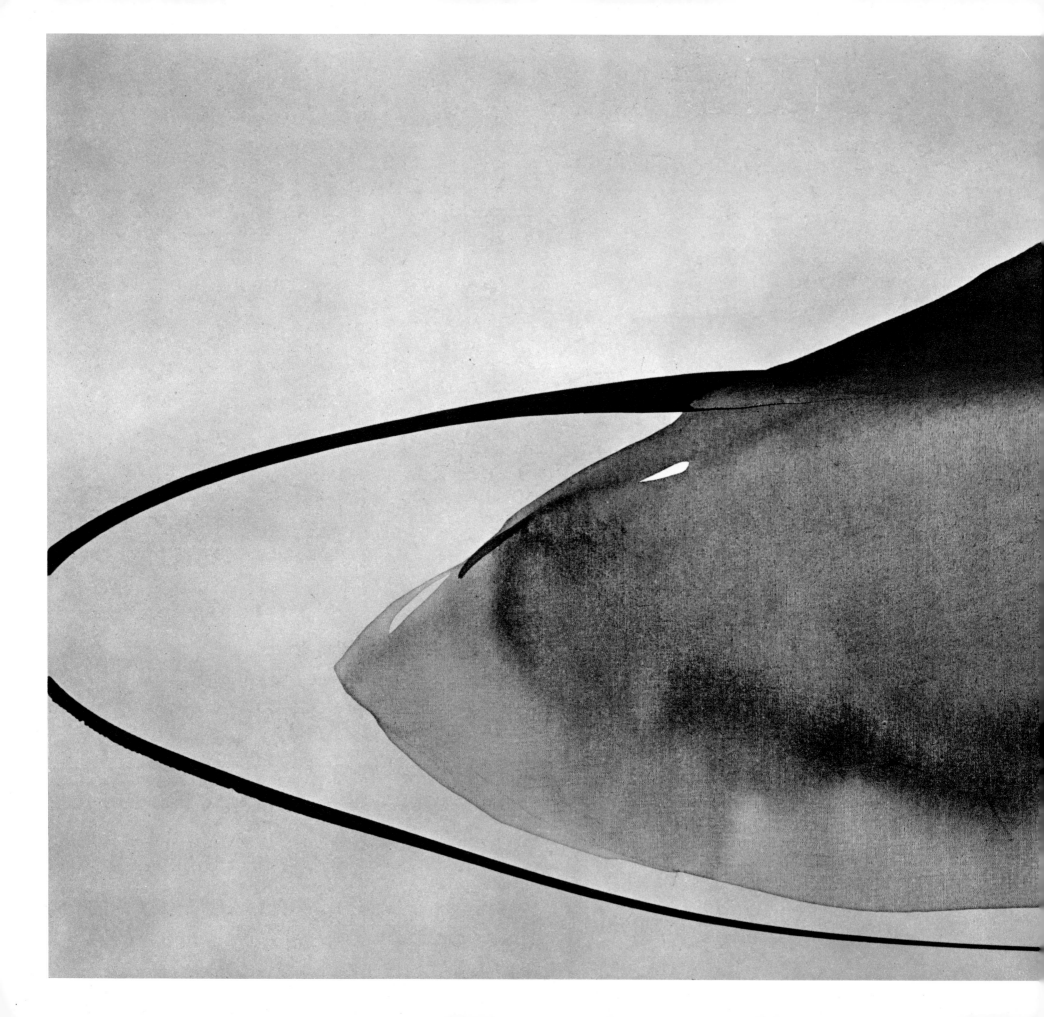

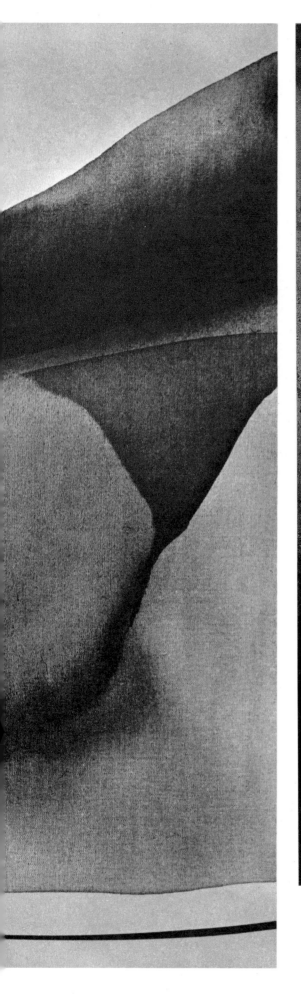

26.
Sounding. 1956. Oil and Chrysochrome on canvas, 64 × 45″. Private collection

◀25. *Phenomena Blue Loop.* 1963. Acrylic on canvas, 25 5/8 × 31 7/8″. Private collection

27.
Eye of Sleep. 1955. Oil
on canvas, 51 × 36''.
Private collection, Paris

28.
The Archer. 1955. Winsor Newton powdered pigments, oil, and Chrysochrome on canvas, 51 × 31″. The Albright-Knox Art Gallery, Buffalo, N.Y.

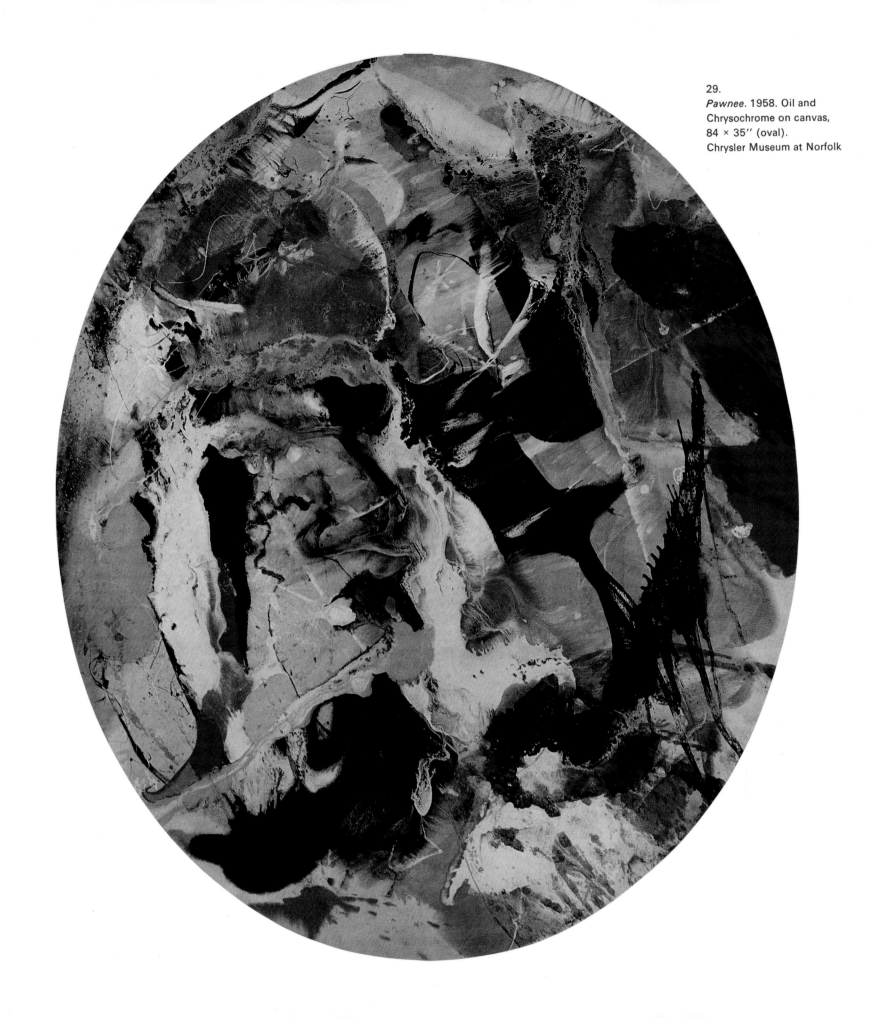

29.
Pawnee. 1958. Oil and
Chrysochrome on canvas,
84 × 35'' (oval).
Chrysler Museum at Norfolk

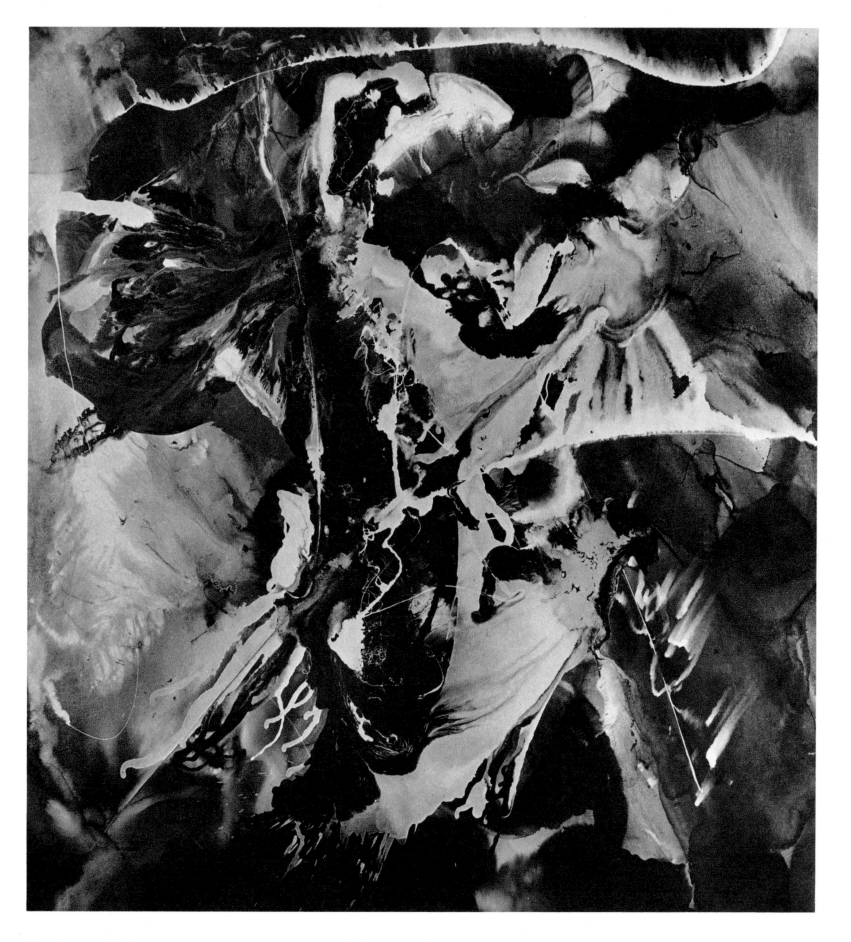

30. *St. George*. 1958. Oil and Chrysochrome on canvas, 84 × 75''. Collection Prof. William D. Johnson, Kingsville, Texas

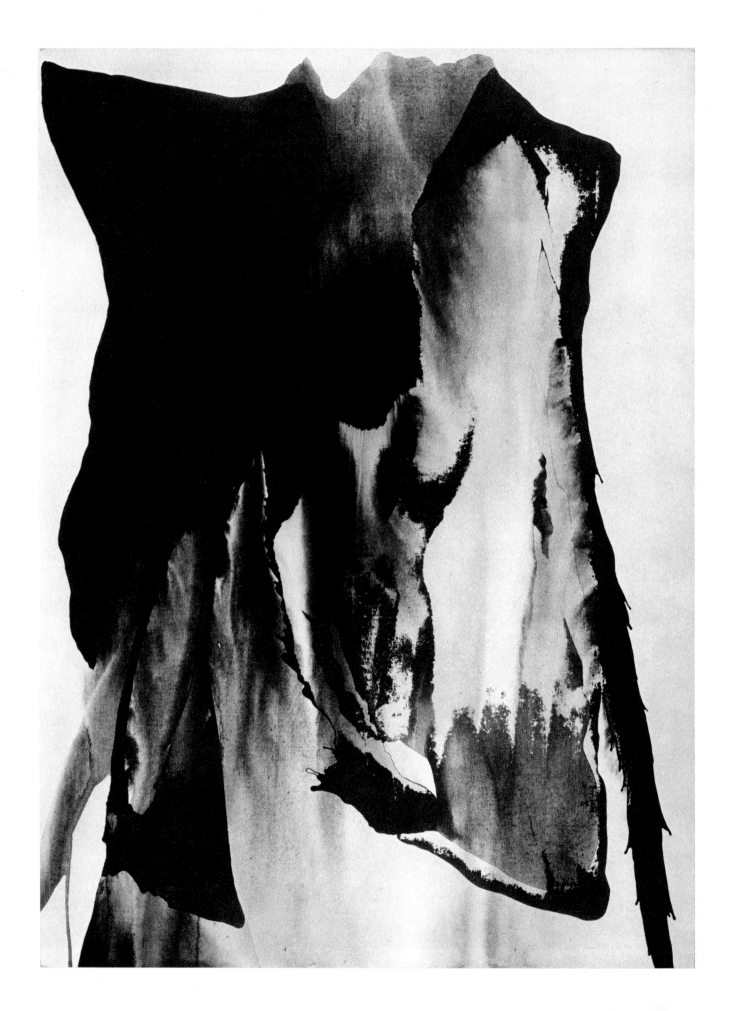

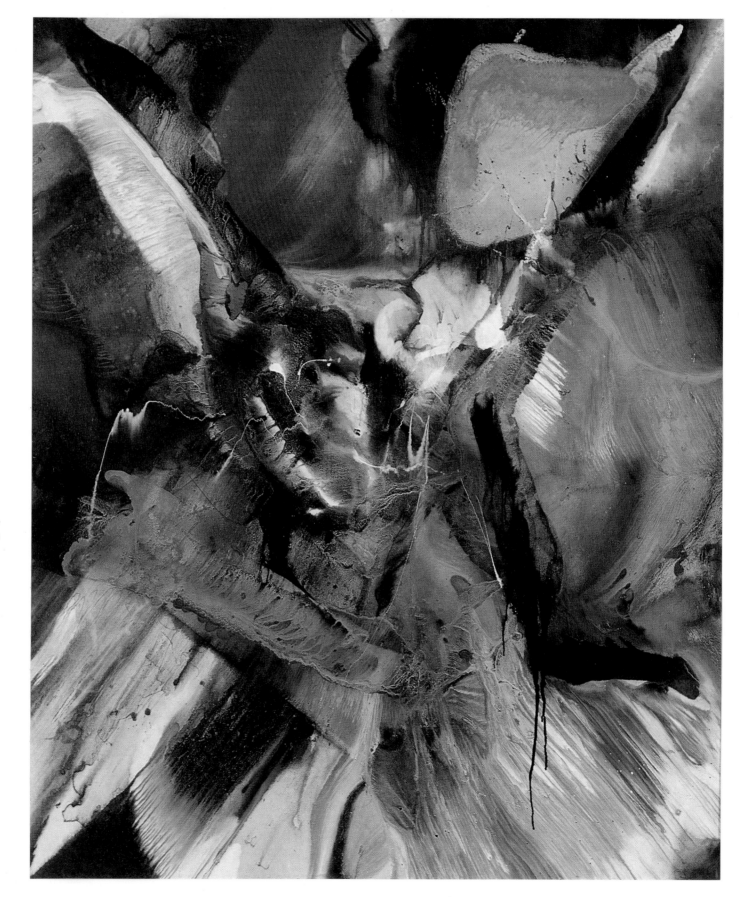

◀31.
Phenomena Ring Rang Rung.
1961. Acrylic on canvas,
77 × 57''. National Collection
of Fine Arts, Smithsonian
Institution, Washington,
D.C. Gift of S.C.
Johnson and Son, Inc.

32.
Umbra. 1958. Oil on can-
vas, 60 × 50''. Collection
Mr. and Mrs. A. H. Low,
Tel Aviv

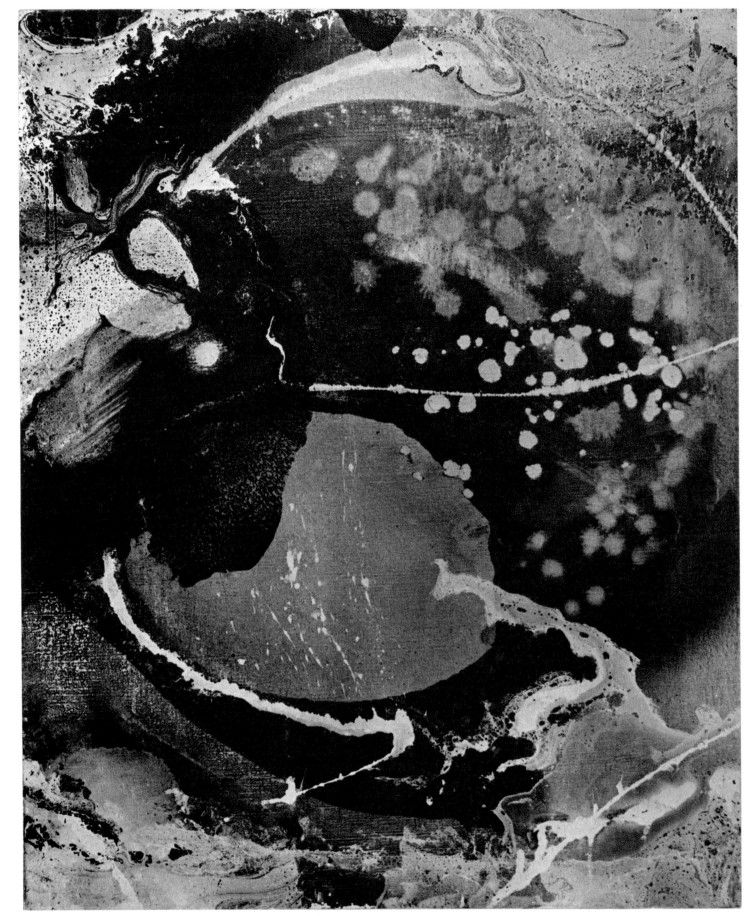

33.
Uranus. 1956. Oil and
Chrysochrome on canvas,
29 × 24''. Collection Mrs.
Anthony Gibbs, London

34 (opposite page).
Eyes of the Dove Sun Ring.
1959. Oil and Chrysochrome
on canvas, 30 × 40''. Col-
lection Mr. and Mrs. Frank
Lobdell, Palo Alto, Calif.

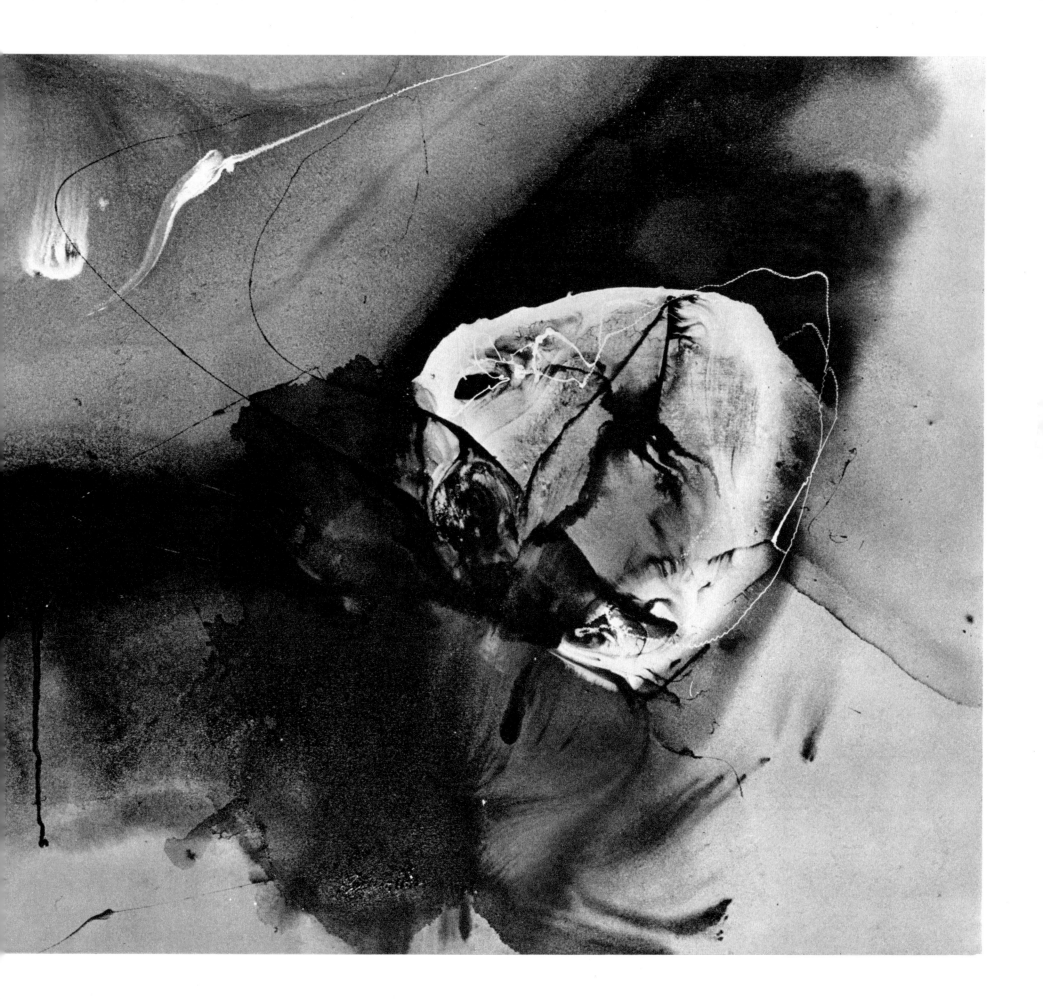

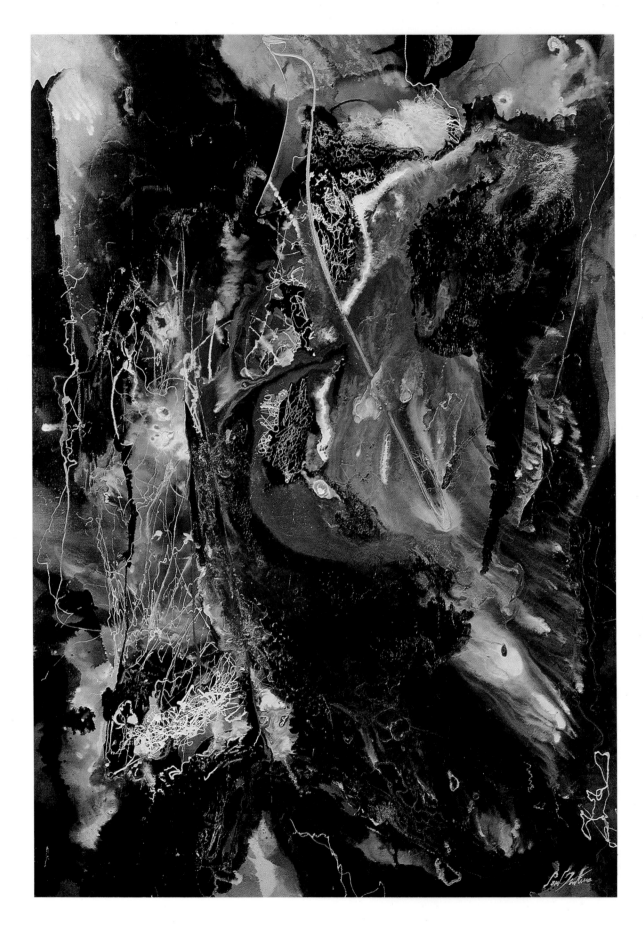

35.
Darkling Plain. 1957.
Oil and Chrysochrome on
canvas, 64 × 38''. Martha
Jackson Gallery, New York
City

36.
Cry of the Peacock. 1956.
Oil on canvas, 63 3/4 ×
51 1/8″. Collection Bernard and Ursula Schultz,
Frankfort

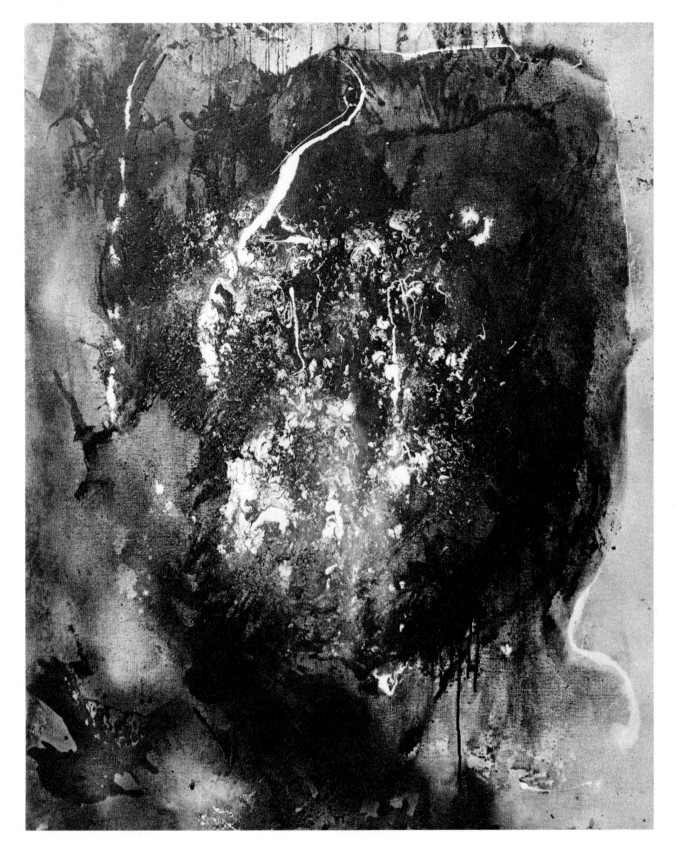

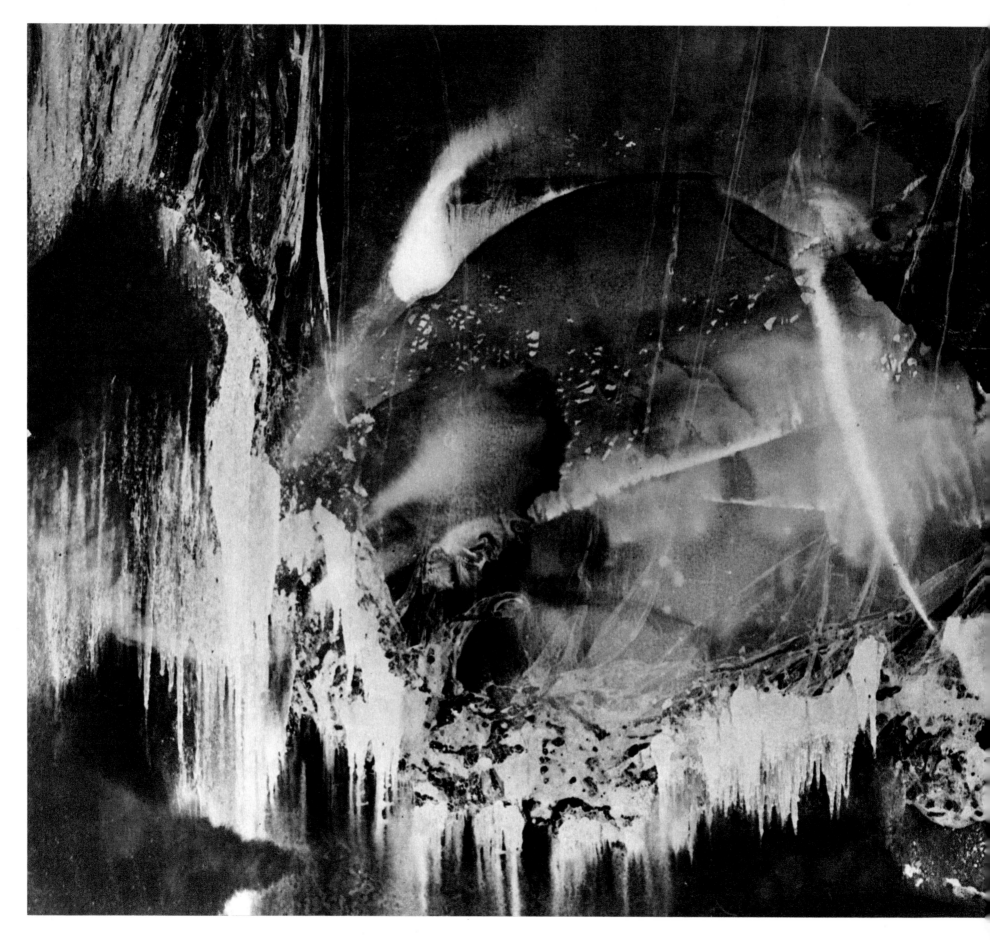

37. *The Prophecy*. 1956. Oil and Chrysochrome on canvas, 51 × 77''. The Solomon R. Guggenheim Museum, New York City

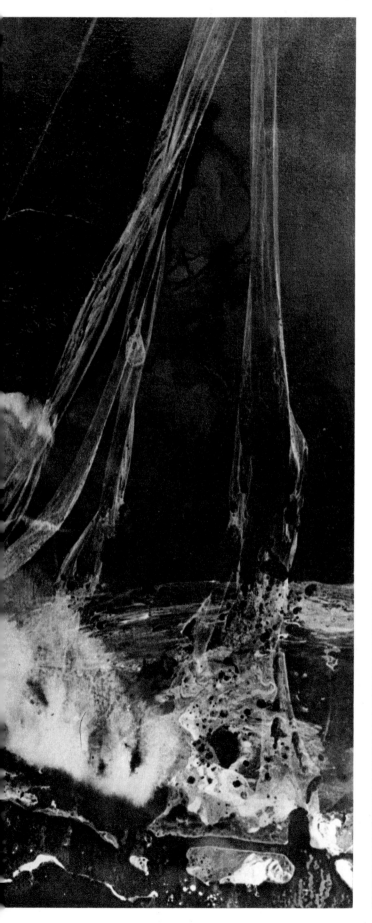

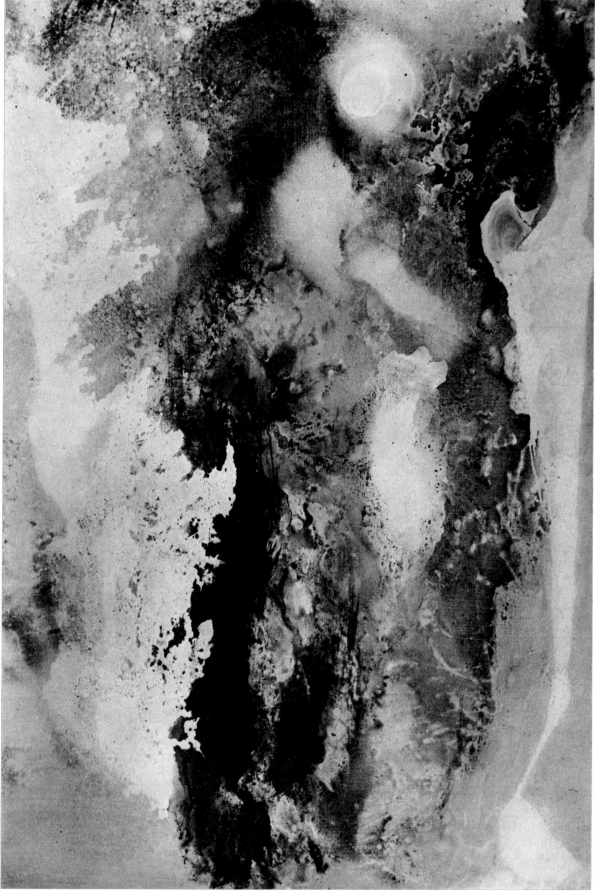

38. *Open Valley*. 1956. Oil on canvas, 77 × 51''. Collection Mr. Patrick Lannan, Palm Beach, Fla.

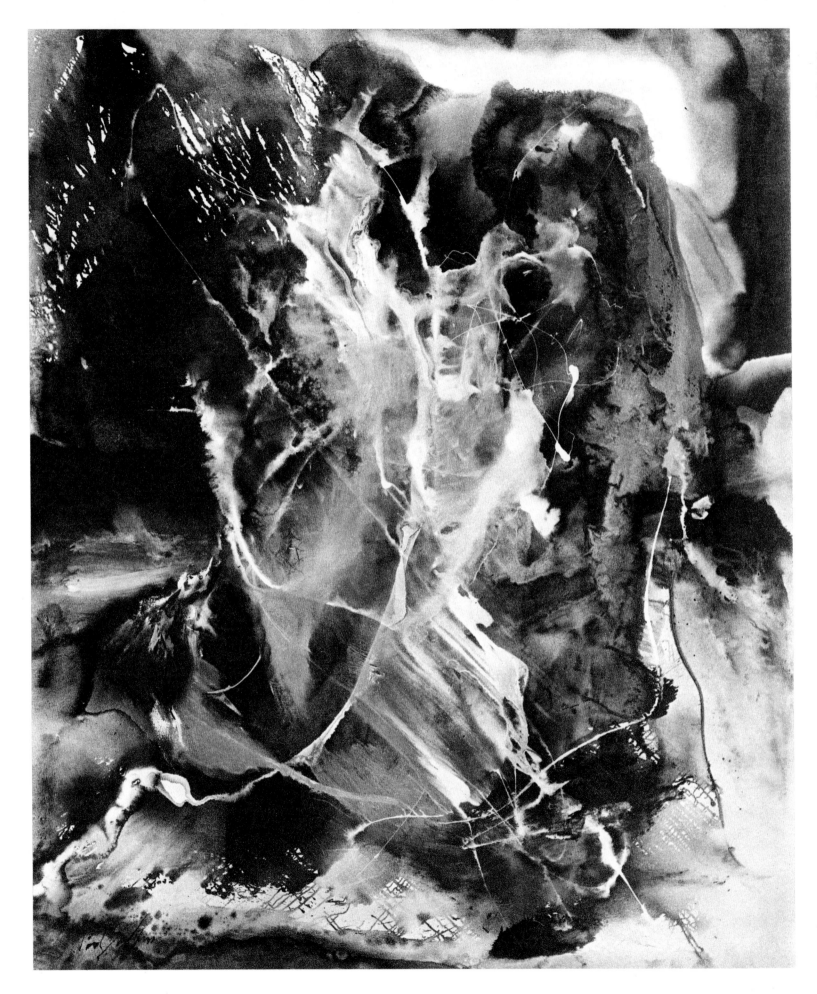

39.
To Queequeg. 1956. Oil
and Chrysochrome on canvas,
78 3/4 × 65''. Collection
Mrs. Anthony Gibbs, London

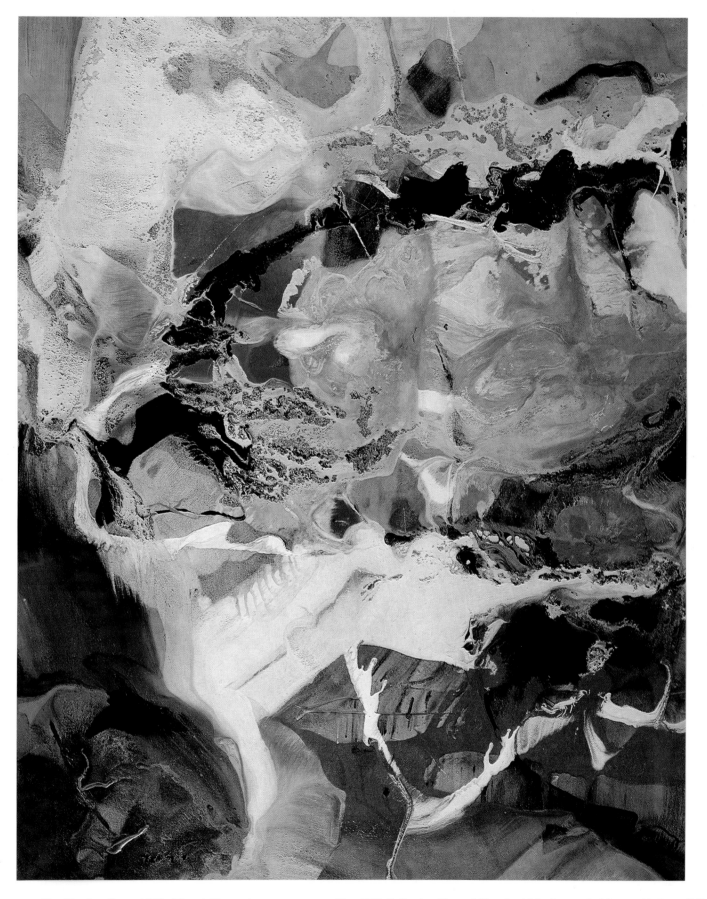

40. *Natchez Trace.* 1958. Oil and Chrysochrome on canvas, 81 × 64''. Collection Mr. and Mrs. David Anderson, Ardsley-on-Hudson, N.Y.

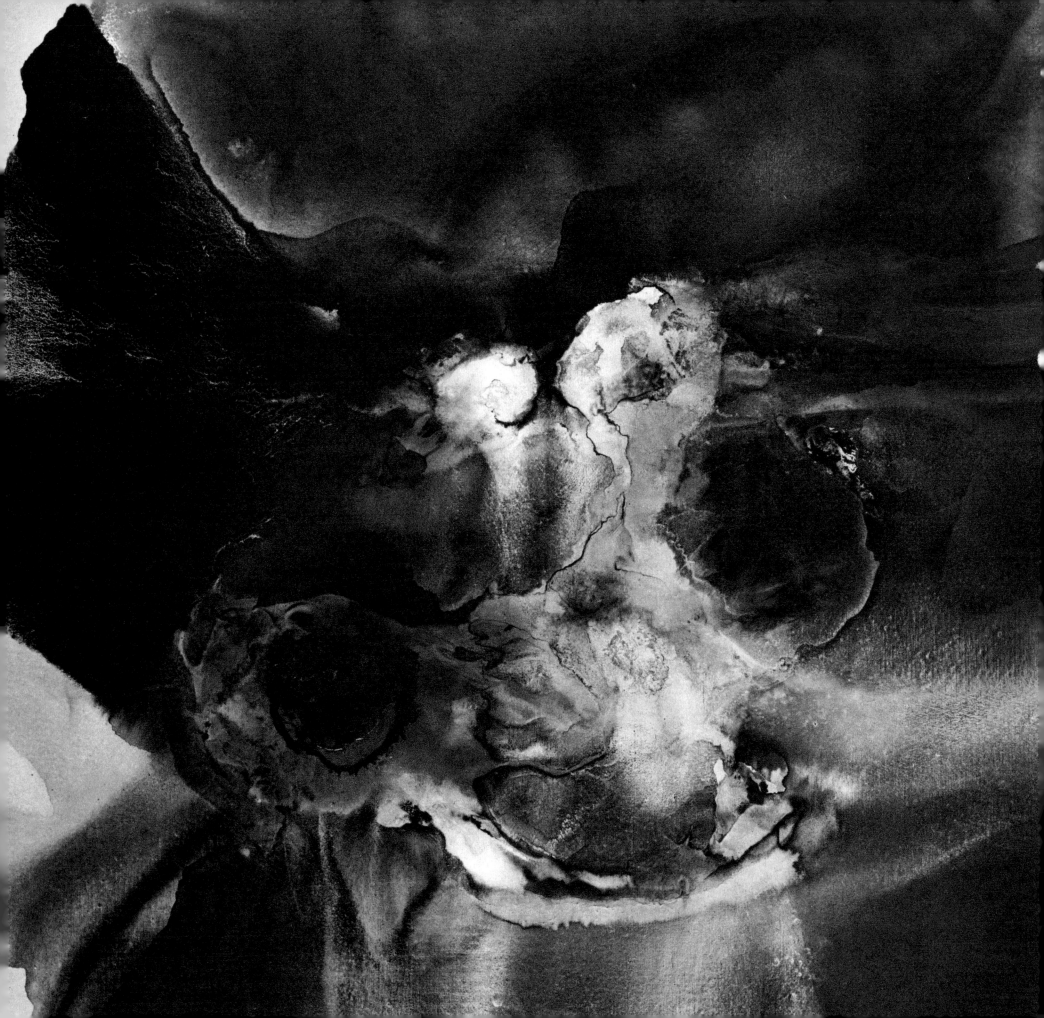

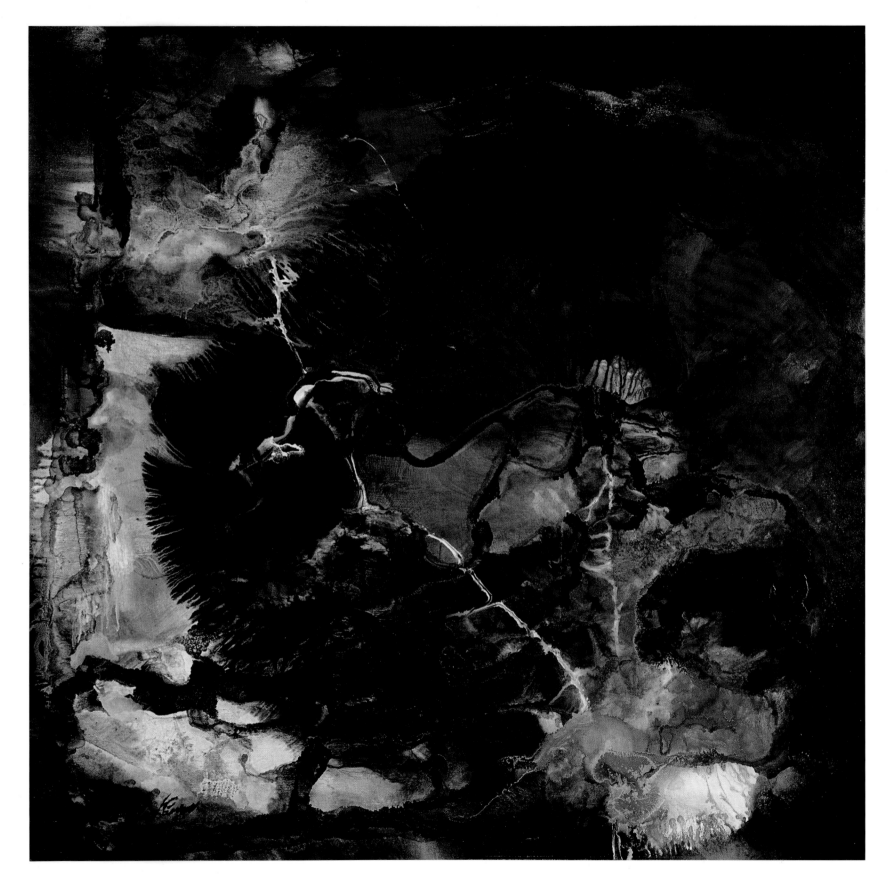

42. *Western Sphinx*. 1958. Oil on canvas, 64 × 67''.
Collection Dr. Robert Sager, Taos, N.M.

◄41. *Phenomena High Water*. 1961. Oil and acrylic on canvas, 37 × 37''.
Collection Felix Naggar, Paris

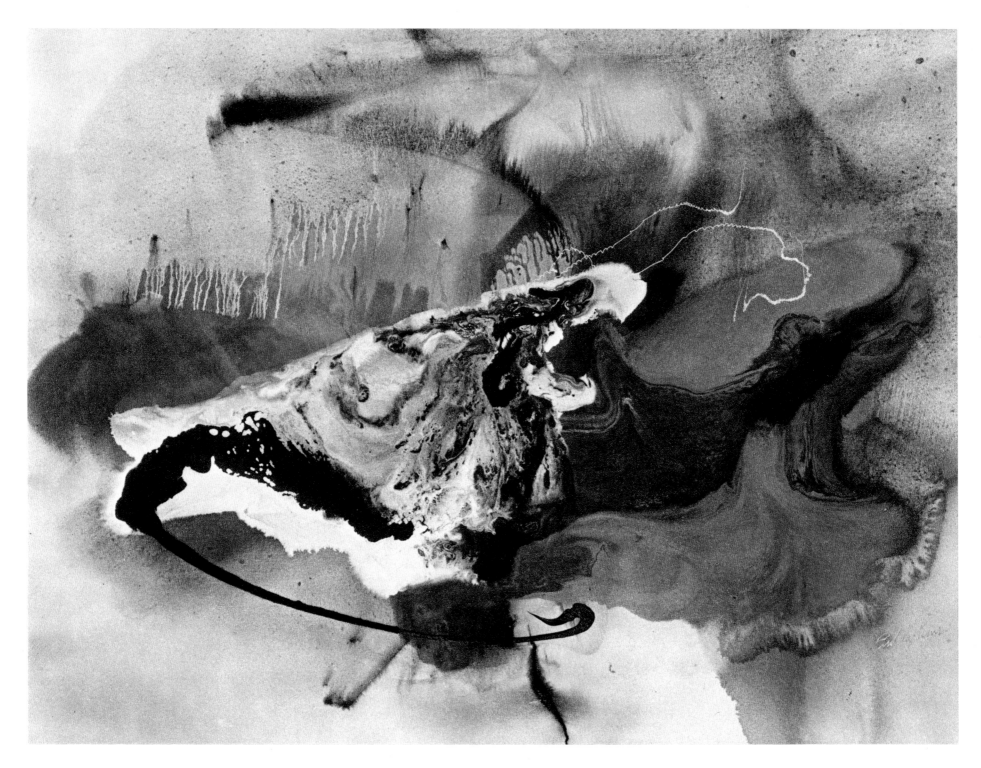

43. *Eyes of the Dove Magic Langoustine*. 1959. Oil and Chrysochrome on canvas, 30 × 40″. Collection M. O. L. Lynton, London

44.
Violet Archipelago. 1959.
Oil and Chrysochrome on
canvas, 77 × 55''. Collec-
tion Mr. and Mrs. James
Jones, Paris

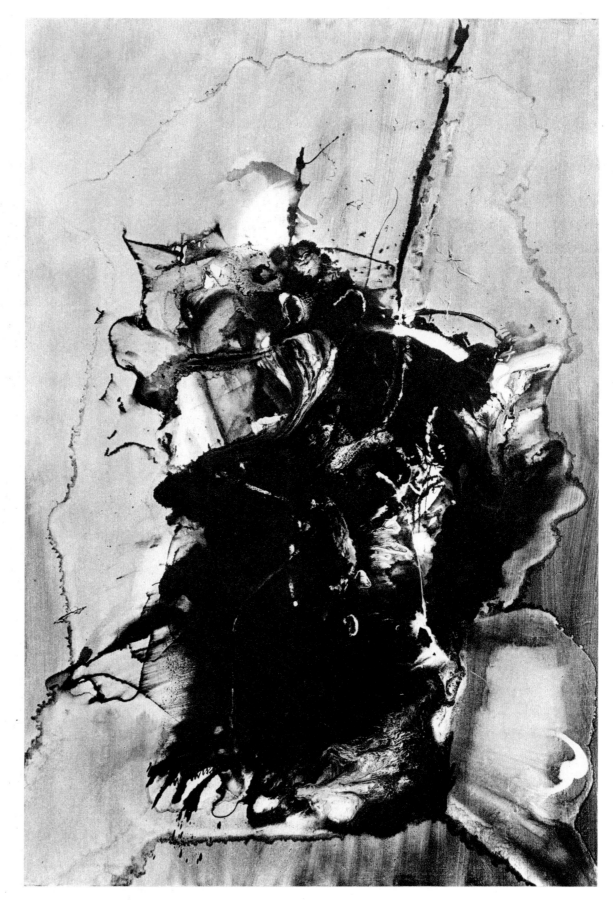

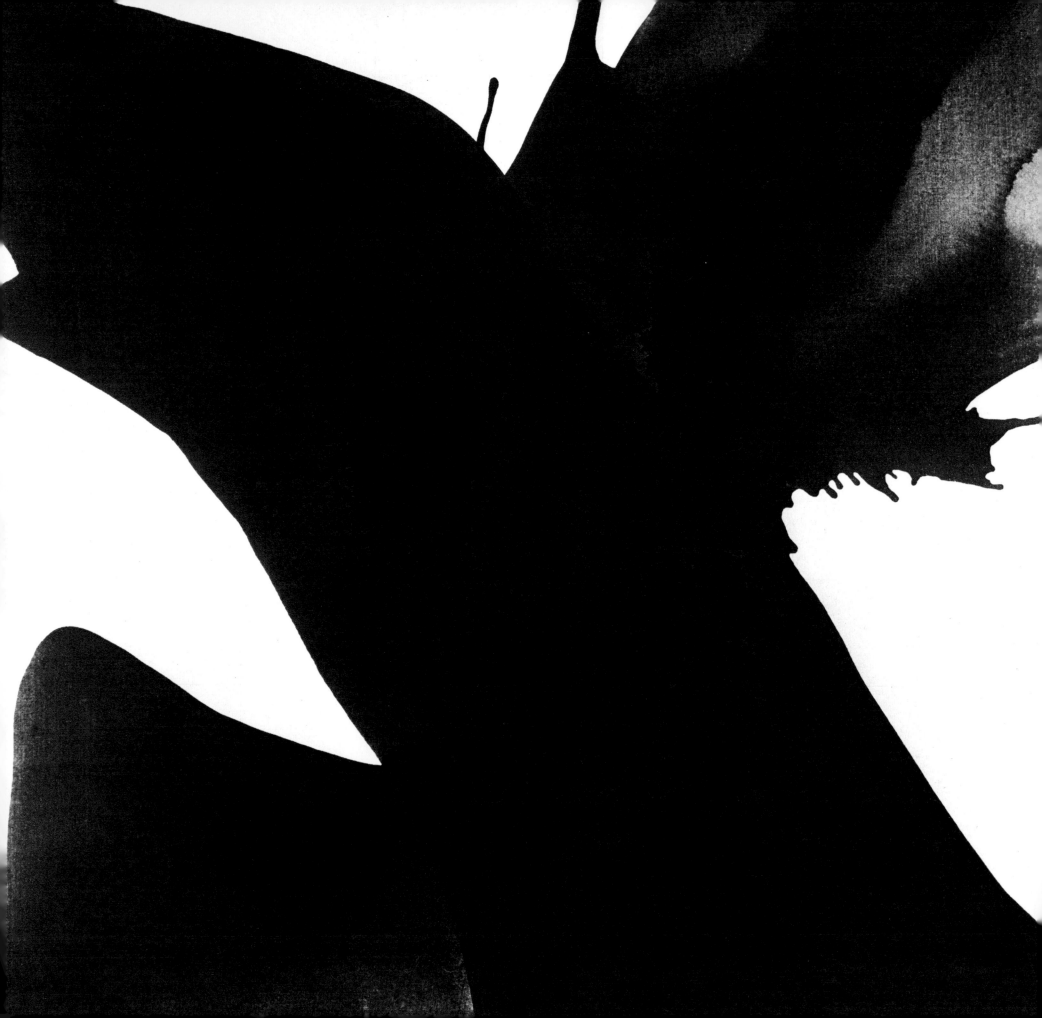

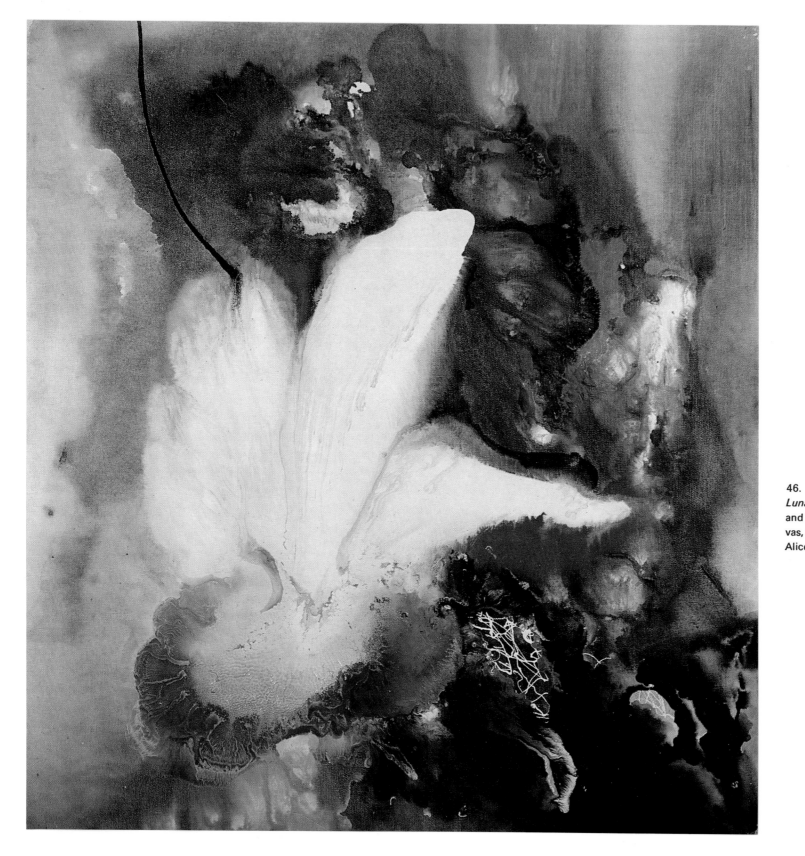

46.
Lunar Moth. 1958. Oil
and Chrysochrome on can-
vas, 39 × 35''. Collection
Alice Baber, New York City

◄45. *Phenomena Solstice Seen*. 1962. Acrylic on canvas, 37 × 37''. Private collection, Paris

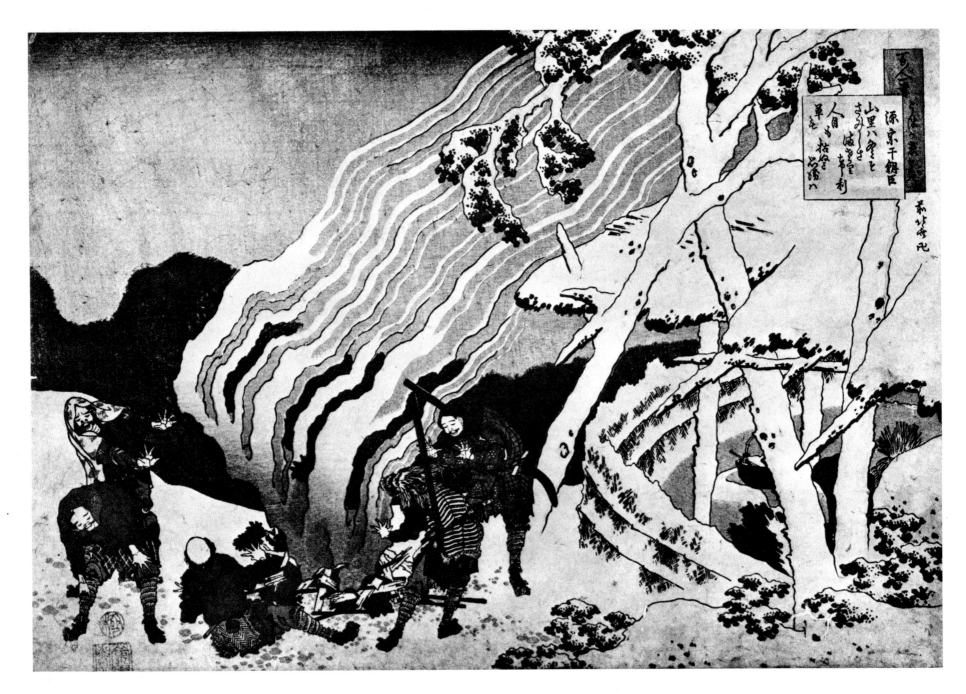

47. Hokusai : Woodblock print from the series *One Hundred Poems by Master Poets.* c. 1840. The Louvre, Paris

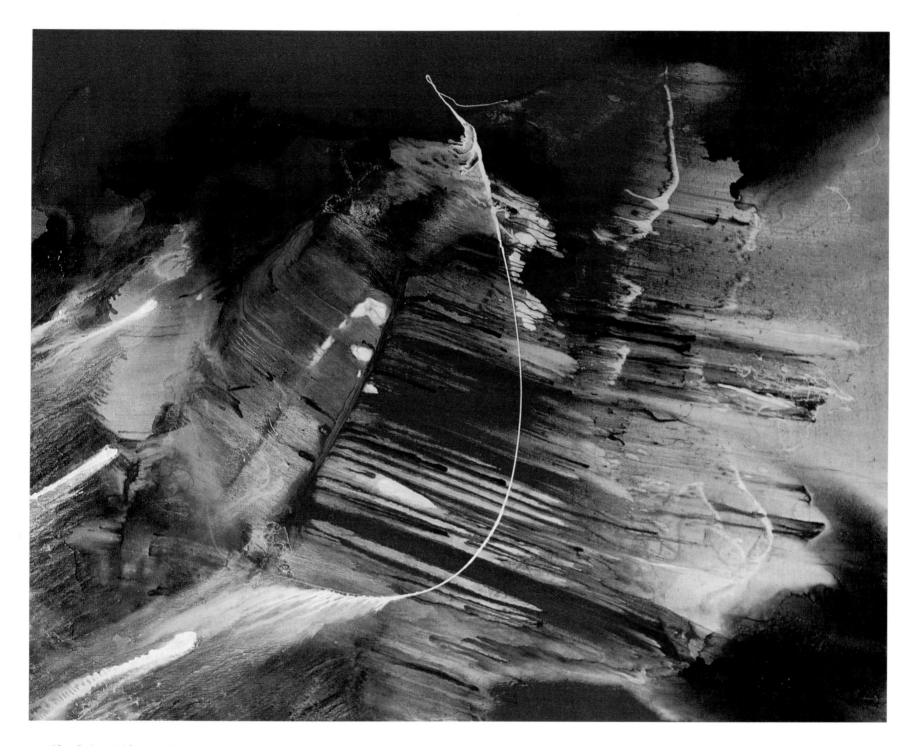

48. *Dakota Ridge*. 1958. Oil and Chrysochrome on canvas, 50 × 64''. Hirshhorn Museum and Sculpture Garden, Smithsonian Institution, Washington, D.C.

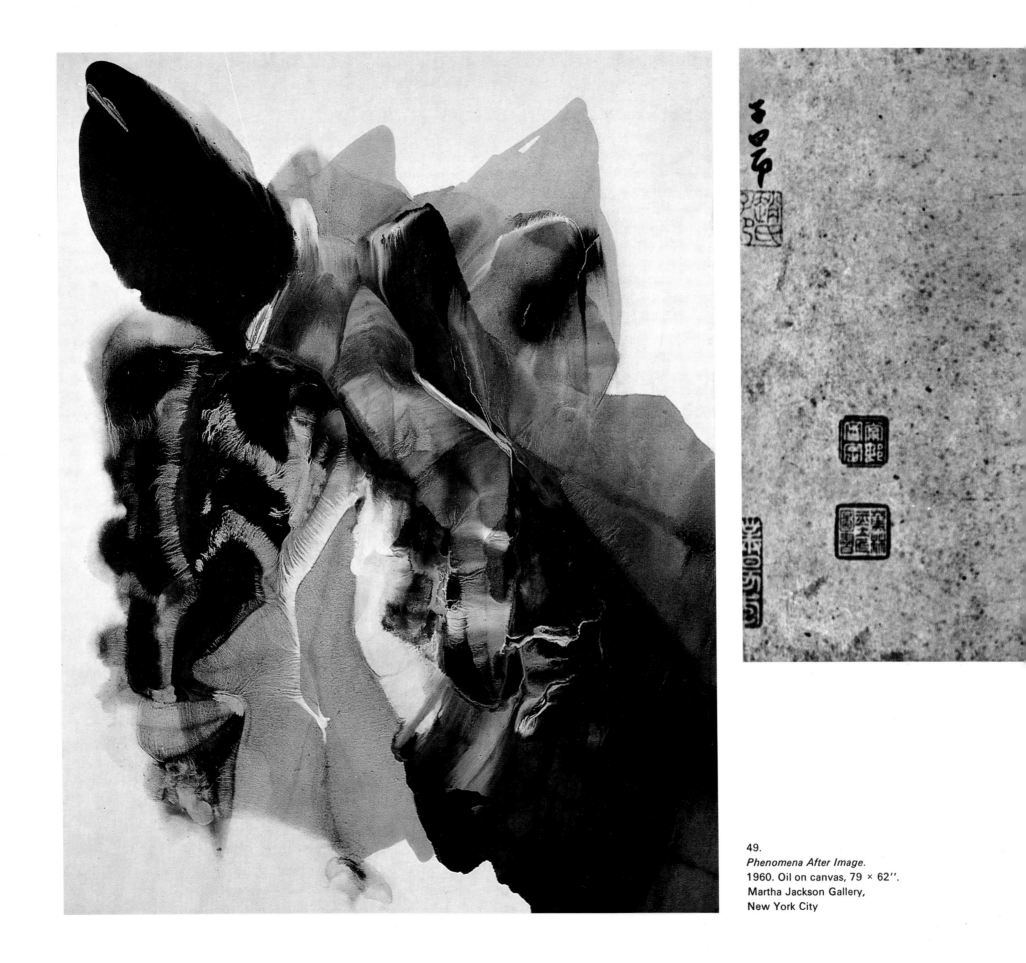

49.
Phenomena After Image.
1960. Oil on canvas, 79 × 62''.
Martha Jackson Gallery,
New York City

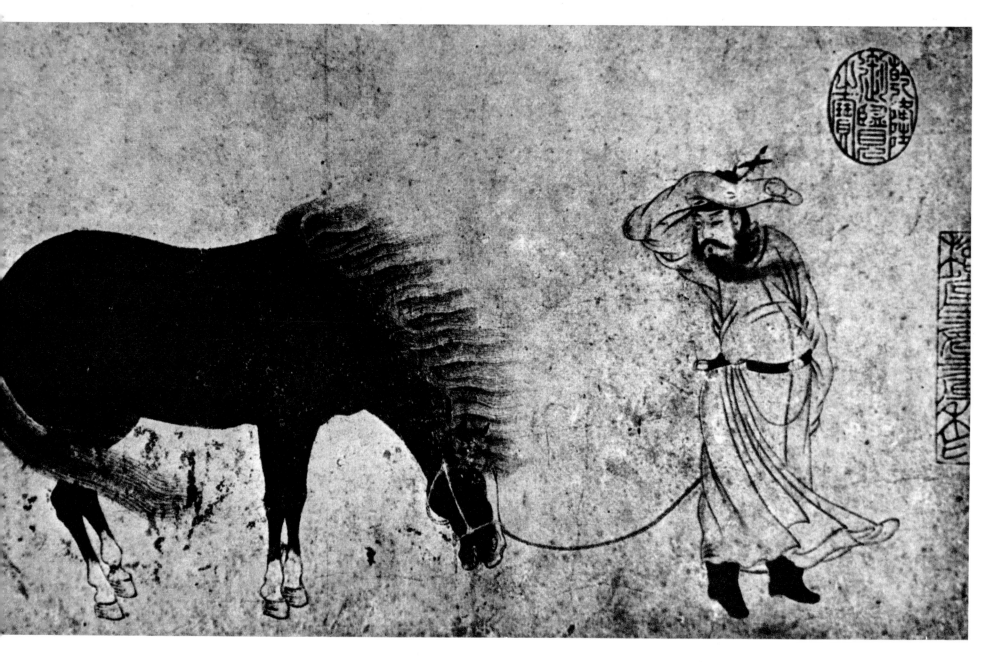

50. Chao Meng-Fu: *Horses and Old Trees.* Yuan Dynasty (1277–1368). Ink on paper, 8 5/8 × 19 1/4''. National Palace Museum, Peking

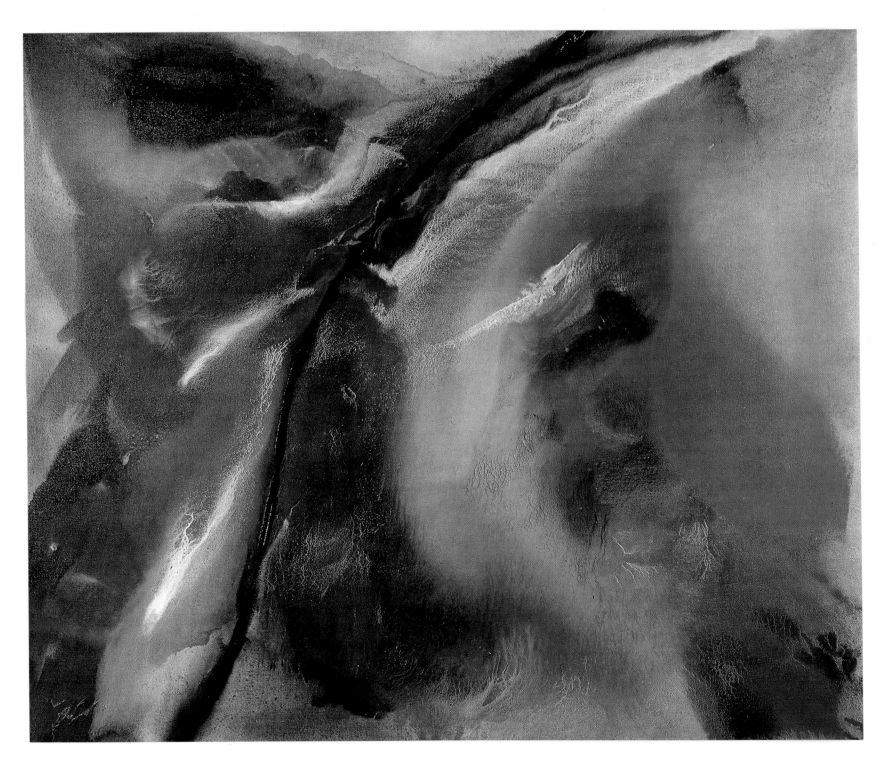

51. *Phenomena Burnt Under.* 1960. Oil on canvas, 38 × 54''. Martha Jackson Gallery, New York City

52.▶
Drawing on scratchboard
after Michelangelo wax
study, 10 × 12''. 1940.
Private collection, New
York City

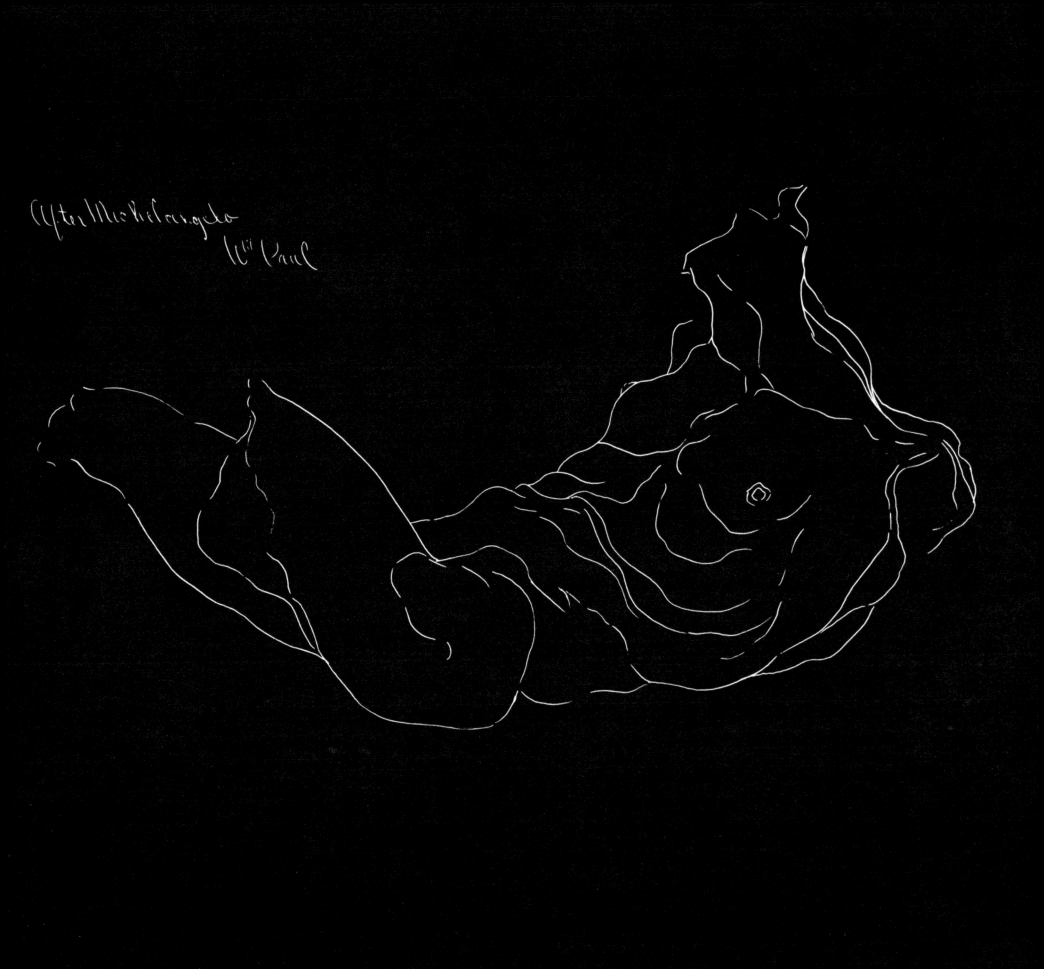

After Michelangelo
W^m Paul

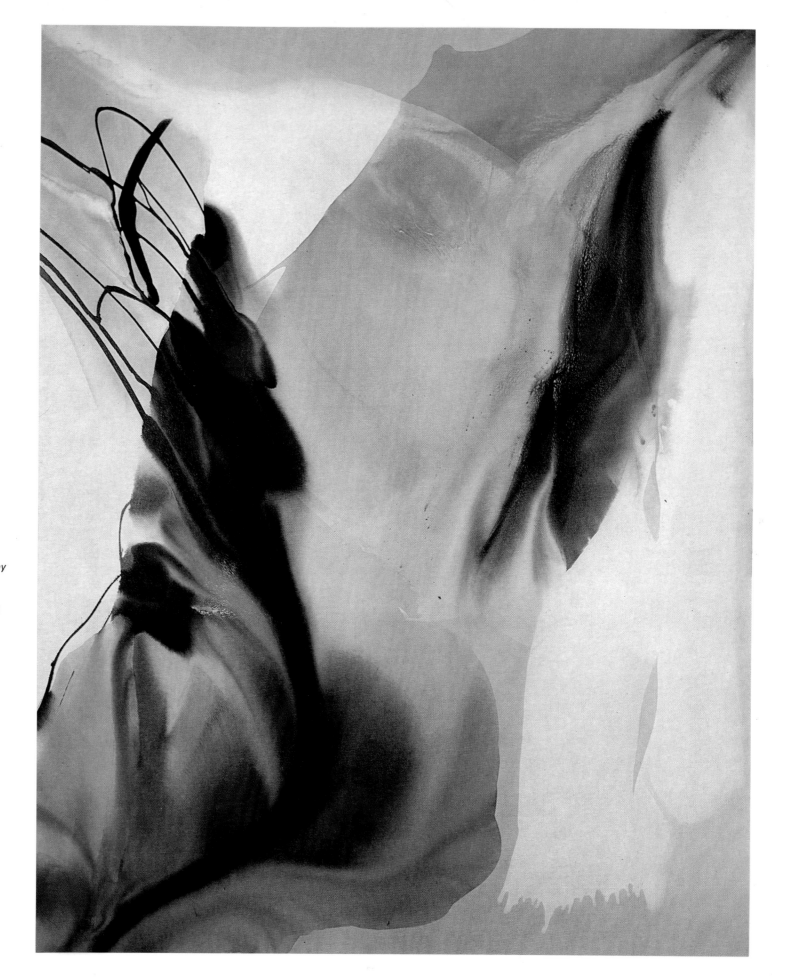

53.
Xerox portrait of the
artist. 1970

54.
*Phenomena Nacreous Gray
Veil.* 1969. Acrylic on
canvas, 10′ × 8′. Collec-
tion Mr. and Mrs. Richard
C. Rubin, New York City

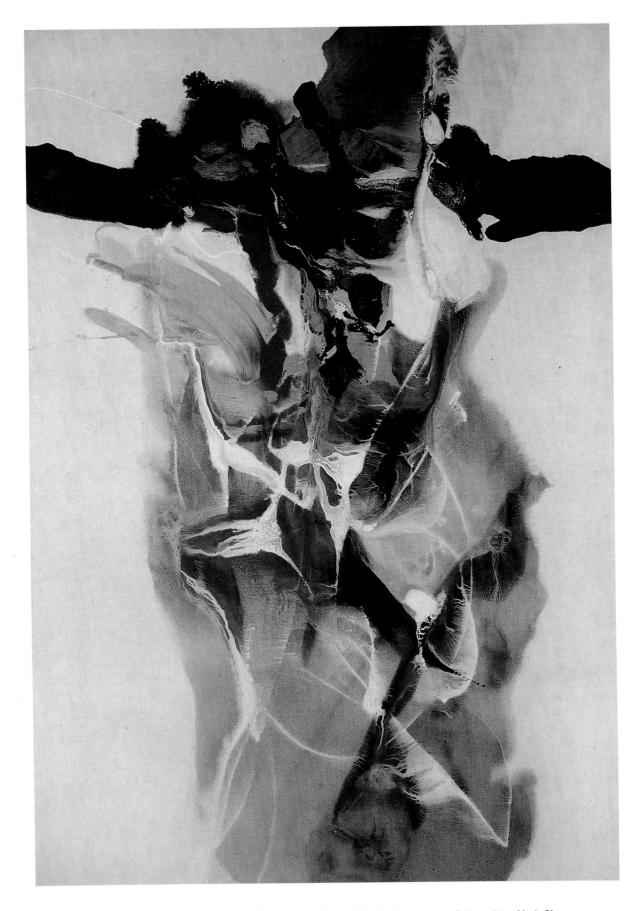

56. ▶
Xerox portrait of the
artist. 1970

55. *Phenomena High Octane.* 1960. Oil on canvas, 66 × 48″. Martha Jackson Gallery, New York City

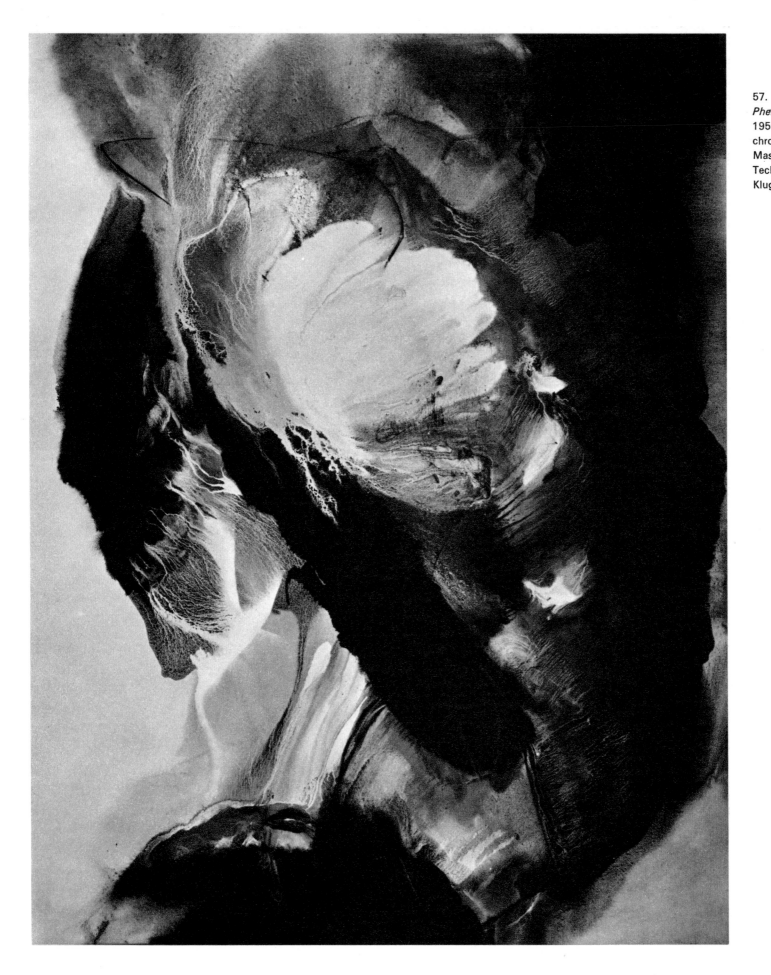

57.
Phenomena Lunar Scarab.
1959–60. Oil and Chryso-
chrome on canvas, 79 × 62''.
Massachusetts Institute of
Technology. Gift of David
Kluger

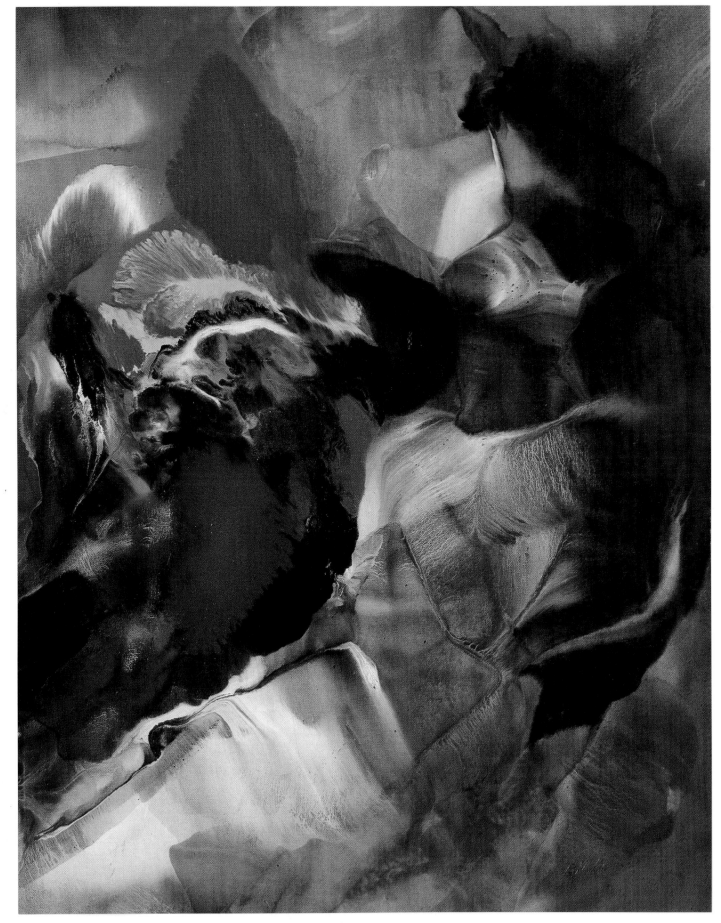

58.
*Phenomena When I Looked
Away*. 1960. Oil and Chryso-
chrome on canvas, 79 × 62".
Collection Dr. and Mrs.
Lester Morrison, Los Angeles

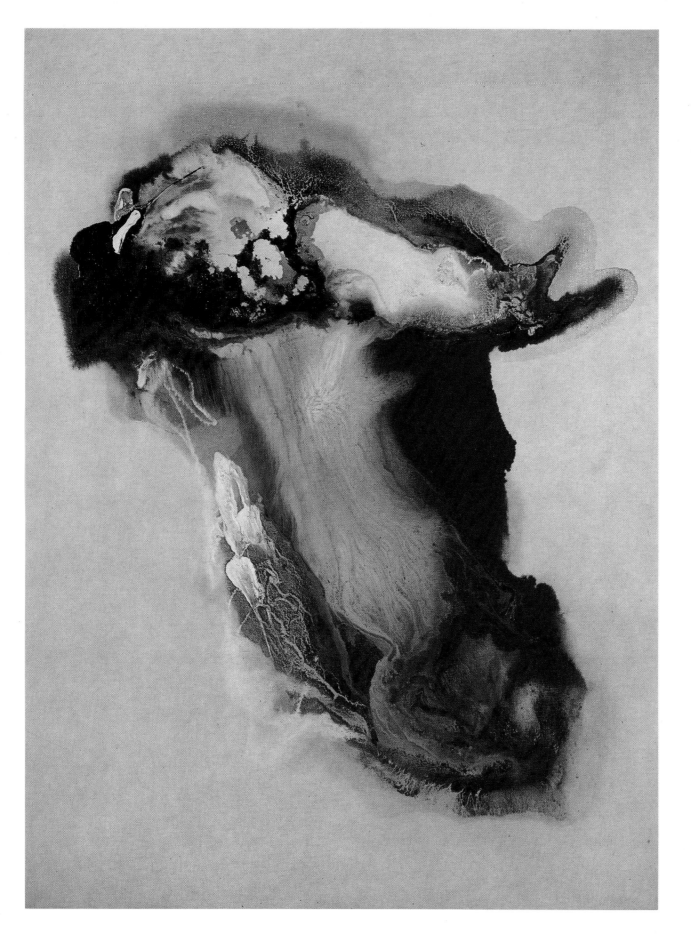

59.
Eyes of the Dove. 1958.
Oil and Chrysochrome on
canvas, 40 × 30″. Collec-
tion the artist, New York
City

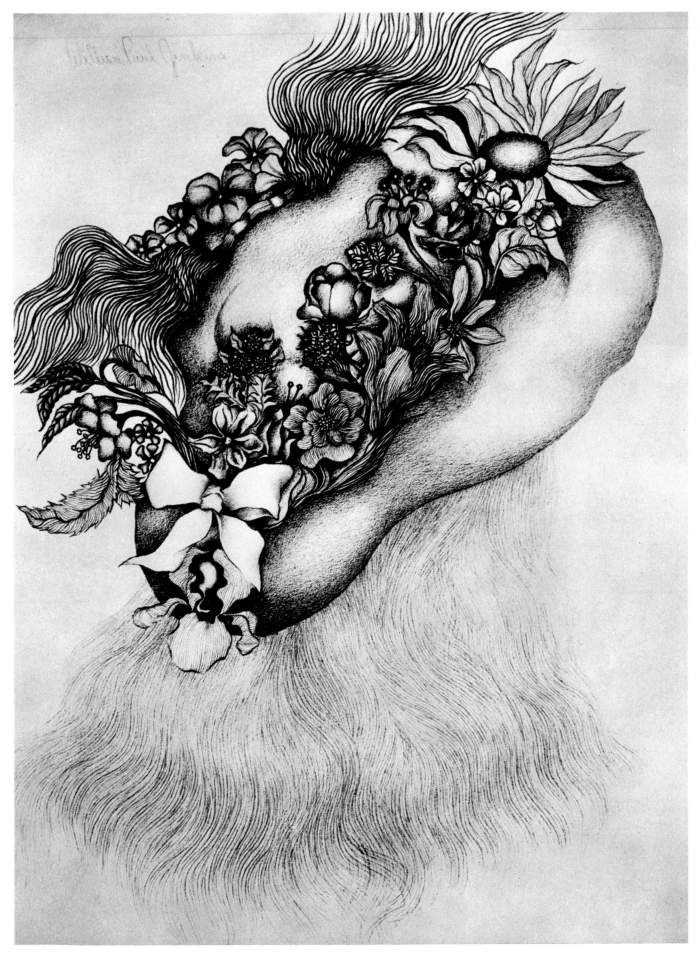

60.
Hat. 1945. Graphite drawing on Whatman illustration board, 20 × 16''. Collection the artist

61.
Phenomena Temperature Vane.
1962. Watercolor on paper,
30 × 22''. Collection Karl
Flinker, Paris

62.
Light Between. 1943.
Graphite drawing on What-
man illustration board,
13 × 12″. Collection the
artist

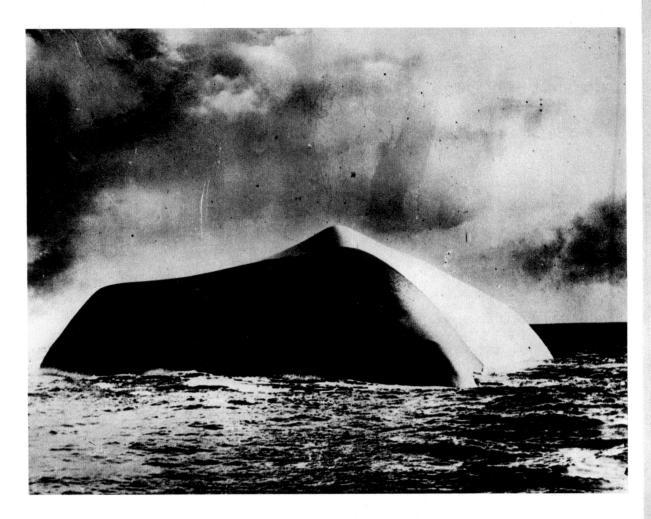

63. Icebergs in the North Atlantic

64.
Phenomena 100 Marine. 1961.
Acrylic on canvas, 38 1/8 ×
63 3/4''. Collection Mr.
and Mrs. James Jones, Paris

65. *Phenomena Jacob's Pillow.* 1961. Acrylic on canvas, 25 1/4 × 39 3/8''. Private collection, Paris

66. Icebergs in the North Atlantic

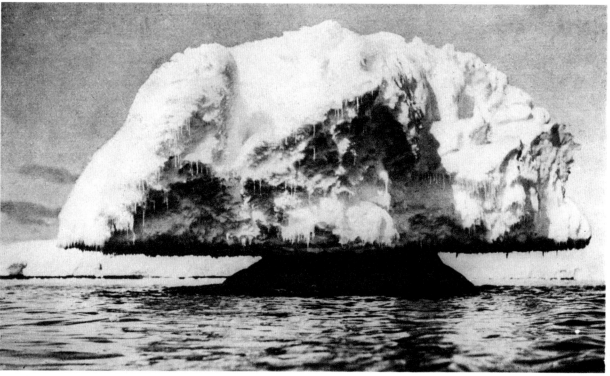

67.
Phenomena Near Euphrates.
1961. Acrylic on canvas,
77 × 56''. Stanford University Museum. Gift of William Janss

68.
Phenomena Votive. 1962–63.
Acrylic on canvas, 77 × 56″.
Walker Art Gallery, Liver-
pool

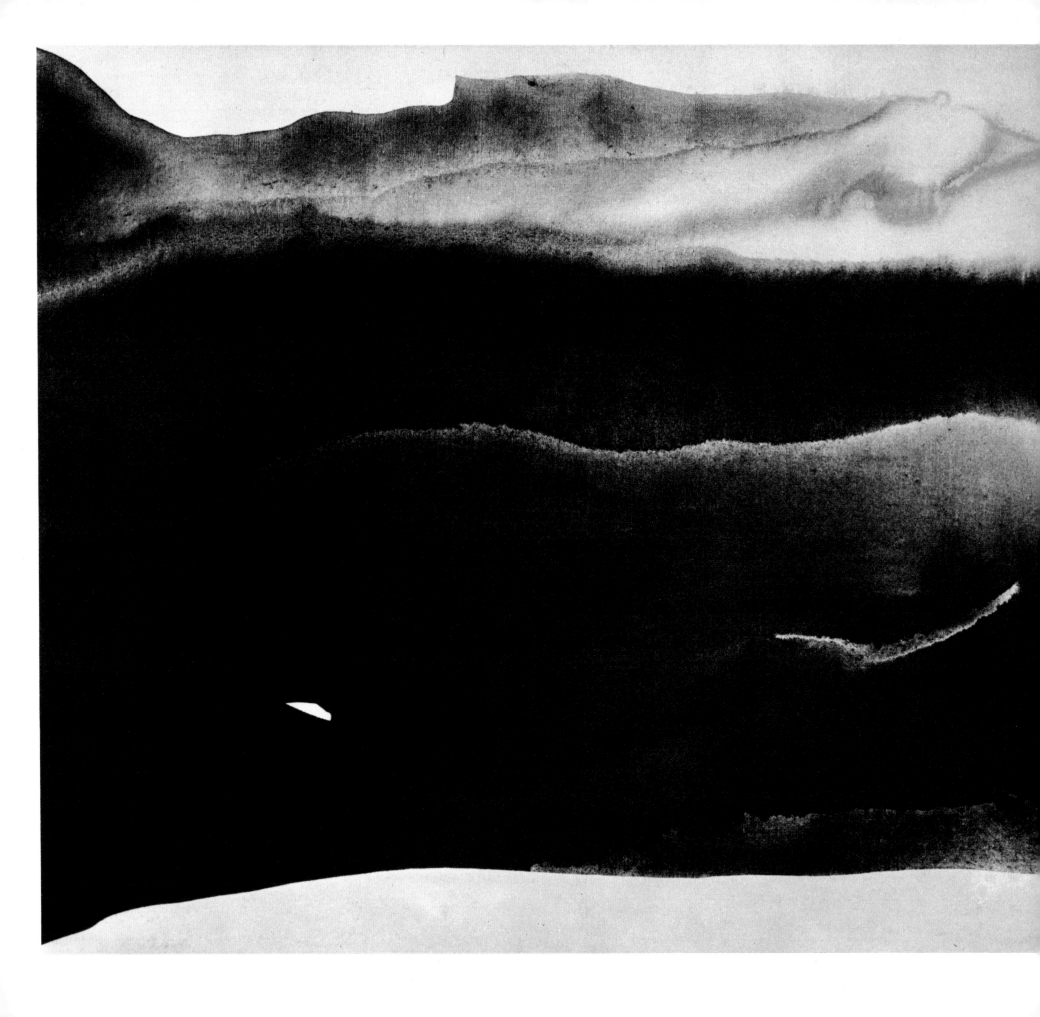

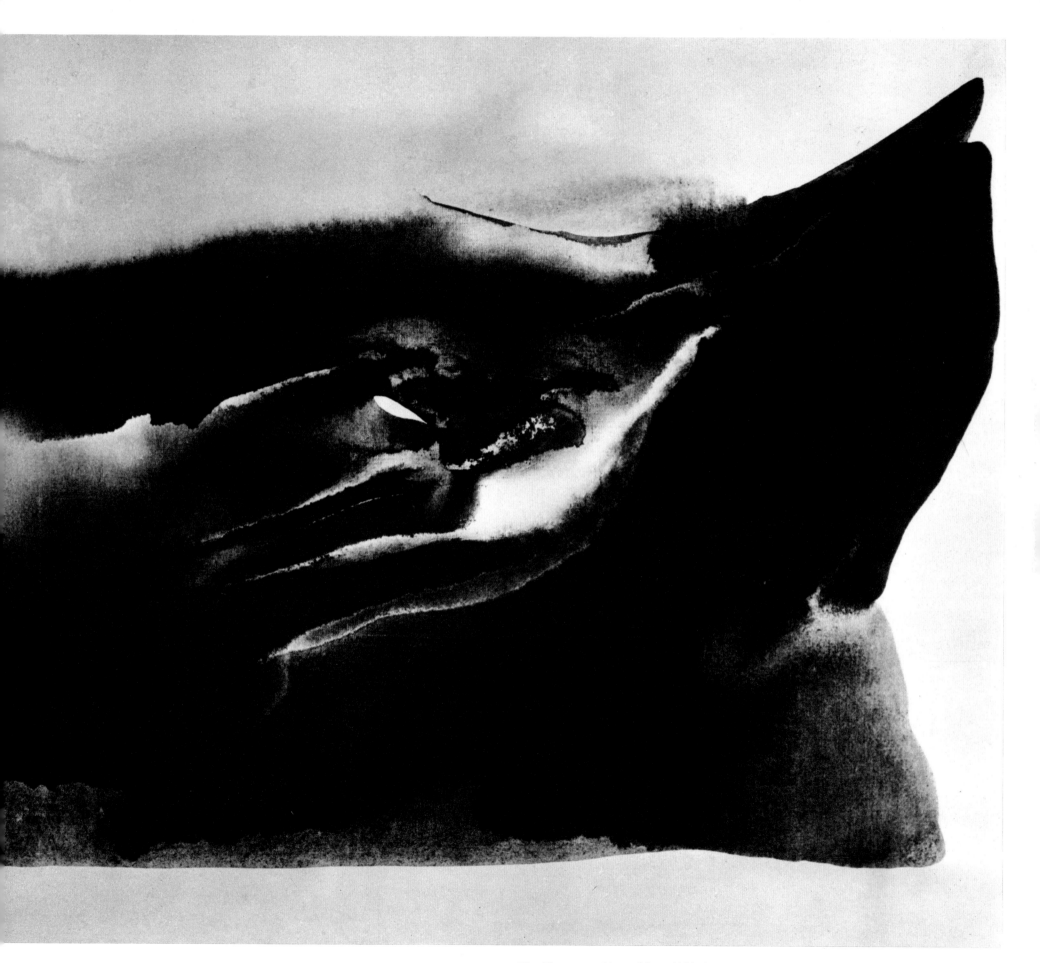

69. *Phenomena Leopard Pass.* 1964. Acrylic on canvas, 27 5/8 × 63''. Collection Karl Flinker, Paris

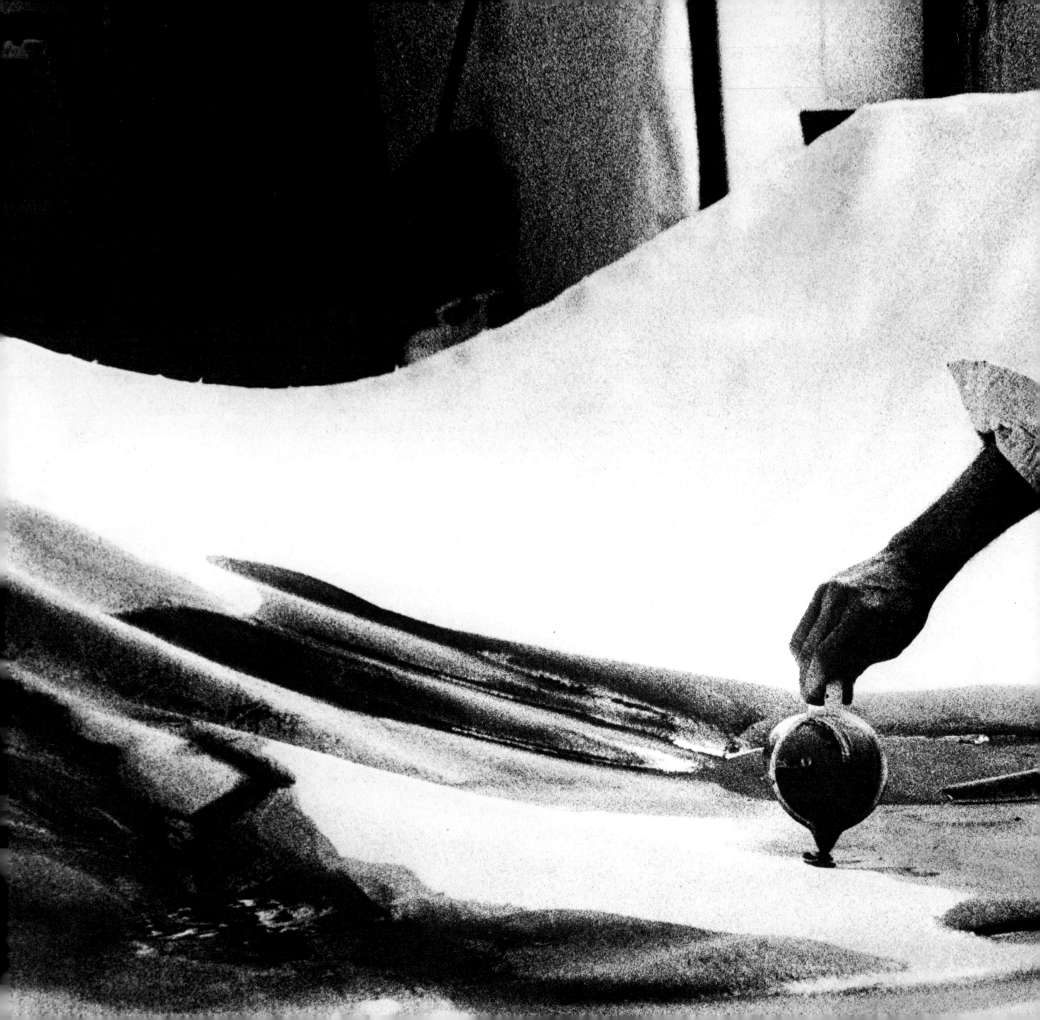

70. Photograph of the artist by Shunk-Kender. 1963

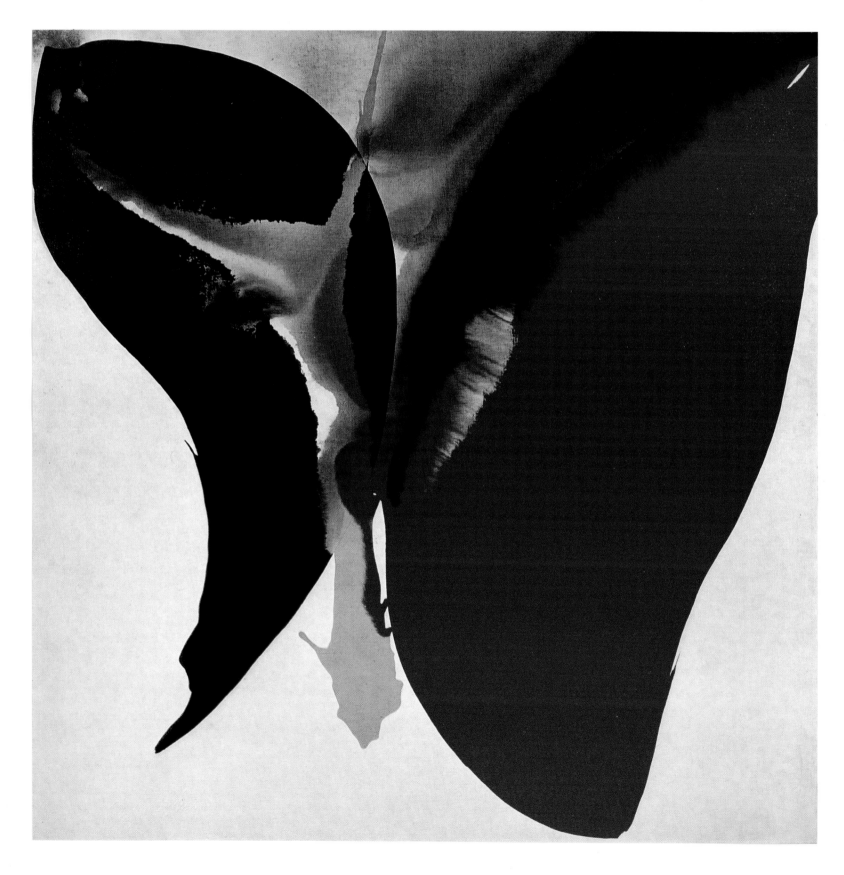

71.
Phenomena Red Wing. 1962.
Acrylic on canvas, 39 ×
39''. Collection Mr. David
Kluger, New York City

72.▶
Drawing from *Paris Suite.*
1970. Ink, actual size.
Private collection

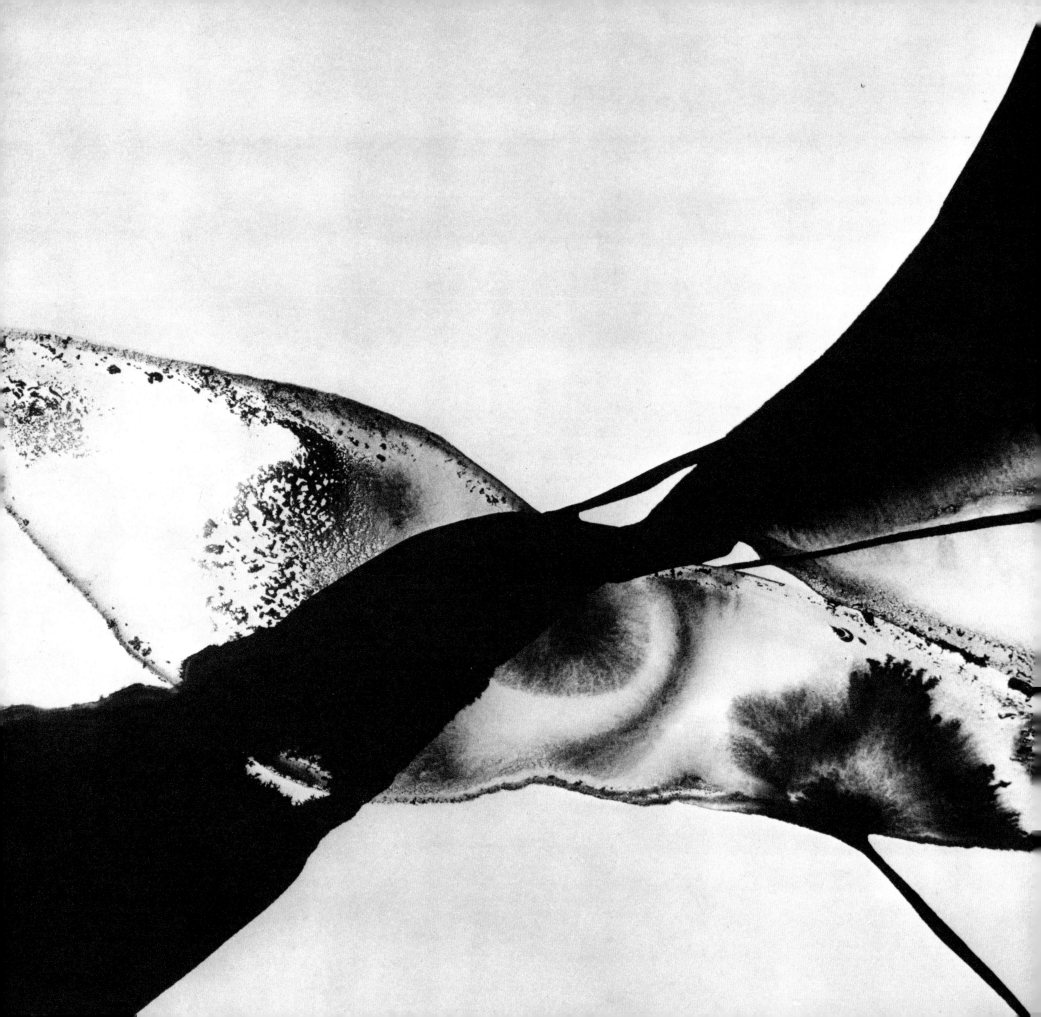

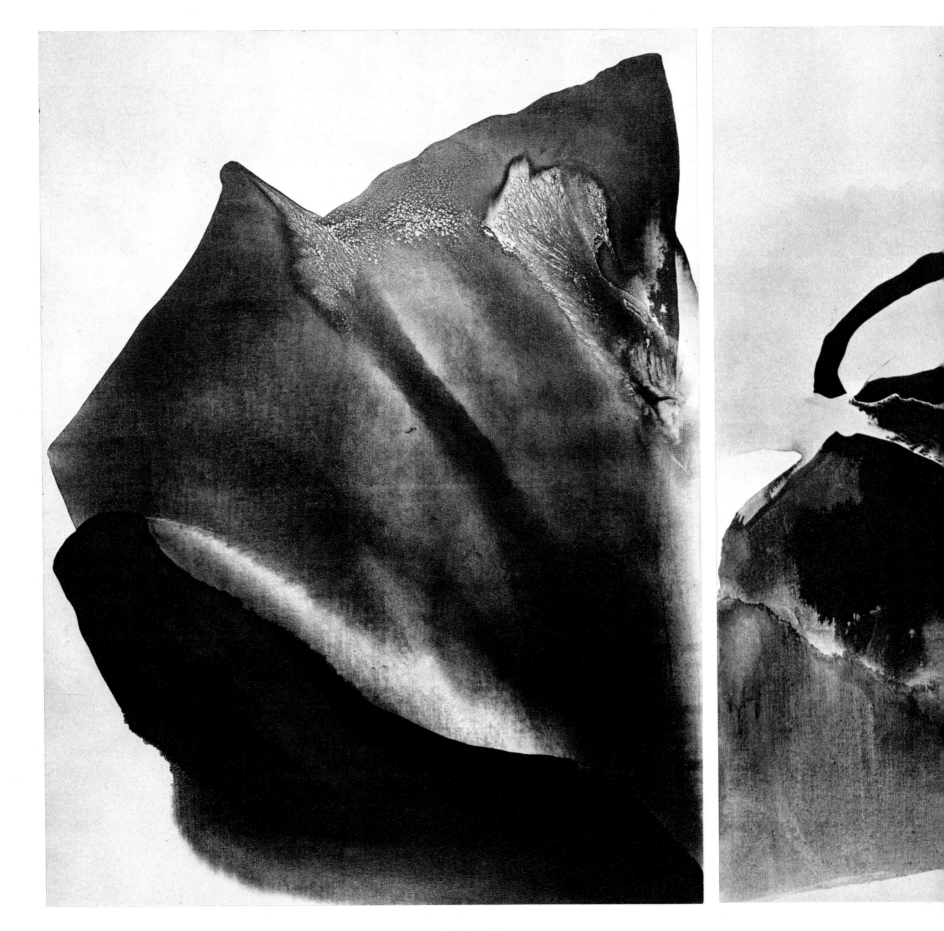

73. *Phenomena Lifted Stigma.* 1961. Acrylic on canvas, 45 5/8 × 35''. Private collection, Paris

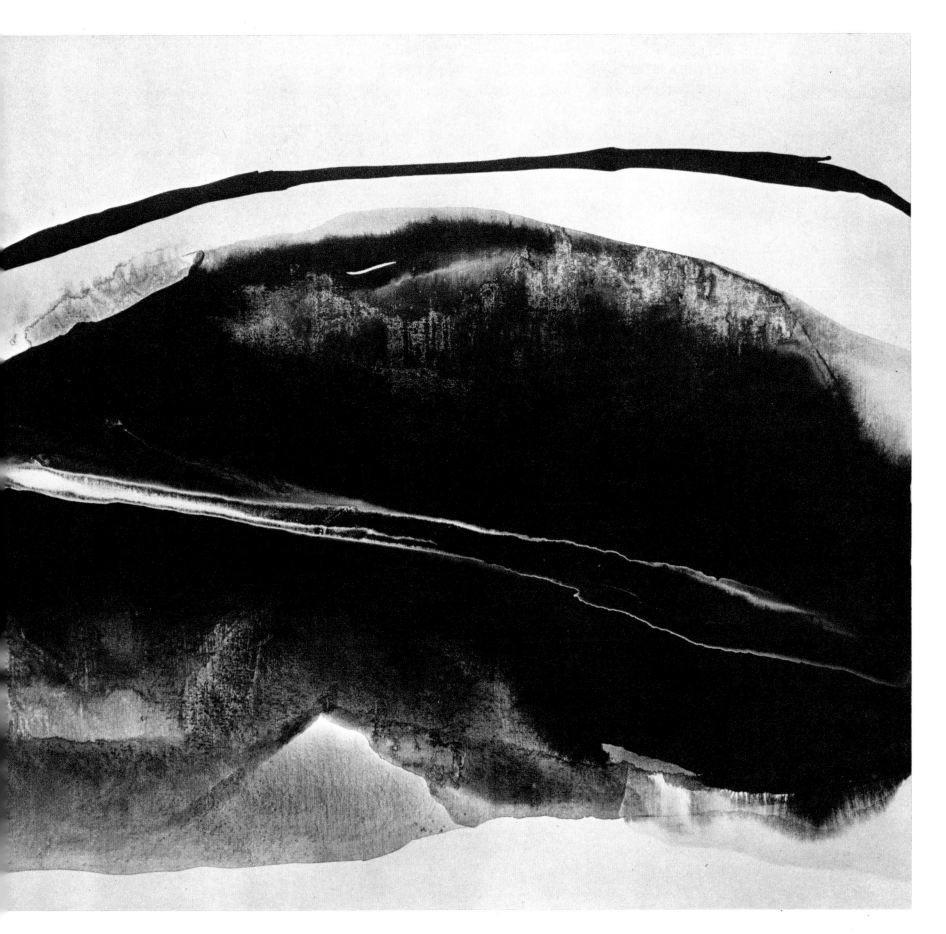

74. *Phenomena Delta Born.* 1961. Acrylic on canvas, 51 1/8 × 69 5/8''. Private collection

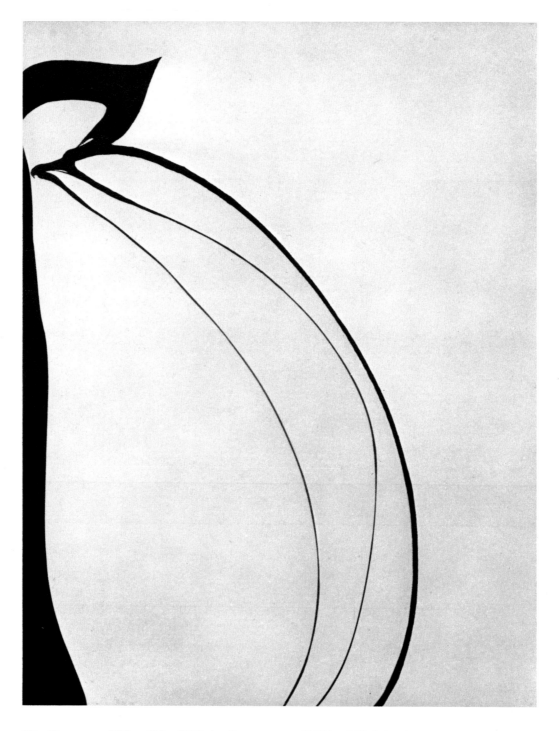

75. *Phenomena White of Ides.* 1963. Acrylic on canvas, 45 5/8 × 35″. Collection Daniel Gervis, Paris

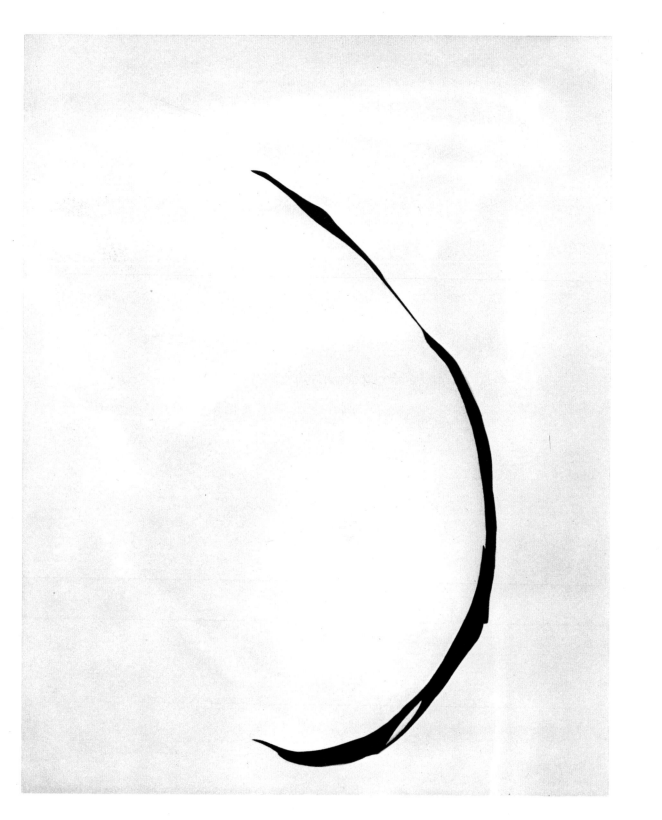

76. *Phenomena Ivory*. 1960. Acrylic on canvas, 40 × 26''. Collection Karl Flinker, Paris

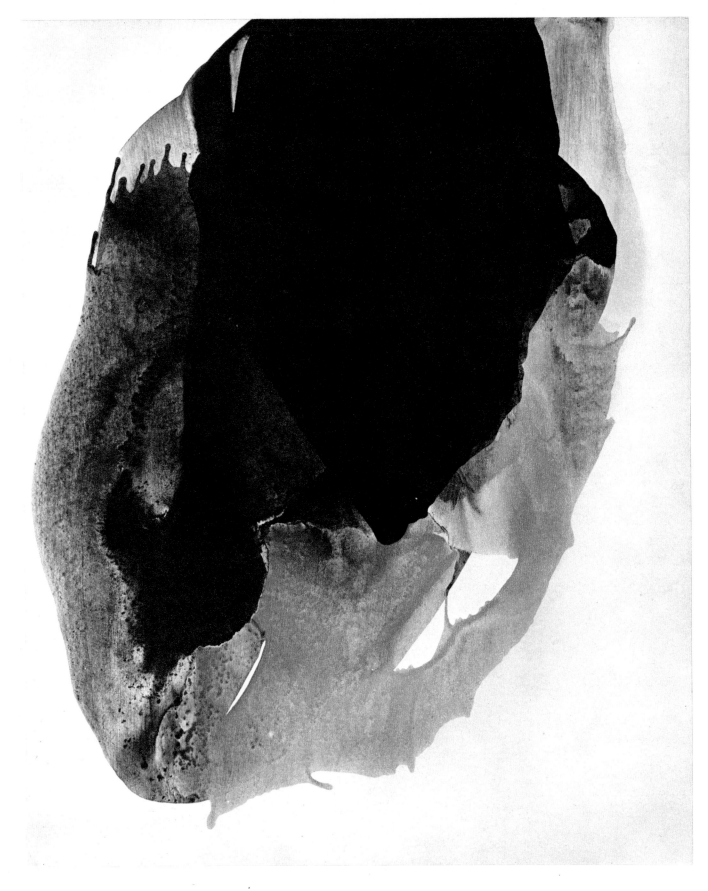

77. *Phenomena Pen Dragon.* 1961. Acrylic on canvas, 64 × 51″. The Solomon R. Guggenheim Museum, New York City

78.
Phenomena Break Silk. 1961.
Watercolor on paper, 93 ×
43''. Private collection

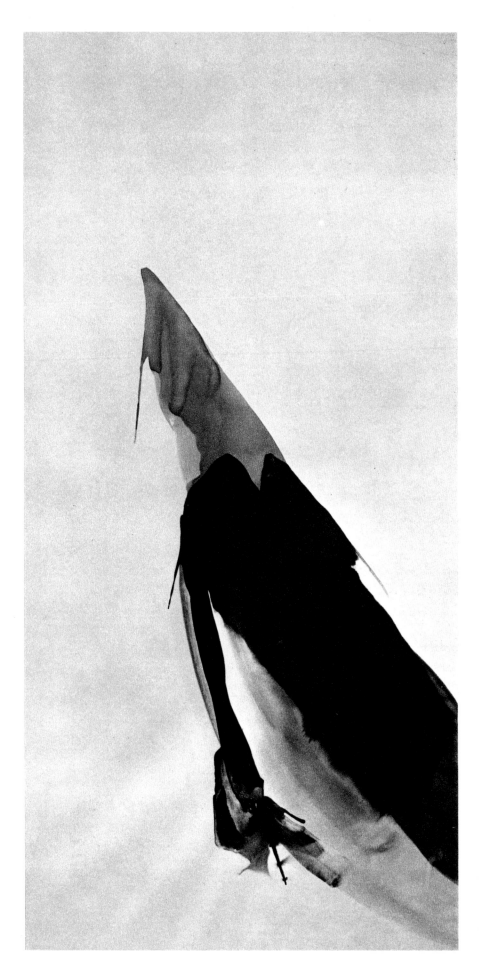

79. ▶
Phenomena Play of Trance.
1962. Acrylic on canvas,
64 × 51″. Collection Prime
Minister and Mrs. Pierre
Trudeau, Ottawa, Canada

80. Photograph of the artist by Syeus Mottel. 1969

81.
Phenomena Code Weather.
1964. Acrylic on canvas,
50 × 23''. Collection Dr.
Jack Stuart Kern, New York
City

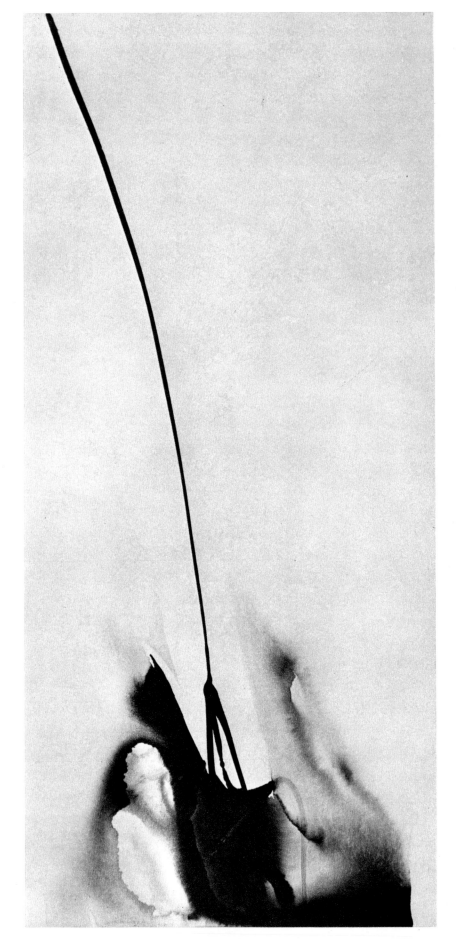

82.
Phenomena Zen Bow String.
1969. Acrylic on canvas,
64 1/2 × 38''. Collection
Brayton Wilbur, Jr., Hills-
borough, Calif.

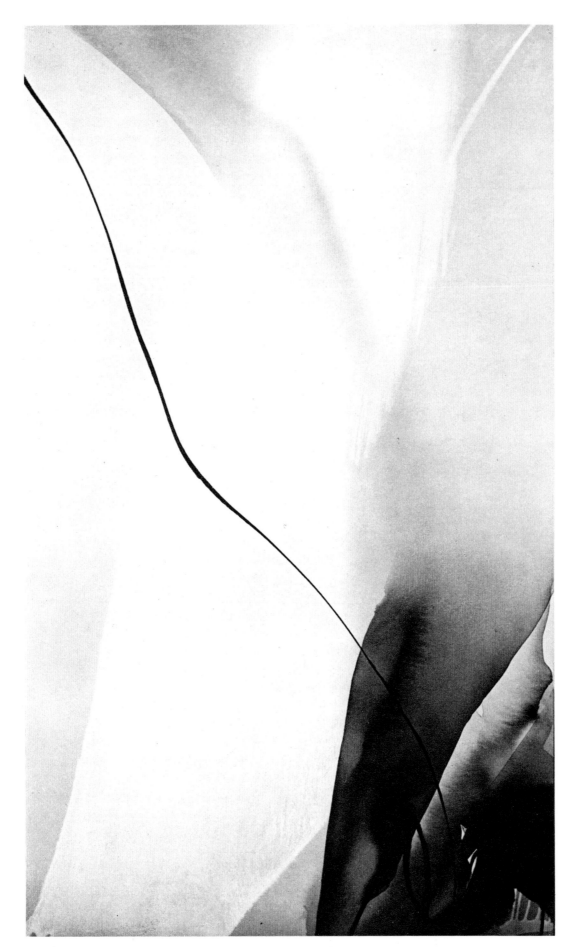

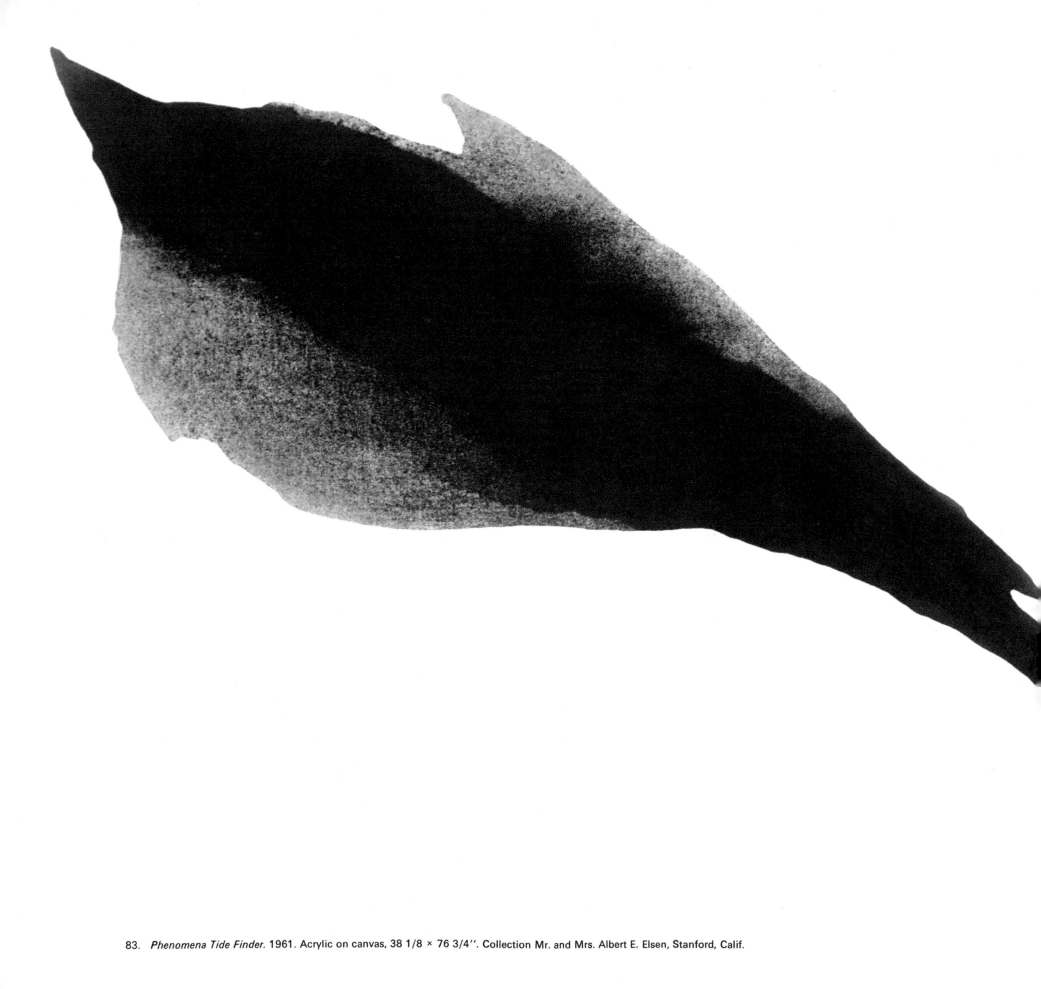

83. *Phenomena Tide Finder.* 1961. Acrylic on canvas, 38 1/8 × 76 3/4''. Collection Mr. and Mrs. Albert E. Elsen, Stanford, Calif.

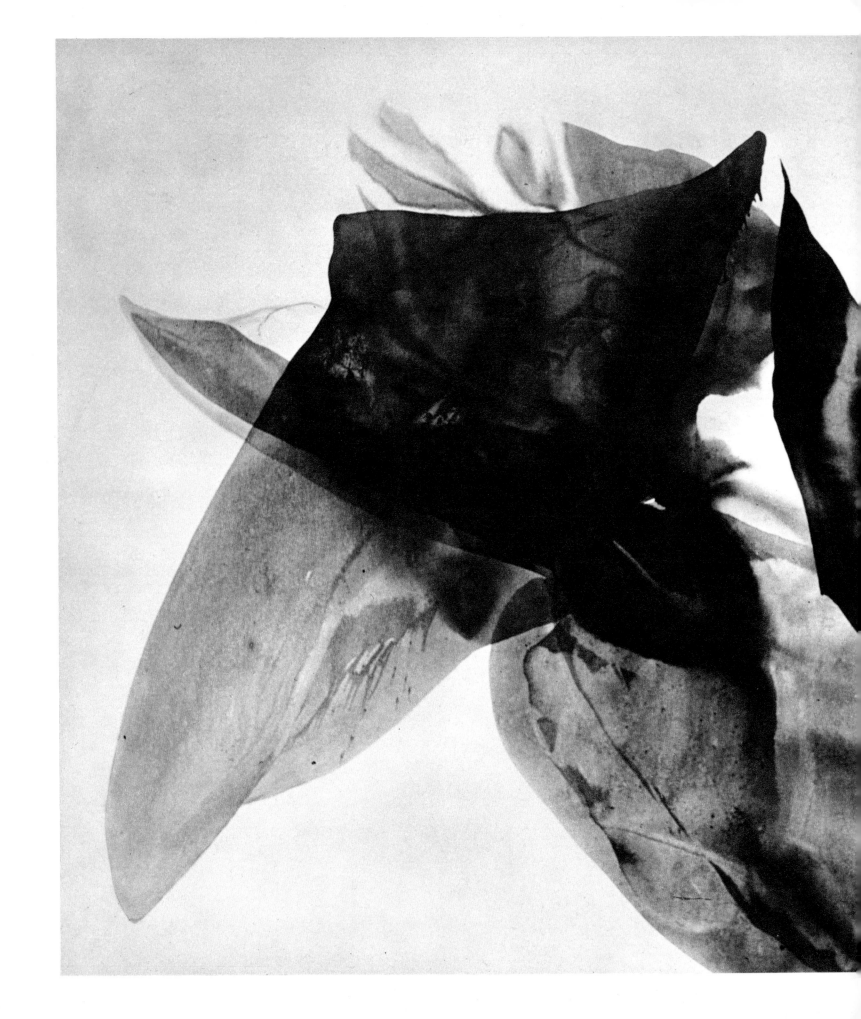

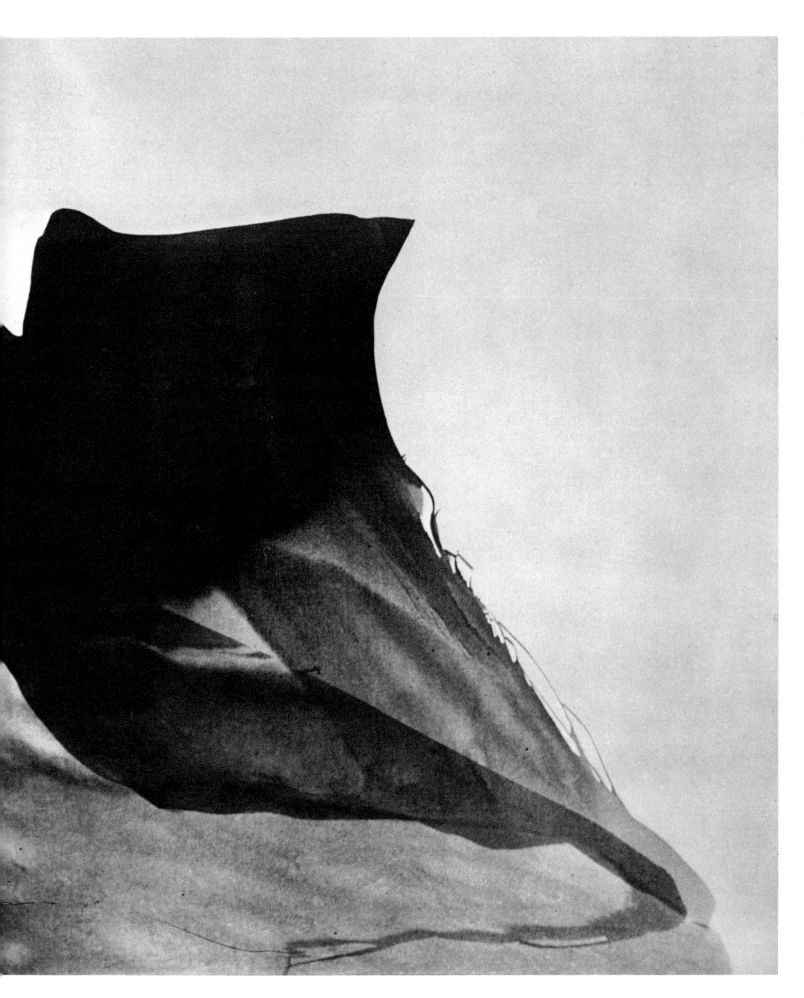

84.
Phenomena Blue and Yellow.
1963. Acrylic on canvas,
6′ × 9′. Staatsgalerie,
Stuttgart

85. *Phenomena Over the Cusp*. 1961. Acrylic on canvas, 6'5'' × 10'7''. Collection Mrs. Albert D. Lasker, New York City

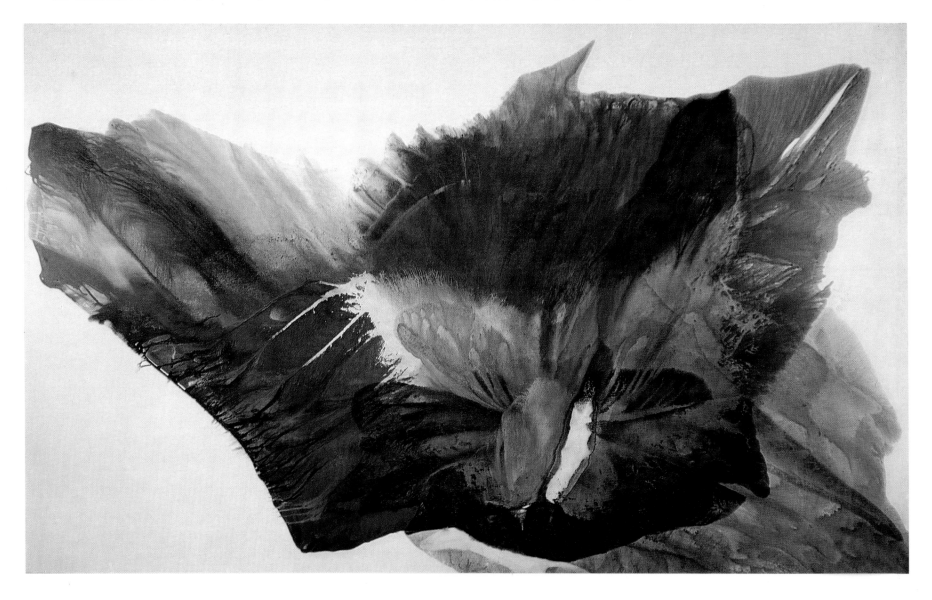

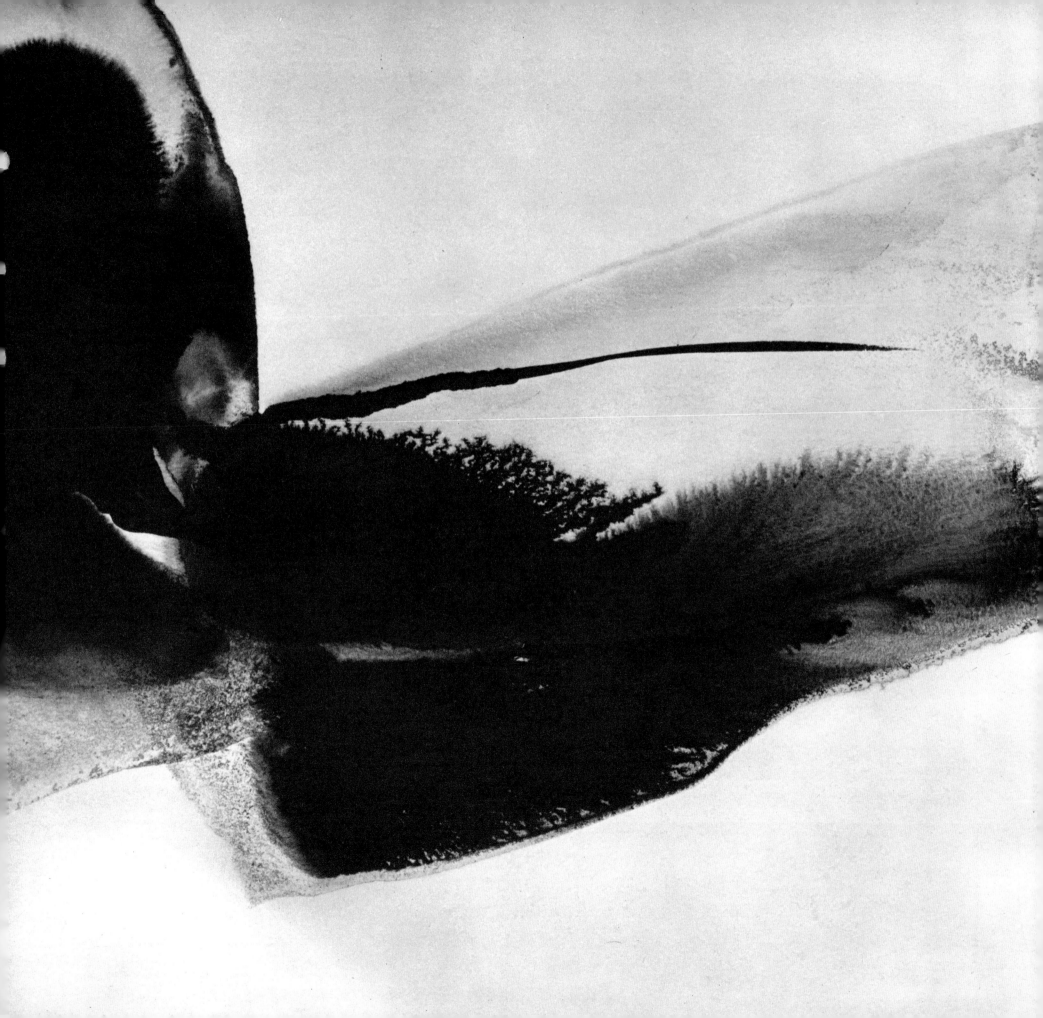

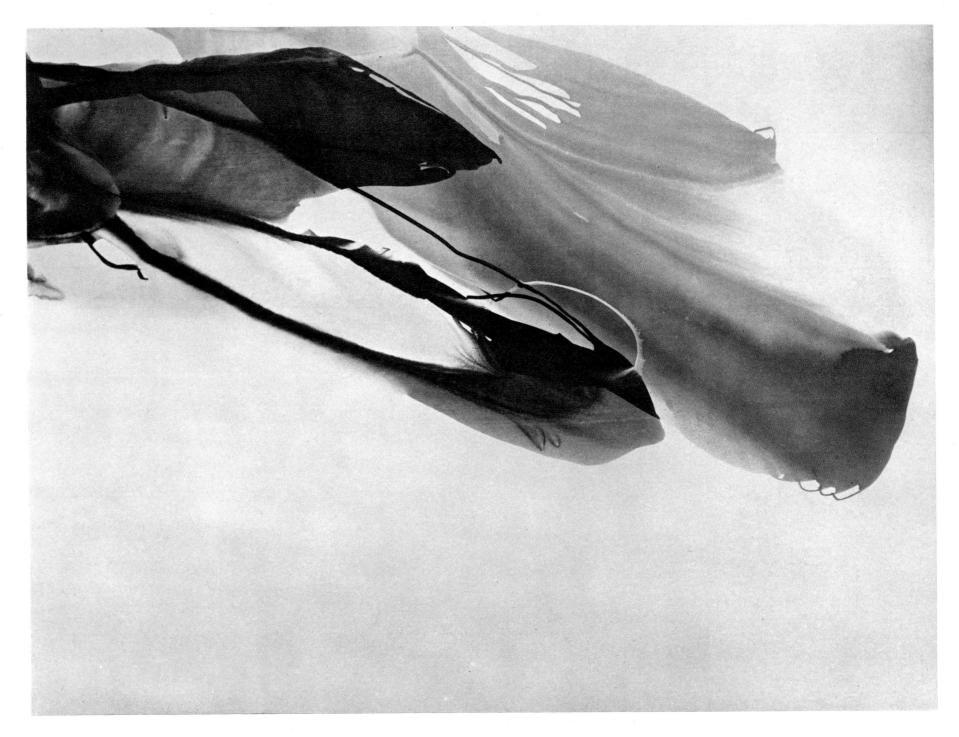

87. *Phenomena Point Swing Flank.* 1964. Acrylic on canvas, 9'9'' × 6'5''. Krannert Art Museum, University of Illinois, Champaign-Urbana

88.
Phenomena with Backlash.
1963. Watercolor on paper,
30 × 22''. Collection Peter
Cochrane, London

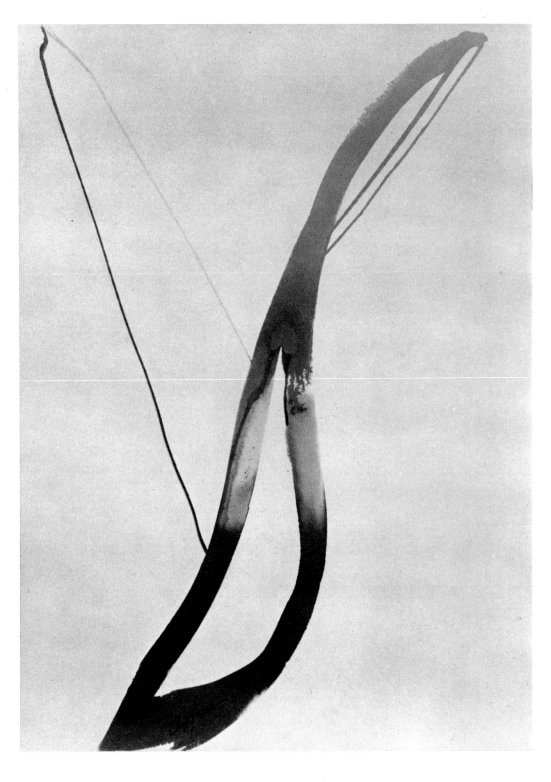

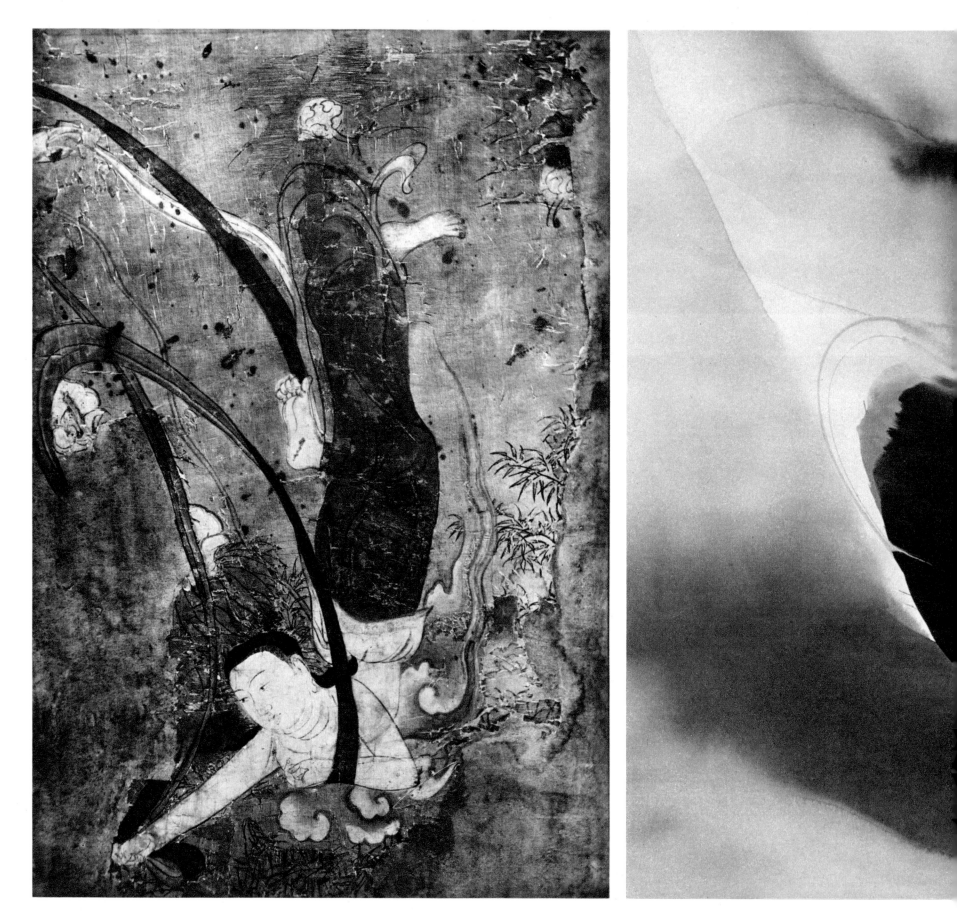

89. Sung Dynasty (960–1279) painting by unknown artist. Musée Guimet, Paris

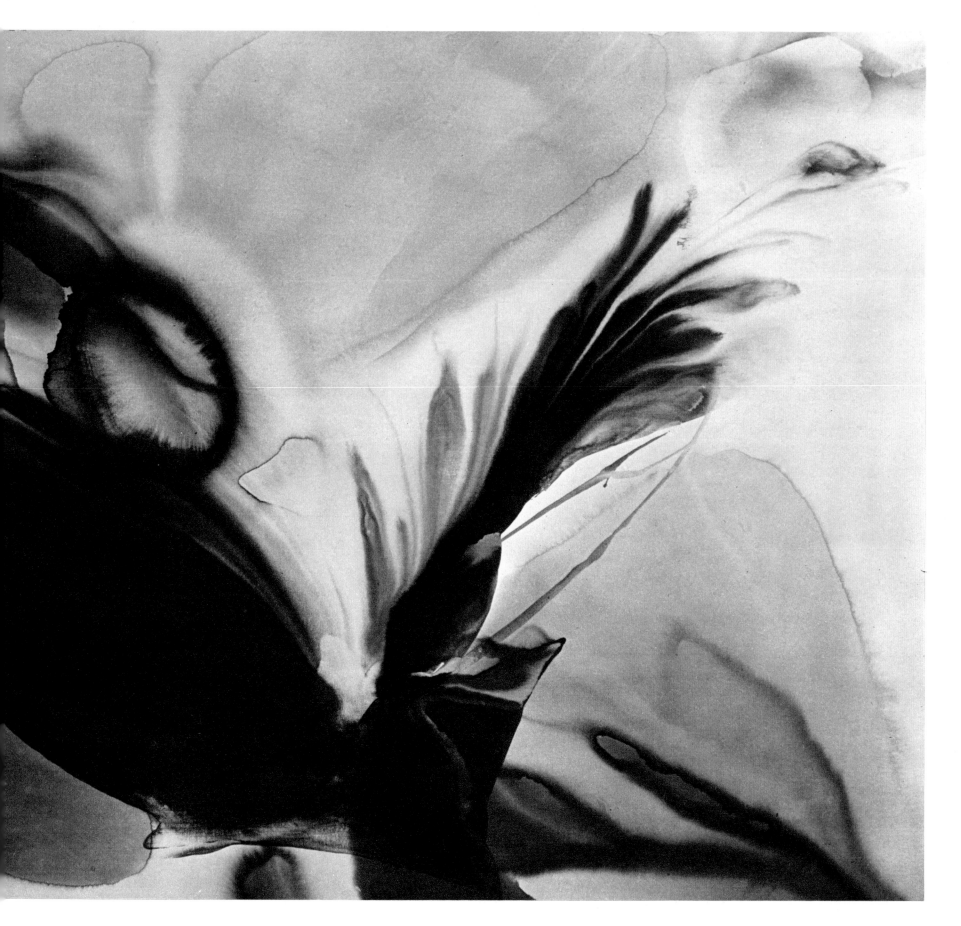

90. *Phenomena Stance of Change.* 1968–69. Acrylic on canvas, 6'5'' × 9'6''. Art Gallery of Ontario, Toronto

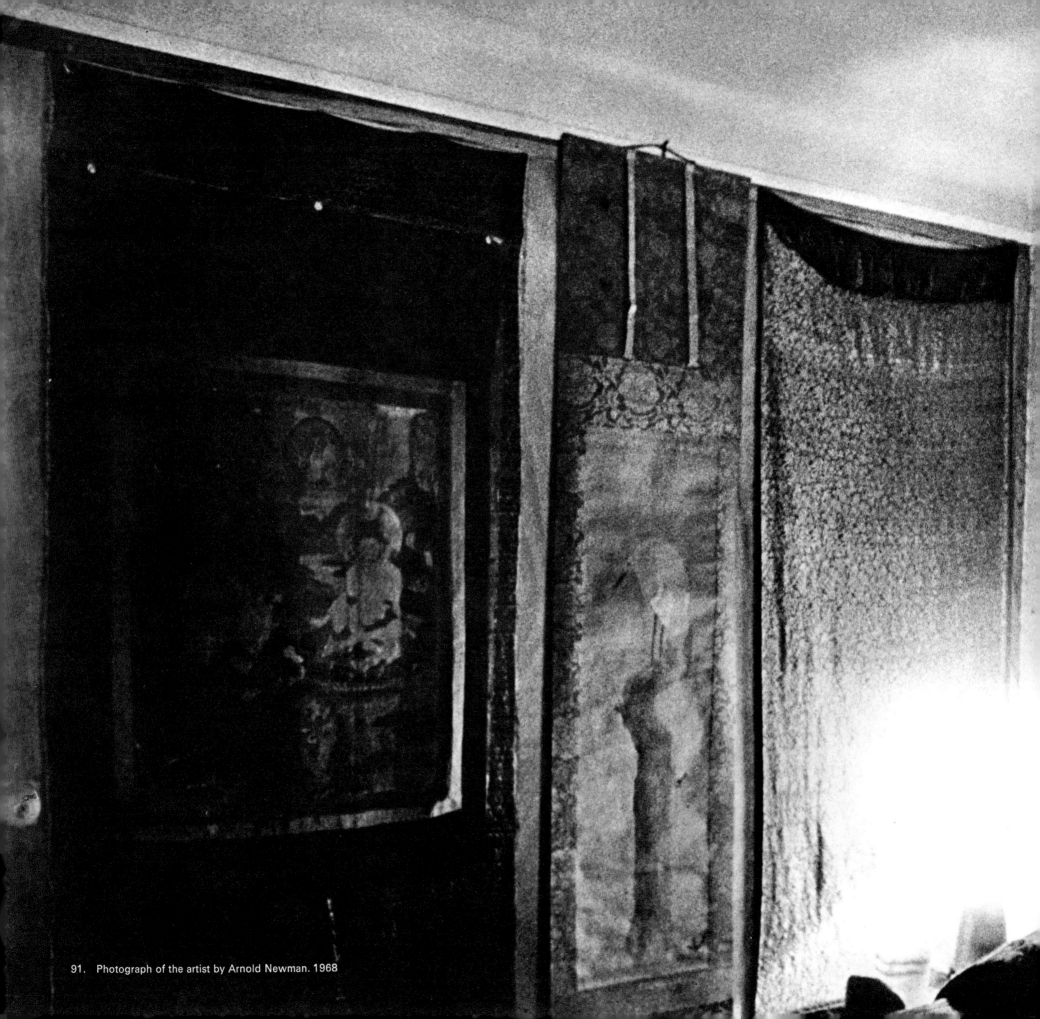

91. Photograph of the artist by Arnold Newman. 1968

92. *Phenomena Ramashandra Ramashandra.* 1962. Acrylic on canvas, 76 3/4 × 59".
Collection Mr. and Mrs. Robert Schoenberg, St. Louis

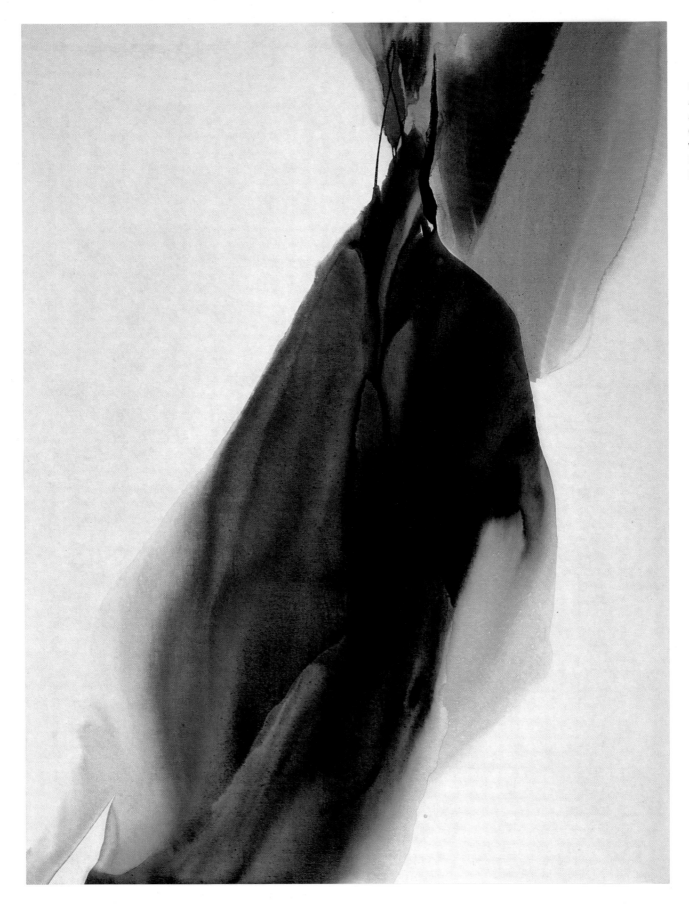

93.
Phenomena Diagonal Points Right. 1966. Acrylic on canvas, 77 × 59 1/4''. University of California Art Museum, Berkeley. Gift of David Kluger

94.
Phenomena Baraka. 1966.
Acrylic on canvas, 62 5/8
× 38 1/8'': Collection Mr.
and Mrs. Ravi Kumar, Paris

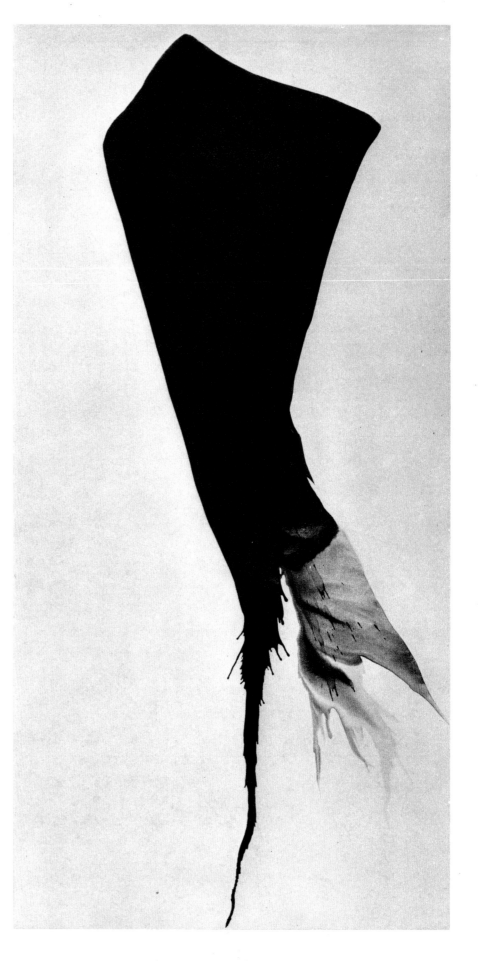

95.
Photograph of the artist
by Claude Picasso. 1969

96.
Phenomena Mirror Mirror.
1961. Watercolor on paper,
30 × 22''. Collection
Cavellini, Brescia, Italy

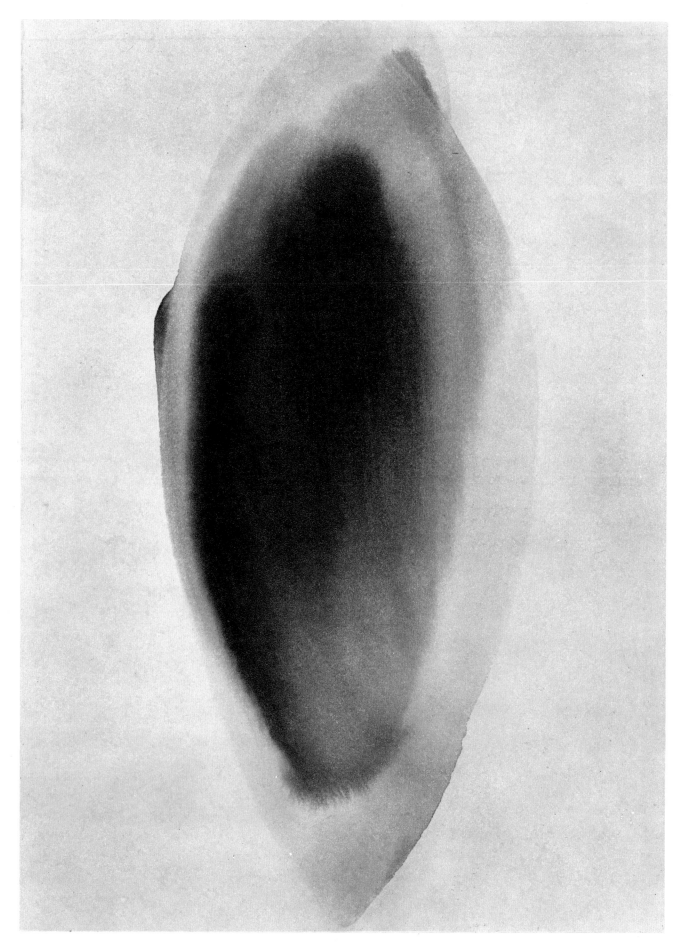

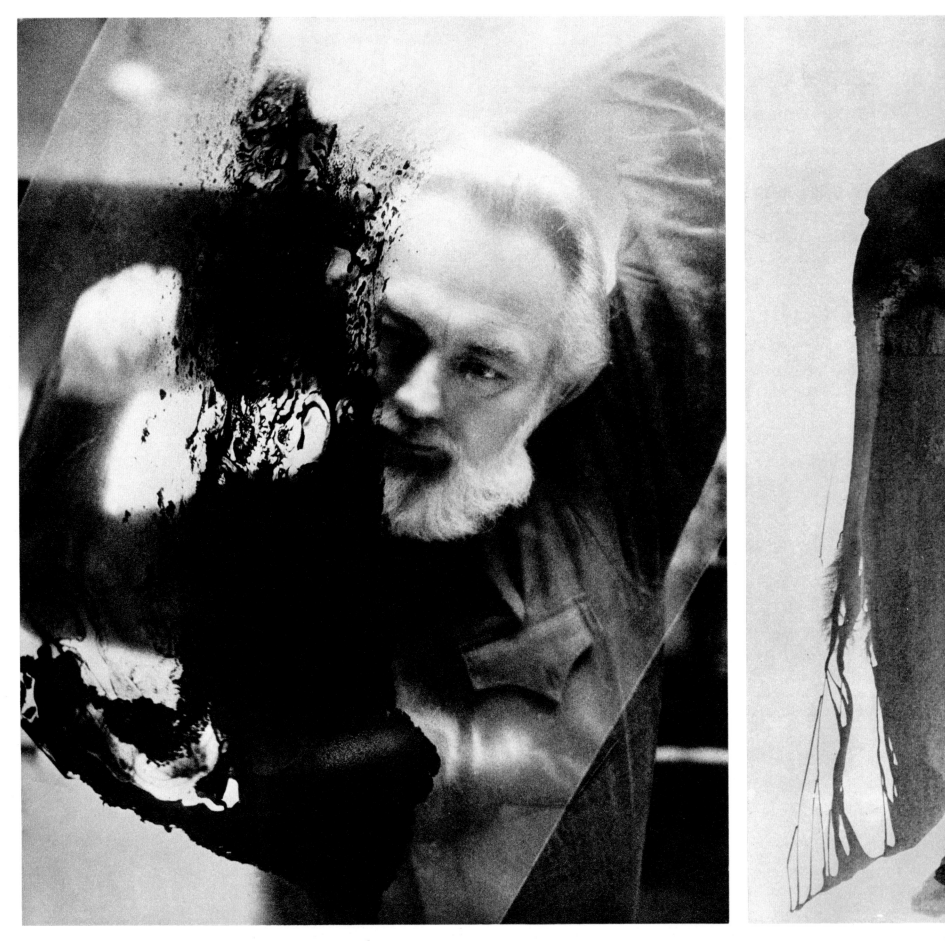

97. Photograph by Syeus Mottel of the artist making a "light graphic." 1969

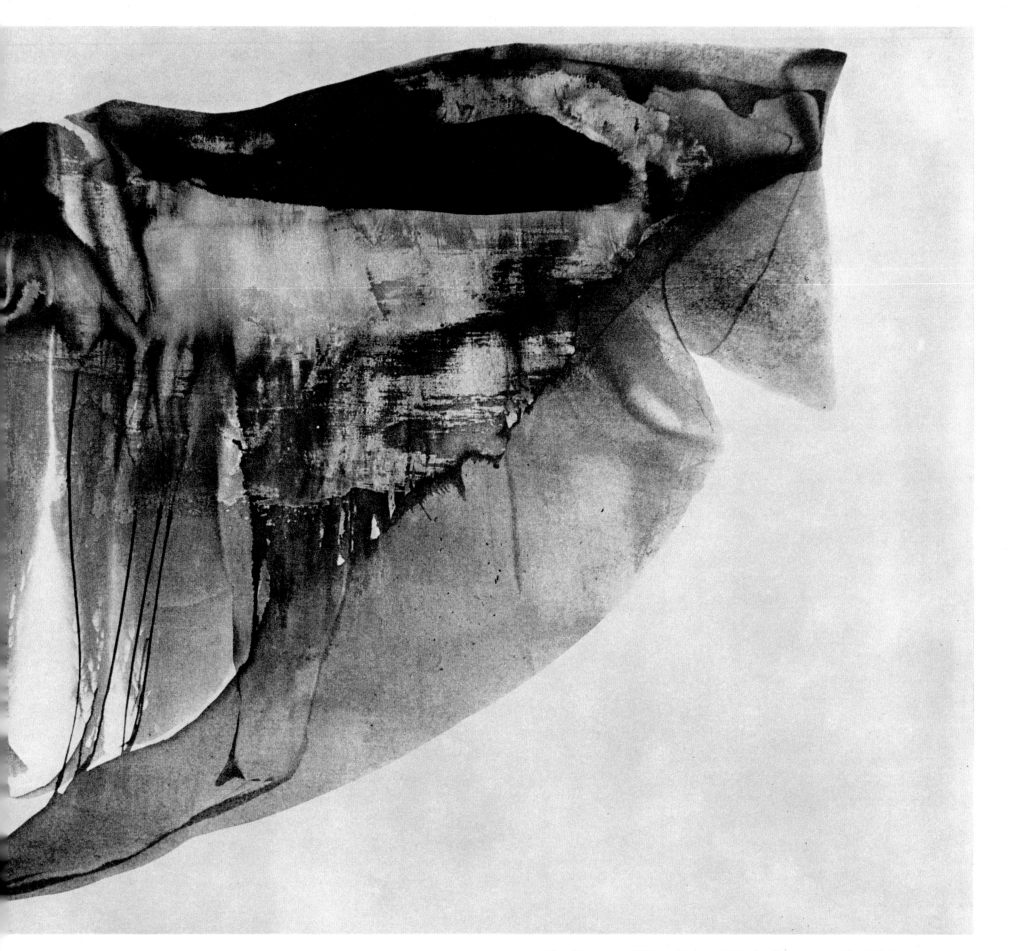

98. *Phenomena Off Cape Hatteras*. 1961. Acrylic on canvas, 6' × 10'. Private collection

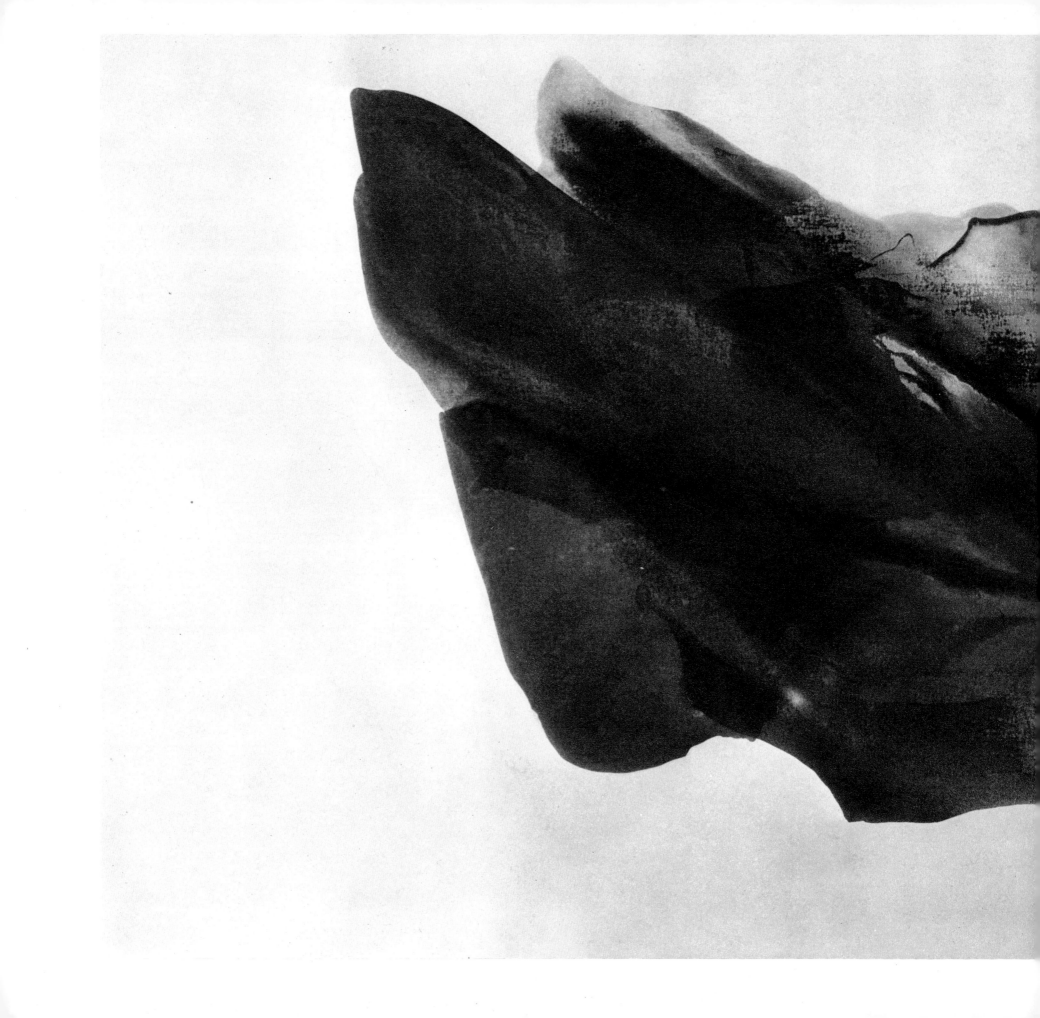

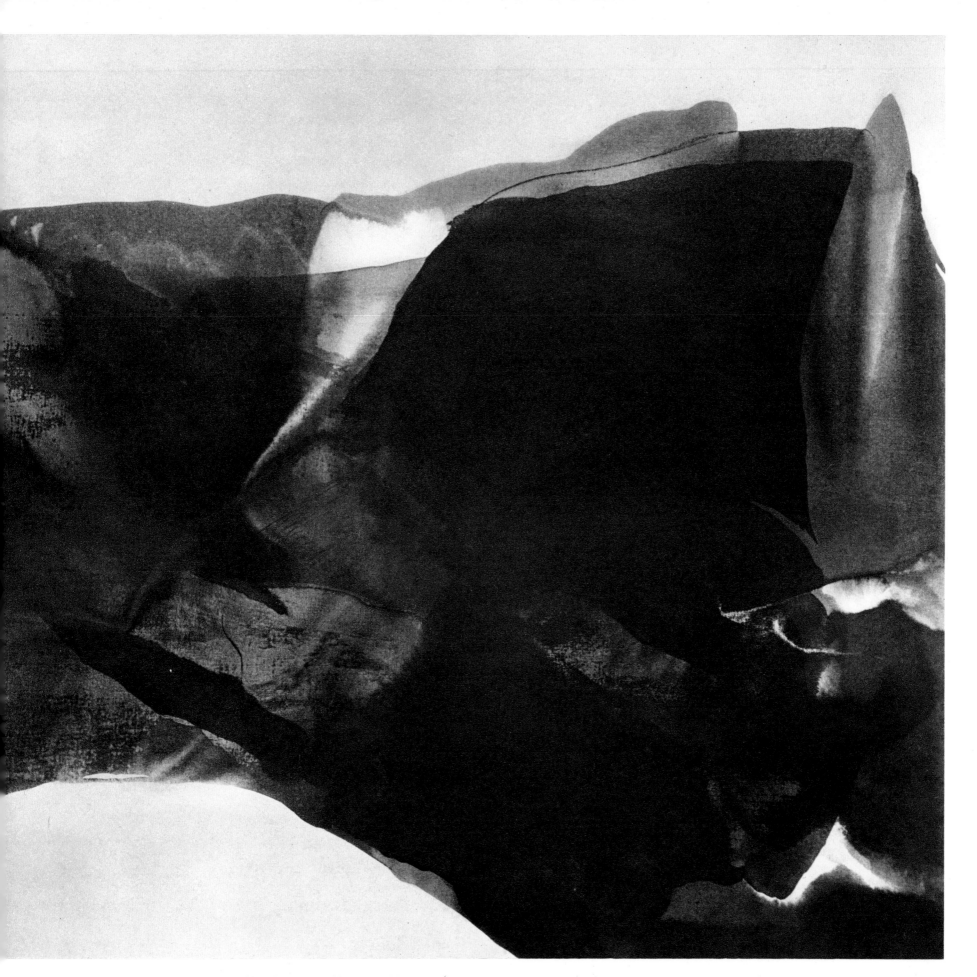

99. *Phenomena Aftermath*. 1962. Acrylic on canvas, 5′ × 9′7 3/4″. Bezalel National Art Museum, Jerusalem. Gift of Baroness Alix de Rothschild

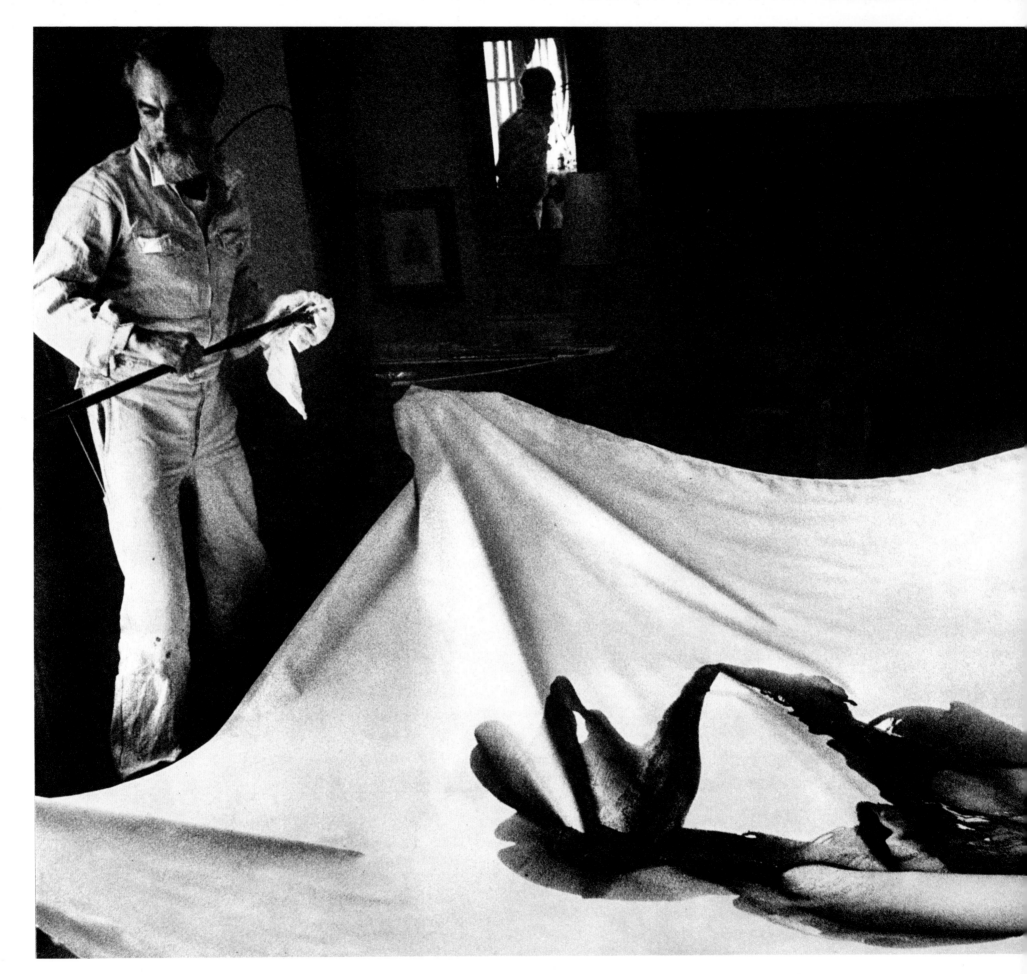

100. Photograph of the artist by Shunk-Kender. 1963

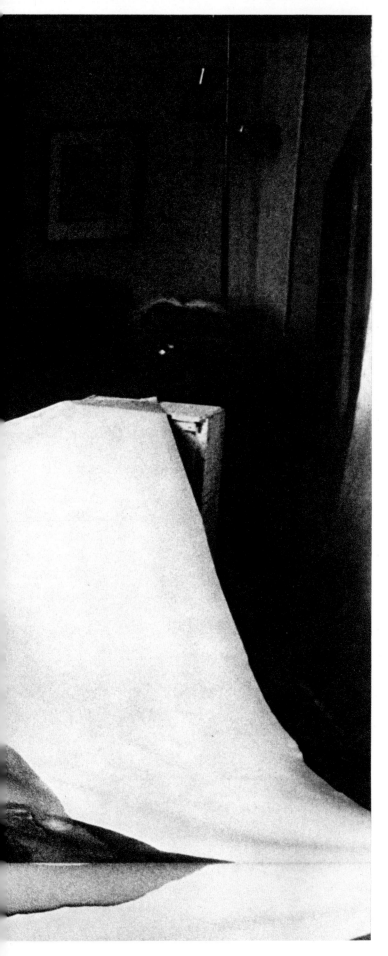

101.
Photograph by Marianne
Adelmann of an ivory knife

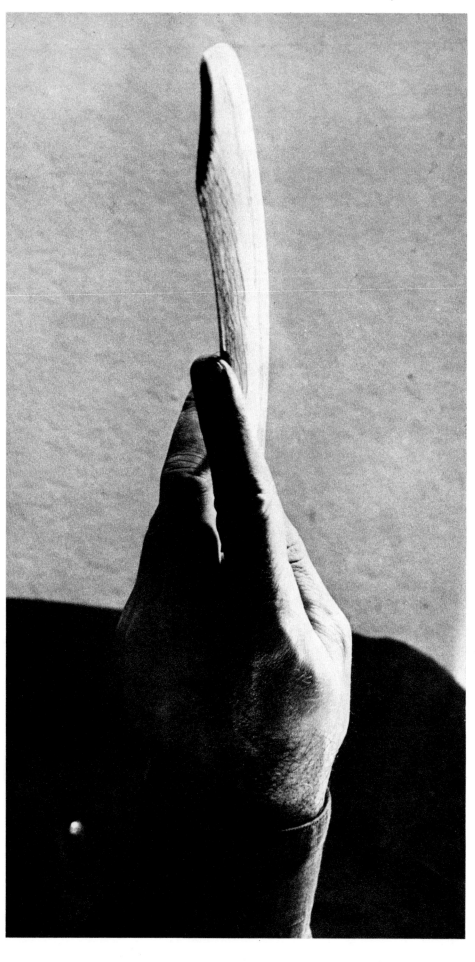

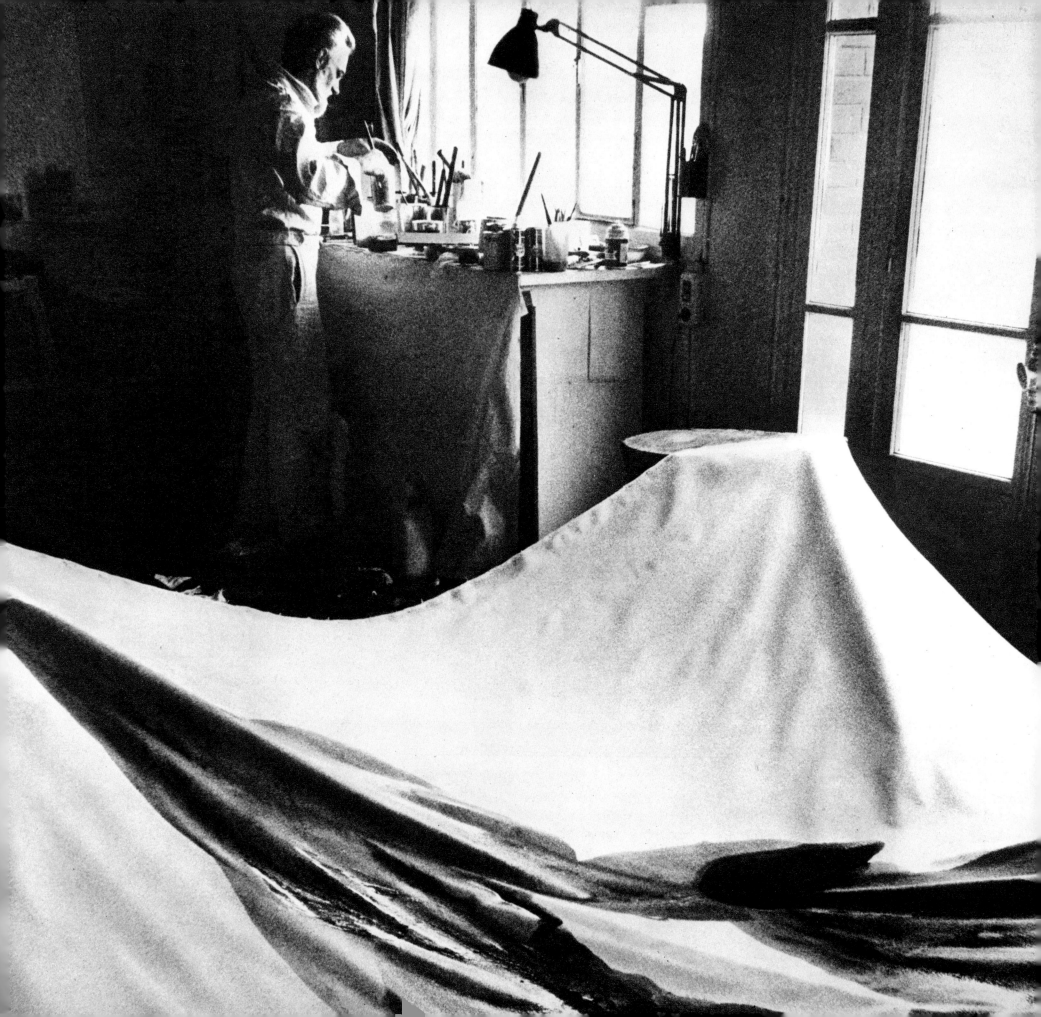

103. *Phenomena Reverse Spell.* 1963. Acrylic on canvas, 6'5'' × 9'7 3/4''. Hirshhorn Museum and Sculpture Garden, Smithsonian Institution, Washington, D.C.

104. *Phenomena Big Blue*. 1960–61. Acrylic on canvas, 57 1/4 × 76 3/4''. Stedelijk Museum, Amsterdam

105.▶
Photograph by Jan Yoors
taken during filming of
The Ivory Knife. 1964

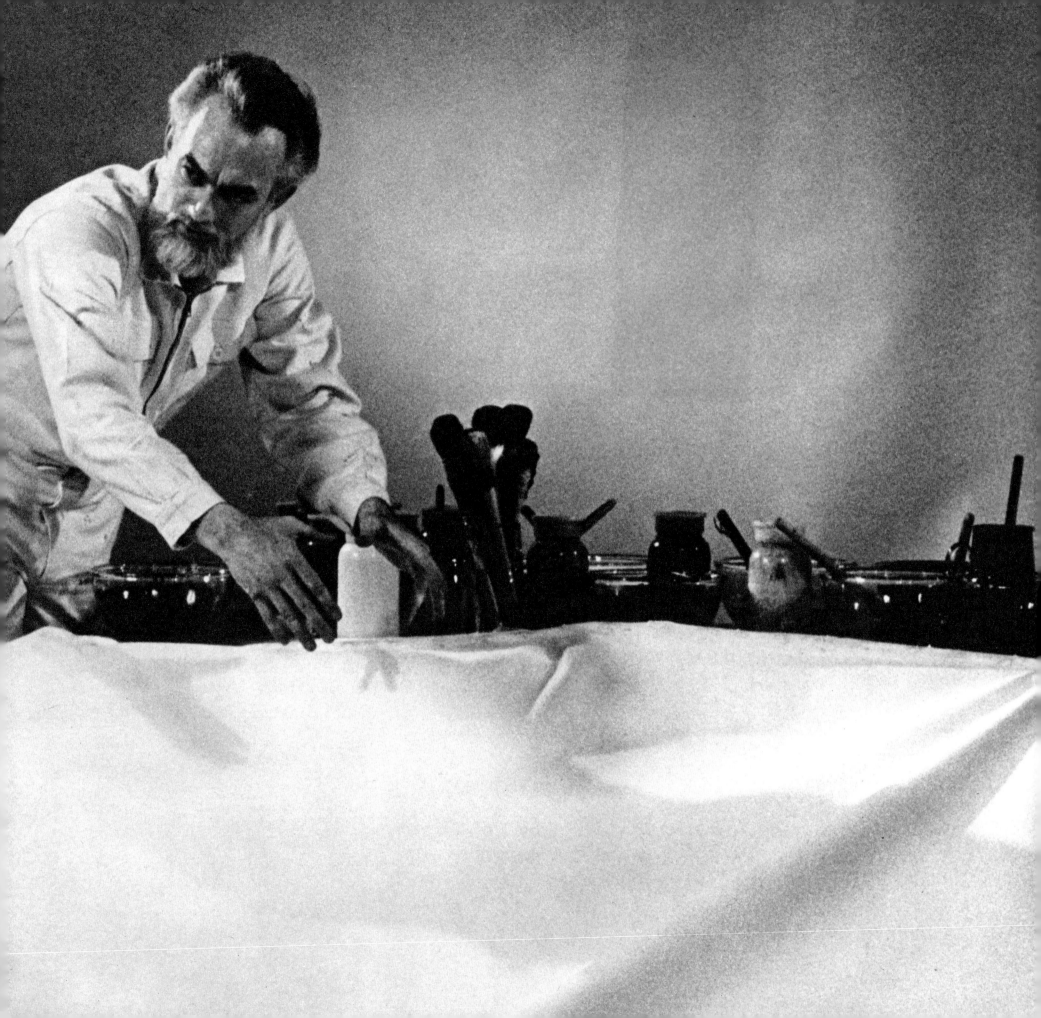

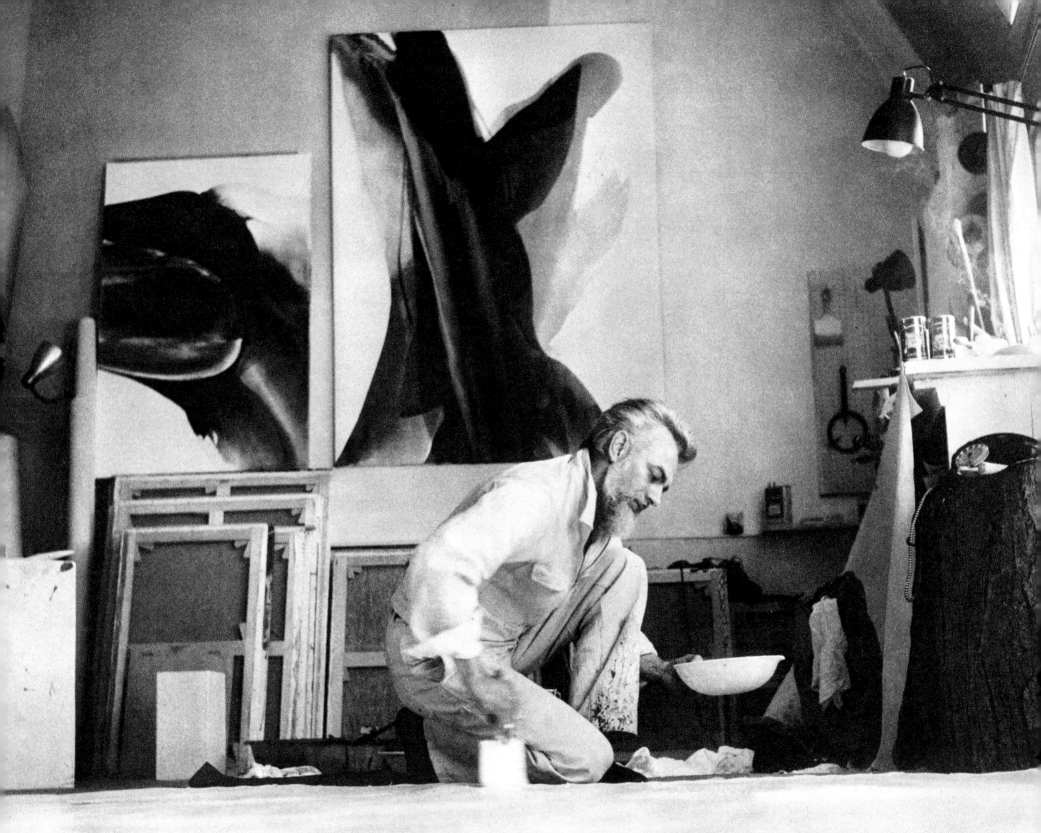

106. Photograph of the artist by Shunk-Kender. 1963

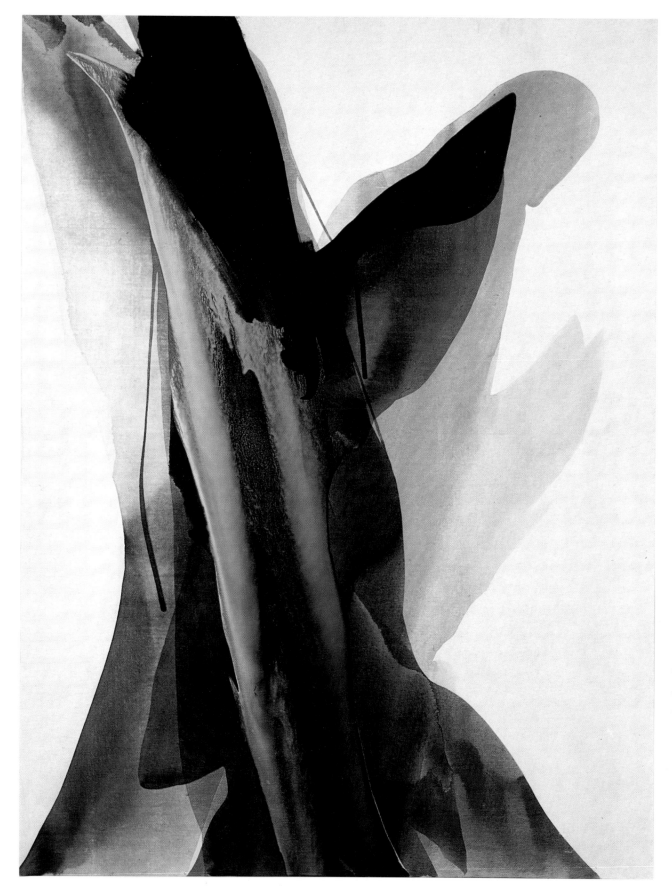

107.
Phenomena Alter Tide.
1963. Acrylic on canvas,
77 × 59''. Des Moines Art
Center. Gift of
Mrs. Albert D. Lasker

108.
Phenomena Grisaille. 1969.
Acrylic on canvas, 92 ×
73''. Collection Hilarie
Paula Jenkins, New York
City

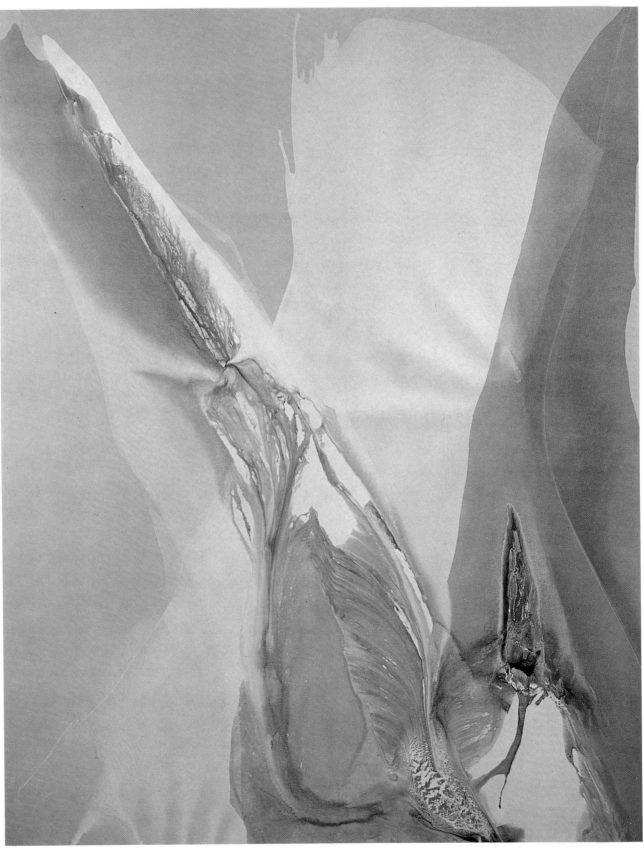

109. Photograph of the artist by Shunk-Kender. 1963▶

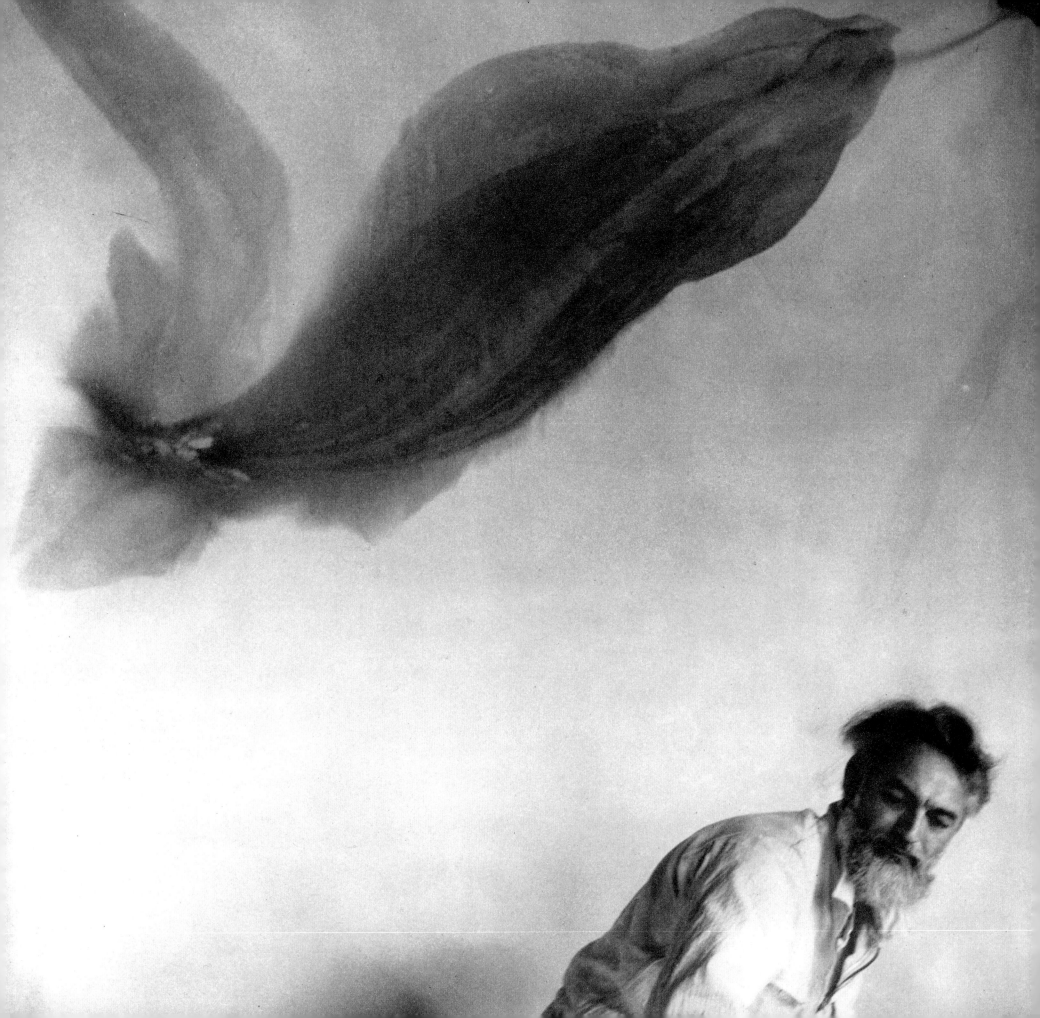

110.
Phenomena Near Carnac.
1962. Acrylic on canvas,
65 × 51 1/8''. Collection
Lefebvre-Foinet, Paris

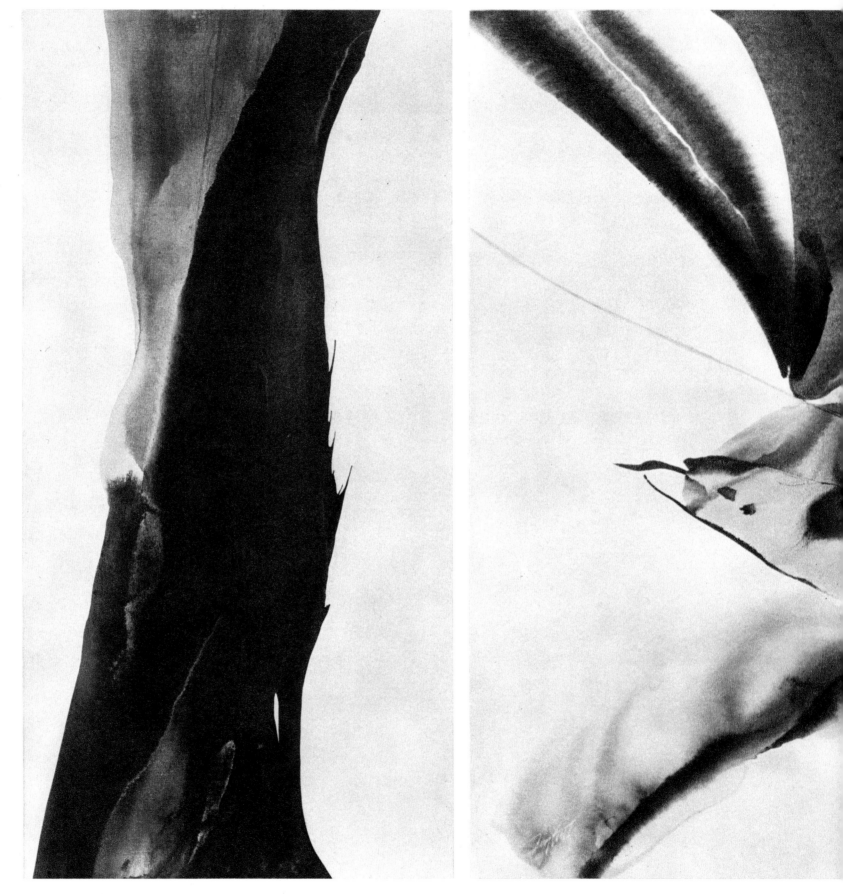

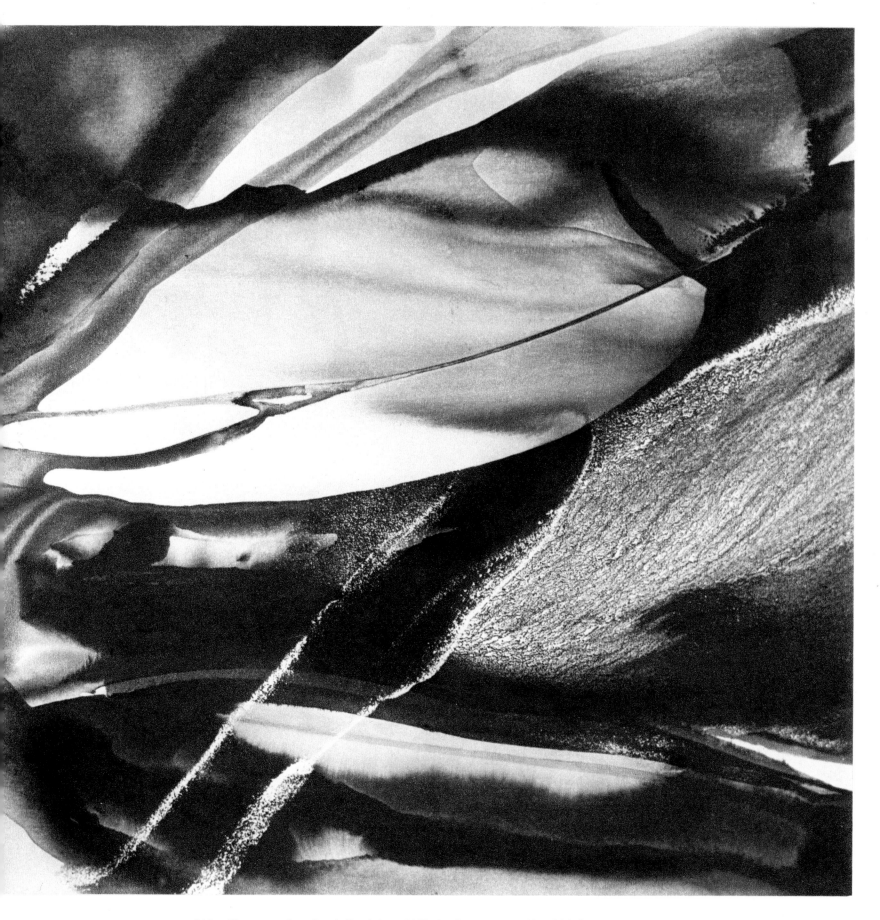

111. *Phenomena Start Break, Break Start.* 1965. Acrylic on canvas, 40 × 60''. Collection Mr. and Mrs. Richard C. Rubin, New York City

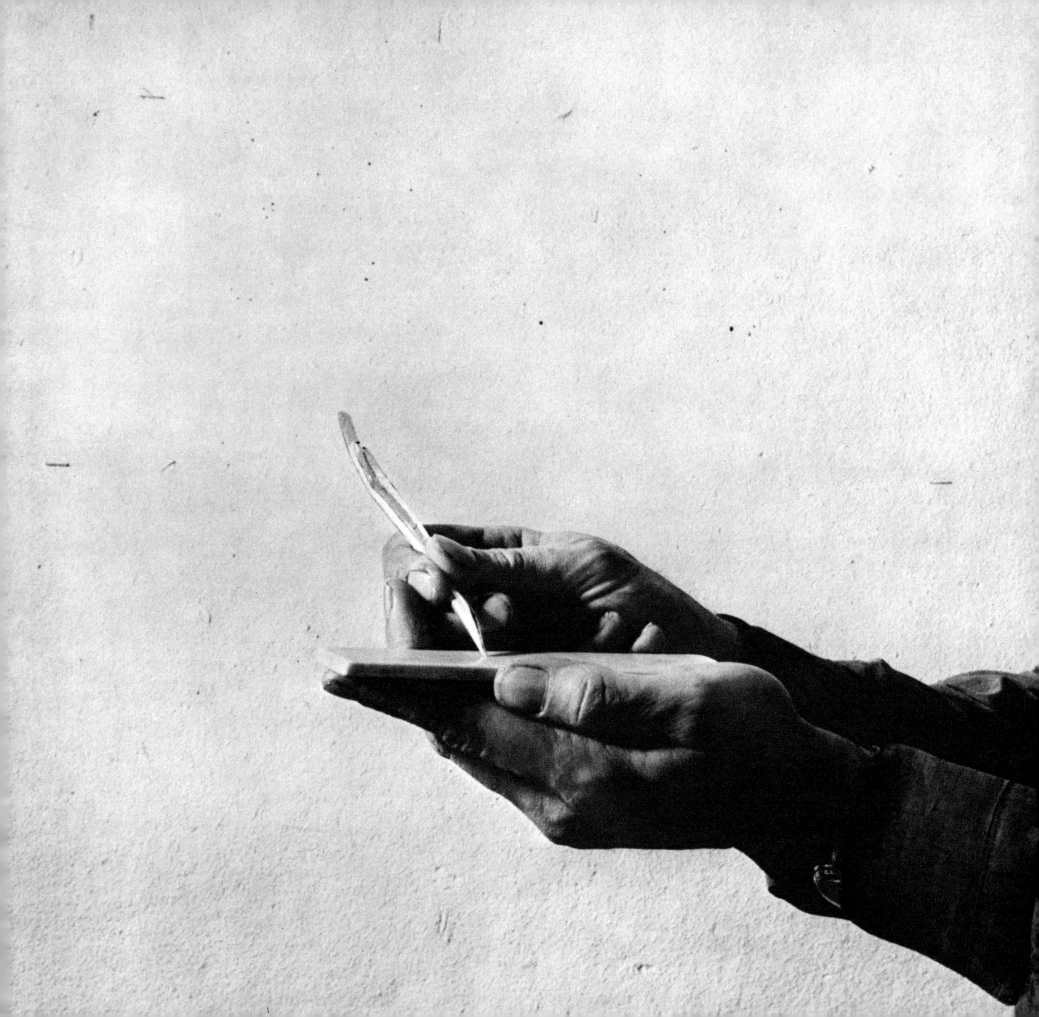

◀112.
Photograph by Marianne
Adelmann of the artist draw-
ing with silverpoint. 1963

113.
Phenomena Yellow Strike.
1963. Acrylic on canvas,
80 × 40''. The Museum of
Modern Art, New York City.
Gift of David Kluger

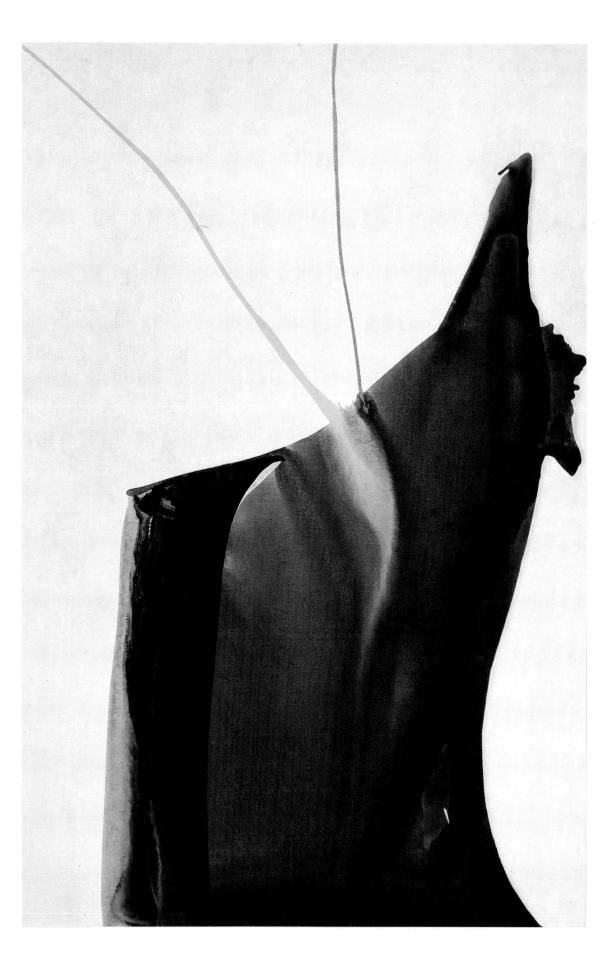

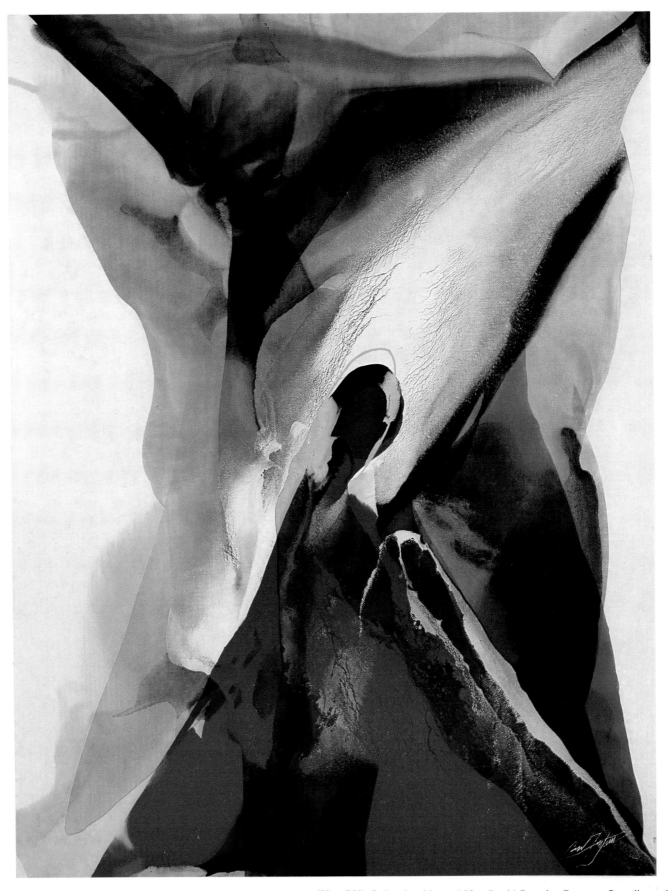

114. *Phenomena Phenomena.* 1967. Acrylic on canvas, 76 × 59''. Collection Mr. and Mrs. David Douglas Duncan, Castellaras, France

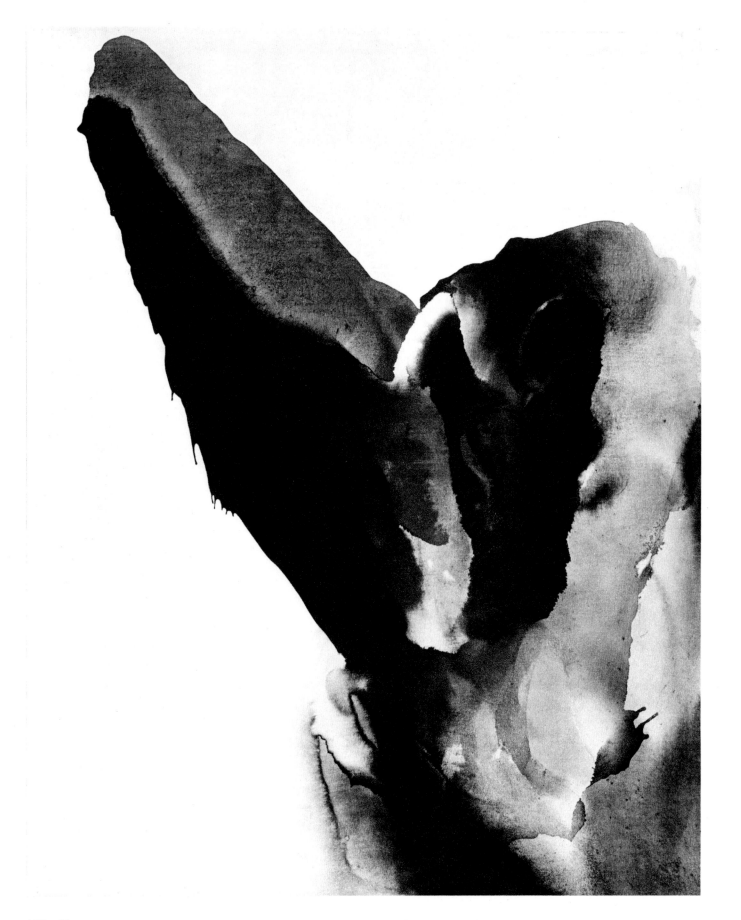

115. *Phenomena Fly Sandman.* 1960. Acrylic on canvas, 76 3/4 × 57 1/2″. Collection Constant Wormser, Paris

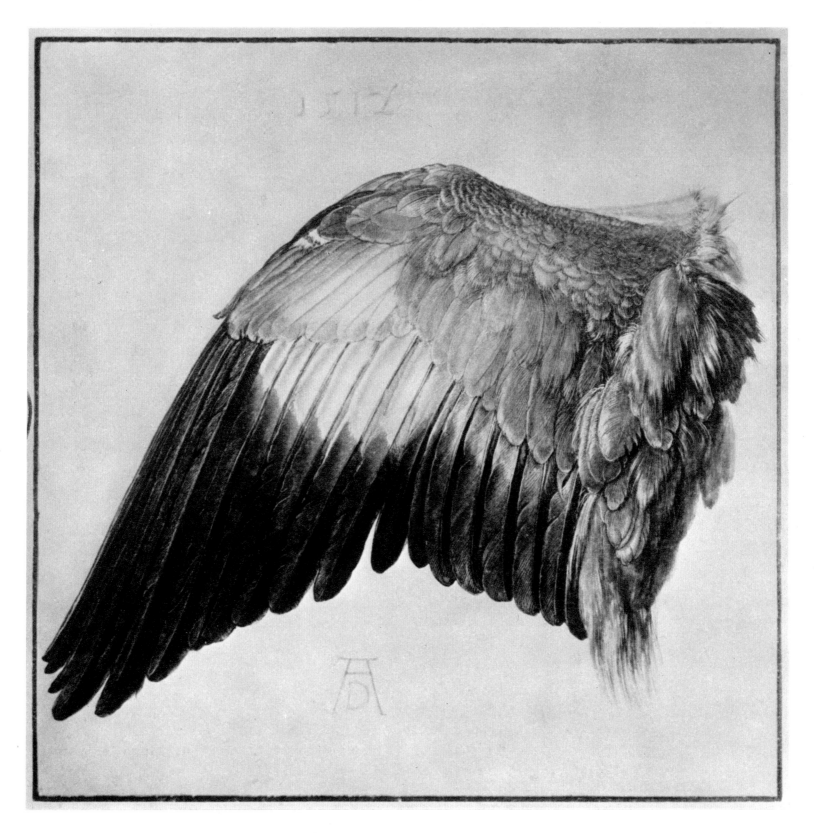

116. Albrecht Dürer: *Wing of a Blue Roller*. 1512. Watercolor and gouache on vellum, 7 3/4 × 7 7/8''. Albertina, Vienna

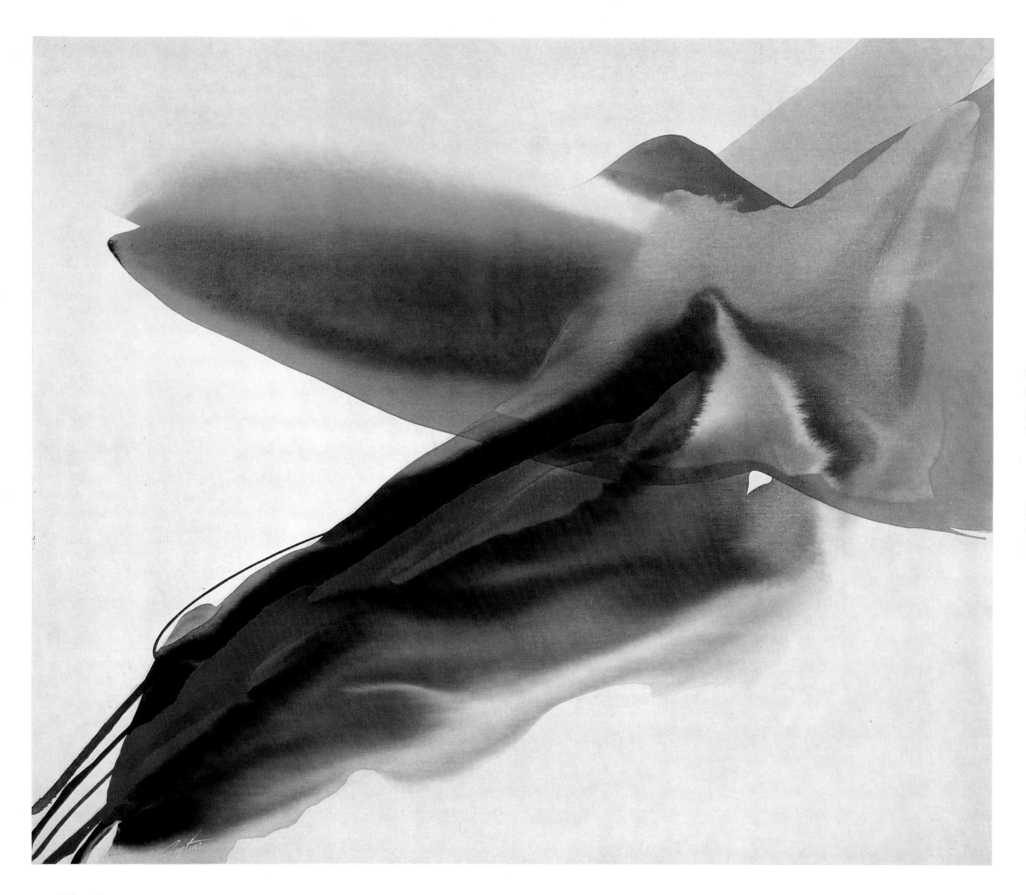

117. *Phenomena High Water Mark.* 1967. Acrylic on canvas, 60 × 72''. Collection Mr. and Mrs. Myron Minskoff, New York City

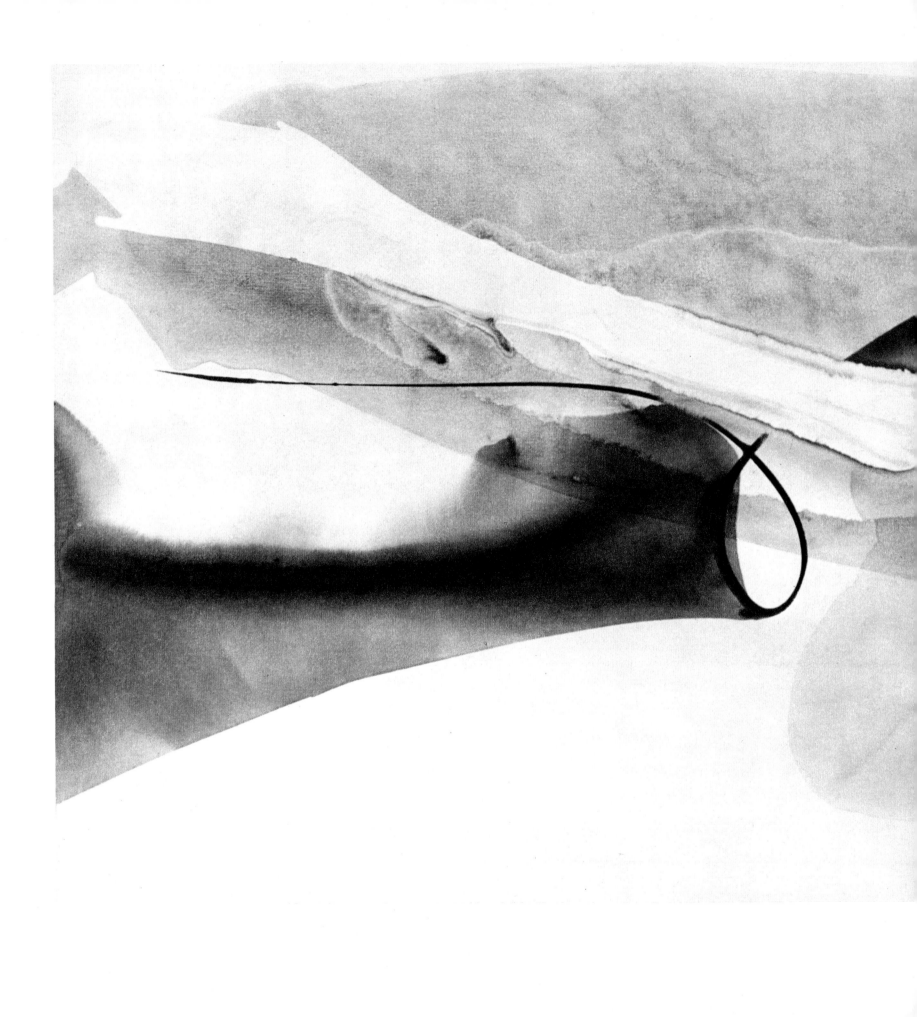

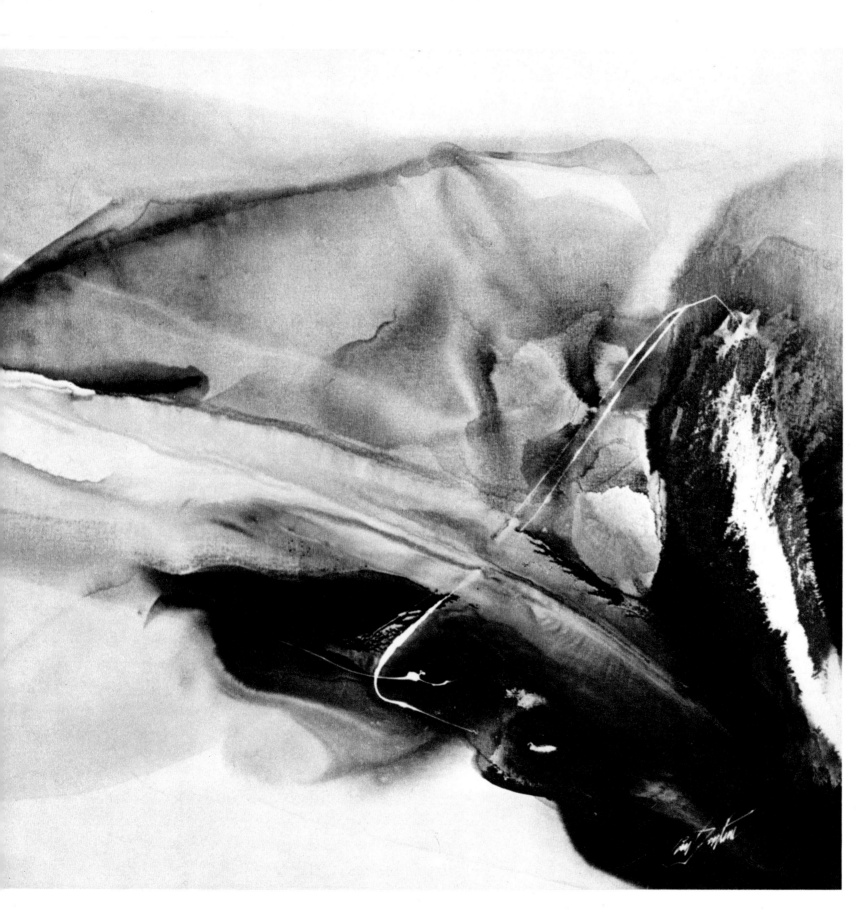

118. *Phenomena Broken Loop.* 1969. Acrylic on canvas, 35 × 72″. Collection Mr. and Mrs. Harry W. Anderson, Atherton, Calif.

119. Photograph of the artist by Akira Kokubo. 1971

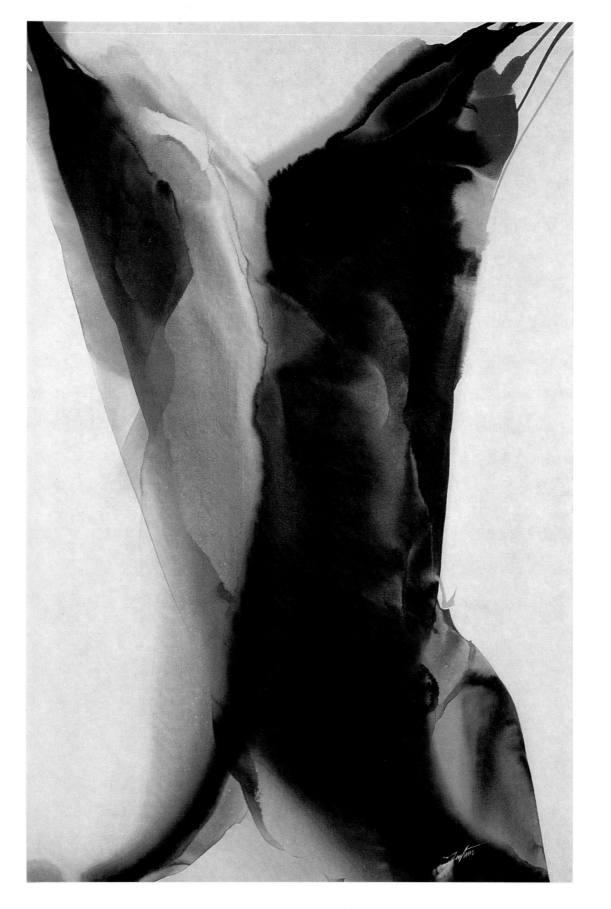

120. *Phenomena Samothrace.* 1967. Acrylic on canvas, 72 × 48''. Dallas Museum of Fine Arts. Gift of the Meadows Foundation

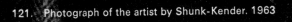
121. Photograph of the artist by Shunk-Kender. 1963

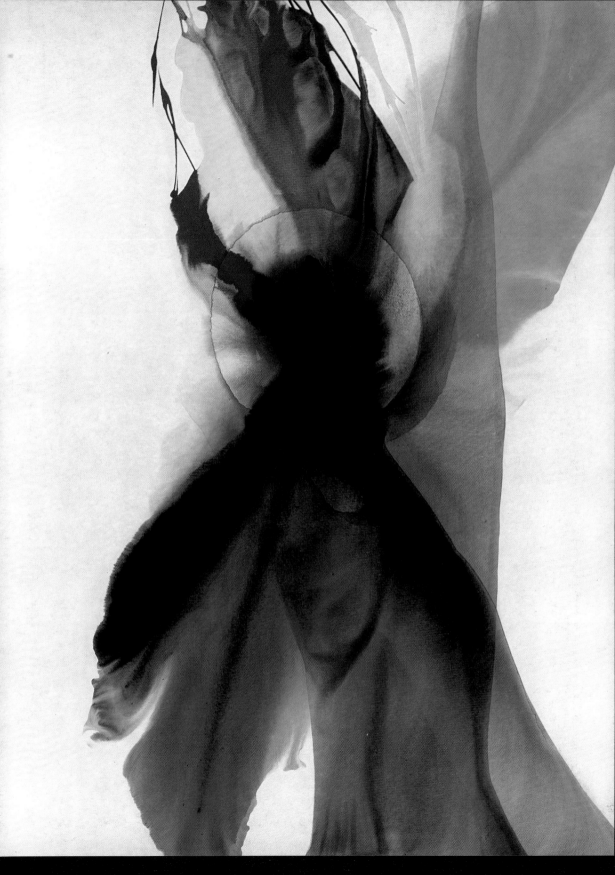

122. *Phenomena Sign of Zagorsk.* 1968. Acrylic on canvas, 64 × 48''. Collection the artist, Paris

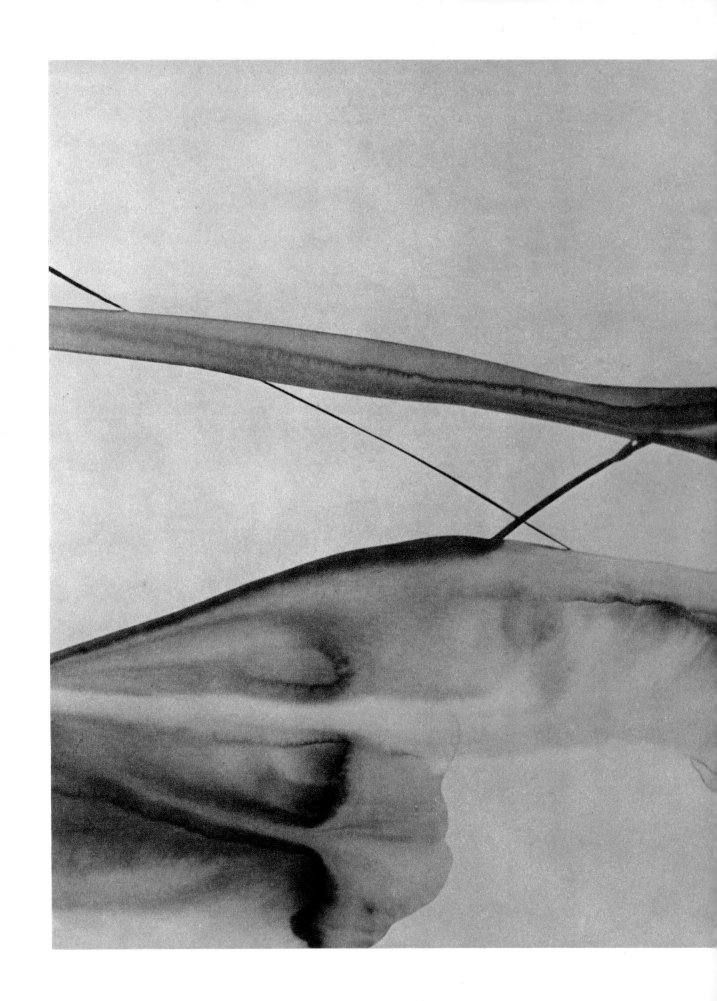

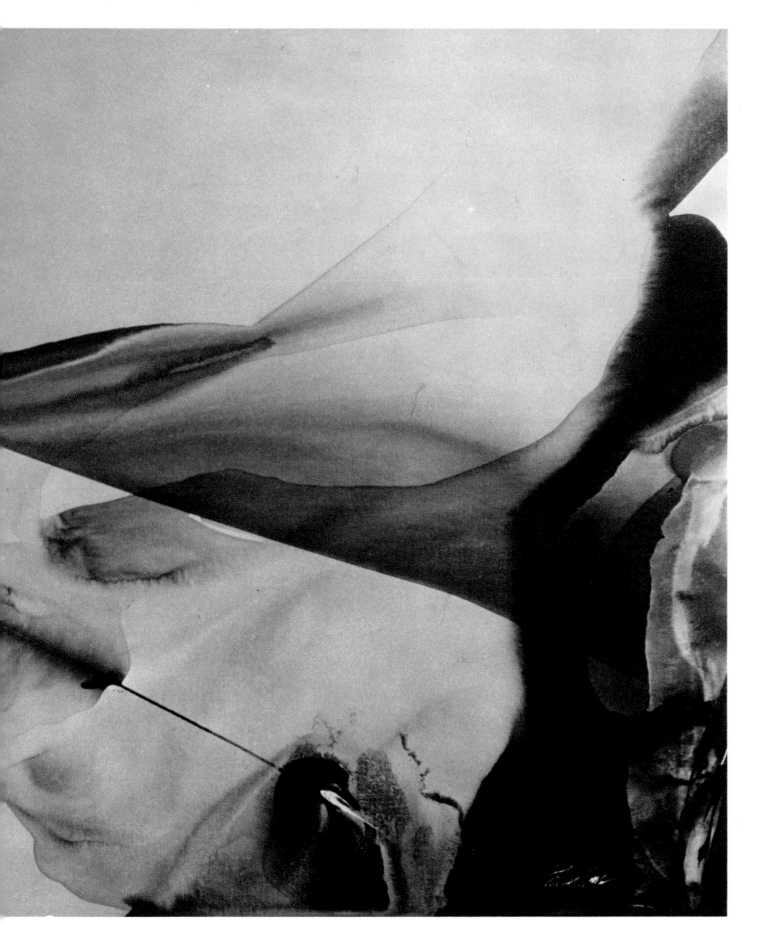

123. *Phenomena Topanga Early*. 1969. Acrylic on canvas, 38 × 64''. Collection Mr. and Mrs. Richard Adler, New York City

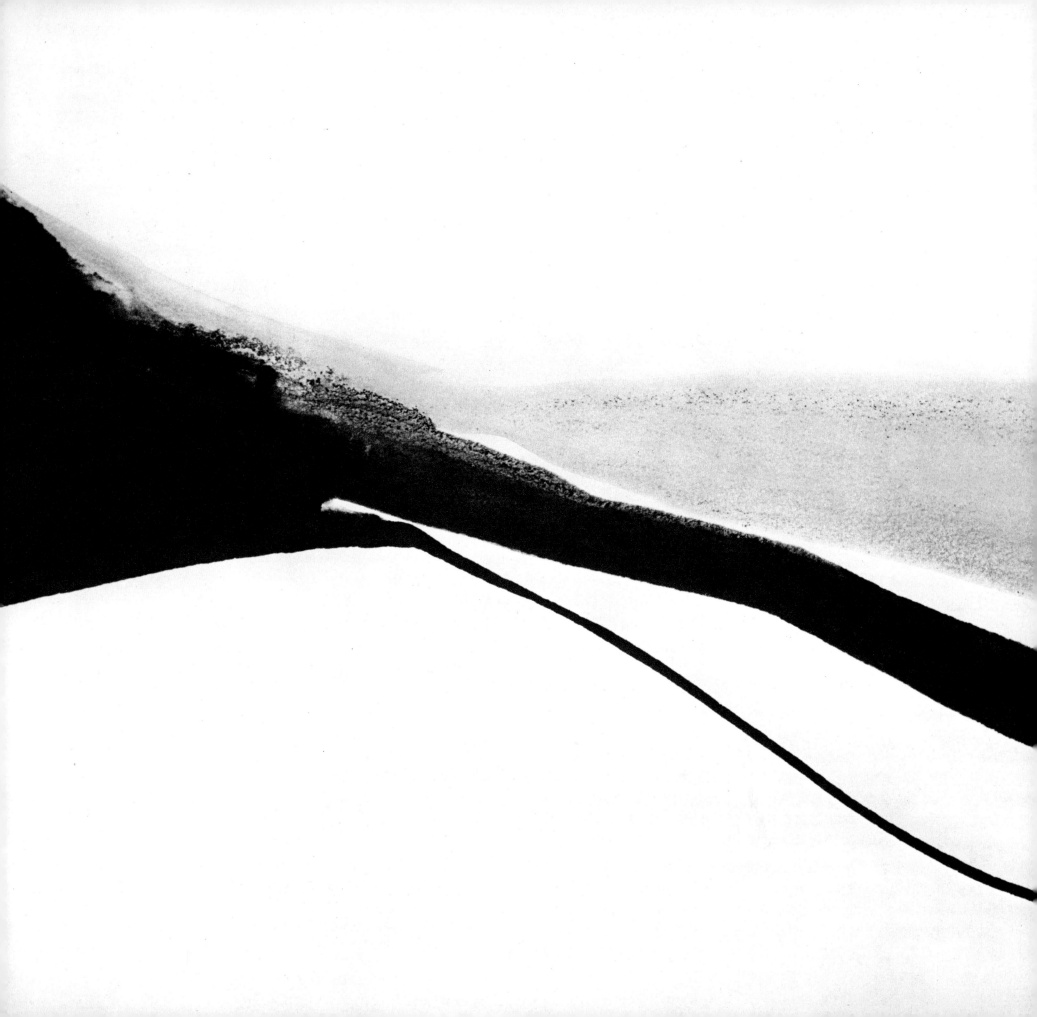

126. Drawing from *Paris Suite*. 1970. Ink, actual size. Private collection ▶

125. *Phenomena Kwan Yin.* 1969. Acrylic on canvas, 7′4″ × 9′11″. Whitney Museum of American Art, New York City

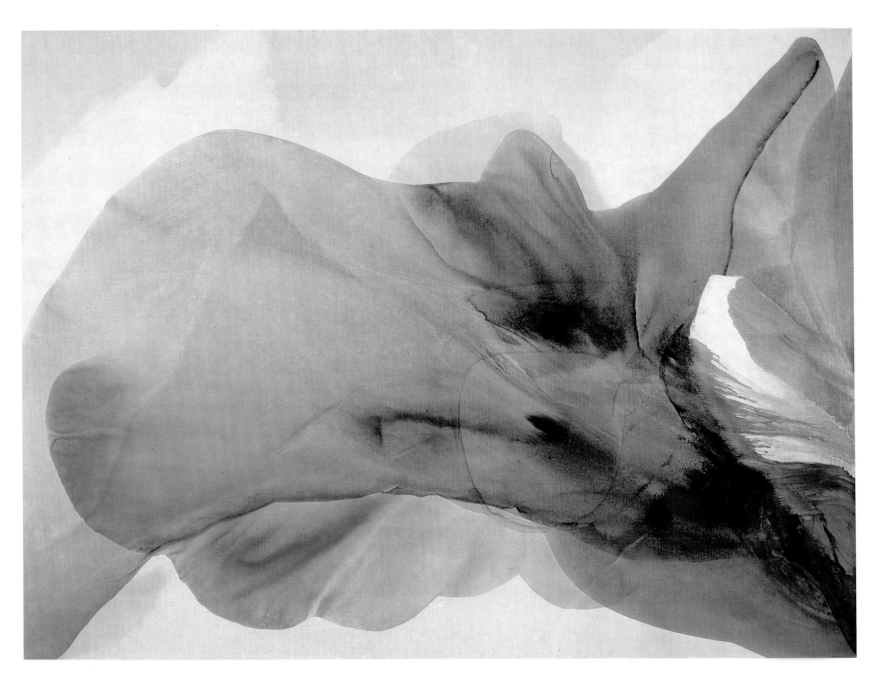

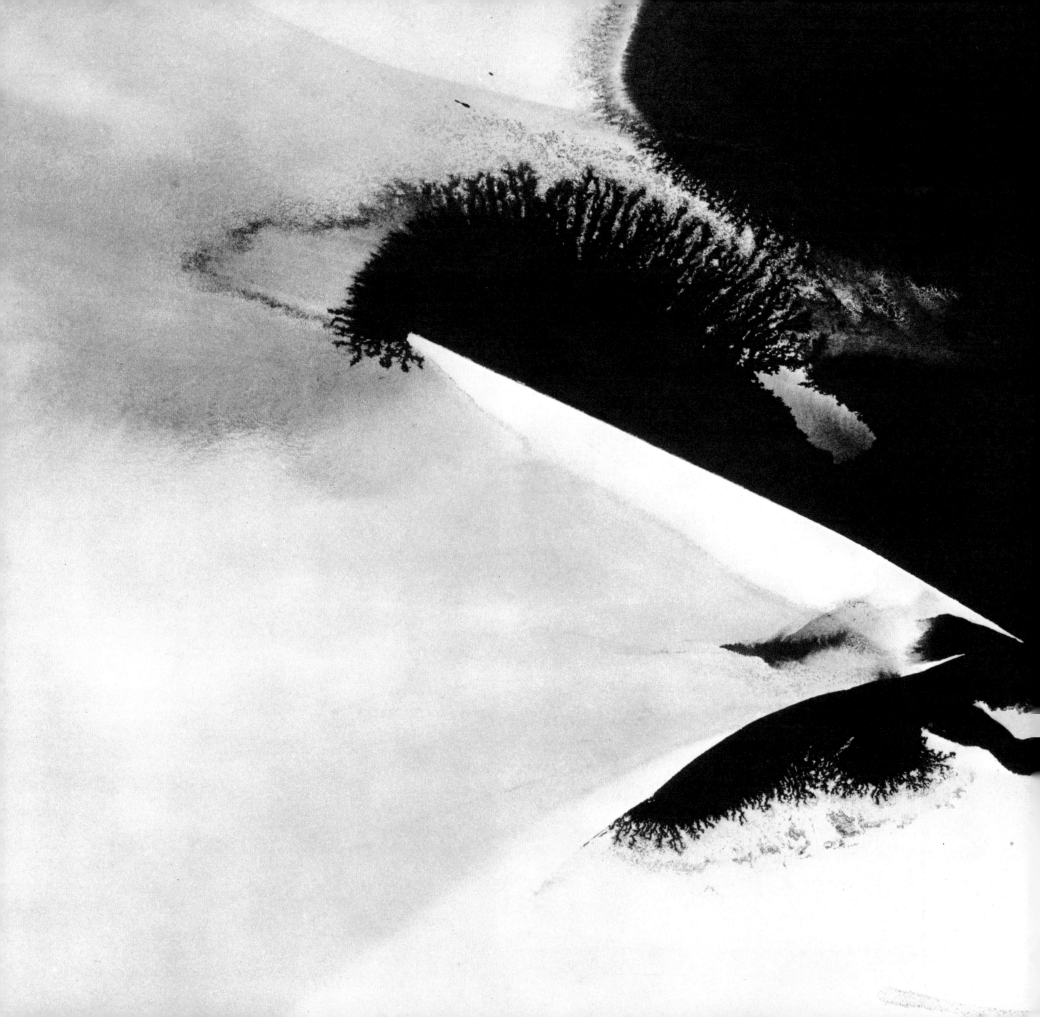

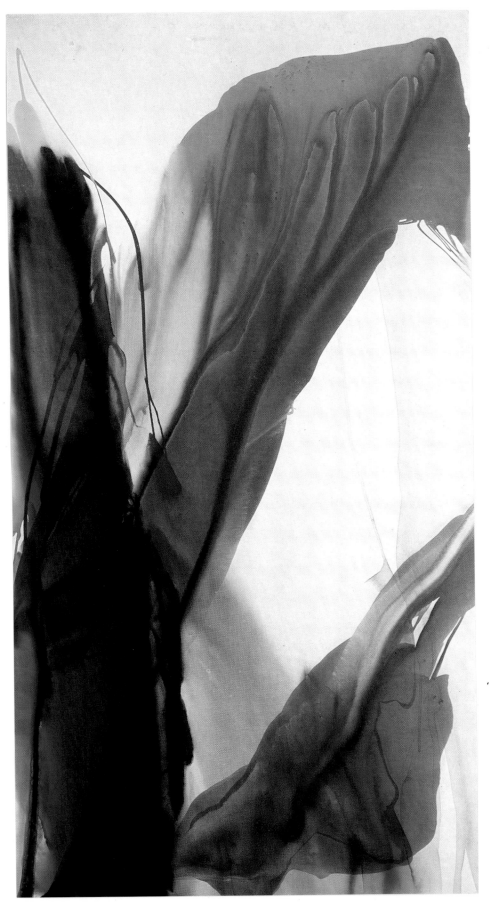

127.
Phenomena Yonder Near.
1964. Acrylic on canvas,
9'8'' × 5'3 1/2''. Tate
Gallery, London. Gift of
David Kluger

128.
Photograph of the artist
by David Douglas Duncan.
1963

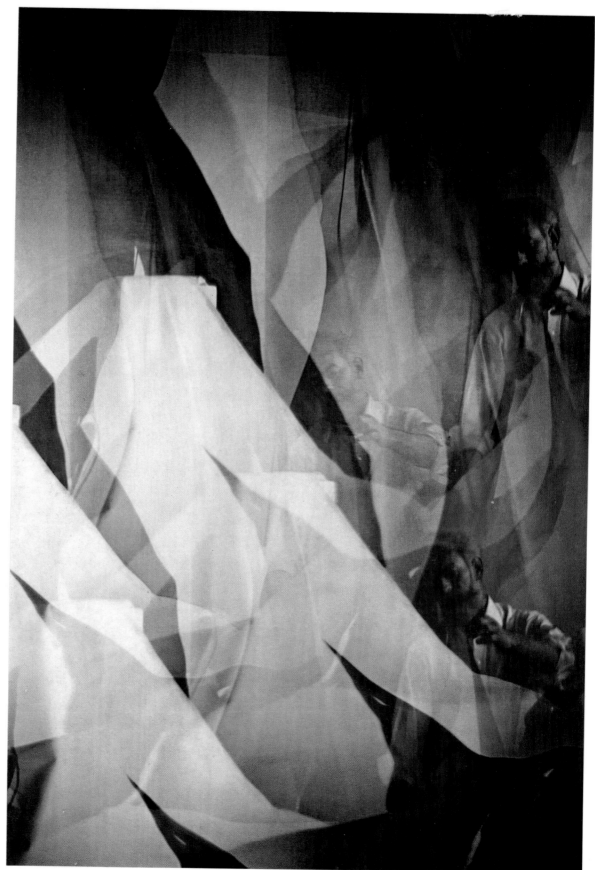

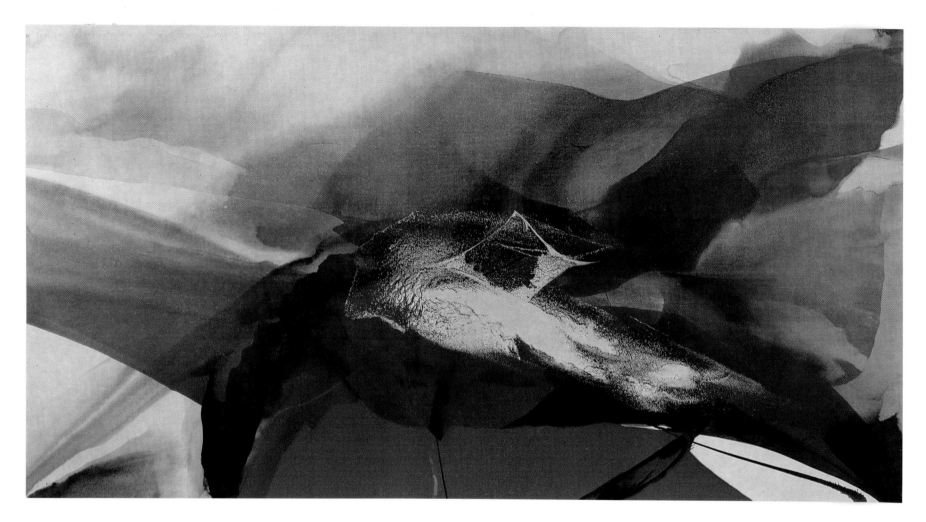

129. *Phenomena Day of Zagorsk.* 1966. Acrylic on canvas, 5′ × 9′6′′. Corcoran Gallery of Art, Washington, D.C.

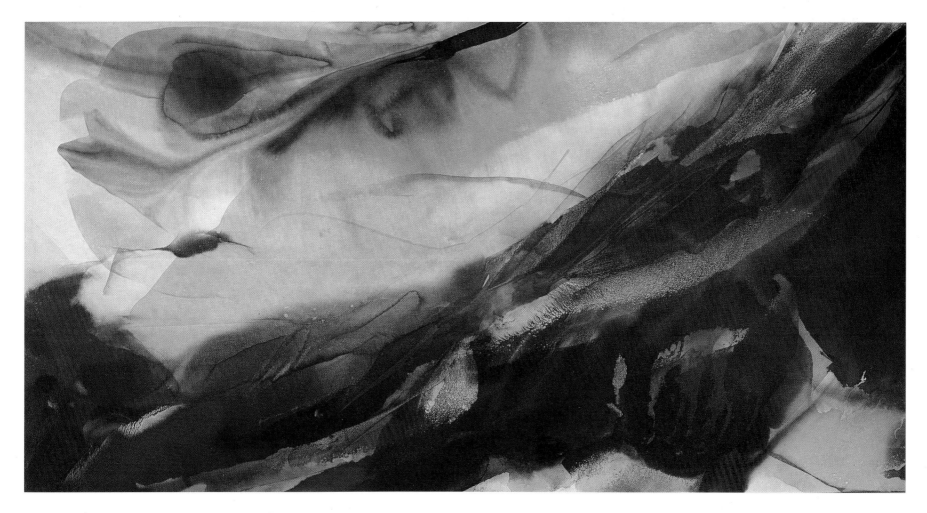

130. *Phenomena Sun Over the Hourglass*. 1966. Acrylic on canvas, 5′ × 9′6′′. Smithsonian Institution, Washington, D.C.

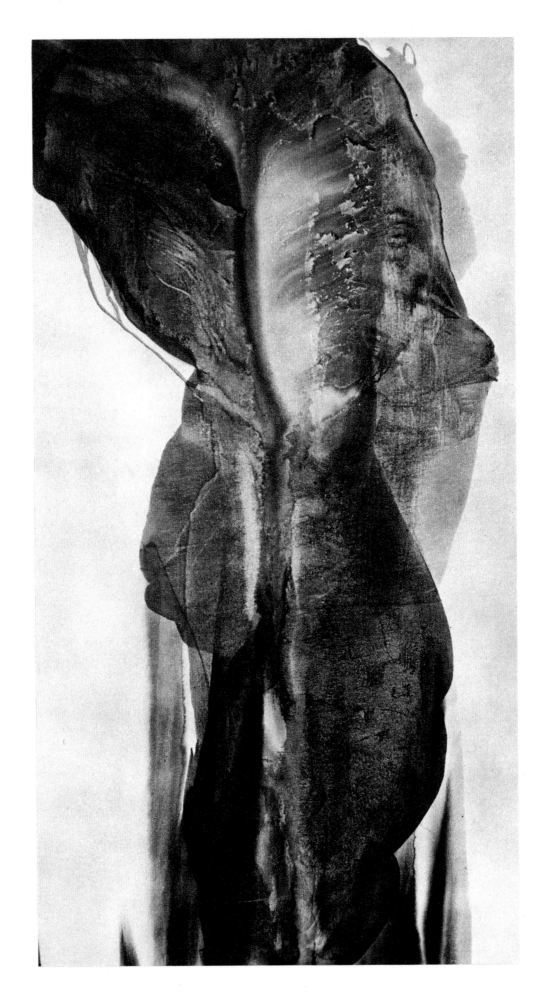

131.
Phenomena Open Vessel.
1964. Acrylic on canvas,
9'8'' × 5'. Phoenix Art
Museum, Phoenix, Ariz.

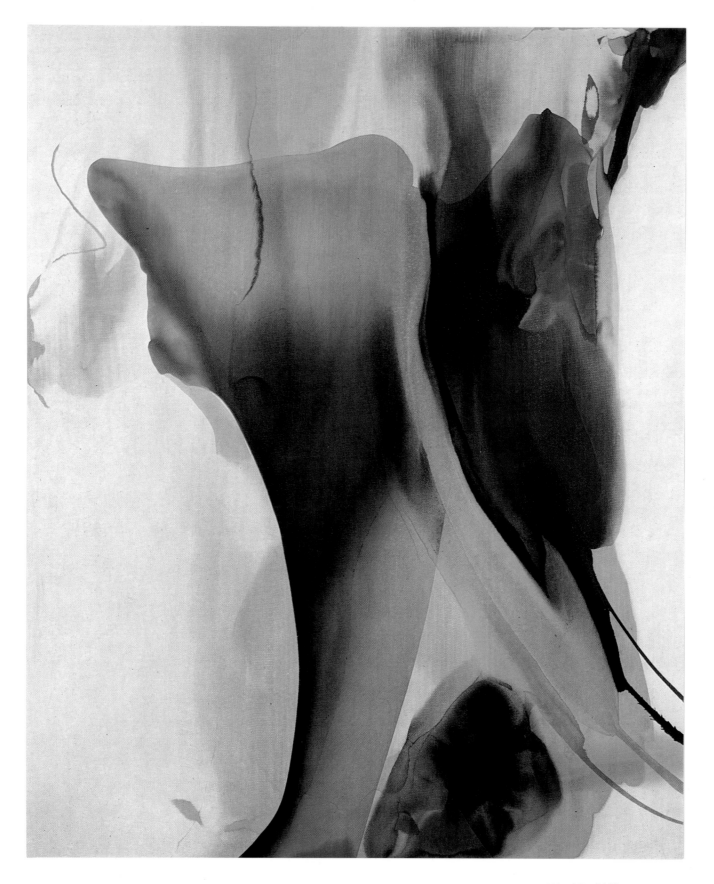

132. *Phenomena Uranus Burns*. 1966. Acrylic on canvas, 85 × 70''. Stedelijk Museum, Amsterdam. Gift of David Kluger

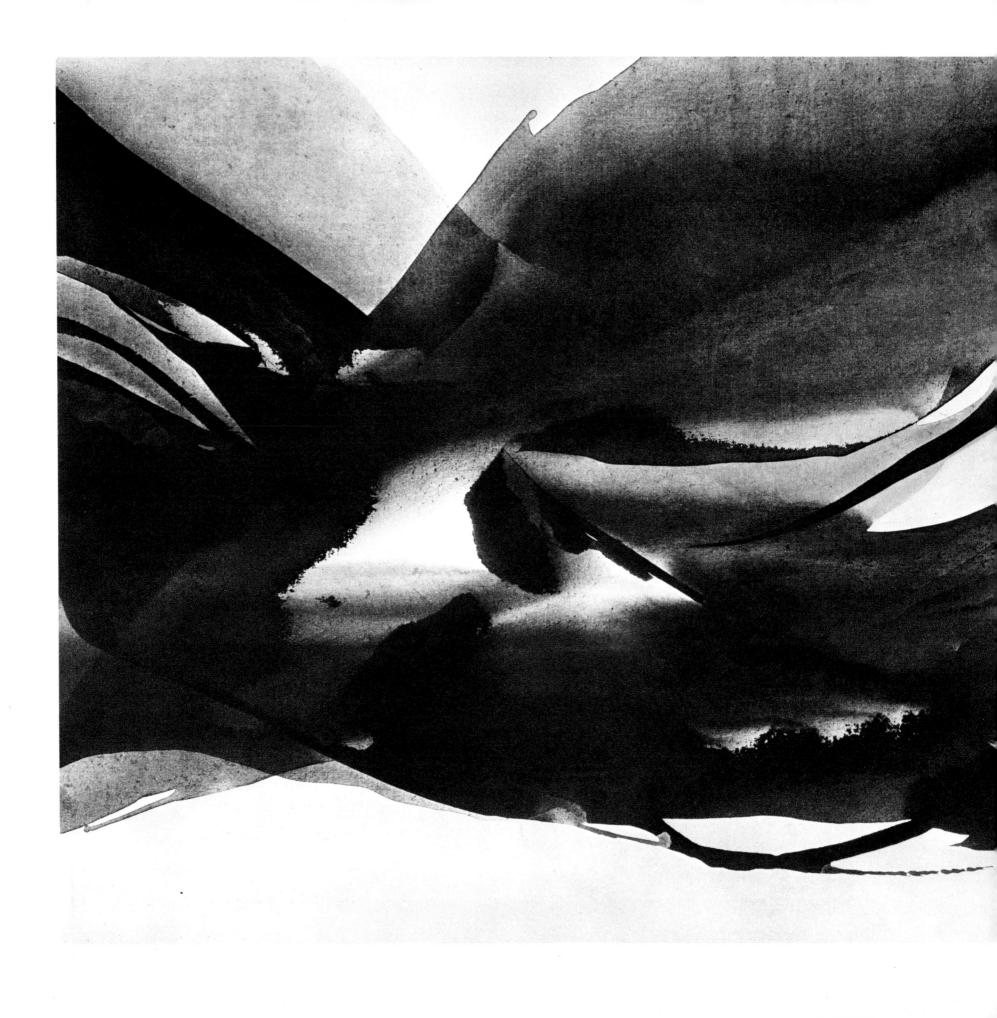

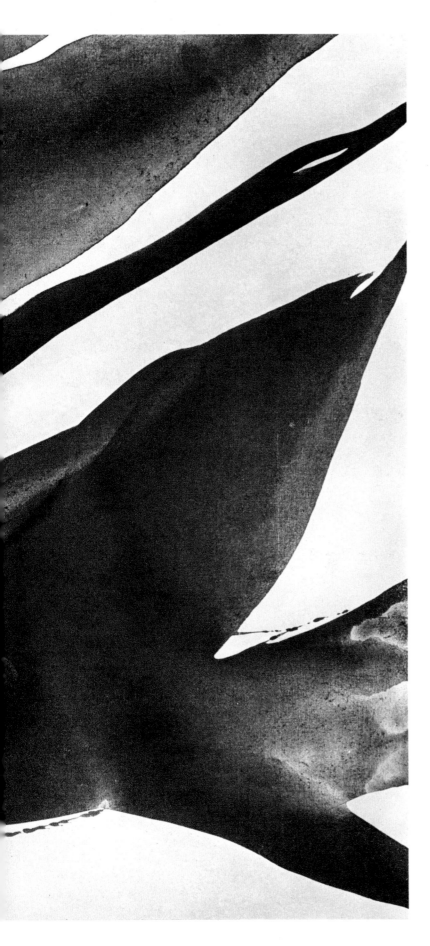

133.
Phenomena Nearing Isthmus.
1962–63. Acrylic on can-
vas, 47 1/4 × 66 7/8''.
Collection C. C. Martin,
Los Angeles

134. Photograph of the artist by Claude Picasso. 1969

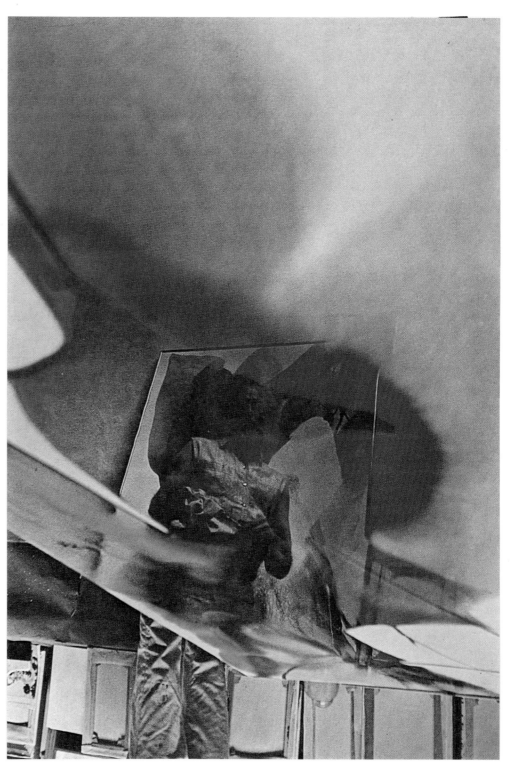

135.
Phenomena 831 Broadway.
1963. Acrylic on canvas,
9'3" × 5'9". Collection
Arnold Scaasi, New York
City

136.
Phenomena Astral Signal.
1964. Acrylic on canvas,
9'8'' × 6'8''. Collection
Mr. and Mrs. Harry W. Anderson, Atherton, Calif.

137. *Phenomena High Mantle.* 1964. Acrylic on canvas, 40 × 30''. Collection Mr. and Mrs. David Douglas Duncan, Castellaras, France

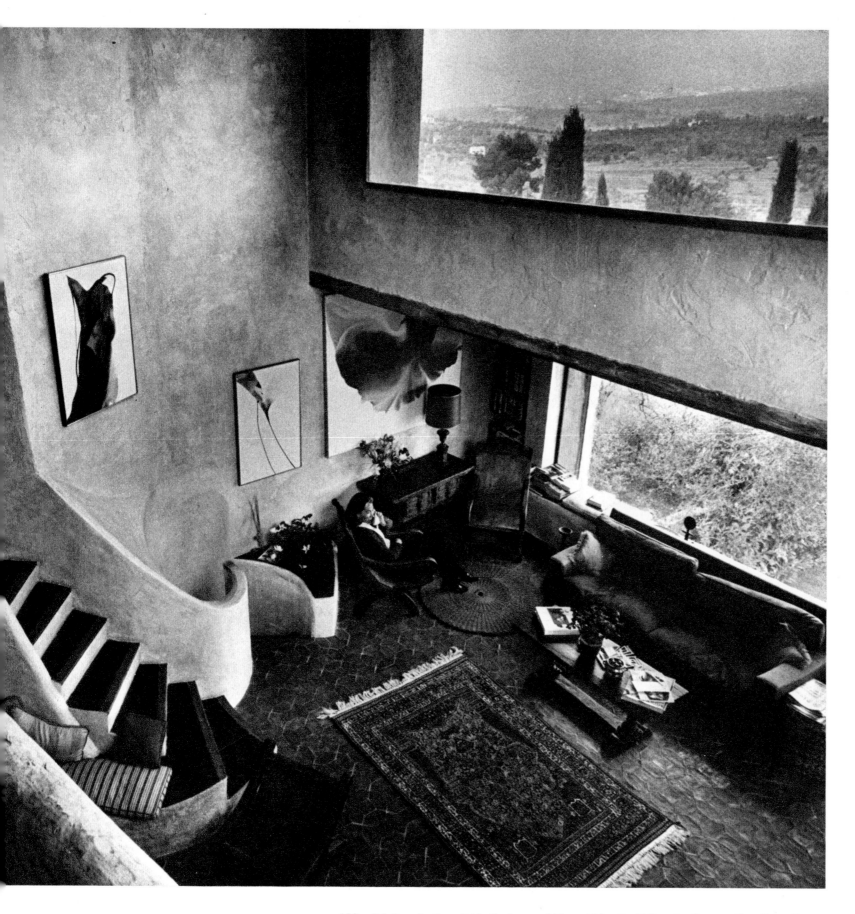

138. Paintings by the artist in the house of Mr. and Mrs. David Douglas Duncan, Castellaras, France

139.
Anaconda. 1956. Oil and
Chrysochrome on canvas,
63 3/4 × 51 1/8''. Collec-
tion Michel Tapié, Turin

140.
Phenomena Graced by Three.
1968. Acrylic on canvas,
64 × 48''. The University
of Texas at Austin, Mich-
ener Collection

141. *Phenomena Salem Rock*. 1963. Acrylic on canvas, 36 × 28 3/4''. Private collection, New York City

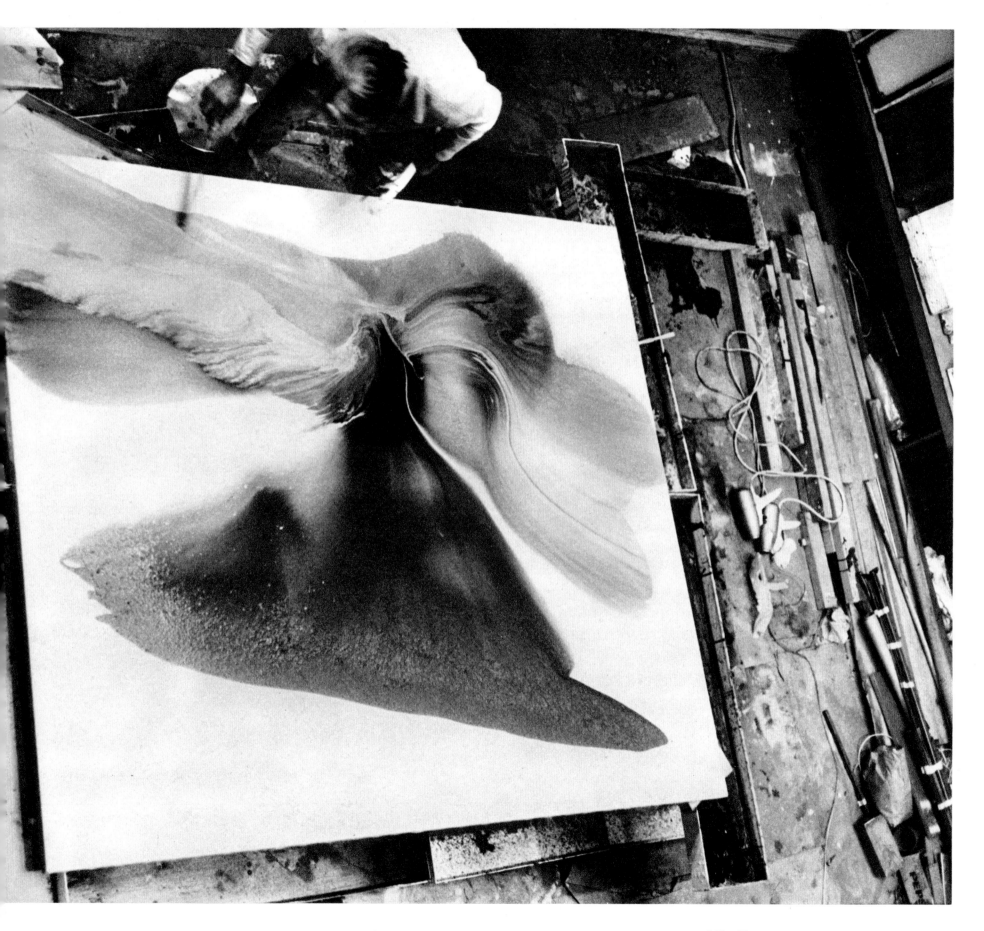

142. Photograph of the artist by Jay Jacobs. 1971

143. Drawing from *Paris Suite*. 1970. Ink, actual size. Private collection

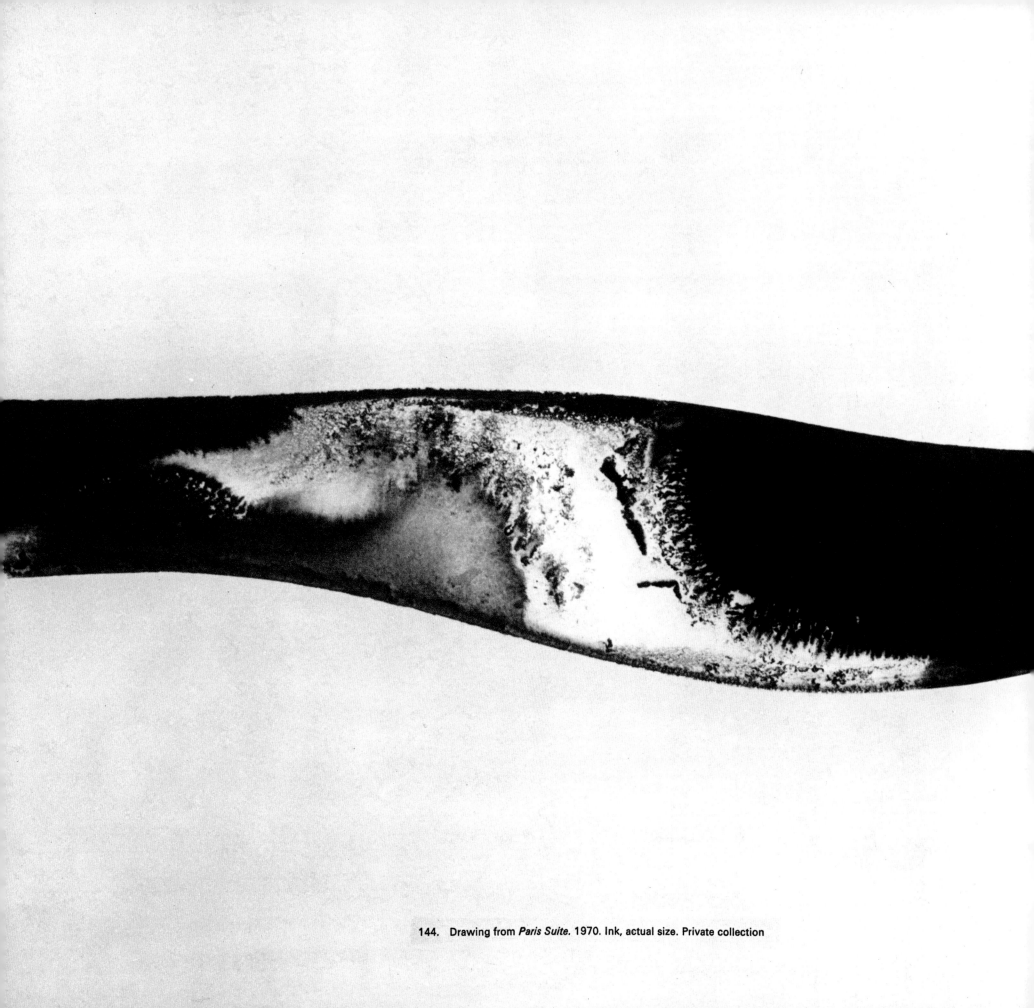

144. Drawing from *Paris Suite*. 1970. Ink, actual size. Private collection

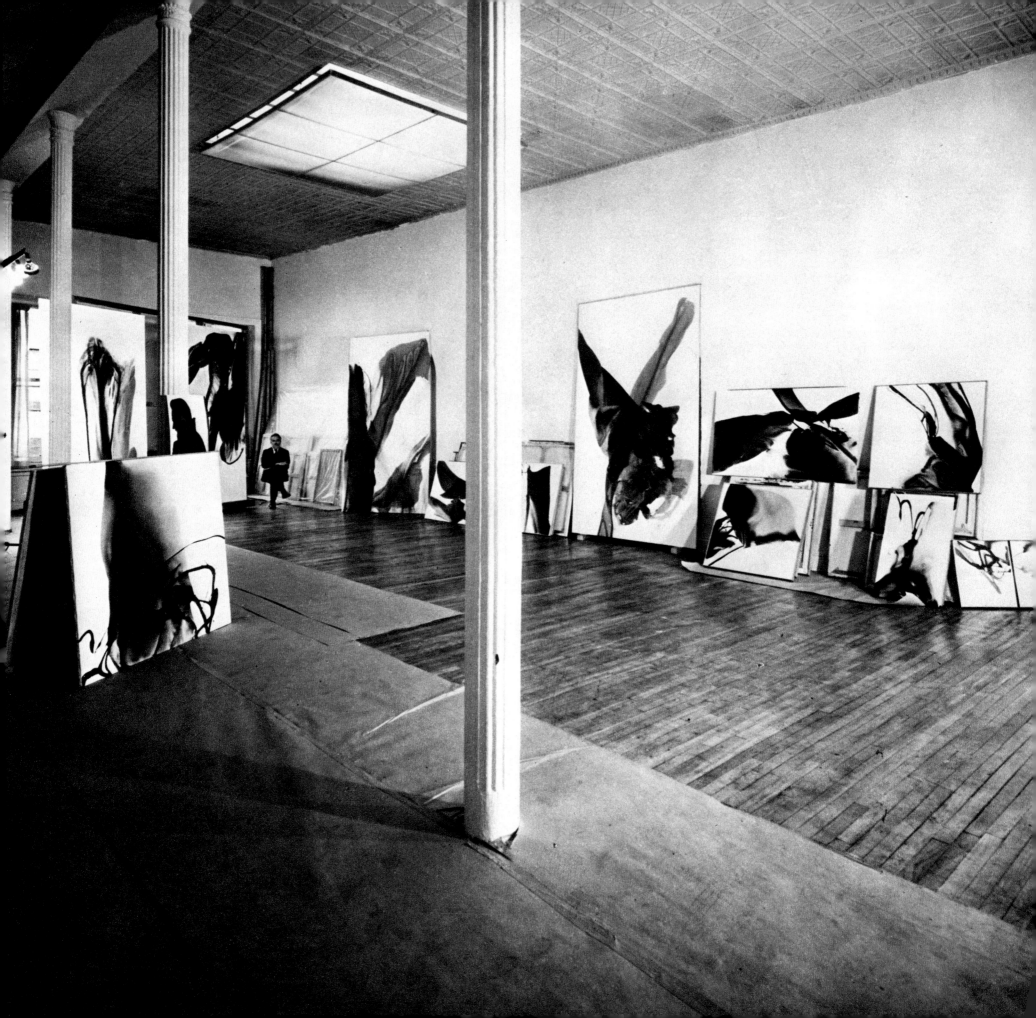

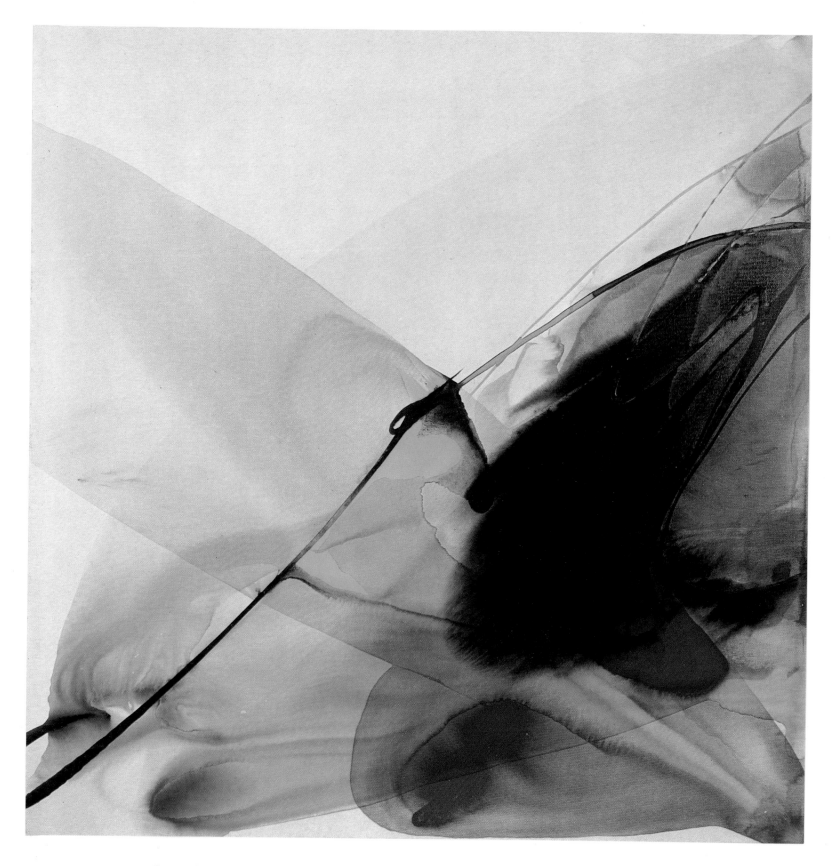

146. *Phenomena Sound of Grass*. 1968. Acrylic on canvas, 39 × 38″. Collection Mr. and Mrs. Leonard S. Field, New York City

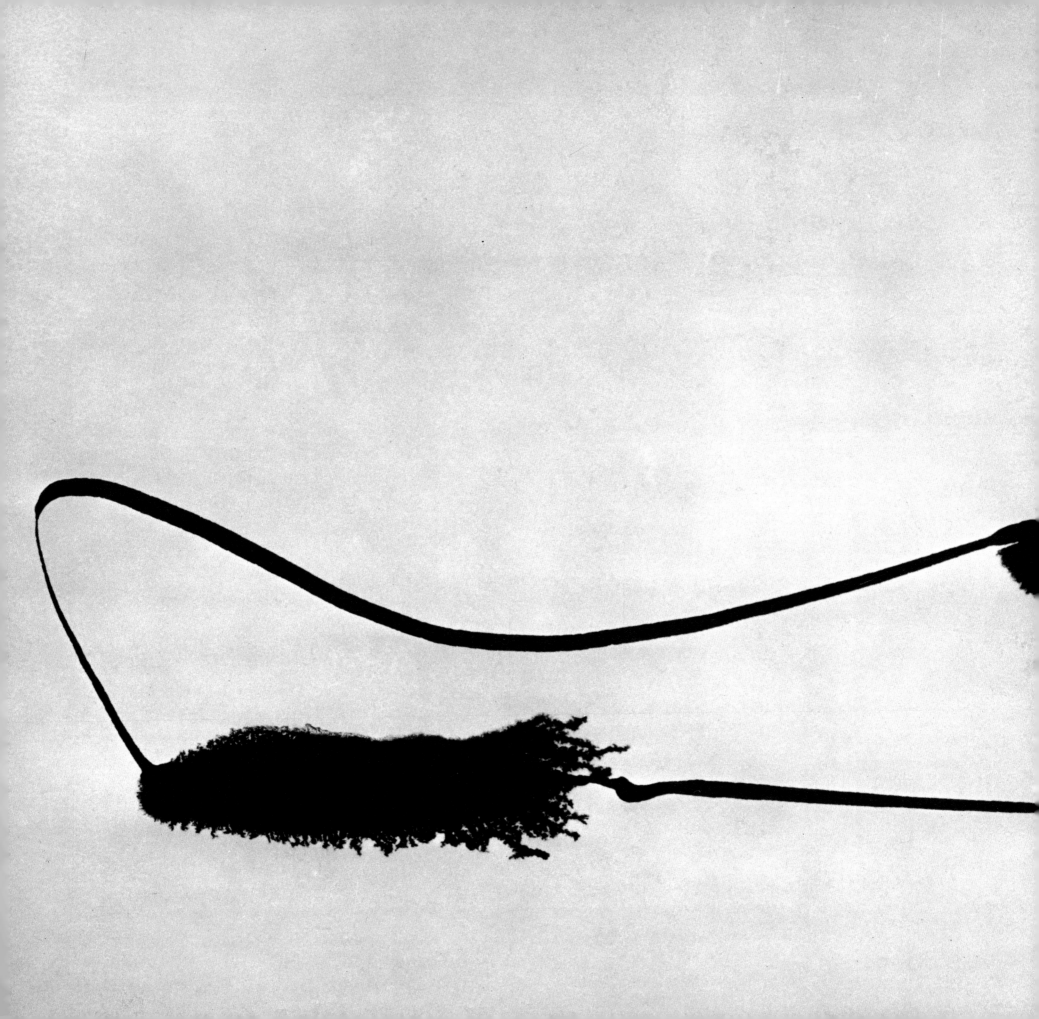

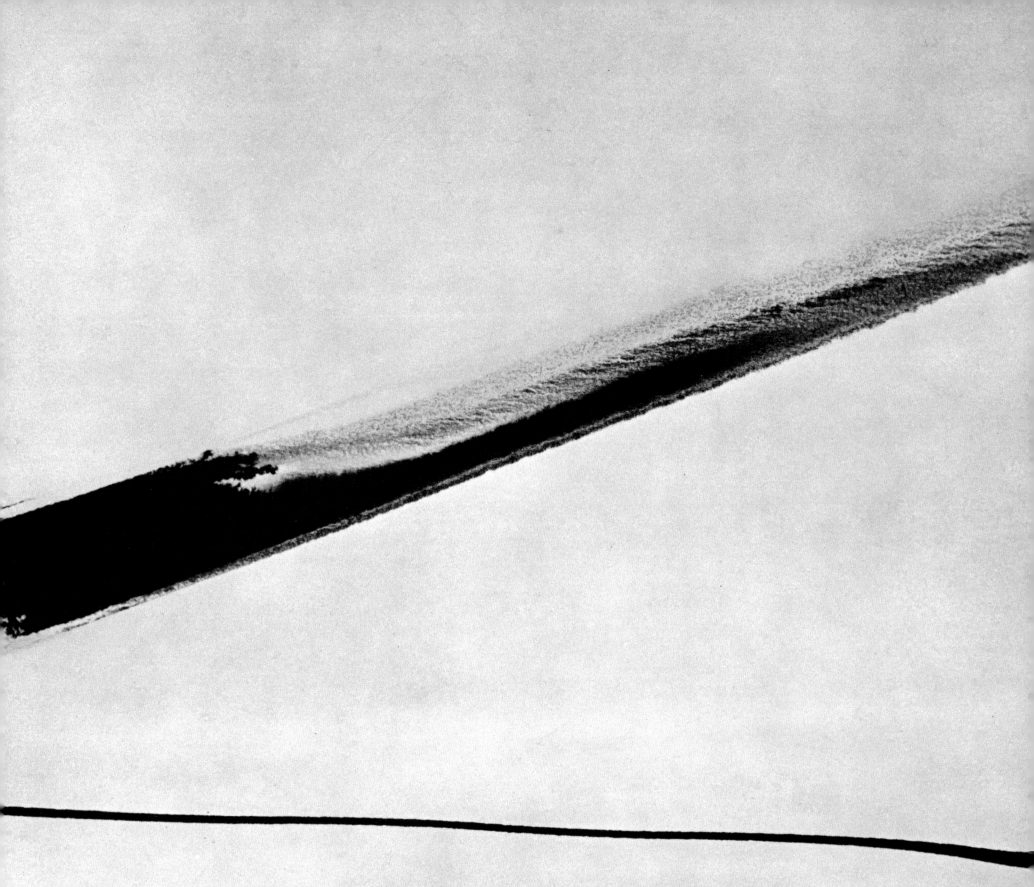

147. Drawing from *Paris Suite*. 1970. Ink, actual size. Private collection

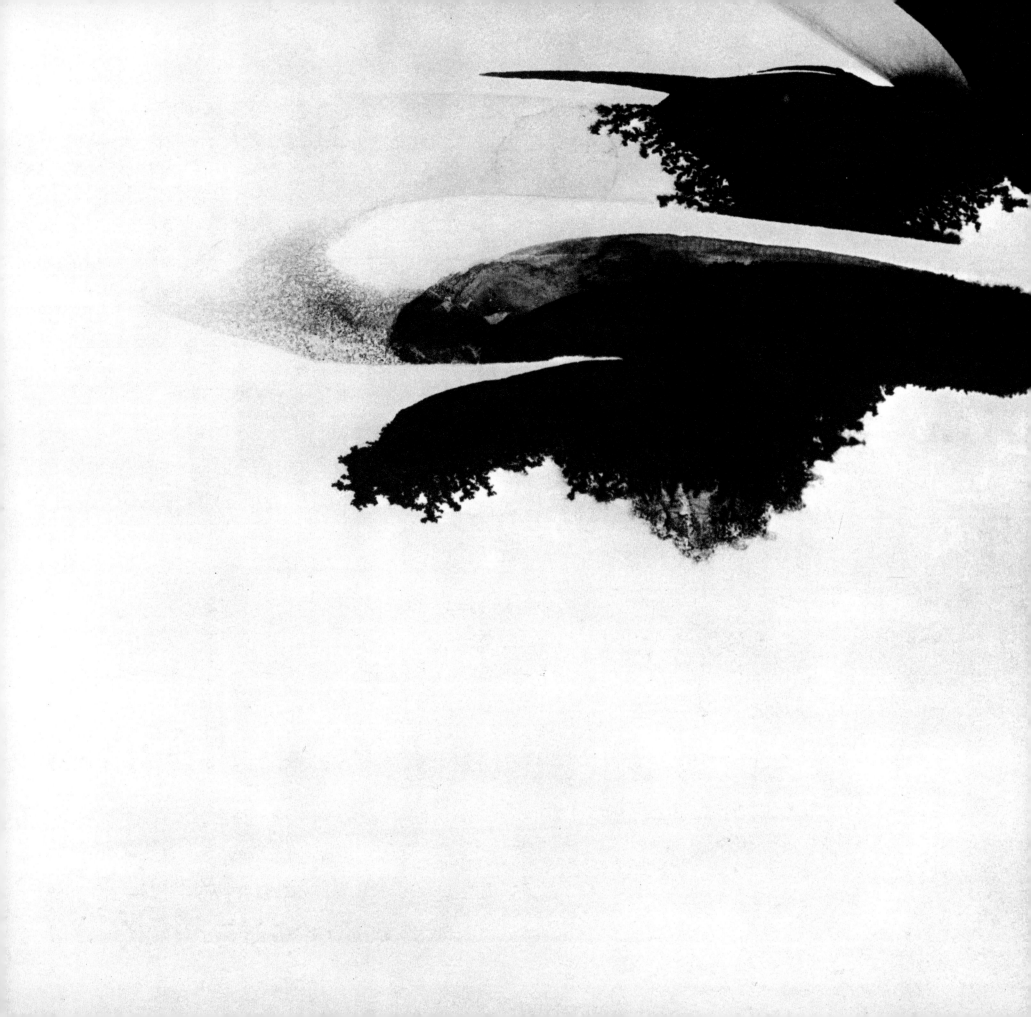

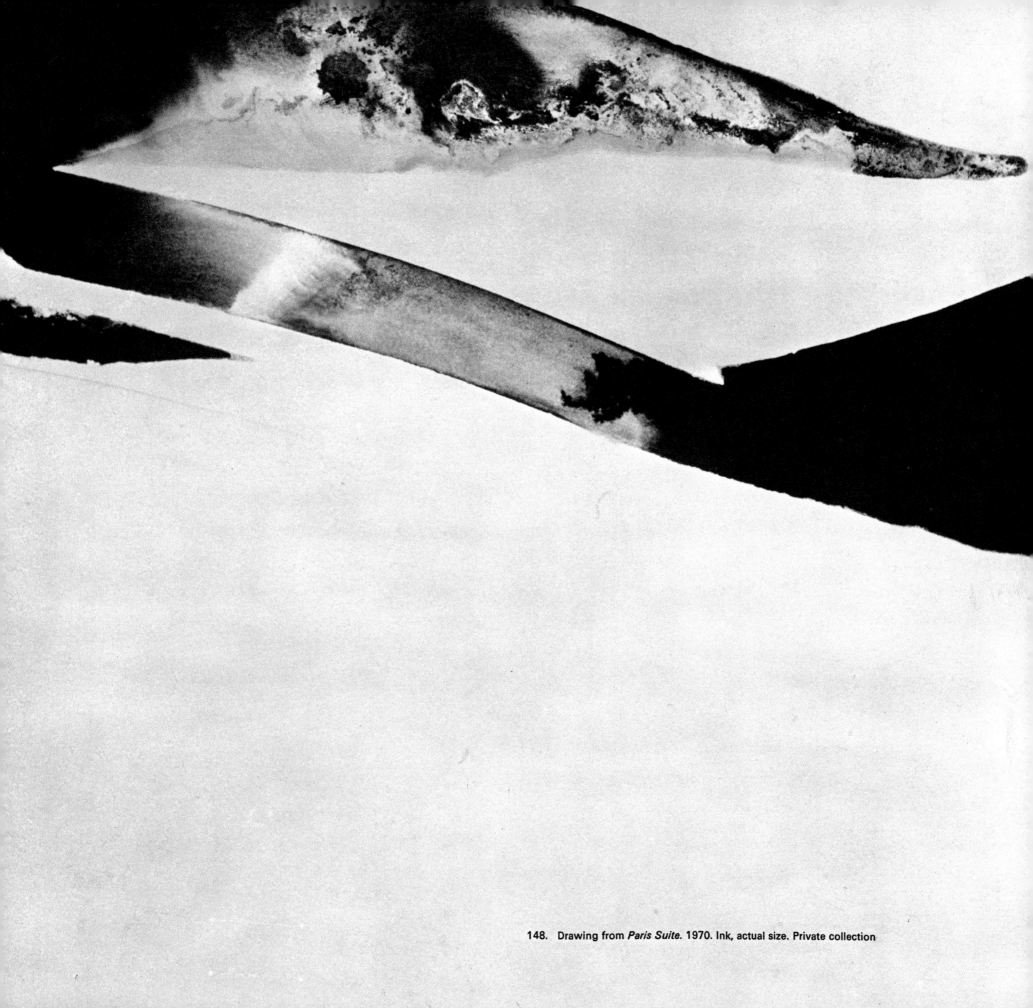

148. Drawing from *Paris Suite*. 1970. Ink, actual size. Private collection

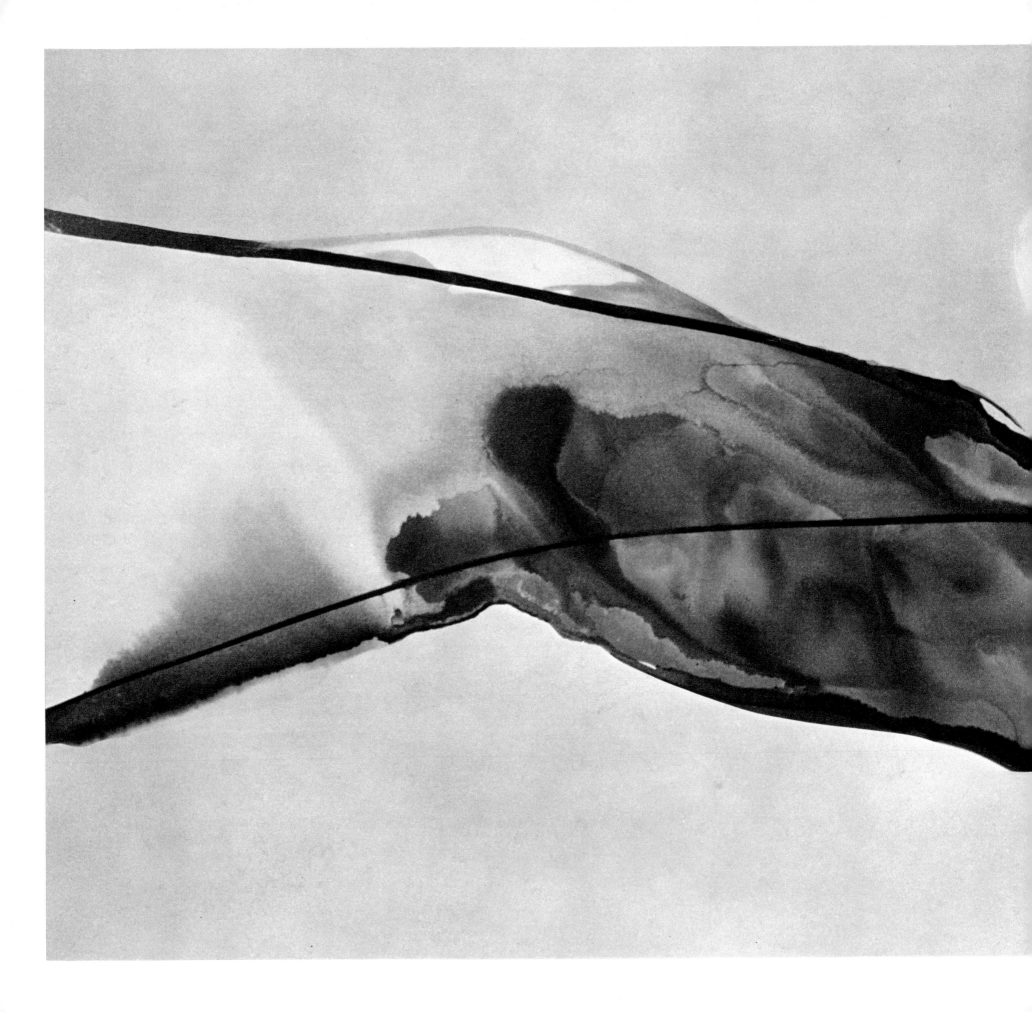

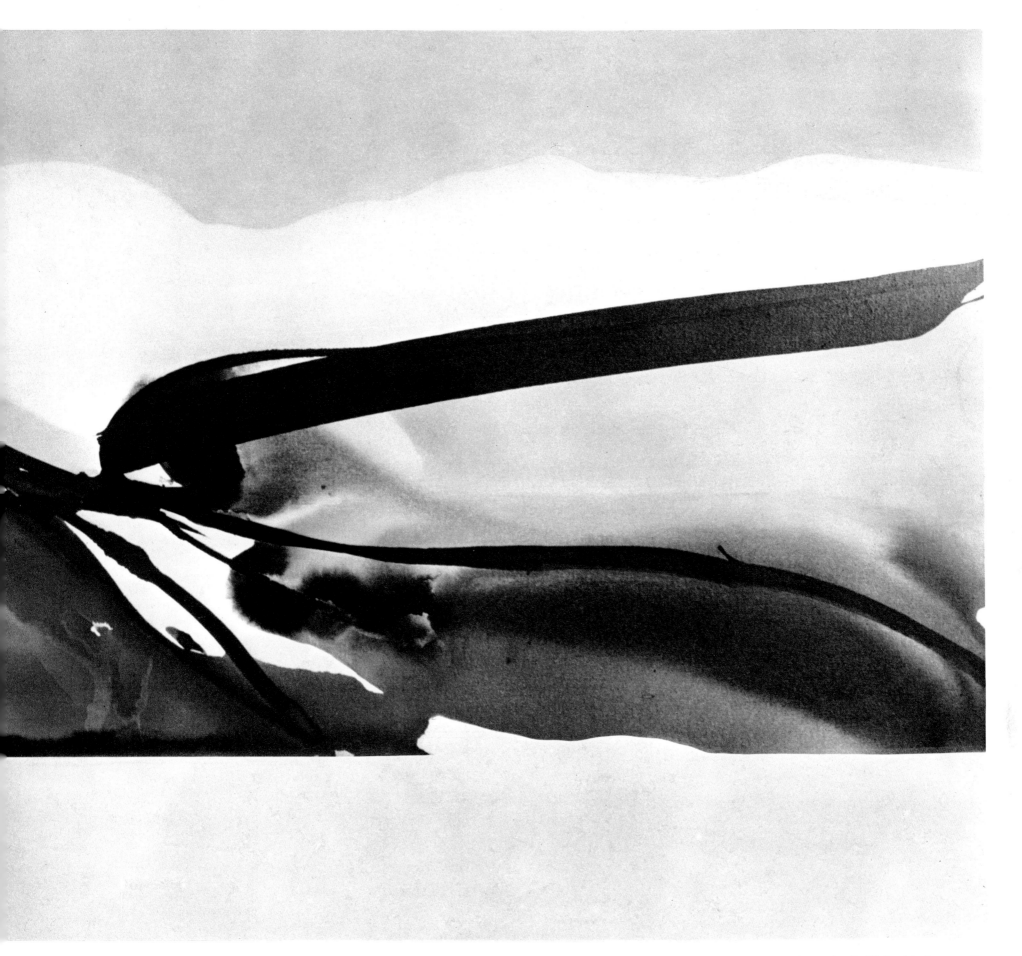

149. *Phenomena Burn the Haze*. 1966. Acrylic on canvas, 20 × 70″. Collection Dr. Wollowick, Sarasota, Fla.

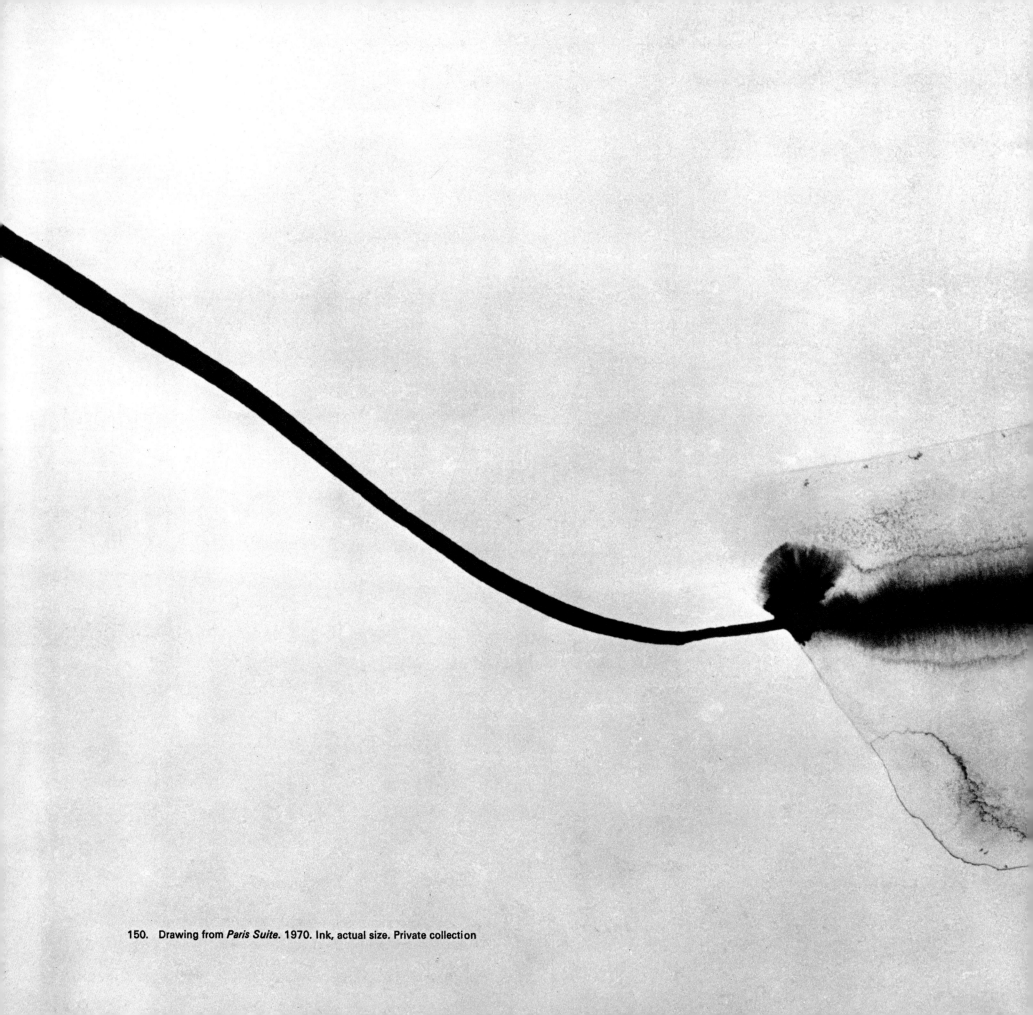

150. Drawing from *Paris Suite*. 1970. Ink, actual size. Private collection

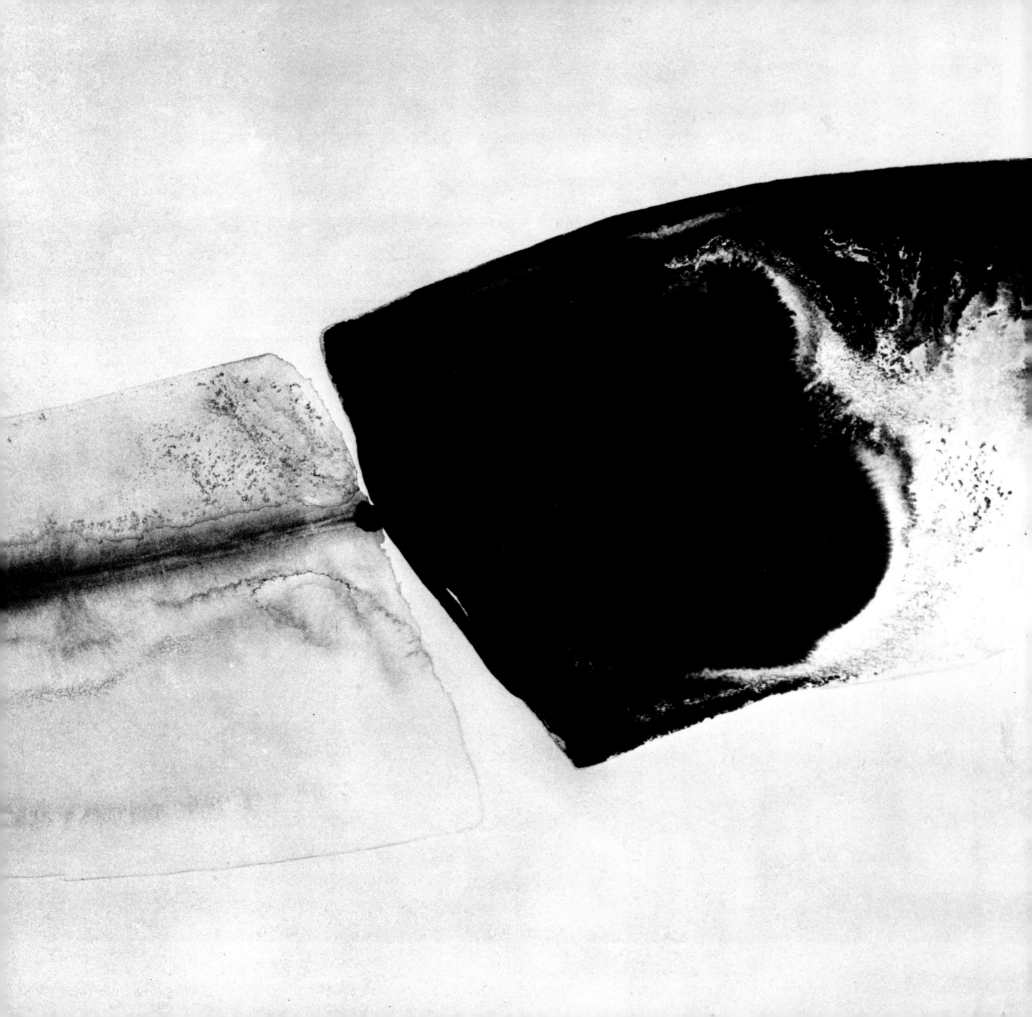

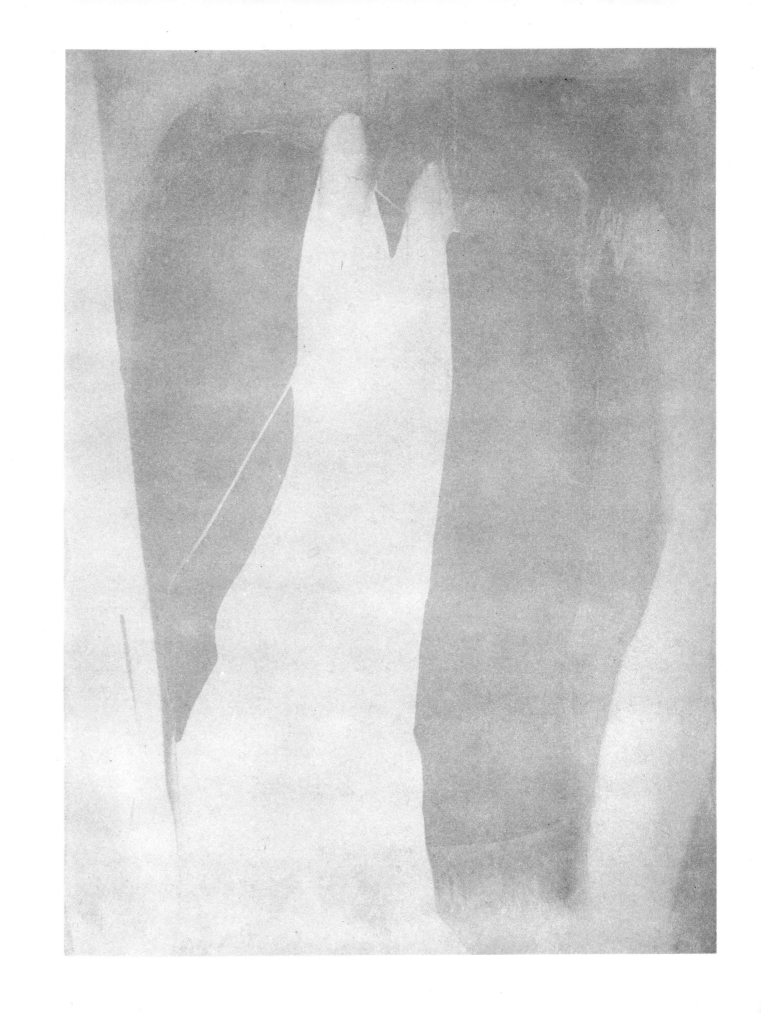

151 and 152.
Phenomena Two by Sea. 1968
(two panels). Acrylic on
canvas, each panel 9'10'' ×
7'6''. Stanford University
Museum, Palo Alto, Calif.

153. Photograph of the artist by Shunk-Kender. 1963

154. Icebergs in the North Atlantic

155.
Egyptian Profile. 1953.
Gouache and ink on Egyptian
papyrus, 42 × 29''. Private
collection

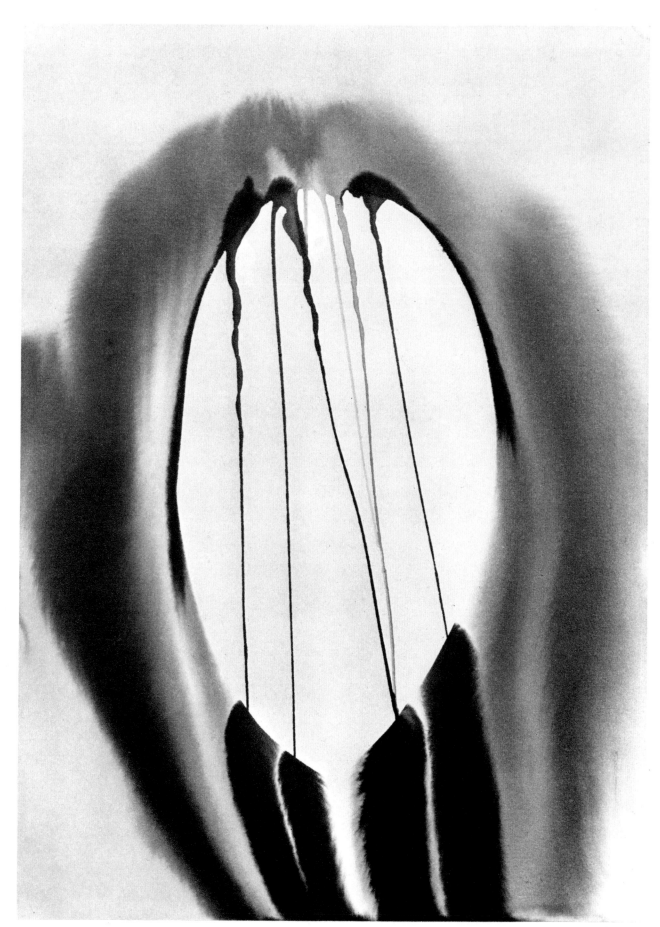

156.
Phenomena Mirror Vanish.
1961. Watercolor, 30 ×
22''. Collection Karl Flin-
ker, Paris

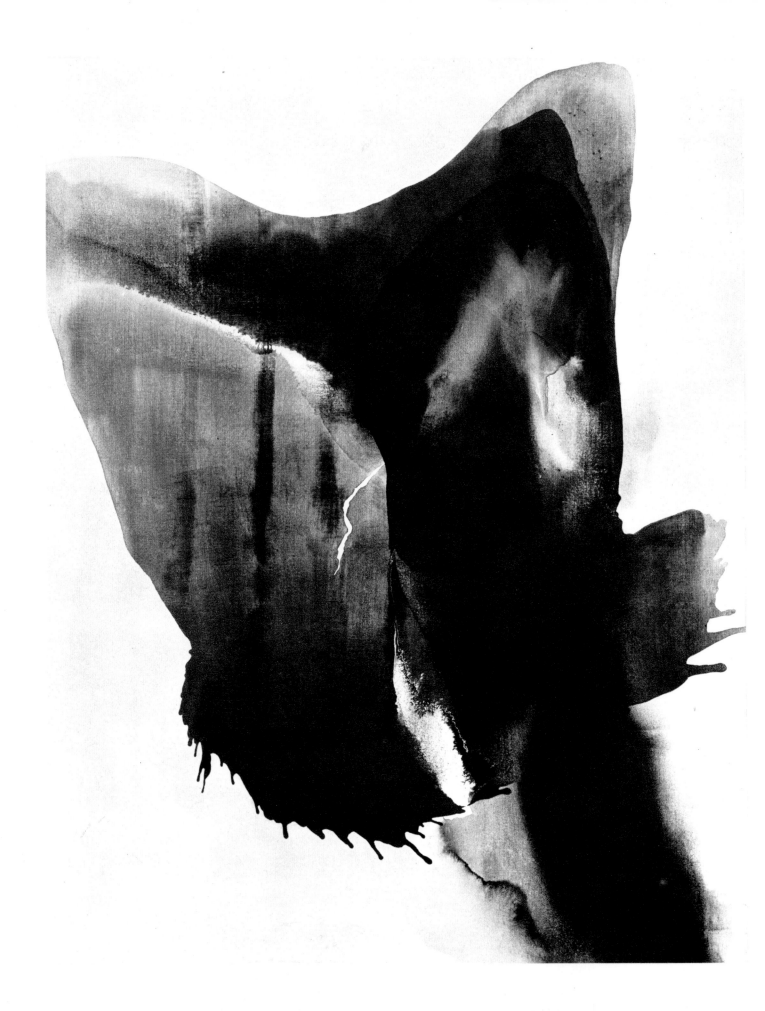

157.
Phenomena Saracen. 1961.
Acrylic on canvas, 63 ×
51 1/8''. Collection Mr.
and Mrs. Clark Ambrose,
New York City

158.
Phenomena Over Albi. 1960.
Oil and Chrysochrome on
canvas, 77 × 51″. Collec-
tion Sam Francis, Santa
Monica, Calif.

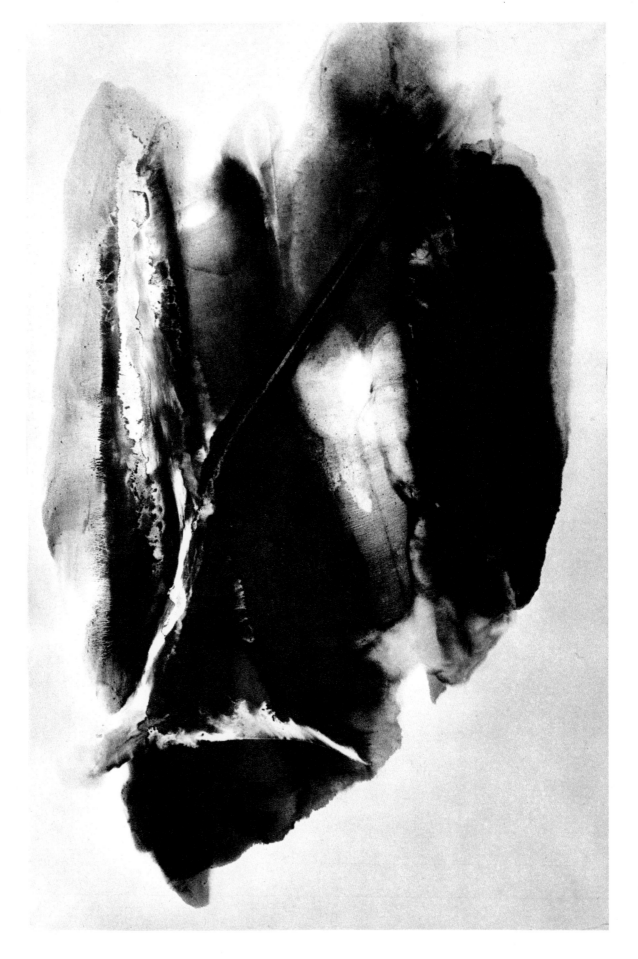

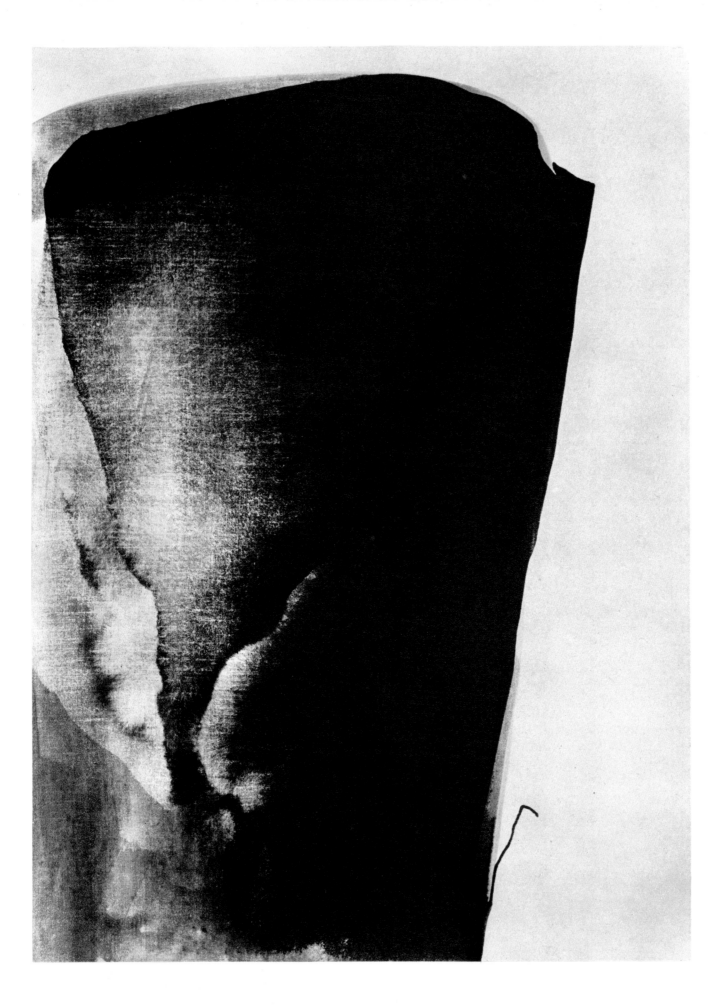

159.
Phenomena Over Dynasty.
1961. Acrylic on canvas,
51 1/8 × 35 3/8''. Collec-
tion Charles Lienhard,
Zurich

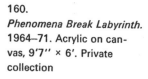

160.
Phenomena Break Labyrinth.
1964–71. Acrylic on canvas, 9'7'' × 6'. Private
collection

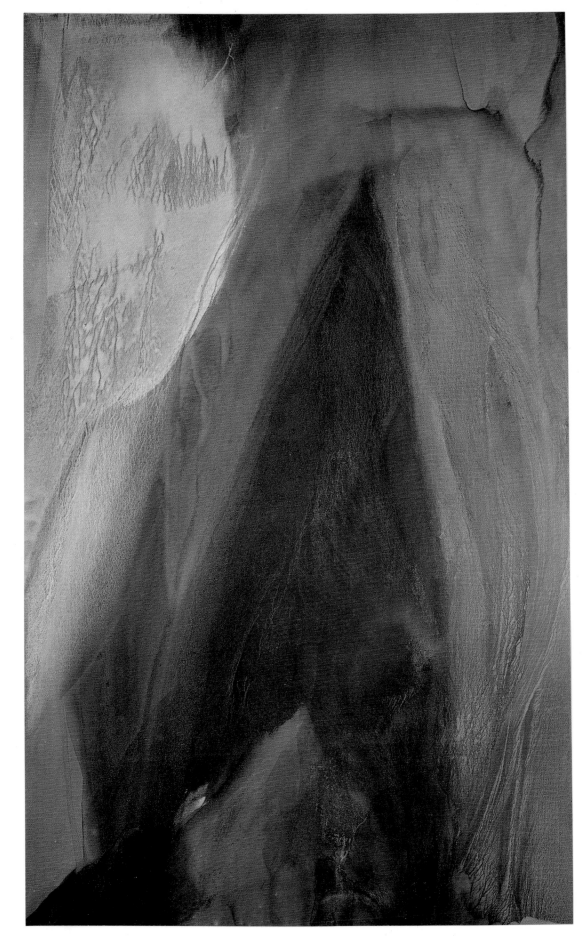

161.
Detail of *The Virgin and the Canon Van Der Paele* by Jan van Eyck. 1436. Groeningemuseum, Bruges, Belgium

162. ▶
Phenomena Noh Veil. 1971. Acrylic on canvas, 39 × 39''. Private collection

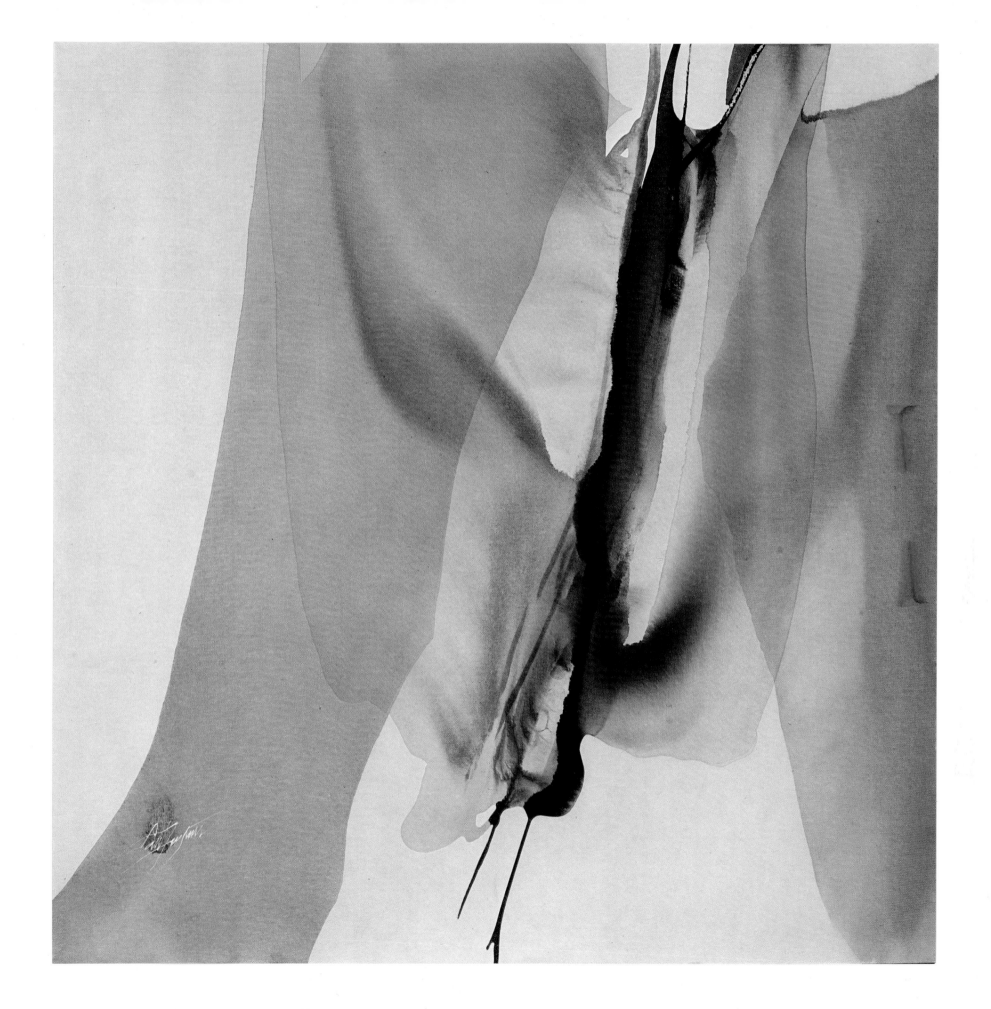

163. Detail of *The Virgin and the Canon Van Der Paele* by Jan van Eyck. 1436. Groeningemuseum, Bruges, Belgium

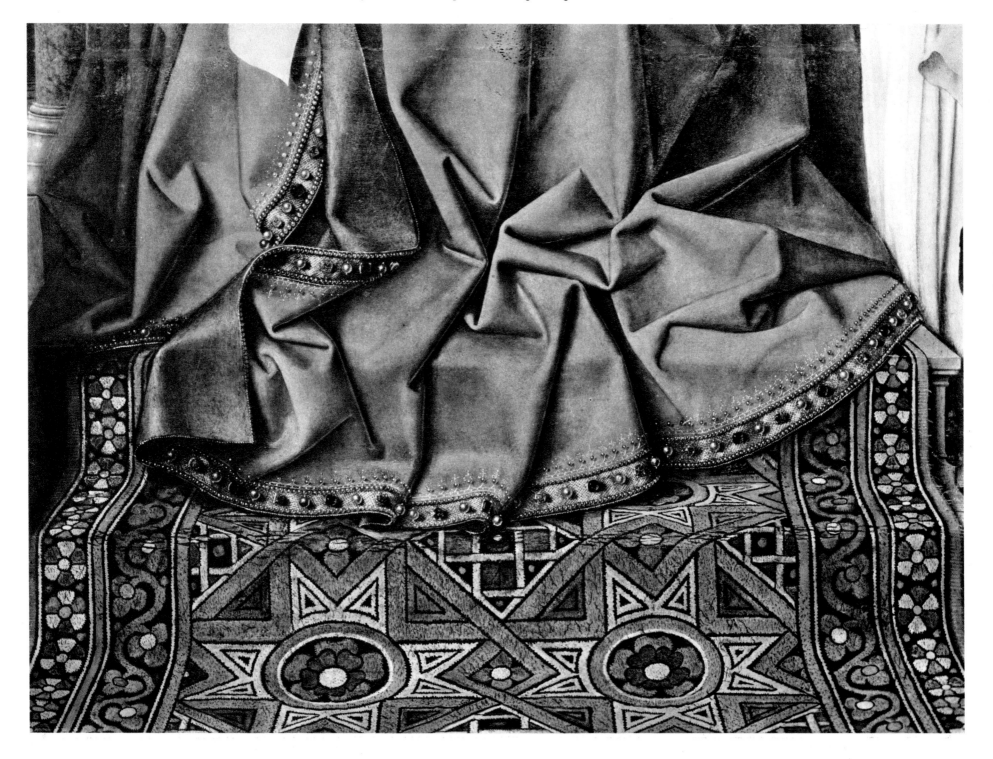

164. *Phenomena Imago Terra*. 1971. Acrylic on canvas, 59 × 76''. Collection Katherine Komaroff, New York City

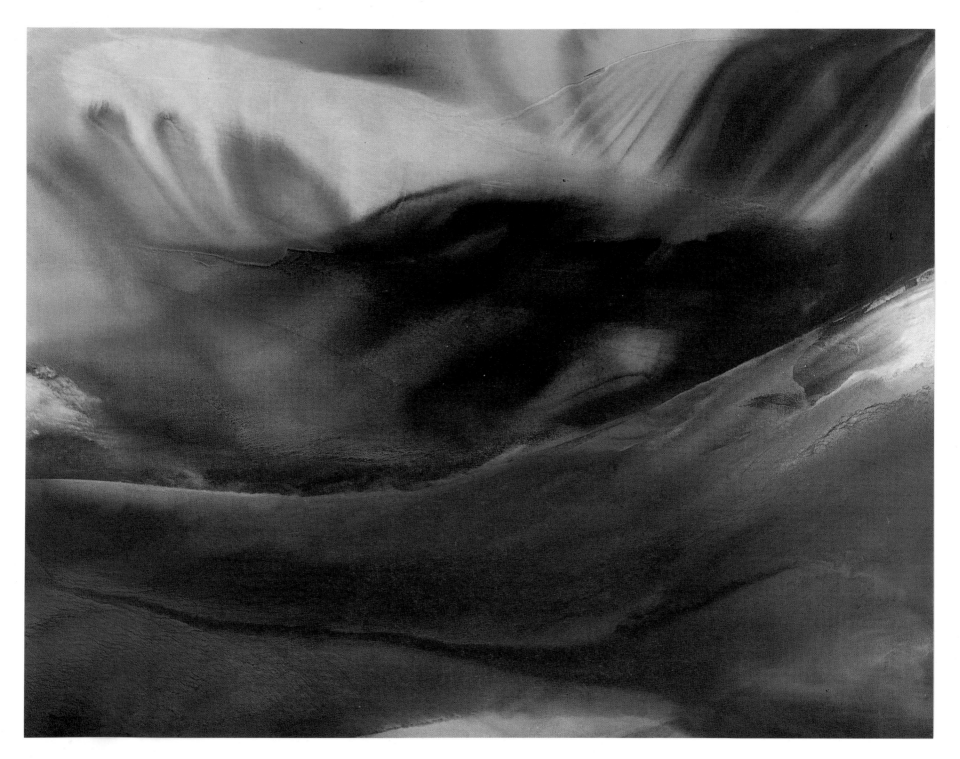

165.
Phenomena Upright. 1963.
Acrylic on canvas, 60 ×
40''. Collection Mr. and
Mrs. Stephen Smith, New
York City

166.▶
Phenomena Panning Gold.
1971. Acrylic on canvas,
91 × 73''. Collection the
artist

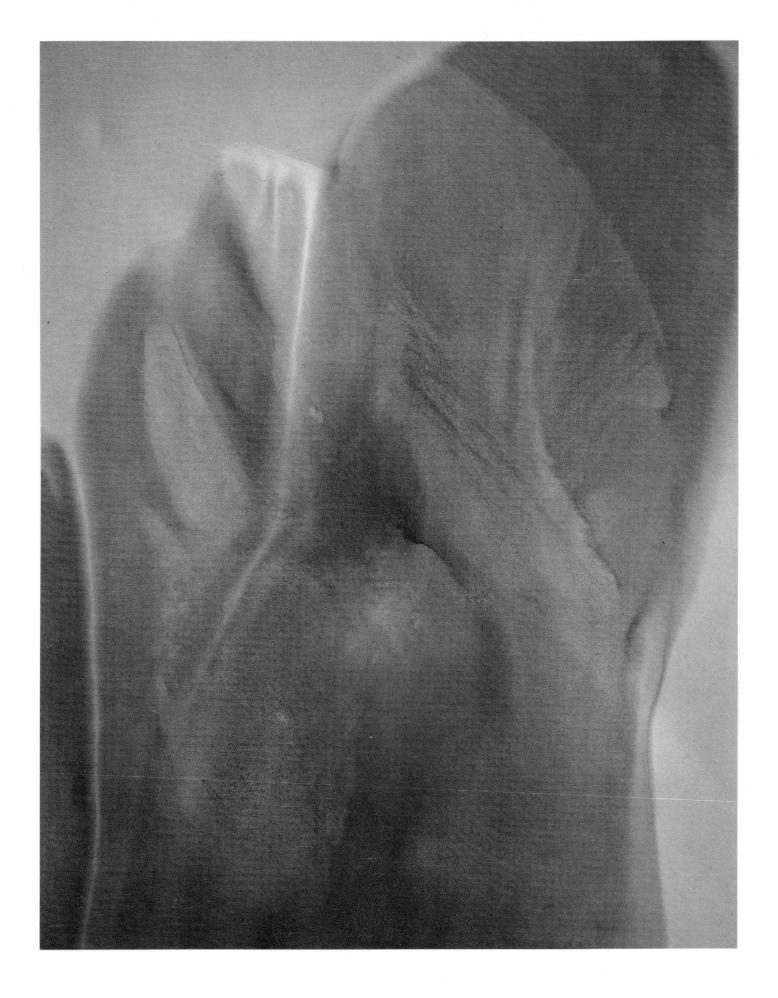

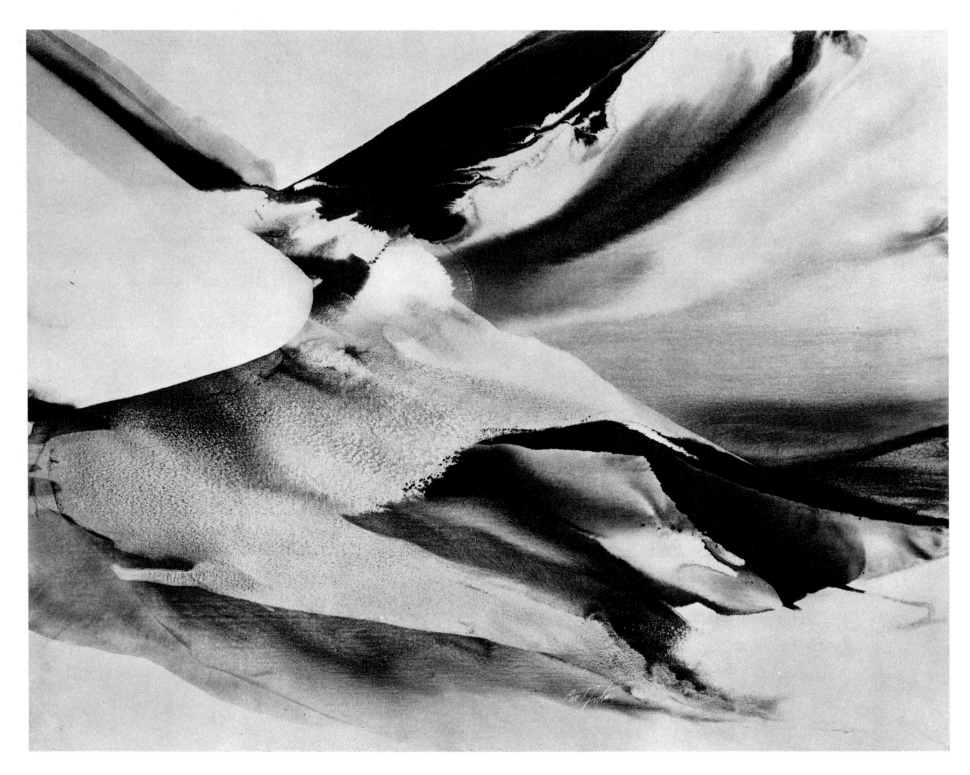

167. *Phenomena Astral Scape.* 1969. Acrylic on canvas, 40 × 80''. Private collection

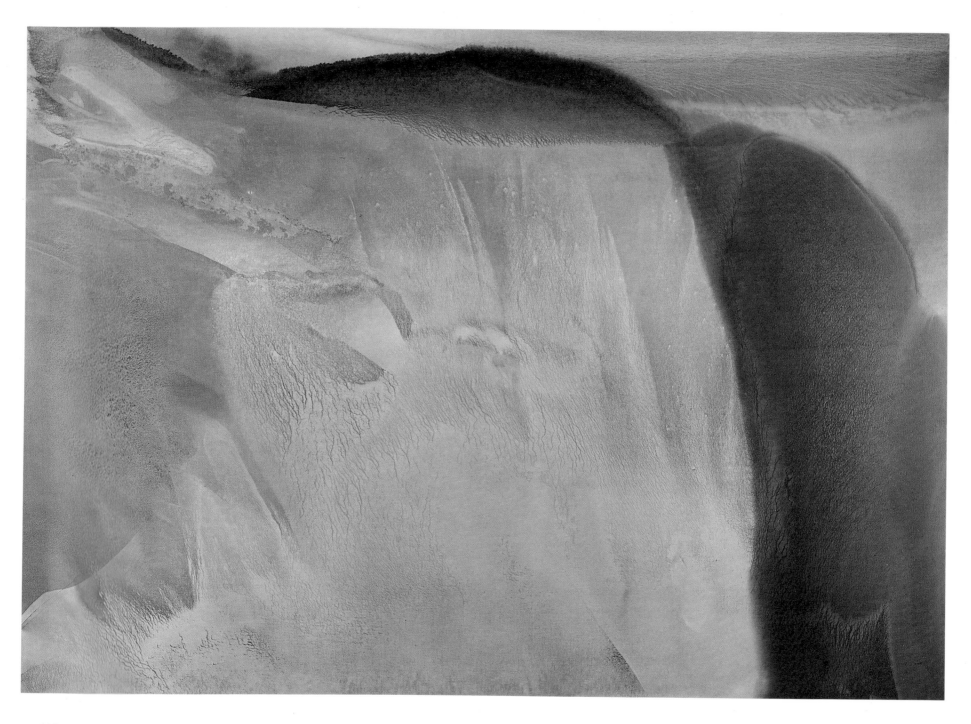

168. *Phenomena Jonas View*. 1972. Acrylic on canvas, 47 × 67''. Collection the artist

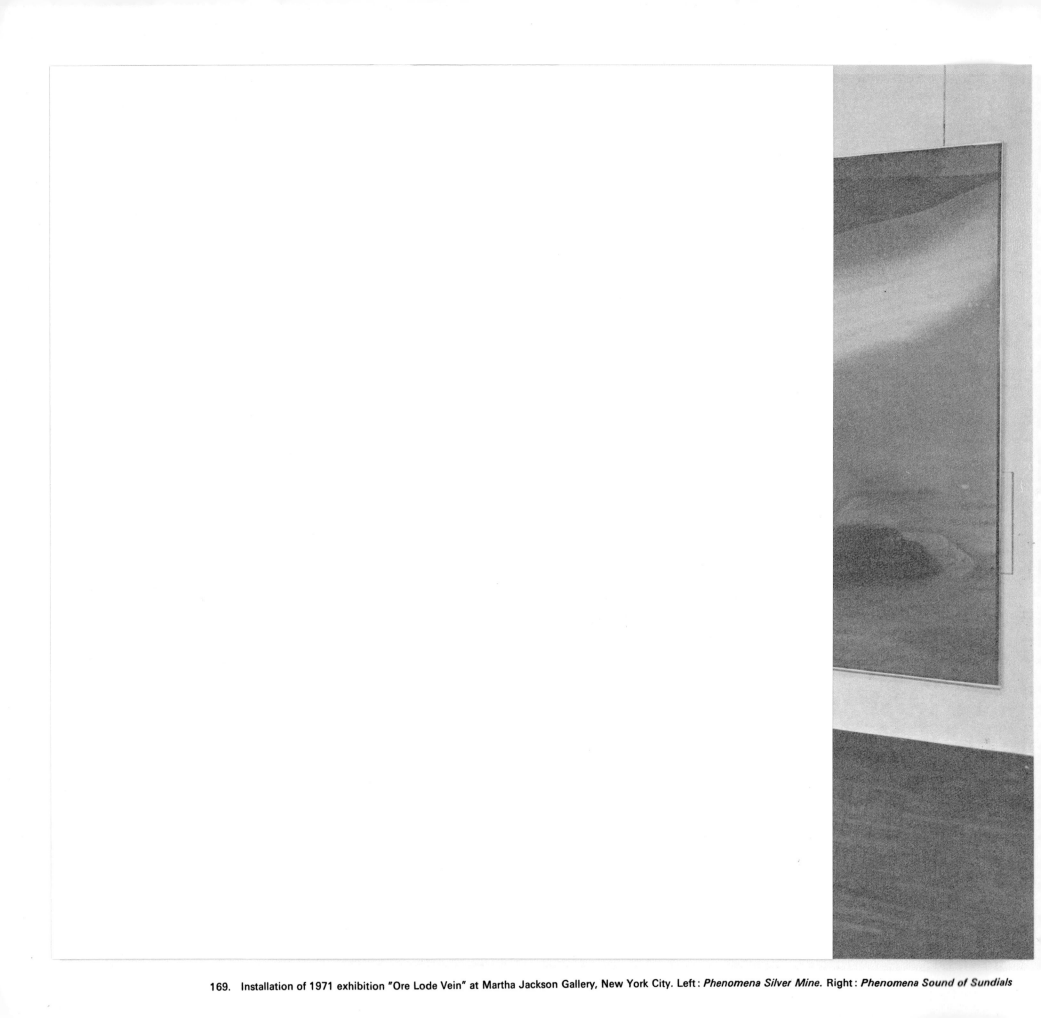

169. Installation of 1971 exhibition "Ore Lode Vein" at Martha Jackson Gallery, New York City. Left: *Phenomena Silver Mine*. Right: *Phenomena Sound of Sundials*

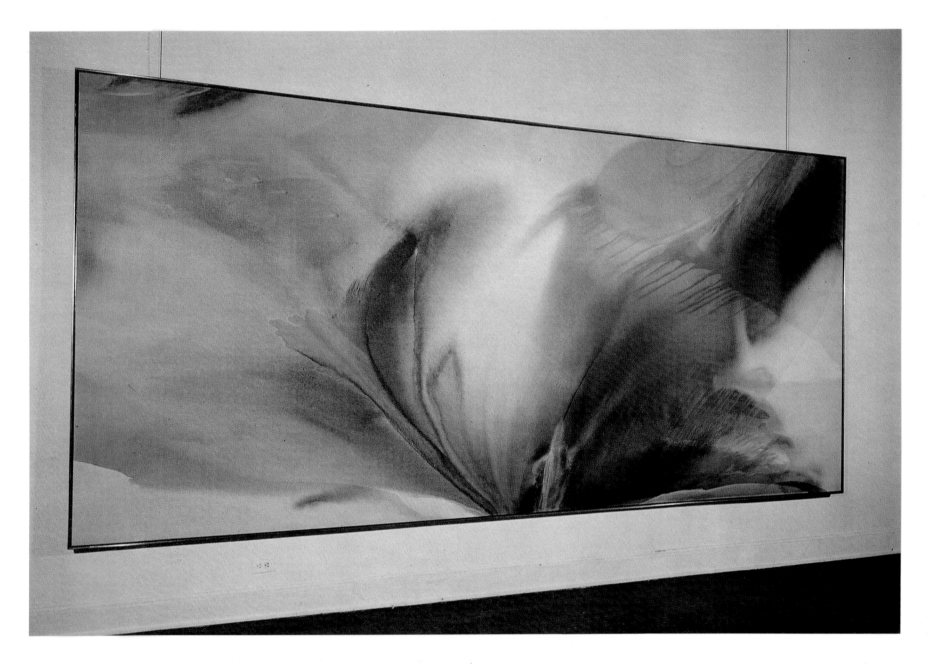

170. *Phenomena Divining Rod.* 1971. Acrylic on canvas, 7′ × 15′. Corcoran Gallery of Art, Washington, D.C.

.171. Photograph of the artist by Shunk-Kender. 1963

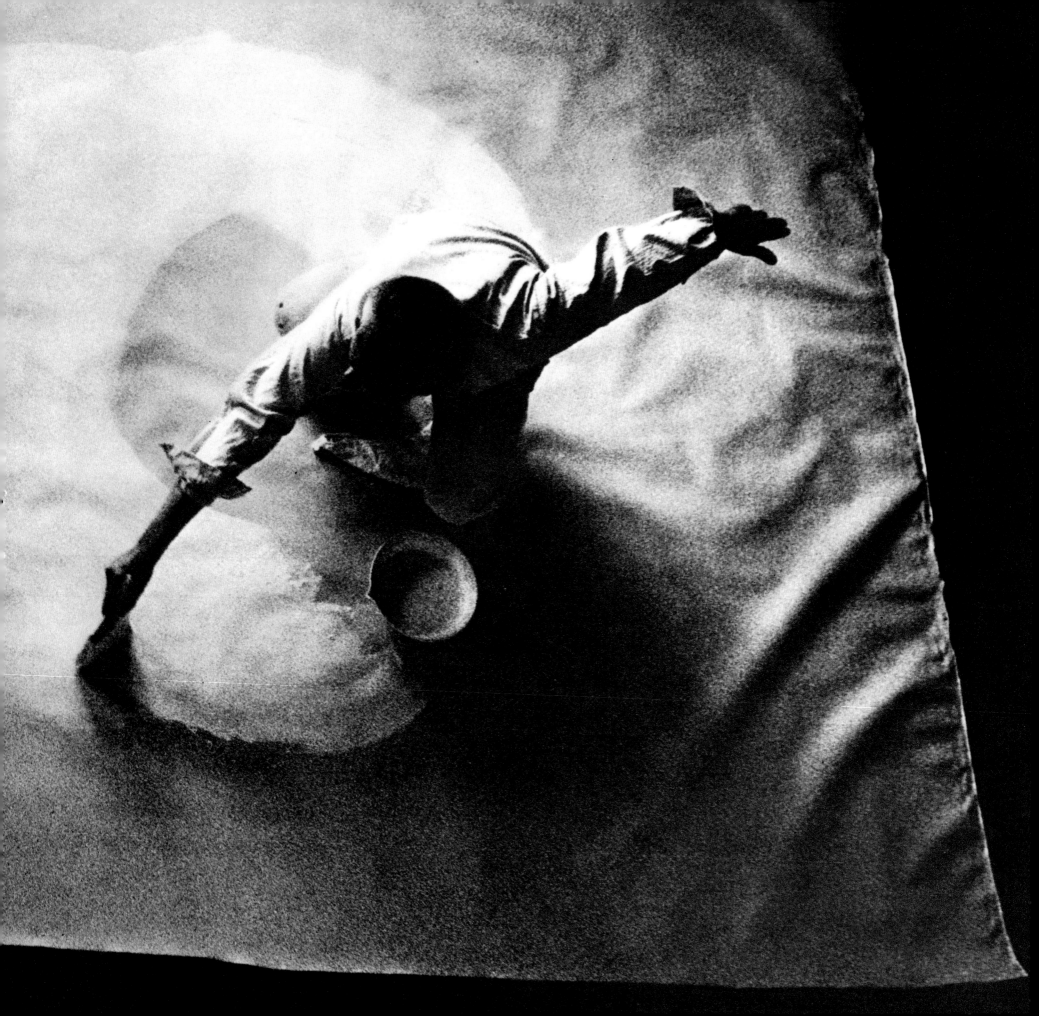

1923 William Paul Jenkins is born July 12 in Kansas City, Missouri, to Nadyne Fellers and William Burris Jenkins. His father is in real estate, his mother is a newspaper publisher and journalist.

1937–42 Graduates from Norman Grade School in Kansas City. Receives a fellowship to attend the Kansas City Art Institute. Attends Westport Junior High School, where he is encouraged by his English drama teacher, Marjorie Patterson, to explore poetry, writing, and drama. Constantly visits William Rockhill Nelson Gallery. During the summers, continues his studies at the Kansas City Art Institute. Works in a ceramic factory with ceramist James Weldon.

1943–46 Works at the Youngstown Playhouse. After graduating from Struthers High School, Ohio, acts professionally at the Cain Park Theater. Is awarded a fellowship to the Cleveland Playhouse. Enters the United States Naval Air Corps, serves as a pharmacist's mate.

1944 Marries Esther Ebonhoe, a scene and costume designer for the Pittsburgh Playhouse.

1945–48 After his discharge from the Service in the spring of 1945 he attends a playwriting course at Carnegie Institute of Technology. During this period he continues to paint in oils without formal training.

1948–52 Moves to New York City to attend the Art Students League. During his four years at the League, studies with Yasuo Kuniyoshi, Morris Kantor, Charles Alston, John Carroll, and Byron Browne. Studies with Kuniyoshi for the entire four years. Meets Matsumi Kanemitsu and Daniel Maloney. Introduced to the teachings of G. I. Gurdjieff in P. D. Ouspensky's *In Search of the Miraculous*, in which Gurdjieff delineates his concepts of "Objective Art." These theories haunt but at the same time create questions in Jenkins's mind that he does not resolve until later.

1953 January and February, travels to Italy, Sicily, and Spain; settles in Paris in March. Meets other American artists and finds a small apartment on Rue Notre Dame du Champ.

Meets Michel Tapié, the spokesman for the *Art Informel* group. Is greatly influenced by Carl Gustav Jung's *Psychology and Alchemy* and *I Ching: The Confucian Book of Changes*. In Vence visits the Matisse Chapel and is impressed by the simplicity of the stained-glass windows and the light that filters through them.

1954 March, first one-man show at the Studio Paul Facchetti, Paris. The text of the catalogue is written by the critic Edouard Jaguer. The critics Kenneth B. Sawyer of the *Paris Herald Tribune* and James Fitzsimmons of *Arts and Architecture* give this first one-man show serious attention.

April, establishes an atelier at 15 Rue Decrès, Paris 14. June, one-man show at Zimmergalerie Franck, Frankfort, Germany. Kenneth B. Sawyer writes the catalogue text. Participates in his first group show, "Divergences," at the Galerie Arnaud, Paris. Meets Martha Jackson and her son David Anderson in Paris. July 21, daughter Hilarie Paula Jenkins is born in Paris.

He begins to paint with Winsor Newton powdered pigments and Chrysochrome, a viscous enamel paint.

1955 First American one-man show, Zoe Dusanne Gallery, Seattle. The Seattle Art Museum is the first museum to purchase a Jenkins painting.

Meets George Wittenborn in New York City through Mark Tobey. Martha Jackson invites Jenkins to become a member of her new gallery at 32 East 69th Street, New York City.

1956 March, first one-man show in New York City, Martha Jackson Gallery. Catalogue text written by Kenneth B. Sawyer. From this show John I. H. Baur purchases *Divining Rod* for the Whitney Museum of American Art, New York City. *Observations of Michel Tapié*, edited by Esther and Paul Jenkins, is published by George Wittenborn.

Fall, returns to Paris, meets Peter Cochrane of Arthur Tooth and Sons, London, who invites him to exhibit in a group show, "The Exploration of

Paint," with Dubuffet, Appel, Francis, and Riopelle the following season.

1957 One-man show at Galerie Stadler, Paris; catalogue text written by Michel Tapié. From this show Peggy Guggenheim buys *Osage*, a large oil painting. Esther and Paul Jenkins are divorced. During the year, exchanges studios with Joan Mitchell; Jenkins takes her St. Mark's Place studio in New York and she takes his studio at 15 Rue Decrès, Paris. In New York visits Clement Greenberg's Bank Street apartment and sees the paintings that Morris Louis completed in the winter of 1954.

1958 Starts *Eyes of the Dove* series at St. Mark's Place studio. November, one-man show, Martha Jackson Gallery. Joseph H. Hirshhorn buys the painting *Dakota Ridge* from this show.

Meets James and Gloria Jones at Dr. Daniel T. Schneider's house in New York. Is given an ivory Eskimo knife by Alice Baber. This and other ivory knives are later used as tools in his painting.

1959 One-man show, Galerie Stadler, Paris. In a catalogue statement Clement Greenberg writes of Jenkins: "One of the most individual painters of his time."

Philip Pavia gives Jenkins large quantities of Italian rag paper and encourages him to paint with watercolor. Jenkins begins to experiment with dry pigments suspended in acrimedium. Works in both oil and acrimedium. Begins to title his paintings *Phenomena* accompanied by an identifying word or phrase.

1960 Travels to Spain, meets Juan Eduardo Cirlot. Returns to Paris, where Norman Bluhm introduces him to Karl Flinker. Has the following one-man shows: Arthur Tooth and Sons, London; Martha Jackson Gallery, New York City; Esther Robles Gallery, Los Angeles (watercolors); Gallery of Realities, Taos, New Mexico.

1961 One-man show, Martha Jackson Gallery. First one-man show at Galerie Karl Flinker, Paris. Catalogue text by James Jones. *The Paintings of Paul Jenkins*, with texts by Kenneth B. Sawyer, Pierre Restany, and James Fitzsimmons, is published in Paris by Editions Two Cities.

Uses Joan Mitchell's studio at Rue Fremicourt, Paris; paints watercolors. Meets David Kluger and Mary Lasker, who become collectors of his work and donate works to major museums.

1962 Spring, meets Albert Elsen at the Rodin Museum, Paris. Meets Sheila and David Douglas Duncan in Paris. One-man shows in Zurich, Paris, Los Angeles, Milan, Rome, Cologne.

1963 In Paris David Douglas Duncan, using a prismatic spectrum lens, photographs Jenkins working. Publication of *Jenkins*, an interview text by Jean Cassou.

One-man shows in London, Paris, Stockholm.

1964 Marries the painter Alice Baber.

One-man shows in New York; Hanover, Germany; Copenhagen; New Delhi; Tokyo. In Tokyo he meets Jiro Yoshihara, who invites him to Osaka, where he and Alice Baber have a two-artist show with the Gutai Artists.

A film, *The Ivory Knife: Paul Jenkins at Work*, directed by Jules Engel and produced by Martha Jackson, is put into production.

1965 Travels to Madrid.

One-man shows in Paris and Detroit.

Seeing Voice Welsh Heart is published by Karl Flinker in Paris; it is printed by Fernand Mourlot and has six original color lithographs by Jenkins and seventeen poems by Cyril Hodges.

1966 Travels to Russia.

At a contributors' meeting the Museum of Modern Art has a showing of *The Ivory Knife*. The film is also shown at the Venice Film Festival and is awarded the Golden Eagle Award.

Gonthier in Paris publishes Jenkins's *Strike the Puma*, a full-length play started in 1958 and finished in 1965. One-man shows in New York; Montreal; Philadelphia; London; Scottsdale, Arizona.

1967 Decides not to have any one-man shows this year.

Does a series of lithographs at Pratt Graphics

with printer Juergen Fischer: *Passing Noon*, a four-color lithograph, and a black-and-white portfolio titled *Post Meridian*.

His play, *Strike the Puma*, is produced off-Broadway, directed by Vasek Simek.

1968 Begins a series of lithographs with Michael Knigin of Chiron Press.

Introduced by Mark Tobey to Venetian glass master Egidio Costantini in Venice. Begins to collaborate on glass sculptures with Costantini in Murano.

One-man shows in Paris; Toronto; Lucerne, Switzerland; New York.

1969 One-man exhibition at the Martha Jackson Gallery, New York. Does first "light graphic" with Harry Lerner of Triton Press, which is published by New York Graphics. Executes a "portfolio calendar" for Gilman Park of Universe Books.

Martha Jackson dies in Los Angeles, July 4.

1970 Completes a series of black-and-white lithographs, *Alternate Black and White Seven, 1970*, with Michael Knigin of Chiron Press.

One-man shows in New York and Detroit.

1971 Has his first retrospective in an American museum, "Paul Jenkins Retrospective," at the Museum of Fine Arts, Houston; the catalogue text is written by Gerald Nordland; Universe Books publishes a hardbound edition.

One-man shows in New York; Chicago (watercolors); San Francisco (watercolors). *Art Gallery* magazine publishes an article on Jenkins by Jay Jacobs.

He sculpts from a nine-ton piece of French limestone for the Salk Institute, La Jolla, California (untitled), and is commissioned to do a stone piece for the City of New York. Commissioned to do *Sanctuary*, a "light graphic" (36 × 57"), for Abrams Original Editions, at Triton Press.

1972 Completes a series of lithographs, *The Four Seasons*, with printer Andrew Vlady for Abrams Original Editions.

One-man shows in New York City (graphics); San Francisco; Toledo, Ohio; London.

1973 One-man shows in New York City (watercolors) and Paris. The Santa Barbara Museum of Art has proposed an exhibition of watercolors and glass sculptures for the winter. The Corcoran Gallery, Washington, D.C., has proposed a major watercolor exhibition for the winter.

EXHIBITIONS

ONE-MAN EXHIBITIONS

1954 Studio Paul Facchetti, Paris.
Zimmergalerie Franck, Frankfort.
1955 Zoe Dusanne Gallery, Seattle.
1956 Martha Jackson Gallery, New York City.
1957 Galerie Stadler, Paris.
1958 Martha Jackson Gallery, New York City.
Arthur Tooth and Sons, London.
1959 Galerie Stadler, Paris.
1960 Arthur Tooth and Sons, London.
Martha Jackson Gallery, New York City.
Esther Robles Gallery, Los Angeles
(watercolors).
Gallery of Realities, Taos, New Mexico.
1961 Galerie Karl Flinker, Paris.
Martha Jackson Gallery, New York City.
1962 Galerie Charles Lienhard, Zurich.
Galerie Karl Flinker, Paris (watercolors).
Esther Robles Gallery, Los Angeles.
Galleria Toninelli Arte Moderna, Milan.
Galleria Odyssia, Rome.
Kunstverein, Cologne.
1963 Arthur Tooth and Sons, London.
Galerie Karl Flinker, Paris.
Galerie Eva de Buren, Stockholm.
1964 Tokyo Gallery, Tokyo.
Court Gallery, Copenhagen.
Kumar Gallery, New Delhi.
Martha Jackson Gallery, New York City.
Kestner-Gesellschaft, Hanover (first
European retrospective).
1965 Galerie Karl Flinker, Paris.
Gertrude Kasle Gallery, Detroit.
1966 Martha Jackson Gallery, New York City.
Galerie Agnes LeFort, Montreal.
Hope Makler Gallery, Philadelphia.
Arthur Tooth and Sons, London.
Gallery of Modern Art, Scottsdale,
Arizona.
1968 Galerie Daniel Gervis, Paris.
Moos Gallery, Toronto.
Galerie Raber, Lucerne, Switzerland.
Martha Jackson Gallery, New York City.

1969 Martha Jackson Gallery, New York City.
1970 Martha Jackson Gallery, New York City.
Gertrude Kasle Gallery, Detroit.
1971 Martha Jackson Gallery, New York City.
Richard Gray Gallery, Chicago
(watercolors).
Suzanne Saxe Gallery, San Francisco
(watercolors).
Museum of Fine Arts, Houston, Texas
(first American retrospective).
1972 San Francisco Museum of Art, San
Francisco (retrospective).
Images Gallery, Toledo, Ohio.
Gimpel Fils, London.
Abrams Original Editions, New York City
(first one-man graphics exhibition).
Corcoran Gallery of Art, Washington,
D.C. (watercolor retrospective)

GROUP EXHIBITIONS

1954 "Divergences," Galerie Arnaud, Paris.
1955 "Signes Autres," Galerie Rive Droit,
Paris.
"Artistes Etrangers en France," Petit
Palais, Paris.
"Kunst 1955," Saarlandmuseum,
Saarbrücken, Germany.
Galleria Spazio, Rome.
Martha Jackson Gallery, New York City.
1956 "Recent Drawings U.S.A.," Museum of
Modern Art, New York City.
Galerie Stadler, Paris.
Galerie Rive Droit, Paris.
"New Trends in Paintings," Arts Council
of Great Britain, London.
"Drawing in Black and White," Martha
Jackson Gallery, New York City.
"New Aspects of Space," Martha

277

Jackson Gallery, New York City.
"Forecasts," American Federation of Art (traveling exhibition).

1957 "The Exploration of Paint," Arthur Tooth and Sons, London.
"Orto Arte," Sala Gaspar, Barcelona and Madrid.
"Young America 1957," Whitney Museum of American Art, New York City.
"Post-Picasso Paris," Hanover Gallery, London.

1958 "Corcoran Biennial," Corcoran Gallery of Art, Washington, D.C.
"Carnegie Bicentennial International Exhibition of Contemporary American Painting and Sculpture," Carnegie Institute, Pittsburgh.
"Nature Abstracted," Whitney Museum of American Art, New York City.

1959 Kunstverein, Cologne.
"Arte Nuova," Turin Art Festival, Turin, Italy.
American Federation of Arts, Tokyo.
Gutai Festival, Osaka, Japan.
"Biennial Exhibition," Krannert Art Museum, University of Illinois, Champaign-Urbana.
"20th Biennial Watercolor Exhibition," Brooklyn Museum of Art, New York City.
"Recent Developments in Painting," Arthur Tooth and Sons, London.

1960 Galerie Neuf Ville, Paris.
Dwan Gallery, Los Angeles.
Galerie Karl Flinker, Paris.
"New Forms, New Media," Martha Jackson Gallery, New York City.
"Contemporary American Painting," Columbus Gallery of Fine Arts, Ohio.

1961 "Carnegie International," Carnegie Institute, Pittsburgh.
"Abstract Expressionists and Imagists,"

Solomon R. Guggenheim Museum, New York City.
"American Artists," United States Information Service, London.
"Contemporary American Painting and Sculpture," Krannert Art Museum, University of Illinois, Champaign-Urbana.
"Whitney Annual, 1961," Whitney Museum of American Art, New York City.

1962 "Watercolors," Thibaut Gallery, New York City.
Gallery Suzanne Bolag, Zurich.
"Paris Comparisons," The Louvre, Paris.
"Painting International," Martha Jackson Gallery, New York City.
"Salon du Mai," Musée d'Art Moderne, Paris.
"Whitney Annual, 1962," Whitney Museum of American Art, New York City.
"Seattle World's Fair," Seattle, Washington.
"American Art Since 1950," Poses Institute of Fine Arts and Institute of Contemporary Art, Brandeis University, Waltham, Massachusetts.
"Confrontation of the Object," Musée des Arts Décoratifs, Paris.
Galerie Dumont, Cologne, Germany.
"Gegenwart '62," Haus am Waldsee, Berlin.
"Recent Developments in Painting V," Arthur Tooth and Sons, London.

1963 "Réalités Nouvelles," Musée d'Art Moderne, Paris.
"American Artists A-Z," Art Institute of Chicago; American Cultural Center, Paris.
"66th Annual American Exhibition," Art Institute of Chicago.

"Watercolors International," Brooklyn Museum of Art, New York City.

"New Acquisitions," Solomon R. Guggenheim Museum, New York City.

"Eleven Americans," Martha Jackson Gallery, New York City.

"Art U.S.A. Now," Royal Academy of Arts, London (traveling exhibition to Tokyo; Washington, D.C.; and Amsterdam).

1964 "Painting and Sculpture of a Decade," Tate Gallery, London.

"Art U.S.A., Johnson Collection," Whitney Museum of American Art, New York City.

Gutai Museum, Osaka, Japan.

"The Peter Stuyvesant Collection," Amsterdam.

"The Larry Aldrich Contemporary Collection," The Aldrich Museum of Contemporary Art, Ridgefield, Connecticut.

"The Edward Joseph Gallagher III Memorial Collection," University of Arizona Art Gallery, Tucson.

Galerie Brusberg, Hanover, Germany.

1965 "Watercolors, Prints, and Drawings," Pennsylvania Academy of Fine Arts, Philadelphia.

"Painting and Sculpture Today," Herron Art Museum, Indianapolis, Indiana.

"Painting Without a Brush," Institute of Contemporary Art, Boston.

"Whitney Annual," Whitney Museum of American Art, New York City.

"8th International Biennial," Tokyo.

"Art Across America—The Mead Corporation Collection," Knoedler Gallery, New York City.

"Contemporary American Painting and Sculpture," Krannert Art Museum, University of Illinois, Champaign-Urbana.

"Abstract Watercolors by 14 Americans," Museum of Modern Art, New York City.

Gallery of Modern Art, Scottsdale, Arizona.

1966 "30th Biennial Exhibition," Corcoran Gallery of Art, Washington, D.C. (Jenkins wins silver medal for painting).

"American Landscape: Changing Frontier," Smithsonian Institution, Washington, D.C.

"Explosion Inaugurale," Galerie Lutèce, Paris.

"Maximum 12″ × 20″," Galerie Bonino, New York City.

"2nd Salon International," Galerie Pilotes, Lausanne, Switzerland.

1967 "The Art of Organic Form," National Museum of Natural History, Washington, D.C.

"Contemporary American Painting and Sculpture," Krannert Art Museum, University of Illinois, Champaign-Urbana.

"Dada, Surrealism, and Their Heritage," Museum of Modern Art, New York City.

"Seventeen Loves," "Selections for Museum Acquisition," and "A Christmas Show," Martha Jackson Gallery, New York City.

1968 "Icons and Ideas," circulated by the Smithsonian Institution, Washington, D.C.

"Loan Exhibition," Krannert Art Museum, University of Illinois, Champaign-Urbana.

"In Honor of Dr. Martin Luther King, Jr.," Museum of Modern Art, New York City.

"Group Exhibition," Martha Jackson Gallery, New York City.

Georgia Museum of Art, Athens, Georgia.

"Second Annual Invitational," Kent
State University, Kent, Ohio.
"Six Painters from Martha Jackson
Gallery," Fort Worth Art Center, Fort
Worth, Texas.
"Holland Festival," Gemeentemuseum,
The Hague.
"American Printmaking 1968," Guild
Hall, East Hampton, New York.

1969 "Scultura in Vetro della Fucina degli
Angeli," Venice.
"1969 Exhibition of Painting and
Sculpture," Indianapolis Association of
the Arts, Indianapolis.
Esther Bear Gallery, Santa Barbara.
"Art Collection of Owens-Corning,"
Toledo Museum, Toledo, Ohio.
"Paintings Courtesy of Martha Jackson"
John Bolles Gallery, San Francisco.
"Paintings from New York Art Galleries,"
Wilmington Society for the Arts,
Delaware Art Center, Wilmington,
Delaware.

1970 "From the Michener Collection," The
University of Texas, Austin.
"The Second Flint International," Flint
Institute of Art, Flint, Michigan.
"Trends in Twentieth Century Art,"
University of California at Santa
Barbara, Santa Barbara.
"Glass Sculpture of Fucina degli Angeli,"
Doge's Palace, Venice.
"The Director's Choice," Flint Institute of
Art, Flint, Michigan.

Galerie d'Art Moderne, Basel, Switzerland.
"The Recent Years," Montclair Art
Museum, Montclair, New Jersey.
"Inner Space," Compass Gallery, New
York City.
"American Painting 1970," Virginia Art
Museum, Richmond.
"1970 Midyear Show 35," The Butler
Institute of Art, Youngstown, Ohio.
"Annual Watermedia Painting Exhibition,"
Brooklyn Museum of Art, New York
City.
"Peinture Contemporaine," Musée des
Beaux Arts de Caen, Caen, France.

1971 "American Painting and Sculpture
1948–1969," Krannert Art Museum,
University of Illinois, Champaign-
Urbana.
"20th Century Painting from the New
York University Art Collection," Hudson
River Museum, Yonkers, New York.
"American Painting Since World War II,"
Delaware Museum, Wilmington.
"Kent Annual Invitational," Kent State
University, Kent, Ohio.
"Ceroli Multiple," Kolophon Gallery,
Milan, Italy.
"Art from the Chase Manhattan Bank
Collection," Finch College Museum,
New York City.
"International Sculpture Symposium of
New York," Cooper-Hewitt Museum of
Design, New York City.

BIBLIOGRAPHY

BY PAUL JENKINS (in chronological order)

Observations of Michel Tapié. Edited jointly with Esther E. Jenkins. New York: George Wittenborn, 1956.

"A Cahier Leaf," *It Is*, no. 2, Autumn 1958, p. 13.

"An Abstract Phenomenist," *The Painter and Sculptor*, Winter–Spring 1959, pp. 2–5.

"American Abstract Painting Is," *It Is*, no. 3, Winter–Spring 1959, pp. 8–9.

"Panel: Non-American Painting," *It Is*, no. 3, Winter–Spring 1959, pp. 77–78.

"A Reply to Purity," *It Is*, no. 5, Spring 1960, p. 40.

"Gustave Moreau: Moot Grandfather of Abstraction," *Art News*, vol. 60, no. 8, December 1961, pp. 46–48, 67–69, ill.

"Beauford Delaney: A Quiet Legend," *Art International*, vol. 6, no. 10, December 20, 1962.

Strike the Puma. Paris: Gonthier, 1966. A play.

"Jenkins Paints an Opinion," *Art News*, vol. 65, no. 7, November 1966, pp. 54–55, 73–75, ill.

"Giora's Room," unpublished article on the room Giora Novak created at Asia House, New York City. 1971.

BOOKS AND MONOGRAPHS

Arnason, H. H. *History of Modern Art*. New York: Harry N. Abrams, 1968, p. 623, ill.

Berckelaers, Ferdinand Louis. *Dictionary of Abstract Painting*. New York: Tudor, 1957. (ill.: *Solstice*)

———. *Dictionary of Abstract Painting with a History of Abstract Painting*. New York: Paris Book Center, 1958, p. 194.

———. *Ein halbes Jahrhundert abstracte Malerei*. Munich and Zurich: Droemer-Knaur, 1962, pp. 276, 306. Biographical notes. (ill.: *Phenomena Fly Sandman*)

Cassou, Jean. *Jenkins*. Paris: Editions de la Galerie Karl Flinker, 1963.

Cummings, Paul. *A Dictionary of Contemporary American Artists*. New York: St. Martin's Press, 1966, p. 156, ill.

2e Salon International de Galeries Pilotes Lausanne. Lausanne: Musée Cantonal des Beaux-Arts, 1966, pp. 133, 140. (ill.: *Phenomena Soothsayer*)

Elliot, George P. "Lascaux and Jenkins," *14 Poems*. Lanham, Maryland: Goosetree Press, 1964.

Hodges, Cyril. *Seeing Voice Welsh Heart*. Paris: Karl Flinker Gallery, 1965. (six original lithographs by Paul Jenkins)

Janson, H. W. *History of Art*. New York: Harry N. Abrams. New and enlarged ed., 1969, p. 541, pl. 81.

Matusow, Marshall. *The Art Collectors Almanac, No. 1, 1965*. Huntington, Long Island: Jerome E. Treisman, 1965, p. 276. Biographical notes. (ill.: *Phenomena Reverse Spell*)

Nordness, Lee, ed., and Weller, Allen S. *Art USA Now*. New York: Viking, 1962, vol. 2, pp. 384–87. Biographical notes by Roland F. Pease, Jr. (ill.: *Brayen Vessel, The Prophecy, Lunar Moth*)

1er Salon International de Galeries Pilotes Lausanne. Lausanne: Musée Cantonal des Beaux-Arts, 1963, pp. 88, 95. (ill.: *Natchez Trace*)

Rosenberg, Harold. *The De-Definition of Art*. New York: Horizon Press, 1972. (ill.: *Phenomena Grisaille*)

Sawyer, Kenneth B.; Restany, Pierre; and Fitzsimmons, James. *The Paintings of Paul Jenkins*. Paris: Editions Two Cities, 1961.

Weller, Allen S. *The Joys and Sorrows of Recent American Art*. Urbana: University of Illinois Press, 1968, pp. 68, 87, pl. 67. (*Phenomena Point Swing and Flank* reproduced on cover in color)

ARTICLES AND REVIEWS
(in chronological order)

Fitzsimmons, James. "Art," *Arts and Architecture,* May 1954, p. 30, ill. p. 8.

"Avant-garde in Paris," *Arts,* vol. 29, June 1955.

Hagen, Yvonne. "Art Notes," *Herald Tribune, Paris Edition,* March 31, 1956.

"First New York One-man Show at Jackson Gallery," *Arts,* vol. 30, no. 61, March 1956.

"Exhibition at Jackson Gallery," *Art News,* vol. 55, no. 86, April 1956.

Ashton, Dore. "Avant-garde Champion," review of *Observations of Michel Tapié, The New York Times Book Review,* May 20, 1956.

"Exhibition at Tooth's Gallery," *Architectural Review,* vol. 121, no. 270, April 1957.

"Exhibition Galerie Stadler," *Apollo,* vol. 65, no. 185, May 1957.

"Exhibition at Jackson," *Art News,* vol. 57, no. 16, November 1958.

"One-man Show at Jackson," *Arts,* vol. 33, no. 57, November 1958.

"Paul Jenkins chez Martha Jackson," *France-Amérique,* November 2, 1958.

Shubert, Hannelore. "Kunstausstellungen im Rheinland," *Das Kunstwerk,* vol. 13, no. 1, July 1959, p. 29.

Rubin, William S. "Younger American Painters," *Art International,* January 1960, pp. 24–31, ill.

Alloway, Lawrence. "Is Paul Jenkins Surrealist?" *Art News and Review,* March 1960, p. 3.

"Visions of Space," *New York Times,* March 23, 1960.

Strauss, M. "London Exhibition," *Burlington Magazine,* vol. 102, no. 177, April 1960.

"Exhibition Jackson Gallery," *Arts,* vol. 34, no. 53, June 1960. (ill.: *Phenomena with Nitrogen*)

Whittet, G. S. "Exhibition in London," *Studio,* vol. 159, no. 222, June 1960.

"Exhibition Jackson Gallery," *Art News,* vol. 59, no. 15, Summer 1960.

Hodin, J. P. "Grande-Bretagne: La Saison Londonienne," *Quadrum,* no. 9, Summer 1960, p. 178.

Jones, James. "Moving Shapes Without Name," *Art International,* March 1961, pp. 22–26, ill.

Time Magazine, April 17, 1961, p. 68. Review with black-and-white reproductions.

"Les Expositions à Paris," *Aujourd'hui,* vol. 5, no. 37, May 1961.

Mellquist, J. "Paris Advances in Sculpture and Painting," *Apollo,* May 1961, p. 150.

Michelson, A. "American Month in Paris," *Arts,* vol. 35, no. 19, May 1961.

"Exhibition Jackson Gallery," *Art News,* vol. 60, no. 17, November 1961. (ill.: *Phenomena Tide Finder*)

Raynor, Vivien. "Exhibition Jackson Gallery," *Arts,* vol. 36, no. 47, November 1961.

"A Source of Wonder in Watercolor," *New York Times,* Sunday, January 16, 1962.

"Les Expositions à Paris," *Aujourd'hui,* vol. 6, no. 39, February 1962. (ill.: *Phenomena Ultra Looking Glass*)

Schneider, Pierre. "Watercolors," *Art News,* March 1962.

"Ausstellung in Zürich," *Das Kunstwerk,* vol. 49, sup. 113, May 1962.

Sutton, Keith. "Chromatic Phenomenology of Paul Jenkins," *Metro,* June 1962, pp. 50–59, ill.

Morucchio, B. "Paul Jenkins," *Aujourd'hui,* vol. 7, nos. 28–29, January 1963.

"Le Paysage," *Connaissance des Arts,* no. 132, February 1963, p. 69. (*Phenomena Falling Mountain* reproduced in color)

Cirlot, Juan Eduardo. "The World of Paul Jenkins," *Studio,* March 1963, pp. 106–9, ill.

Gordon, A. "Exhibition at Arthur Tooth and Sons," *Connoisseur,* vol. 152, no. 191, March 1963. (ill.: *Phenomena Blue Mound*)

Roberts, K. "Exhibition at Tooth's," *Burlington Magazine,* vol. 105, no. 179, April 1963.

Butor, Michel. "Conversation dans l'atelier avec

Paul Jenkins," *Cimaise*, ser. 10, no. 3, July–October 1963, pp. 14–21, ill.

Bayl, Friedrich. "Wohlbefinden in Mysterium," *Das Kunstwerk*, December 1963, pp. 24–26.

Colombo, J. R. "Paul Jenkins at the Gallery Moos, Toronto," *Canadian Art,* January–February 1964, p. 13, ill.

Elsen, Albert. "Paul Jenkins: The Marvels of Occurrence," *Art International*, vol. 8, no. 2, March 1964, pp. 66–70, ill.

Elsen, Albert E. "Paul Jenkins' *Phenomena Danger—Pass Left* (1964)," *Art Association of Indianapolis Bulletin, Herron Museum of Art*, June 1965, pp. 32–57.

"Exhibition at Jackson," *Art News*, vol. 63, no. 8, March 1964. (ill.: *Phenomena Telltale*)

Thwaites, John Anthony. "The New Image," *Arts*, May–June 1964, pp. 102–9, ill.

"Porträt," *Das Kunstwerk*, vol. 19, no. 50, April 1966.

Ballantine, Michael. "Jenkins Exhibition at Galerie Agnes LeFort," *Montreal Star*, September 1966.

"Exhibition at Jackson," *Art News*, vol. 65, no. 12, December 1966.

Rosenberg, Harold. "The Art World—the Nineteen Sixties: Time in the Museum," *The New Yorker*, July 29, 1967, pp. 76–82.

Eagle, J. "Artists as Collectors," *Art in America*, vol. 55, nos. 57–58, November 1967, pp. 54–63, ill.

"Exhibition at Jackson Gallery," *Art News*, vol. 67, no. 16, May 1968.

"Exhibition at Jackson Gallery," *Arts*, vol. 42, no. 59, June/Summer 1968.

Gallego, J. "Crónica de Paris," *Goya*, vol. 88, no. 237, January 1969.

"De Kooning—Other New York Art Shows," *This World*, Sunday, March 1, 1969.

"Exhibition Jackson Gallery," *Art News*, vol. 68, no. 29, March 1969.

"Exhibition Jackson Gallery," *Arts*, vol. 43, no. 24, March 1969.

"Images," *Arts*, March 1969, pp. 23–25, ill.

Mellow, J. R. "Exhibition Jackson Gallery," *Art International*, vol. 13, no. 56, May 1969.

Karshan, Donald. "Graphics '70: Paul Jenkins," *Art in America*, January–February 1970, pp. 48–51, ill. (includes an original offset lithograph printed by Triton Press in an edition of 50,000)

"Exhibition Jackson Gallery," *Art News*, vol. 69, no. 16, March 1970.

"Exhibition Jackson Gallery," *Arts*, vol. 44, no. 63, March 1970.

Ratcliff, C. "Exhibition Jackson Gallery," *Art International*, vol. 14, no. 80, May 1970.

Jacobs, Jay. "Paul Jenkins," *Art Gallery*, December 1971, pp. 41–56, ill.

"Ariel Art," *M.D. of Canada*, vol. 13, no. 4, April 1972, pp. 76–81, ill. p. 81.

EXHIBITION CATALOGUES

1954 Studio Paul Facchetti, Paris. *W. Paul Jenkins*. Text by Edouard Jaguer.

1956 Martha Jackson Gallery, New York City. *Paul Jenkins.*

1957 Galerie Stadler, Paris. *L'Oeuvre de Paul Jenkins.* Text by Michel Tapié.

Hanover Gallery, London. *Post-Picasso Paris* (cat. no. 27, ill.).

Arthur Tooth and Sons, London. *The Exploration of Paint.* Introduction by Lawrence Alloway.

Whitney Museum of American Art, New York City. *Young America 1957* (cat. nos. 36–39, ill.).

1958 Carnegie Institute, Pittsburgh. *The 1958 Pittsburgh Bicentennial International Exhibition of Contemporary Painting and Sculpture.*

The Corcoran Gallery of Art, Washington, D.C. *The Twenty-sixth Biennial Exhibition of Contemporary American Painting* (cat. no. 91).

1959 Krannert Art Museum, University of Illinois, Champaign-Urbana. *Contemporary American Painting and Sculpture* (cat. no. 57).

Galerie Stadler, Paris. *Paul Jenkins.* Statement by Clement Greenberg.

Arthur Tooth and Sons, London. *Paul Jenkins.* Text by Pierre Restany.

1960 Columbus Gallery of Fine Arts, Ohio. *Contemporary American Painting.*

Arthur Tooth and Sons, London. *Paul Jenkins' First London Exhibition* (erroneous title).

Walker Art Center, Minneapolis. *60 American Painters 1960* (cat. no. 29).

1961 Carnegie Institute, Pittsburgh. *The 1961 Pittsburgh International Exhibition of Contemporary Painting and Sculpture.* (cat. no. 181).

Solomon R. Guggenheim Museum, New York City. *American Abstract Expressionists and Imagists.* Text by H. Harvard Arnason (cat. no. 28, ill.).

Galerie Karl Flinker, Paris. *Moving Shapes Without Name.* Text by James Jones.

Krannert Art Museum, University of Illinois, Champaign-Urbana. *Contemporary American Painting and Sculpture* (p. 79, ill.).

1962 Galerie Charles Lienhard, Zurich. *Paul Jenkins.* Text by Irving Sandler.

The Poses Institute of Fine Arts, Brandeis University, Waltham, Massachusetts, and the Institute of Contemporary Art, Boston. *American Art Since 1950* (cat. no. 30).

Galleria Toninelli Arte Moderna, Milan. *Paul Jenkins.* Text by James Jones.

U.S.I.S. (United States Information Service). *Art USA Now* (traveling exhibition organized by Lee Nordness).

1963 The Art Institute of Chicago. *66th Annual American Exhibition: Directions in Contemporary Painting and Sculpture* (cat. nos. 35, 36, ill.).

Galerie Karl Flinker, Paris. *Paul Jenkins: Peintures récentes.*

Arthur Tooth and Sons, London. *Paul Jenkins.* Text by John Ashbery.

1964 Kestner-Gesellschaft, Hanover. *Paul Jenkins.* Texts by Werner Schmied, James Jones, Jean Cassou.

Tate Gallery, London. *Painting and Sculpture of a Decade, 1954–64* (cat. nos. 260, 261).

Tokyo Gallery, Tokyo. *Paul Jenkins Exhibition.* Text by Soichi Tominaga.

University of Arizona Art Gallery, Tucson. *The Edward Joseph Gallagher III Memorial Collection.*

1965 Mead Corporation, Dayton, Ohio. *Art Across America.* Circulated 1965–67 (cat. no. 18, ill.).

Krannert Art Museum, University of Illinois, Champaign-Urbana. *Contemporary American Painting and Sculpture,* pp. 92–93, ill.

1966 The Corcoran Gallery of Art, Washington, D.C. *30th Biennial Exhibition.* Jenkins was awarded the silver medal (cat. nos. 38–42, ill.).

1967 Krannert Art Museum, University of Illinois, Champaign-Urbana. *Contemporary American Painting and Sculpture* (cat. no. 46).

Carnegie Institute, Pittsburgh. *The 1967 Pittsburgh International Exhibition of Contemporary Painting and Sculpture.*

Martha Jackson Gallery, New York City. *Treasures from Inventory I: "Seventeen Loves."*

1968 The Museum of Modern Art, New York City. *Dada, Surrealism and Their Heritage.* Text by William S. Rubin.

National Museum of Natural History, Washington, D.C. *The Art of Organic Form.*

1969 Martha Jackson Gallery, New York City. *Paul Jenkins: New Paintings 1968–69.*

1970 Martha Jackson Gallery, New York City. *Paul Jenkins: New Paintings 1969–70.*

1971 Martha Jackson Gallery, New York City. *Paul Jenkins: New Paintings.*

1971-72 Museum of Fine Arts, Houston, and San Francisco Museum of Art. *Paul Jenkins: A Retrospective Exhibition.* Text by Gerald Nordland (ill.).